To me there is no past or future in art. If a work of art cannot live always in the present it must not be considered at all.
— Pablo Picasso

The first half of the twentieth century was witness to tremendous change. From the rise of the motor car to the invention of the computer, through devastating wars, political conflict and surging consumerism, this was the birth of the modern age. How could artists respond adequately to this new world?

From Pablo Picasso and Sonya Delaunay to Andy Warhol and Yayoi Kusama, Brandon Taylor introduces us to the friendships and rivalries, exhibitions and manifestoes that sparked radical approaches to art.

We hear artists in their own words and see their remarkable works and bold experiments, as they pushed the creative boundaries at a time of unprecedented turbulence.

Beautifully illustrated and wonderfully readable, this essential guide tells the story of how an international network of artists used their vision and ingenuity to navigate, protest and celebrate the modern world – and, in doing so, changed art forever.

to Roy

MAKE IT MODERN

from

Donald Taylor

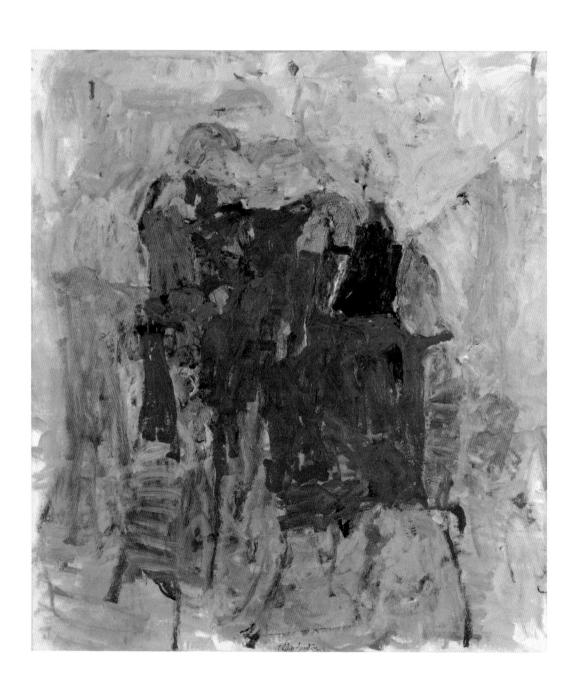

MAKE IT MODERN

A History of Art
in the 20th Century

Brandon Taylor

Yale University Press
New Haven and London

Contents

Preface

The art called 'modern' in this book belongs to a time roughly between the rise of the motor car and the invention of the computer – the half-century from 1910 to around 1965. Perhaps few periods in Western culture contain so many tensions: between technical and commercial sophistication on the one hand and social displacement on the other; between the promise of rising prosperity and the realities of actual poverty; between the city and the country; between hope and despair; all against a backdrop of international tension on a nearly unprecedented scale. How were visual artists to navigate these patterns of headlong change?

It comes as no surprise to find that art itself in the period was prone to great diversity. The reader will be familiar with terms like Cubism, Expressionism and Surrealism, but there were many other style labels too. As early as 1925 a book was published titled *The Isms of Art: 1914–1924* that illustrated no fewer than seventeen art categories from that single ten-year period, presented in temporal sequence as if the new art was proliferating from year to year.[1] To the authors, two young artists, the implication was of a kind of Darwinian logic within modern art, one of enthusiastic procreation followed quickly by germination, maturity and replacement by younger and more relevant growth. They would be surprised, I think – even troubled – to learn how well those seventeen terms have survived, as well as how challenging it remains, a full century later, to properly understand them today.

Nowadays, of course, we no longer assume that modern art unfolded evolutionarily, in the sense of developing organically from within. The reason is clear. All art properly so-called must be responsive to events beyond the studio; events that intrude with often dramatic and unpredictable force. In the present case, two world wars, economic fortunes and misfortunes, the struggle of many Western nations for definition and redefinition, all set the tone for what the modern artist reckoned to be fitting for the times. Remember too that aside from war and ideology, the developed world was suddenly one of remarkable things: of aeroplanes, motor cars and telephones; of smoking factories, blast furnaces and mass production lines; of photography, film, radio and eventually television, all of them powerful technologies that changed irreversibly the tenor of everyday life for the majority. It was in such a context that the most basic questions began to form themselves. What was modern experience really like? What was a modern object? A modern image? A modern technique of art? What position should the artist try to occupy in the changing social landscape of the day?

To the latter question the answer is at least partially clear. The injunction to 'make it modern' always carried a certain risk. On the whole, the self-consciously modern artist would urge their immediate publics to resist the pull of familiarity, to see the contemporary world as one of ambiguity and paradox, to be apprehended in a spirit of experiment, of freedom from norms. The risks would be many, and the likelihood of disapproval great. Yet a conviction in the timeliness of the newest work would eventually carry the day. The modern artist may well have reached beyond popular expectation, but this was absolutely necessary, if art in the modern period was to meet the needs of a particular present – as well as suggest the shape of things to come.

The 1910s:
When Human
Nature Changed

The years before and during the First World War must be reckoned among the most turbulent in the history of the West. Everything seemed to be in motion. The transfer of large populations from the countryside to the cities, the rise of international competition to industrialise and rearm, a barrage of new discoveries in literature, technology and the sciences – all this belongs to a period of invention but also of instability. Travel and information flow accelerated together. Older patterns of sociability seemed to be under threat. A young artist attempting to make headway in the period would need to ask him- or herself – and did ask – what techniques of art would need revising, not only to comprehend the new environment but also to articulate it. By 1910 Impressionist painting was widely felt to be exhausted. The world could no longer be understood as – to use the poet Baudelaire's phrase – a 'transitory and fugitive' spectacle, to be rendered as light and movement alone. Urban life was becoming mechanised – for good or ill. Nor could such a world be captured in the practices known as Post-Impressionism, in which different forms of escape had been tried: escape to the countryside, or to the presumed simplicities of Europe's remote colonies, even an imagined Orient. Soon after the start of the new decade such yearnings would be overtaken by the puzzling mechanics of the Cubist style, one of analysis, fragmentation and tentative reconstruction of the visible world. Yet this development was contestable too. Centred in Paris (at this stage still the capital of modern art), Cubism was obliged to share its territory with a manner called Futurism – a term with almost as many meanings – that, like Cubism, would undergo many modifications throughout the years of the First World War. In the meantime, a manner known as Expressionism – for the most part German – would plumb the intensities of that nation's Romantic past.

Perhaps few events in modern history can be compared in futility and shame with the conflict that opened in August 1914. By the time of its grisly end four years later – five years if we count the prolongation of the Armistice negotiations into 1919 – three once powerful empires had vanished from the map: the Austro-Hungarian Empire to the south, riven by disputes in the Balkans; the German Empire to the north, destroyed by its ambitions to challenge entrapment by its neighbours France and Russia; and the Russian Empire itself, already wounded in the revolution of 1905 and then destroyed with finality in 1917. Looking back a few years later, the writer Virginia Woolf reflected that 'on or about December 1910 human character changed' – or 'human relations', as she also put it.[1] It was as clear to her then as it is now that, in the unfolding circumstances, the task of art was to change too.

CHAPTER 1

The Impulse to Express

Throughout Europe in the years before the First World War the art of mainly younger artists underwent a very particular kind of change. Studio talk as well as more public announcements began to reveal ambitions for some altogether new kinds of work. To observers it was soon clear that those ambitions included an urge to revisit the means as well as the subjects of art; to return to what the artists believed were lost simplicities; to revive older or more distant habits of directness and intensity; above all, to forget about copying nature faithfully, as if that alone was significant or real.

Spiritual or emotional freshness was undoubtedly one aim of the gathering trend. Yet the terms of this 'return' were not uniform across the nations of Europe. When in 1905 a group of artists in the north German city of Dresden began to associate under the name Die Brücke (The Bridge), their declared concern was to assert independence from the teaching academies of the day and to elevate specifically German sensibilities over and against the priorities most usually accorded in art by the French. For the Brücke artists Ernst Ludwig Kirchner, Erich Haeckel, Karl Schmidt-Rotluff and Fritz Bleyl – joined by a fifth member, Max Pechstein, in 1906, and a sixth, Emil Nolde, who joined briefly during 1906–7 – the new attitude required a roughening of the delicate divided-colour techniques of French Impressionist painting in an almost artisanal manner: using broader brushes and often crude – by comparison – techniques of composition and design. In discarding nuance, 'sensitivity', or any particular desire to please, Brücke artists were in effect attempting to exchange one intended viewing audience for another. 'As youth,' a woodcut announcement of the group read, 'we carry the future and want to create for ourselves freedom of life and movement against long-established older forces. Anyone driven to create with directness and authenticity belongs to us.' The woodcut medium was ideal for exhibition announcements too (**fig. 1.1**).[1] Nor were Die Brücke paintings and graphic works intended to appeal to the 'correct' social world of the professions, military duty and church attendance – rather to a pattern of life away from the towns and cities where new kinds of behaviour could be tried. The resources for such an escape attempt were not difficult to find. Perhaps it was the writings of Friedrich Nietzsche that helped the Brücke artists develop the defiance and optimism that their paintings reveal, even supplied the image of 'he who is a bridge' between subservience to given conditions and an exhilarating state of freedom.[2]

Easier to confirm is that Kirchner and his colleagues would make repeated visits to the Dresden Ethnographical Collections, at the time among Europe's largest collections of artefacts from Africa and Oceania, and indulge their interest in the works of cultures

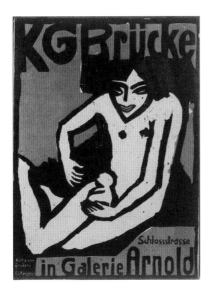

remote from their own – German colonies, primarily, but also the cultures of India, Japan and China that were fast becoming the focus of the West European gaze. A third circumstance is that there already existed in Germany so-called Wandervogel (Roaming Bird) groups, devoted to walking in the countryside, wearing loose-fitting clothes – or none – camping, dancing and folk song; activities undertaken both as a 'return' to rootedness in the natural world and at the same time a 'way forward' towards less decorated and less complex social patterns of life. Whether as 'return' or 'advance', as 'going beneath' or 'going over': in whatever spatial or temporal metaphor, Brücke sensibility marked a rupture between the artifice of conventional life in the fast-expanding cities and a more primal existence beyond them. In such a frame of mind, the Brücke painters visited the Moritzburg Lakes to the north of Dresden, returning with material for paintings, etchings and woodcuts documentary of the – sometimes private, often crowded – Wandervogel life, one in which honest nakedness rather than erotic pleasure seems to have been the dominant key (**fig. 1.2**).

For all their communal wanderlust, the Brücke artists were of unequal temperament and varying ambition. By 1908 some of them were beginning to respond to the attractions of Berlin, by now a crowded and dynamic city of some 3.5 million (and growing) but also a place in which to ply the dealer network, research exhibition opportunities and explore possibilities for international exchange. A seventh member, Otto Mueller, joined the group there in 1910. Yet Die Brücke as an association had to face rejection when attempting to exhibit *en masse*. It seems that Haeckel and Kirchner alone found the city environment conducive. Kirchner's own graphic style underwent an immediate transition towards the Gothic, towards nervous linear marking, elongated figures and visually flattened crowd scenes, and above all, towards the predatory life of the streets. By 1911 or 1912 he was reacting to the fast-expanding city as a contradictory cauldron of modernity in which the individual must struggle to define behaviours that could truly be called 'free'. His paintings of street prostitutes and their clients in the Potsdamer Platz and other central areas seem to capture something of the sexual frisson of the contemporary city as well as reflect – and reflect on – the alienations of an increasingly commodified urban life (**fig. 1.3**).

The city as a cauldron of contradictions: such too was the experience of the painter Ludwig Meidner, from Silesia via an art training in Breslau, who after a brief time in Paris arrived in Berlin and inevitably encountered Kirchner and his Brücke colleagues. Meidner found that he had little sympathy with their work. He did not share their

1.1 Ernst Ludwig Kirchner, *Die Brücke Woodcut*, 1905–7.
Exhibition poster for the Brücke artists community
Dresden. Woodcut, 83 × 61 cm.

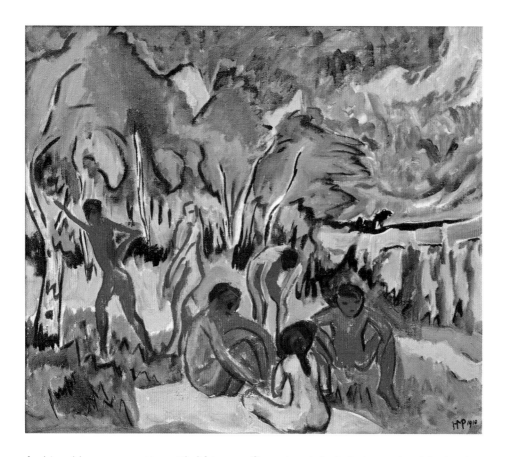

fashionable preoccupation with African or Oceanic artefacts but was struck instead by the city as a spectacle of noise, sight and sound, one that seemed to him to promise only wreckage and despair. Yet equally, his agitated paintings gather up the excitement of the city's cacophonous forms. 'We must learn to see more intensely and more honestly,' Meidner wrote in a credo of 1914. Even before the outbreak of war in August of that year his paintings were depicting the terrors of the conflict to come. 'Are not our big-city landscapes all battlefields filled with mathematical shapes? ... A street isn't made of tonal values but is a bombardment of whizzing rows of windows, or screeching lights ... a thousand jumping spheres, scraps of human beings, advertising signs, and shapeless colours ...' The city is 'our real homeland', as he expressed it, one of vivid exultation mixed with desperation and fear (**fig. 1.4**).[3]

Such responses to the life of the pre-war city stand at the opposite pole to images painted by Emil Nolde, whose project from the beginning was to mine the more archaic customs and mentalities of remote rural communities – and less frequently

1.2 (*above*) Max Pechstein, *Open Air (Bathers at Moritzburg)*, 1910. Oil on canvas, 70 × 80 cm, Wilhelm Lehmbruck Museum, Duisberg

1.3 (*opposite, left*) Ernst Ludwig Kirchner, *Berlin Street Scene*, 1913/14. Pastel, 40 × 30 cm. Brücke Museum, Berlin

1.4 (*opposite, right*) Ludwig Meidner, *Apocalyptic Vision*, 1912. Oil on canvas, 72.8 × 88.4 cm. Leicester Museum and Art Gallery

the bohemian life in Berlin, where his winter paintings were mostly done. Nolde was from the north German coastal area of Schleswig, near the Danish border, and his background and temperament led him to a fascination with the energies of dance: the dance festivals of the rural community, the play energy of children, and the spontaneous release of inhibitions among youthful inhabitants of the city. His paintings of the period were done rapidly, with broad brushes or else smudged with the fingers, in high-keyed colour within a tightly packed format of composition (**fig. 1.5**). Biblical themes, landscape in a raw state – such preoccupations lent to all of Nolde's practice an emotional intensity at once dark and celebratory. It would not be long before the term 'expression*ism*' was used to refer to specifically German attitudes to art and literature that added to Meidner's metropolitan darkness a sensibility to landscape, one rooted in the Romantic period of Germany's past.

Yet Germany was a nation of many parts, and further south, specifically in the Bavarian capital Munich, the mood among artists was very different. The Russian-born Vasili Kandinski had moved there in the 1890s and had witnessed the flowering of Jugendstil, an ornate nature-based visual language popular in both art and design. Aloof and cosmopolitan, Kandinski had formed his own artists' group, Phalanx, and in the early years of the new century spent time in Italy, Paris, Berlin, Switzerland and North Africa in connection with his own exhibitions as well as in pursuit of a conviction that colour *in itself*, severed from its descriptive functions, might supply the beginnings of a new attitude. It would be an outlook shared with music and poetry too. By 1908 Kandinski was living in Murnau, a village on the Staffelsee lake just south of the city, with his partner, the artist Gabriele Münter, and was at work on a series of paintings titled with the musical terms 'improvisation' and 'composition'. The fluid and sensuous character of these works (there would be ten *Compositions* and dozens of *Improvisations* throughout his long career) was engendered by a smudged painting technique combined with heightened and arbitrary-seeming colour. We know from five 'Letters from Munich' Kandinski wrote for the Russian art and literature magazine *Apollon* at the time that he viewed the mission of art to consist of a renunciation of 'external' nature in favour of what he calls 'the internal'. Van Gogh and Gauguin are

mentioned among those he considered forerunners. And 'one thing has led to another', Kandinski tells his Russian readers: 'Slowly, the inwardly necessary has assumed and continues to assume preponderance over the outwardly necessary, just as throughout the whole of our youthful culture the spiritual is beginning to outweigh the purely material.' He would reflect a few years later on his wish that the hand of the artist 'be not dependent upon reason, but rather, contrary to the dictates of reason, often creates what is correct of its own accord'. In another image, he says that the painter needs both logic and intuition, but 'under the control of the spirit [*der Geist*], without which an altogether proper work of art is impossible'. To a degree, these statements reflect his interest in the teachings of Theosophy, both fashionable and intellectually powerful at the time.[4] In a more technical vein, Kandinski spoke of 'dissolving' the objects in a picture in order to circumvent any verbal description – any remaining subservience to literature.[5] *Improvisation 9* is an example of the method (**fig. 1.6**). One sees a suggestion of standing figures, lower left, various approximately defined landscape forms, a castle, but little else that can be described – until we notice a horse and rider atop a hill, apparently in command of a view and in readiness to somehow conquer the territory that lies ahead. Kandinski affirmed that his horse-and-rider motif meant a figure who searches, who conquers, a seeker after the 'truth' of representation that only pure visual ciphers, intuitively assembled, could convey.

Despite Kandinski's declared aversion to verbal explanation, he soon had two important theoretical texts in preparation, which together have come to define a moment in the new art and a demonstration of the difficulties of its explanatory languages. Firstly, he had recently finished a piece of writing that would be published in late 1911 by Piper Verlag in Munich titled *Über das Geistige in der Kunst* (*Concerning the Spiritual in Art*), a long and rambling – but immediately influential – essay written to ensure that his ideas about 'inner necessity' would be discussed. Multiple analogies

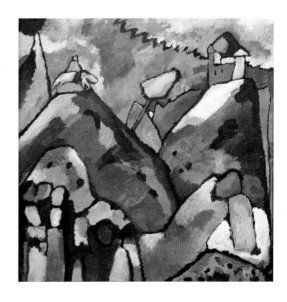

are explored between the resources of painting (colour, line, composition) and the rhythms of dance (including ballet) and music: their tones, combinations, colours and intensities, including their dissonances; all of which promised painting a place in 'an age of purposeful creation', one that would itself 'stand ... in a direct, organic relationship to the creation of a new spiritual realm'.[6] But secondly, Kandinski produced, this time with the painter Franz Marc, a compilation of new writings on art by a panoply of Russian, French and German artists and critics to accompany the second of two exhibitions in Munich titled *Der Blaue Reiter* (*The Blue Rider*) – the addition of 'blue' to Kandinski's rider motif signifying the spiritual (*das Geistige*) and even the ethereal beyond. *Der Blaue Reiter Almanac*, as it was called, of May 1912, is remarkable in its intellectual scope. It included speculations by Kandinski's new acquaintance, the composer and painter Arnold Schoenberg, musical compositions by Alban Berg and Anton von Webern, a vigorous attack on Russian academic art by the painter David Burlyuk, the script for a synaesthetic composition by Kandinski himself titled *Der Gelbe Klang* (*The Yellow Sound*) and an appreciative piece on the Paris artist Robert Delaunay, one of whose recent paintings was included in the second *Der Blaue Reiter* exhibition, in February of the same year. The Der Blaue Reiter phenomenon was one of the great syntheses of 'modern' thinking across the arts in Europe in the period immediately prior to the First World War.

By now, indeed by 1912, the term 'Expressionism' was increasingly in circulation among critics and writers familiar with the new circumstances of art. In common with other terms indicating an attitude or a visual style, it was given emphases not always audible in the words of artists themselves. In the present case, a wish to surpass the qualities of French art and especially Impressionism was paramount – and not only on account of the political tensions between that country and Germany. 'A real painterly

1.5 (*opposite*) Emil Nolde, *Wildly Dancing Children*, 1909. Oil on canvas, 73 × 88 cm. Kunsthalle, Kiel

1.6 (*above*) Vasili Kandinski, *Improvisation 9*, 1910. Oil on canvas, 110 × 110 cm. Staatsgalerie, Stuttgart

fervour can now replace the simple slice of nature,' wrote Paul Schmidt in the magazine *Der Sturm* in January 1912. Impressionism 'required attention to peripheral matters and so distracted rather than focussed one's attention'. The new agenda was to see with purity and intensity, to return to art's ancient mission 'to extract its works from nature according to higher laws'. The attitudes of those he called two 'Teutons' of the north and the south, the Norwegian Edvard Munch and the Swiss Ferdinand Hodler, he cited in his support.[7]

Meanwhile, in Paris, a city long regarded as the centre of art in Europe, changes had occurred that could also be viewed as a 'return' as well as a new beginning. 'What I am after, above all, is expression' – so wrote the painter Henri Matisse about his own artistic ambitions in 1908. Yet for him the term had come to mean, not a display of the artist's emotion or the intensity of his thought, rather an attribute of a painting itself once it was complete. Some three years earlier he had been nominated by the Paris critic Louis Vauxcelles as leader of 'les Fauves' ('the Wild Beasts'), artists working in the Mediterranean south who had begun to use *taches* (smudges) of brilliant hue that when counterposed to one another made for an intense – by comparison with Impressionism – assault upon the eye. For Matisse and his companion André Derain in 1905, an important location had been the environment of the coastal fishing village of Collioure, just north of the border with Spain (**fig. 1.7**). Here, Fauvism had become an early hallmark of a French but also a Mediterranean attitude to light and life. Yet in such a location it was far from being a violent manner, and Matisse was not a wild beast. The atmosphere he had aroused in his paintings was one of sophisticated pleasure, brought to a peak by careful pictorial construction and thoughtful means.

Born in 1869, hence older than the other Fauves, Matisse already had a reputation for resonant colour, abbreviation of form and subtle pictorial structure. By 1908 he was attracting attention internationally, which meant needing to defend his vivid style in words. And though the key term in his newest paintings was 'expression', he was concerned to distinguish it from the new art being practised above all in Germany. 'Expression does not reside in passions glowing in a human face or manifested by violent movement,' Matisse insisted. 'The *entire arrangement* of my pictures is expressive; the place occupied by the figures, the empty spaces around them, the proportions, everything has its share.' And the vehicle of expression for Matisse was 'composition' – as he put it, 'the art of arranging in a decorative manner the diverse elements at the painter's command'. Furthermore, a painting, a drawing or a sculpture must be crafted according to the shape, dimensions and scale of the materials used, such as to guarantee a kind of organic unity in which no element is superfluous. The larger task is that the painter must work, and rework, a given surface in order to 'give to reality a more lasting impression'. A snapshot, as he puts it in a neat put-down of a rival medium, 'reminds us of nothing that we have seen'.[8]

In sum, he now identified the real subject of a painting as nothing other than the effect of the whole. He had visited the French colony of Algeria in 1906, in search of the colours and rhythms of a different pattern of life, and had painted a *Blue Nude* that to

1.7 (*opposite, top*) Henri Matisse, *Landscape at Collioure*, 1905. Oil on canvas, 60 × 92 cm. Statens Museum of Art, Copenhagen

1.8 (*opposite, bottom*) Henri Matisse, *Blue Nude: Memory of Biskra*, 1907. Oil on canvas, 90.6 × 138 cm. Baltimore Museum of Art

some observers involved a distortion, even a corruption, of the female form (**fig. 1.8**). Did the *Blue Nude* inspire serenity and relaxation on account of its naked female form? On the contrary, Matisse explained to an interviewer, the painting itself is serene. 'If I met such a woman in the street, I should run away in terror ... I do not create a woman. *I make a picture* ...'[9] For him, the new qualities of Fauvist art and life were part of a wider *méditerranéisme* – a 'return' on the part of artists of the Paris north to the relentless sunshine and the primal forces of the ancient south. Out of such resources he now offered the following credo: to achieve 'an art of balance, of purity and serenity, devoid of troubling or depressing subject-matter, an art for every mental worker, for the business man as well as the man of letters ... something like a good armchair in which to relax from physical fatigue'.[10]

Not all northern painters who travelled to the Mediterranean can be said to have southernised their work. A young painter from Normandy, Georges Braque, had recently travelled to L'Estaque, a suburb of Marseilles, where Paul Cézanne had painted over sixty landscapes at various stages before his much lamented death in 1906. Braque had painted a group of works that rehearsed some of the spatial and formal devices Cézanne had used in responding to the wooded sea cliffs of L'Estaque – simultaneously flattening while also solidifying the visual scene. Yet on presenting a group of them to the Paris *Salon d'Automne* in October 1908, he was surprised to find that they were all turned down (**fig. 1.9**). In fact it was the verdict of none other than Matisse, who was on the jury. He had looked at Braque's new work and, speaking to the critic Louis Vauxcelles, with the help of a quick sketch of criss-cross lines on a scrap of paper had remarked that Braque's latest paintings were 'made of little cubes'.[11] Neither Vauxcelles nor Matisse had recognised that Braque had been responding to a different problem to Matisse's own. His L'Estaque paintings could not really be called landscapes. They show a collapsing of atmosphere and distance into a pattern of carved planes, crowded forward onto the picture surface, while the greens and limestone colours of L'Estaque are not intensified, rather reduced to basic tonal gradations and basic shapes, what would come to be called 'facets', as if chiselled. His new picture surfaces had been made to look somehow solid and enduring, as if the visual scene was searching for a definite form.

An exceptional artist from Spain was becoming part of this epistemological adventure too. In the two years since 1907 the young Pablo Picasso, by now a regular inhabitant of Paris but without a special taste for the city, had been drawing and painting in a manner he imagined was congruent with the carvings and ritual paintings of non-European countries, notably in Africa and Oceania, examples of which could be found in the Paris museums. Like others, he admired Gauguin, whose escape to the

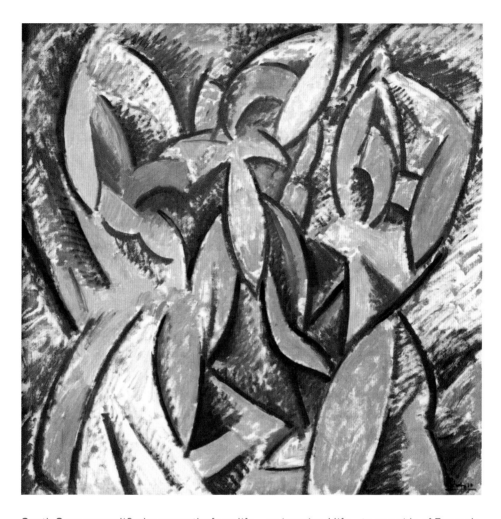

South Seas exemplified a sympathy for a life – an imagined life – to one side of Europe's new indulgence in technology and rapid communication. Yet Picasso's 'return' was achieved in his own way. His large painting *Three Women* of 1908–9, painted at the time of the Matisse–Braque debacle, shows a group of dancing or bathing females rendered in crudely constructed facets of orange and ochre, as if in evocation of some private, primal scene. In a study for the painting we see curving, sculpted slices of anatomy pulsing together, like the workings of an instinctual machine. There was a paradox here, of course; in turning away from the rhythms of the modern city, Picasso had reimagined them elsewhere, in bodies from a 'primitive' community very unlike his own **(fig. 1.10)**. It should be said, too, that 'primitivism' within Cubism's immediate milieu was a multiply coded term, whose meanings were not at all clearly debated at that time.[12] At least, it

1.9 (*opposite*) Georges Braque, *Houses at L'Estaque*, 1908. Oil on canvas, 92 × 60 cm. Hermann and Margrit Rupf Foundation, Kunstmuseum, Bern

1.10 (*above*) Pablo Picasso, *Three Women (Rhythmic Version)*, 1908. Oil on canvas, 91 × 91 cm. Sprengel Museum, Hanover

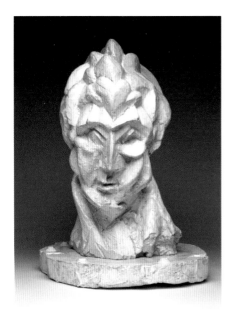

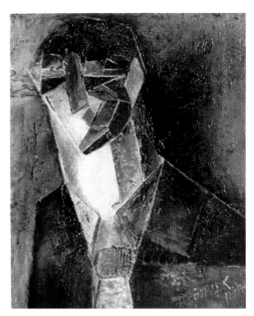

was as if, for Picasso as much as Braque at this stage, Matisse's idea of 'personality' had become recast as a set of carving and roughening procedures that created powerful rhythms within the work itself. By the spring of 1909 Picasso had begun to bring his new techniques indoors and apply them to matters much closer to hand and eye (**fig. 1.11**).

By 1910 reputations were spreading fast. Matisse, Picasso and other exponents of a roughened 'modern' manner were becoming notorious in Russia, from where many young artists had been coming to Paris to study since the turn of the century, even before. And by now, younger Russians were embarking on their own kinds of 'return', in both literature and poetry as well as in the visual arts. In the winter of 1910/11 the painter David Burlyuk with his two brothers Vladimir and Nikolai and their friend the linguist Benedikt Livshits formed a group calling itself Hylaea, the ancient name for part of the Kherson district in south Ukraine that had been the land of the Scythians, where mythological gods and heroes had once roamed. Hylaea soon included the experimental poets Aleksei Kruchenykh, Velimir Khlebnikov and Vladimir Mayakovski, united in a fascination for the roots of Russian dialects, the relation of the poetic image to sound alone, and on a visual level the relation of language meaning to the look of written script. Here was a kind of 'primitivism' that had little to do with overseas colonies or the imagined cultures of Africa and the south; rather, it was concerned with the historical customs and traditions of Russia's vast territories to the east. Of interest to Hylaea were such neglected forms as the *lubok* or wood-block print, children's art, peasant decoration

1.11 (*above, left*) Pablo Picasso, *Head of Fernande* (plaster version), 1909. Plaster, 47 × 35.9 × 34.9 cm. Nasher Sculpture Centre, Dallas

1.12 (*above, right*) Vladimir Burlyuk, *Portrait of Benedikt Livshits*, 1911. Oil on canvas, 45.7 × 35.5 cm. Leonard Hutton Galleries, New York

1.13 (*opposite*) Mikhail Larionov, *Soldier on Horseback*, c. 1911. Oil on canvas, 87 × 99 cm. Tate Gallery, London

and sign painting – the 'other' to urban culture and the means by which a new generation could make a new start. To Vladimir Burlyuk, almost any 'primitive' manner deserved a try (**fig. 1.12**).

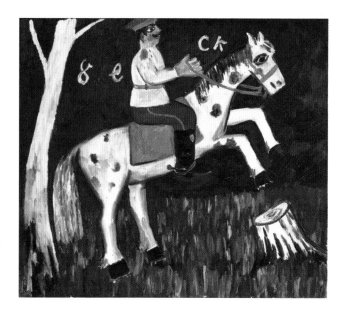

Such attitudes were spreading fast. The painter Mikhail Larionov, having trained under prestigious academic painters in Moscow at the turn of the century, by 1908 had also begun to urge a turn back, or away, from the methods of the academies towards those of the untutored, the artisanal or the materially poor. Village life, or soldiers with their horses, lent a new kind of authenticity to his art (**fig. 1.13**). In the late part of 1909 Larionov, his partner Natalya Goncharova and the painter Aristarkh Lentulov founded the Knave of Diamonds group, whose first exhibition in the winter of 1910/11 displayed their own 'primitive' work alongside that of a number of nascent French Cubists as well as Aleksei von Yavlenski and Kandinski, the latter both based in Munich.[13]

It was a moment of realisation among Larionov's group that national sensibilities were by no means everywhere the same. To the Russians it became clear that their own 'primitivism' signalled interests diverging fundamentally from those of Fauvist or Cubist idioms, or from what would shortly become the Munich Blaue Reiter style. 'We are called barbarians – Asians,' Knave of Diamonds member Aleksandr Shevchenko would write shortly. Shevchenko had trained with Larionov and was sympathetic to his thinking on Russia's Asian identity. 'And we are proud of this, because "Asia is the cradle of nations"; a good half of our blood is Tatar, and we hail the East to come, the source and cradle of all culture and of all arts ...' And Shevchenko would make a further emphasis, one destined to become central to what he preferred to call the 'neo-primitivism' of the new Russian art. 'We demand a good texture [*faktura*] from our works,' he wrote, 'the visual impression of a picture that is created by its surface – by brushstroke, density of paint, character of the painted layer, in a word, by everything that we see on the surface of the picture and that is related to its execution.'[14] It was an important elucidation as well as a statement of how 'Asian' feeling and *faktura* belonged together. A new sensibility had emerged. We shall see in due course how it would propel art in Russia fast, and very far.

CHAPTER 2

Futurism and Cubism

Back in Paris, another term had entered the language of art. On 11 February 1910 the Italian painter Gino Severini, living at that time in Montmartre and one of Picasso's near neighbours in the city, had put his name to a leaflet published in the northern Italian city of Milan titled 'Manifesto of the Futurist Painters'. Signed by four other artists, all but one under twenty-eight years of age, the document was a call to arms. 'We declare war on all artists and all institutions ensnared by tradition, academicism, and above all a nauseating mental laziness,' it declared.

> We must breathe in the tangible miracles of contemporary life, the iron network of speedy communications which envelops the earth, the transatlantic liners, the Dreadnoughts, those marvellous flights that furrow our skies ... How can we remain insensible to the frenetic life of our great cities and the exciting new sensations of nightlife?

As painters they would sweep the whole field of art clean of all themes and subjects that had been used in the past: 'Make room for youth, for violence, for daring!'[1] The sentiments were really those of Filippo Marinetti, a well-connected poet and dramatist who would leave a mark on modern culture like few others. He and his group were highly energised, and the manifesto was their chosen medium of publicity. Marinetti himself had launched Futurism the previous year in a two-part article in the Paris newspaper *Le Figaro*, and he and his group would publish dozens of manifestos over the next ten years, covering sculpture (Umberto Boccioni), variety theatre (Marinetti), photography (Anton Bragaglia), music (Balilla Pratella), architecture (Antonio Sant'Elia), the cinema (Bruno Corra), Futurist woman (Valentine de Saint-Point), noises and smells (Carlo Carrà), cookery (Marinetti again) and much more. The manifestos of Futurism collectively made it sound as if the whole edifice of European culture was tumbling down. And in a sense it was.

Impatience with his country's past was frequently Marinetti's appeal. 'We renounce old Venice, enfeebled by worldly luxury, foreigners, counterfeiting antiquarians, snobbery, universal imbecility and *passéisme*,' he shouted from the top of the Venice Clock Tower on one occasion. 'Let's murder the moonshine! ... All this absurd, abominable and irritating nonsense nauseates us.' To 'murder the moonshine' was to reject *amore*, a romantic conception of love and womanhood that the male Futurists now vowed to revise. The talented poet, painter, choreographer and playwright Valentine de Saint-Point agreed with them. Correcting Marinetti only slightly, she stated that in

fact conventional gender roles deserved equal scorn, that excessive masculinity and excessive femininity were both harmful. 'The fecund moments in history,' de Saint-Point wrote, 'are rich in both masculinity *and* femininity. What is lacking in men and women alike is virility, which is why Futurism, with all its exaggerations, is right.' She pressed the point further in a leaflet on *lussuria* (lust) as a Futurist force: '[W]hen lust clashes with sentimentality, lust is the victor,' she said. It is 'the joyous exultation that drives one beyond oneself, the headiest intoxication of conquest ... the quest of the flesh for the unknown'.[2]

The question was how to transfer these energies into a work of art. When the painters published a second, 'Technical Manifesto' in April 1910 they expressed enthusiasm for transparency and dynamism, for the glare of electric lights on rain-soaked pavements, for the rolling motions of motorised buses reflected in the buildings they were passing. The task of painting, they said, was not to paint an object by itself but 'you must render the whole of its surrounding atmosphere'.[3] Already a start had been made by Boccioni in his painting *Factories at Porta Romana* of 1908, which had treated light in a so-called Divisionist manner learnt from the Italian painters Gaetano Previati and Giovanni Segantini in which, following the French artists Paul Signac, Henri-Edmond Cross and Georges Seurat, they had fragmented light and colour into their components with the suggestion that 'simultaneous' optical sensation could be registered in the viewer's eye. The Futurists now explained how their own kind of simultaneity could be achieved. 'All things move, all things run,' the painters wrote, 'all things are rapidly changing. Moving objects constantly multiply themselves; their form changes like rapid vibrations in their mad career: a running horse has not four legs but twenty, and their movements are triangular.' The consequences were extreme. The new painting of Futurism would express 'our whirling life of pride, passion and speed ... Space itself no longer exists, since objects within it are transparent, inter-penetrating and dynamic'.[4] In his own paintings Boccioni went further still, claiming that a work of art must embody 'simultaneity of states of mind', even intoxicate the viewer by breaking open an object and simultanising everything inside and around it. In *Laughter* of 1911 (a subject seldom addressed by artists before him) he tried to capture the pleasurable discharge of bodily energy in a painting seemingly traversed by X-rays that penetrate the boundaries of solid things. *The Street Enters the House* of 1911 more successfully renders the simultaneity of places and things by fusing inner and outer consciousness, distances, proportions and angles of view, showing how time, movement and subjective consciousness could all be folded into a single painted image (**fig. 2.1**).

Perhaps the Italians could not have predicted that in the larger Paris community 'simultaneity' would become an artistic commitment on an altogether wider scale – albeit on very different terms. To begin with, the practice of carving and flattening the picture plane was already spreading rapidly among artists living in the western suburbs of Puteaux and Courbevoie – hence at a distance from Montmartre where Picasso, Braque and Severini worked and lived. This community, that included Henri Le Fauconnier, Jean Metzinger, Albert Gleizes, Aleksandr Archipenko, the three Duchamp brothers and Roger de La Fresnaye, was meeting to discuss questions of geometry in relation to the interplay of perception, space and time.[5] For some of them, theories of proportion including the puzzling ratio known as the Golden Section necessarily underlie any harmonious and universal design. Others noticed ideas of simultaneity as

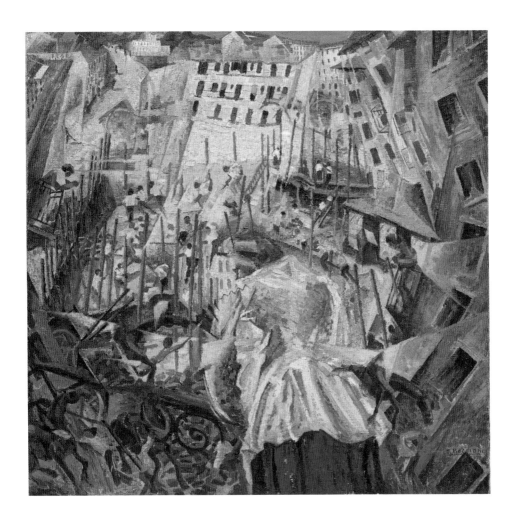

they had appeared in recent writings by the philosopher Henri Bergson, whose interests lay in how sensations constitute a permanent flux in consciousness that could be neither stable nor still. Gleizes, Metzinger and Le Fauconnier from the Puteaux group showed with three others, Fernand Léger, Robert Delaunay and Marie Laurencin, at the *Salon des Indépendants* exhibition in the spring of 1911 – in room 41 – to both critical excitement and public alarm. With that event 'Cubism' became a term of interest and derision alike, as well as a theoretically and practically complex method in art.

We can isolate Jean Metzinger, also a gifted writer, whose paintings of the time contain the suggestion of movement, both of a subject and of the painter relative to a subject. In one statement Metzinger claimed freedom from the photographer's static view in order to create an articulation of light and dark, in which 'the arrangement of the breaks creates the successive aspects, or rhythm' **(fig. 2.2)**. In an important book he and Albert Gleizes published at the end of 1912, those emphases were generalised. They spoke of 'dynamism' as a quality of form, of tactile and motor sensation; and by rejecting the rules of Pythagorean proportion and Euclidean geometry they undercut

the conventions of drawing in the plane that had lasted right up to the recent (and to many, highly puzzling) announcement of space–time relativity. They even recommended the simultaneous appearance in a picture of remote geographical realities, nature, history and desire. It was an attitude that bestowed new freedoms upon art. As they put it in a summary, 'nothing refuses to be said in the painter's tongue'.[6]

Meanwhile, 'simultaneity' was being handled very differently by Robert Delaunay and the painter and designer Sonya Delaunay-Terk. In Robert Delaunay's case it was taking the form of views across Paris painted from the vantage point of an elevated room. The artist would position himself before a window roughly the same shape as the upright rectangle of the canvas such as to afford a glimpse laterally across the city towards the Eiffel Tower, as well as downwards to smaller buildings and their rooftops far below (**fig. 2.3**). In part, such a composition was a patriotic nod to the great iron structure that had been completed to a fanfare of national celebration in March 1889 – but the Tower was also spatial transparency, a foil for light and colour effects as the weather passed across the sky. In Delaunay's work the same formula would produce some evanescent, purely colouristic effects the following year. A sequence of twenty-two paintings he started in the summer of 1912 bear titles like *Windows onto the City*, *Simultaneous Windows* or just *Windows*; and while some retain hints of window edges to left and right, painted steel tower rising in the centre, they achieve a scintillation of light and colour tones in which the steel tower itself almost disappears (**fig. 2.4**). Others would understand Delaunay's windows as affirmations of light alone. The critic

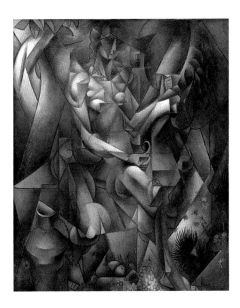

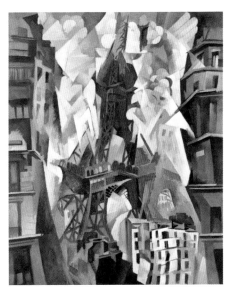

2.1 (*opposite*) Umberto Boccioni, *The Street Enters the House*, 1911. Oil on canvas, 100 × 100.6 cm. Sprengel Museum, Hanover

2.2 (*above, left*) Jean Metzinger, *Woman on Horseback*, 1911–12. Oil on canvas, 162 × 130.5 cm. Statens Museum of Art, Copenhagen

2.3 (*above, right*) Robert Delaunay, *Champs de Mars: The Red Tower*, 1911. Oil on canvas, 160.7 × 128.6 cm. The Art Institute of Chicago, Joseph Winterbotham Collection

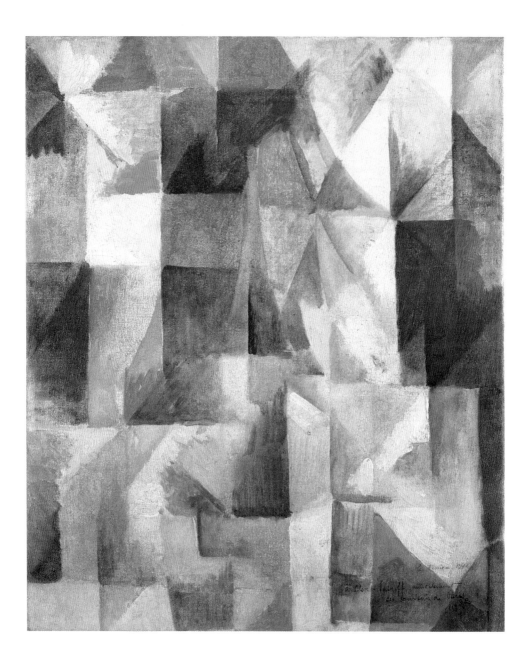

2.4 (*above*) Robert Delaunay, *Windows Open Simultaneously*, 1912. Oil on canvas, 45.7 × 37.5 cm. Tate Gallery, London

2.5 (*opposite*) Sonya Delaunay-Terk and Blaise Cendrars, *Prose of the Trans-Siberian and of Little Joan of France*, 1913. Illustrated book with pochoir and hand-painted parchment wrapper, 196.9 × 35.6 cm unfolded. Museum of Modern Art, New York

Guillaume Apollinaire, an enthusiast of most new art, christened these paintings 'Orphic Cubism' – soon just 'Orphism' – as if to imply a technique that was 'pure', that captured 'elements not borrowed from visual reality'.[7]

In other projects Cubism could become a visual-verbal display. One such, by Delaunay's wife Sonya Delaunay-Terk and the poet and writer Blaise Cendrars (born Frédéric Sauser, in Switzerland), was claimed to be the first simultaneous book, achieved by juxtaposing images and words. A long prose poem by Cendrars titled *La Prose du Transsibérien et de la Petite Jehanne de France* (*Prose of the Trans-Siberian and of Little Joan of France*) took the form of the internal monologue of the poet as he rode the train between Moscow and the Sea of Japan: in which past and present, distant and near, high and low, collide and interact in a manner both moody, erotic and despairing. Arranged vertically on a page measuring two metres when fully opened out, with a continuous stream of different typefaces echoed by swirling patterns and colour loops by Delaunay-Terk, the project exemplified an even more fully 'simultanist' cast of mind (**fig. 2.5**).[8] Delaunay-Terk and Cendrars delighted in pointing out that if all of their book's first edition of 150 copies were placed vertically end to end, they would equal the height of the Eiffel Tower.

But what of the Montmartre Cubists? From the outset Picasso had been hesitant about the simultaneity idea. Back in 1910 he had pondered how to develop the primitivising mannerisms of his recent art. Early in that year he took his faceting technique indoors, completing – among other things – painted portraits of the dealers Ambroise Vollard and Wilhelm Uhde in which those solid individuals are made to dissolve into the flickering atmosphere of the room spaces that enveloped them. Then, arriving at the northern Spanish village of Cadaqués for the summer, the Mediterranean light had seemed to dazzle him, dematerialising his subjects in pictorial articulations of atmosphere (**fig. 2.6**). It seemed an impasse. How to find his way back to the sheer presence of the world in front of him was the problem he now faced. He would not find an answer until the following year. At any rate, Cubism for him would have nothing to do with 'little cubes' at all.

From that point on it was the material and the immaterial that would exist in tension in his best work: witness the towering figure paintings such as *The Accordionist* or *The Poet*, painted in the Pyrenean town of Céret in the summer of 1911, or *The Aficionado* of 1912,

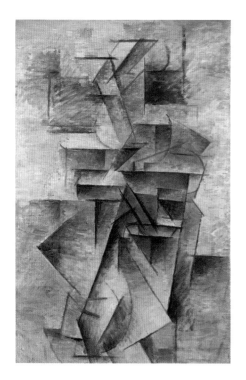

where we see the momentary and the enduring materialised in facets, lines and signlike incidents that signal a human presence – perhaps village characters that Picasso liked for their humour and humility (**fig. 2.7**). These figures seem nearby and palpably real. It is as if his rough-hewn sitters (if sitters there really were) are functioning now as the primitives of the contemporary world, whose physical mode of life and being was somehow continuous with the artist's manner of depicting them. They are not exactly portraits; yet Picasso would seldom paint persons or person substitutes that were not near to hand, even oppressively close, as if to place under scrutiny what it meant to enter a person's ambience and mode of being. In fact proximity rather than simultaneity for Picasso was the thing – and besides, neither he nor Braque liked talking about their art. Meanwhile, they declined to exhibit in the various Salons, and spoke about their work only in humorous or oblique terms. Severini recalled Picasso as 'the rascal from Malaga' on account of his easy virtuosity, his cunning artistic ways.[9] As for the Puteaux artists, they monopolised a smaller Cubist show in the *Salon d'Automne* of 1911. Picasso and Apollinaire, who visited the show together, are reported to have found the latest works of Le Fauconnier, Gleizes, Metzinger, La Fresnaye, André Lhote and Marcel Duchamp 'boring'.[10] Only Fernand Léger escaped their generally low regard.

By 1912 it was clear that the reputation of the new art was spreading internationally, that art collecting and the market for Cubist works were expanding fast. It meant that Cubist practice would have to change. By the early summer of 1912 Picasso and Braque were working in Avignon in the south, where Picasso's attachment to the life of the working man or woman meshed well with Braque's own house decorator background and prompted them both into some important new work. They began experimenting with tangible, flat substances such as patterned oilcloth, newspaper fragments and even *faux-bois* (wood-effect) wallpaper that they now incorporated into the surfaces of their works in a manner that became known as *collage* (literally 'gluing') (**fig. 2.8**). Certain paradoxes arose immediately. Did glued paper really belong to the surface it got stuck to, or did it always look like an interruption, an intrusion upon the sacrosanct conventions of art? What if the receptor surface already had drawing or painting on it? Does a stuck-on image function perceptually the same way a drawn or painted one does?

2.6 (*above*) Pablo Picasso, *Woman with a Mandolin*, summer 1910. Oil on canvas, 91.5 × 59 cm. Museum Ludwig, Cologne

2.7 (*opposite*) Pablo Picasso, *The Accordionist*, 1911. Oil on canvas, 130.2 × 89.5 cm. Guggenheim Museum, New York

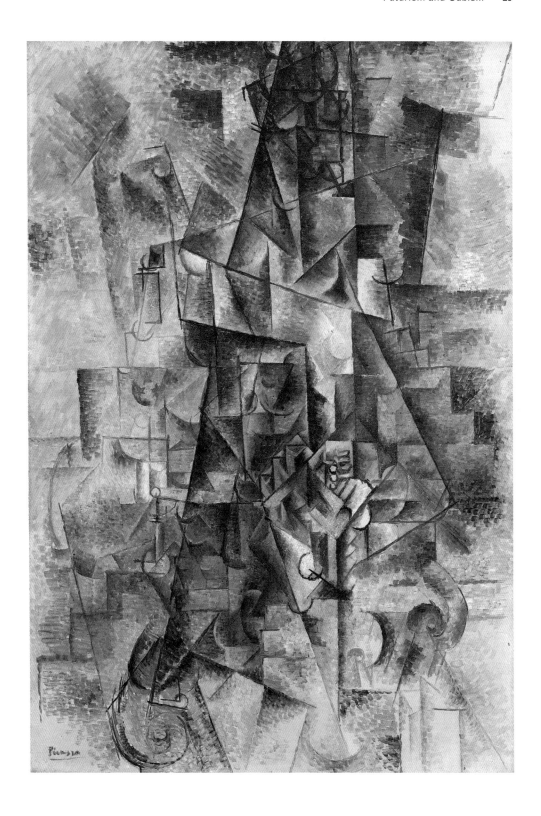

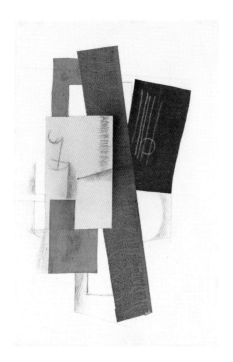

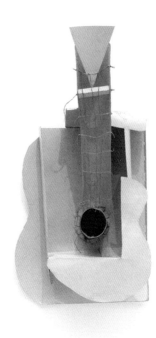

And is gluing essential to collage – or will pinning or stitching do? For both artists such questions were part of the experiment of art. Picasso even began to make objects that straddled the divide between physicality and simulated effect: a series of *Guitars* made of cardboard and string, or sheet metal and wire, that immediately took on the look of a body standing (if upright) or an instrument being played (if lying down) (**fig. 2.9**). What kinds of objects were they, and how was the viewer to negotiate a relation to the material combinations that they showed?

We are close to discussing sculpture, a category whose very survival seemed to be placed in question by such work. One contemporary technique was direct carving, either in wood or in stone, moving away from modelling shapes in clay or plaster in favour of working the stone itself to reveal a single form beneath. This way, a sculpture could be finished by the artist alone – unlike bronze casting – and direct carving would always show the qualities of the block it was made from. As practised in Paris by the Romanian Constantin Brâncuşi and the Italian Amadeo Modigliani, the method could produce sophisticated faceting in three dimensions, giving it the resonance of a non-European, even 'primitive', kind of work (**fig. 2.10**).

A second method, closer to Picasso's, was to take sheets of flat card, paper, fabric or tin and deploy them in an additive as opposed to a subtractive method, hence evacuating rather than intensifying a sculpture's solid core. Such was the

2.8 Georges Braque, *Guitar and Bottle*, 1913. Cut-and-pasted printed and painted paper, charcoal, pencil and gouache on canvas, 99.7 × 65.1 cm. Museum of Modern Art, New York

2.9 Pablo Picasso, *Maquette for Guitar*, 1912. Paperboard, paper, thread, string, twine and coated wire, 65.4 × 33 × 19 cm. Museum of Modern Art, New York

preoccupation of the Russian-born Aleksandr Archipenko, of Raymond Duchamp-Villon (whose career would be cut short by the war) and of Henri Laurens, who would eventually master a Picasso-like faceting technique for still-life objects doubling as a guitar or standing figure, or sometimes both. The young Lithuanian Jacques Lipchitz also understood the implications of Picasso's experiments in planar volume and materiality. For them all in their own way, mass and volume could be represented by its absence, by the gaps between things and the shadows that those gaps can cause (**fig. 2.11**).

Among the Italian Futurists the question of simultaneity and sculpture was important too. As early as 1912 Boccioni himself became obsessed with sculpture and paid visits to Archipenko, Brâncuşi and others to discuss various new ideas. His talk was now of the 'interpenetrating visual planes' that a sculptor as much as a painter might achieve.[11] His speculations bore fruit in a 'Technical Manifesto of Futurist Sculpture', published in the wake of a large Futurist painting exhibition that Marinetti organised in Paris in the early spring of 1912. Nothing short of the actual rhythm of movement was now Boccioni's goal, and in a group of new works he invoked a spiral form in the articulation, as he put it, 'not of the moving body's construction, but of its action'. Four works made initially in plaster created increasingly resolved demonstrations of how the spiral form blurs the body's musculature, clothing, even

2.10 Constantin Brâncuşi, *The Kiss*, 1908. Stone, 35 × 25 × 21 cm. Private collection, London

2.11 Jacques Lipchitz, *Man with a Guitar*, 1915. Limestone, 97.2 × 26.7 × 19.5 cm. Museum of Modern Art, New York

2.12 Umberto Boccioni, *Speeding Muscles*, 1913
(lost work). Victoria and Albert Museum, London

nearby buildings as it moved, embodying in rhythmic and dynamic terms what Boccioni called the moving body's quality rather than its quantity, its 'interior force' (**fig. 2.12**).[12]

Such experiments would prove prescient for modern art. Yet when war was declared by Britain, France and Russia upon Austria-Hungary and Germany in the first week of August 1914 – joined by Italy on the side of the Allies in March 1915 – all artistic groupings had of necessity to change. In France a mood of patriotism took hold: Braque, Derain, Gleizes, Léger – even Apollinaire, who was not French – reported for duty. With the major battlegrounds of the early part of the war so close to Paris, and with the sound of shelling echoing in the streets, Cubism itself had to respond. The young Cubist painter Auguste Herbin got a job in administration and designed schemes for aeroplane camouflage. Others were less fortunate. Braque nearly died from a head wound, and his recovery, during which he nearly lost his sight, took over two years. Many left the city. Juan Gris went to Collioure, near the border with Spain. The Delaunays spent most of the war in Portugal. Marcel Duchamp and Francis Picabia went to New York, as did Gleizes upon his discharge from the army in 1915. The normally supportive Cubist dealers Uhde and Daniel-Henry Kahnweiler, both Germans, were forced to leave France – the latter to Switzerland via Italy where he settled in Bern to study philosophy and write about Cubism from a distance.[13]

The wartime correspondence of Gleizes and Metzinger tells us something of how Cubism changed during the conflict. Back in Barcelona in 1916, Gleizes received letters from Metzinger, in Paris, who had turned to the study of geometry. 'You can't imagine what I've found out since the beginning of the war, working outside painting but for painting ... The result? A new harmony ... Everything is number', Metzinger wrote. 'The mind hates what cannot be measured: it must be reduced and made comprehensible.' In his work he was searching for a kind of certainty, a secure method for achieving what only a work of art could do. In a second letter he says: 'Painting is not a minor art appealing only to physical pleasure [but] a language, with its own syntax and laws ... I am advancing towards synthetic unity.'[14] To combine certainty through clarity, truth in the geometry of the plane, resulting in crystalline forms that gave new meaning to the Cubist facet: such became the goal for several artists at this early stage of the war – likewise an appeal to the rational spirit of the Enlightenment at a time of France's struggle for its very survival (**fig. 2.13**). The young Amédée Ozenfant, who had exhibited before the war and was now editor of a small journal patriotically titled *L'Élan* (*Spirit*), advised artists to take heed of the passage in Plato's *Philebus* to the effect that true beauty belongs to geometrical figures like the circle and the square: a beauty not dependent on subjective judgement but 'pure'.[15] For Pierre Reverdy, a poet well regarded in Montmartre, the imperative was to reposition Cubism as a language of national relevance and purport.

In Italy, the Futurists had actually agitated for war. In a drastic statement, Marinetti's 'Manifesto' of 1909 had declared: '[w]e will glorify war, the only hygiene of the world – militarism, patriotism, the destructive gesture of those who bring freedom.'[16] Marinetti had then launched a campaign of internal publicity – qualifying what he called 'the bellicose patriotism' of the British (for example) with the accusation that they lacked a real thirst for revolution. When the Paris Futurist exhibition had arrived in London in March 1912, it had been given a mocking reception in the press. Yet when the Italians staged an exhibition at the Doré Galleries, London, in April 1914, comprising Boccioni,

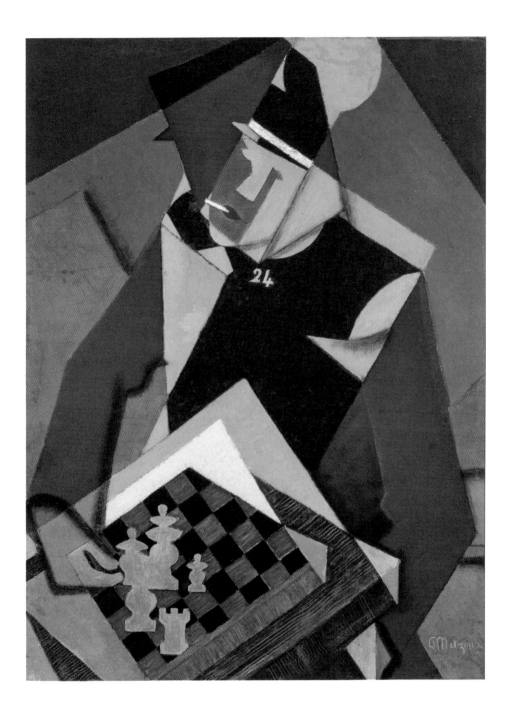

2.13 (*above*) Jean Metzinger, *Soldier at a Game of Chess*, *c*. 1915–16. Oil on canvas, 81.3 × 61 cm. Smart Art Museum, University of Chicago

2.14 (*opposite*) Percy Wyndham Lewis, *Workshop*, 1914–15. Oil on canvas, 76.5 × 61 cm. Tate Gallery, London

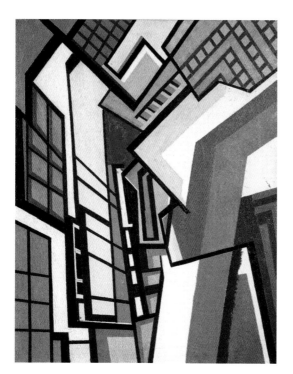

Severini, Luigi Russolo, Carrà, Ardengo Soffici and Giacomo Balla, their energies were directed at sparking a conflict with English art itself. In fact the English artists Christopher Nevinson, Edward Wadsworth, David Bomberg and the artist-polemicist Percy Wyndham Lewis were already somewhat Futurist in their outlook, practising a hard-edged, angular manner of drawing and painting that threw perspectival viewpoints into conflict to achieve some dizzying visual schemes suggestive of industrial interiors seen from high above or far below (**fig. 2.14**). But there was competition with the Italians. Having recently coalesced into what they called the London Group, Lewis and his colleagues were prepared to attack the Italian Futurists on their own terms. At lectures given by the Futurists, heckling was vigorous and fights were provoked in true Futurist style. Lewis made fun of Marinetti's 'automobilism', accusing the Italians of 'childishness' in their attitude towards machinery. Wasn't Britain the nation that had pioneered most of the machinery of the industrial age, right up to the Dreadnought battleships that now ruled the waves? Wasn't Italy a country mired in industrial backwardness and dusty museums? Moreover, Lewis's group was preparing to launch its own magazine, to be called *Blast*, promising an explosion of invective and literary force. It had insults aplenty to throw at Italian Futurism. A declaration titled 'Long Live the Vortex' again ridiculed Marinetti's 'automobilism' and called the Italians' enthusiasm for aeroplanes and fast cars 'the most romantic and sentimental' of modern manners to be found. 'We don't want to go about making a hullabaloo about motor-cars, any more than about knives and forks, elephants or gas-pipes,' *Blast* announced.[17] The British group were to be 'primitive mercenaries' who would work to affirm that the artist of the modern world 'is a savage'. Ezra Pound defined Vorticism as 'a point of maximum energy' in contrast to the dissipated efforts of Italian Futurism, which is no more than 'dispersal, a vortex with no drive behind it'. Marinetti,' Pound wrote, 'is a corpse.'[18]

It must be said that neither Futurism nor Vorticism fared well in circumstances of war. The Vorticists held their single exhibition in London in June 1915, and a war number of *Blast* was published in July. By then, the mood among artists had become sombre. The sculptor Henri Gaudier-Brzeska had been killed. 'War is not magnificent,' Lewis wrote, 'and Vorticists have exhausted interest for the moment in booming and banging.'[19] The Vorticist rebellion was almost over. Frederick Etchells, William

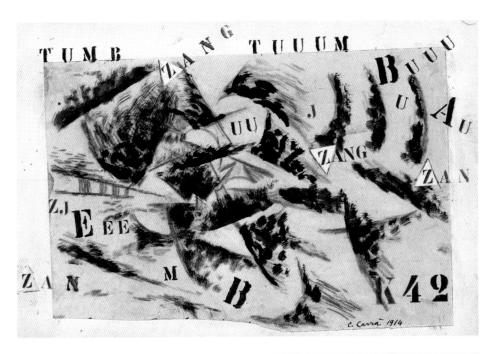

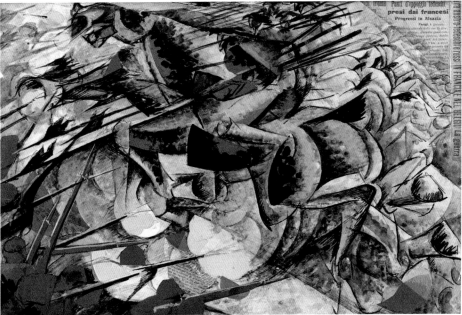

2.15 (*top*) Carlo Carrà, *Atmospheric Swirls –
An Exploding Shell*, 1914. Ink and collage on paper,
27 × 38 cm. Estorick Collection, London

2.16 (*bottom*) Umberto Boccioni, *The Charge of
the Lancers*, 1915. Tempera, collage on cardboard,
32 × 50 cm. Museum of Contemporary Art, Milan

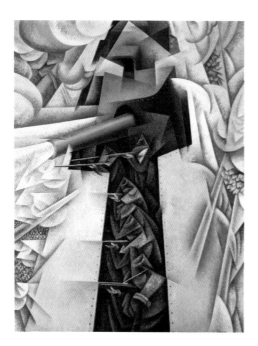

Roberts and Lewis received official war art commissions and Lewis himself produced some harrowing – but no longer Vorticist – images of the weariness, boredom and violence of the battlefield. By the end of the conflict, Wadsworth and Nevinson had abandoned Vorticism altogether.

In Italy, led on by Marinetti's encouragement, Futurist artists signed up for battle in the spring of 1915 expecting to be energised by the conflict. Carrà used Futuristic image-language combinations as explosions in some small-scale works of that time (**fig. 2.15**). Boccioni's paintings from the early part of the war show cavalry horses that would soon be superceded by the tanks and aeroplanes that Futurists were supposed to admire (**fig. 2.16**). Then Boccioni was killed in an equestrian accident in 1916. The Futurist architect Antonio Sant'Elia died in battle in the same year. Severini for his part did not see active service because of ill health; rather, he observed armoured and Red Cross trains passing his flat near the Denfert-Rochereau station in the Paris suburbs, from which vantage point he could participate in the conflict remotely – but, as it turned out, successfully in artistic terms. As Marinetti urged him in a letter of November 1914, 'Try to live the war pictorially, studying it in all its marvellous mechanical forms (military trains, fortifications, wounded men, ambulances, hospitals, parades, etc.). I believe that the Great War, intensely lived by Futurist painters, can produce true convulsions of the imagination.'[20] Severini responded, describing his *Guerre* series as an effort to create a 'plastic ensemble' of aeroplanes, cannon, flags and similar realities as symbols of 'the larger military idea' (**fig. 2.17**).[21]

Of the original Futurists it was Marinetti who pursued the theme of mechanised warfare throughout the conflict, though in activities beyond the visual arts. As he urged in an early manifesto on literature, the writer experiencing the new mechanical life 'will waste no time in building sentences. Punctuation and the right adjectives will mean nothing to him. He will despise subtleties and nuances ... the rush of steam-emotion will burst the sentence's steam-pipe, the valves of punctuation, and the adjectival clamp'. Futurist poetry would be 'a swift, brutal and ... telegraphic lyricism with no taste of the book about it'. Its purpose would not be to suggest ideas but 'to grasp them brutally and hurl them into the reader's face'.[22] And Futurist dance should be ready to play its part. The *danseuses* of the day were inadequate: 'One must imitate the

2.17 Gino Severini, *Armoured Train*, 1915. Oil on canvas, 115.8 × 88.5 cm. Museum of Modern Art, New York

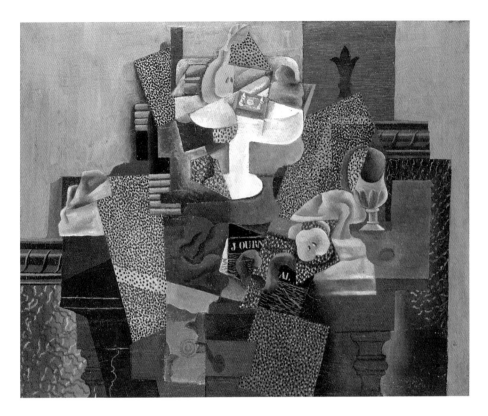

movements of machines with gestures,' he instructed in his 'Dance Manifesto' of 1917.
'The *danseuse*, on hands and knees, will make the form of a machine gun ... stretching
her arms forward she will feverishly shake a white and red orchid between her lips like
a gun barrel in the act of firing ...'[23] Did such a performance ever take place? For the
Futurist visual artists, at any rate, the celebration of war was by this time at an end.

What then of Picasso during wartime? It has always proved difficult to say whether
his wartime work represented a slowing of experimental pace or a new beginning
in disguise. Having spent the summer of 1914 in Avignon, this time with Braque and
André Derain staying nearby, he had returned to wartime Paris in November, to a city
in sombre yet patriotic mood. He was now conspicuously a foreigner – which may help
explain why his new Cubist paintings were marked by a rich stippling and patterning,
almost Pointillist; more bourgeois than before, certainly more French; perhaps designed
as a token of allegiance to the war effort (**fig. 2.18**).

At the same time he did a sequence of portrait drawings in what appears to be
an old-fashioned naturalistic idiom, of the dealer Vollard seated cross-legged on a
chair with canvases stacked behind him (**fig. 2.19**), his friend Max Jacob perched on
a bench, the dealer Léonce Rosenberg in a greatcoat, and in 1916 Apollinaire in an
armchair, his head in a bandage following injury at the front. Deceptively perhaps, these
drawings were far from old-fashioned, in that they reveal an unusually uneven pattern
of contact between pencil and paper, as if to direct our attention to what has caught the
artist's eye – a shadow here or a chair leg there. Correspondingly, the viewer's position

becomes one of looking at a portrait photograph – its clichés, its artifice, its confusion of the unreal and the real. We know that the optical apparatus of the camera had begun to appeal to Picasso's sense of how complex images could be. The hundreds of drawings of a seated (or standing) man that preoccupied him in 1915 and 1916 seem to indicate that he was working out the relation between what the artist knows, what the camera sees, and where a viewer might be located in this triangulation of the act of sight. The large painting known as *Man Leaning on a Table* (or *Seated Man*), finished in May 1916, is a monument to that experiment. It is full of large upright forms, several of them dotted in a manner parodic of Pointillism but which nonetheless evoke tall office buildings in a Futurist city scene (**fig. 2.20**). Picasso then had himself photographed standing proudly before the painting as if to signal an identification with the man in the

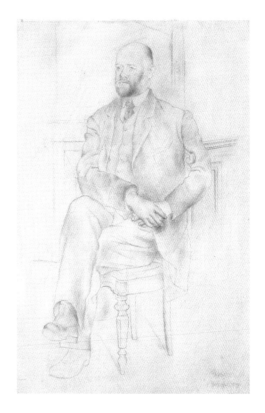

painting as well as demonstrate the changing relations between looking, painting and the camera that sooner or later all modern artists would need to recognise and deploy.[24]

Moreover as a non-French, non-combatant artist in wartime Paris, with his friends fighting or injured or in exile, Picasso's pre-war community was no longer there. It must have seemed providential therefore to have been approached in December 1915 by an ambitious young poet named Jean Cocteau, who proposed collaboration on a new comic ballet, *Parade*, for which he, Cocteau, had written a scenario. Discussion began at once, and planning was soon under way for a performance by the celebrated Ballets Russes, directed by Serge Diaghilev, with music by Erik Satie and choreography by Léonide Massine. By April 1917 Picasso had completed designs for the sets, decor and costumes, some in Cubist and some in more 'naturalistic' style. Aside from the ballet's success in Paris in May that year, the production had the advantage of taking him first to Rome, where he encountered Italian classical and Renaissance art, then to Madrid and finally to Barcelona, the Catalan city where artists greeted him as one of their own. It was a period when many visual styles seemed relevant to him, and he seemed happy to experiment with all of them – as usual with nonchalant skill and ease. In the last year of the war he painted portraits openly based on photographs, such as the portrait of his

2.18 (*opposite*) Pablo Picasso, *Still-Life with Compotier and Glass*, 1914–15. Oil on canvas, 63.5 × 78.7 cm. Columbus Museum of Art, Ohio

2.19 (*above*) Pablo Picasso, *Drawing of Ambroise Vollard*, 1915. Pencil on paper, 46.7 × 32 cm. Metropolitan Museum of Art, New York

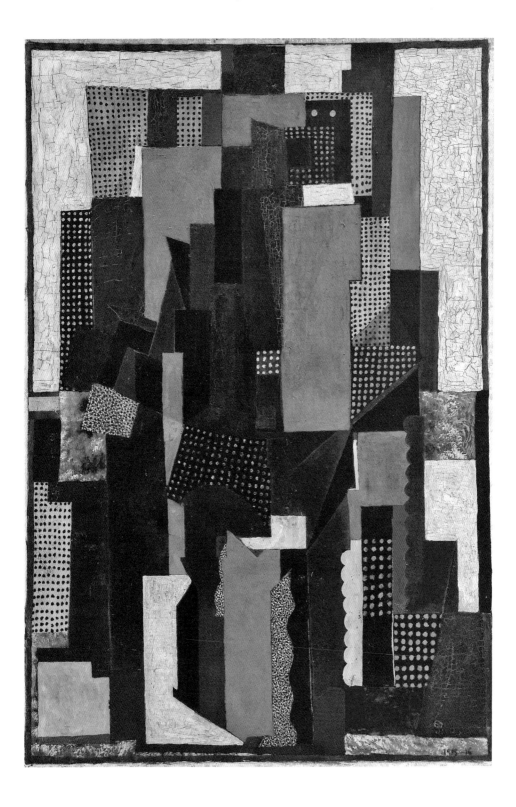

second wife Olga Khokhlova, whom he had met while in Rome with the ballet (**fig. 2.21**). He did stippled reworkings of celebrated paintings from the past, for example a version of Louis Le Nain's *The Peasants' Repast* (1642). There were also some sparse, highly flattened geometrical paintings from 1918 that belonged to the idiom now known as Crystal Cubism, which Metzinger, Gleizes and Ozenfant were all practising by this stage. The Spaniard Juan Gris had followed Picasso in using Pointillist dotting in some of his paintings; though for Gris, notoriously, the use of an even stricter geometry was already a *tour de force* (**fig. 2.22**).

That particular change was supported in print by Pierre Reverdy, by now the editor of the small journal *Nord-Sud*, who recognised the need for change and now referred to Cubism as 'the evolving art of our time'. 'Discipline has in fact been established,' Reverdy wrote to reassure those who considered pre-war Cubist painting to have been disorderly – even going as far as to compare the new direction to the discovery of perspective. To Reverdy, the function of Crystal Cubism was to offer only 'eternal and constant' elements such as the perfect circle of a wine glass rim, or the straight-line edge of a table or a door. Cubism had now to be understood as 'painting itself'. Strong emotion, fantasy, indulgent talk of the artist's vision should be kept right away from art.[25]

By now Braque was returning to paint again after a lengthy and difficult convalescence, and he demonstrated his allegiance to Reverdy's line in a statement in *Nord-Sud* that 'a new spatial figuration comes from simple facts', even 'a kind of certainty ... Emotion must not be an agitated shaking [*tremblement*]'. And still more decisively: 'I love the rule that corrects emotion.' The aim of his new painting would be 'not to *reconstitute* an anecdotal fact but to *constitute* a pictorial one'. Echoing the French philosopher Descartes' maxim 'I think therefore I am', Braque now claimed that self-imposed limitations in art 'impel creation', for 'there is no certainty except in what the mind conceives' (**fig. 2.23**).[26]

2.20 (*opposite*) Pablo Picasso, *Man Leaning on a Table*, 1916. Oil on canvas, 200 × 132 cm. Pinacoteca Agnelli, Turin

2.21 (*above*) Pablo Picasso, *Portrait of Olga Khokhlova*, 1917–18. Oil on canvas, 130 × 88.8 cm. Musée Picasso, Paris

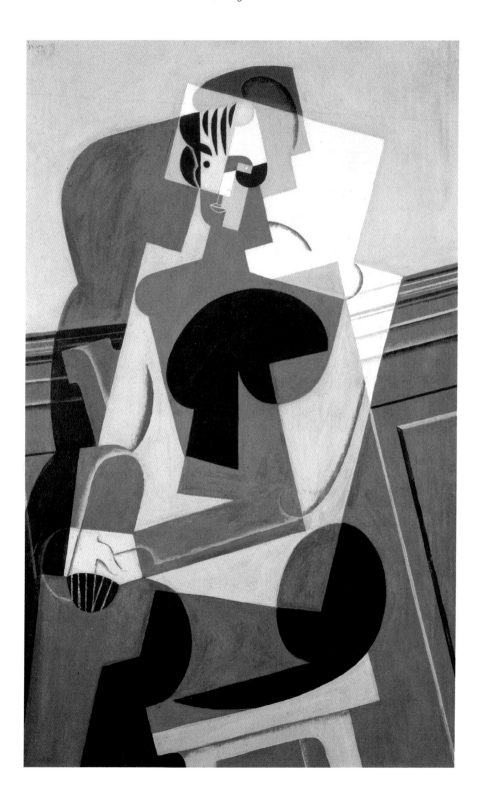

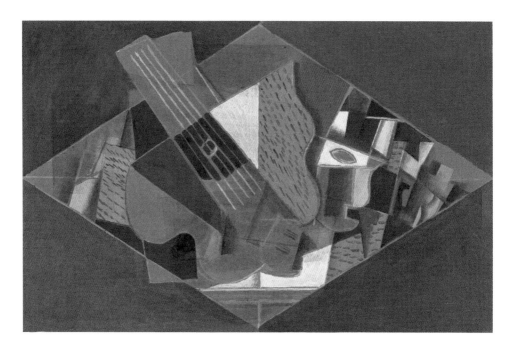

Importantly, the dealer Léonce Rosenberg had managed to combine periods of military duty with attention to the business of art, and was becoming a support agency for Crystal Cubists of every kind. As well as purchasing their works, Rosenberg was able to open a new gallery called L'Effort Moderne in March 1917 and present a succession of one-person shows throughout the next two years, beginning with Auguste Herbin and climaxing with a show of works by Picasso, timed to coincide with the signing of the Versailles Treaty in March 1919. The sequence showed that modern art had not disappeared in wartime, merely changed its quality and its tone. To the gallery-going post-Armistice public, it must have seemed as if Cubism as a short but brilliant phase in French and international art had by now 'evolved' – for better or worse – into a stable yet modern contemporary style.[27]

2.22 (*opposite*) Juan Gris, *Portrait of Josette Gris*, 1916. Oil on wood, 140.5 × 97 cm, Museo Nacional Centro de Arte Reina Sofía, Madrid

2.23 (*above*) Georges Braque, *Still-life with Guitar and Glass*, 1917. Oil on canvas, 60 × 92 cm. Kröller-Müller Museum, Otterlo

CHAPTER 3

Russian Experiments

Already by the time Fauve and Cubist paintings were being shown in Paris around 1908 or 1909, a young generation of artists in Russia were exploring so-called 'primitivist' methods too – but with a difference. For them, artistic authenticity lay not in city life but in the Russian countryside, in the rich iconography of local and regional customs, and in the interplay between art and literature, between the image and the written word. Like others of her generation, Natalya Goncharova adopted this sensibility with enthusiasm. 'Our age is a flowering of art in new form,' she wrote in a statement for her one-person exhibition of 1913. 'It is again the East that has played a leading role. At the present time Moscow is the most important centre of painting' (**fig. 3.1**).[1]

It was a time of self-definition and differentiation in Russian art. Goncharova's partner, Mikhail Larionov, had already taken the lead. In March 1912 he had organised an exhibition, *The Donkey's Tail*, the very title of which derived from a student joke at the *Salon des Indépendants* in 1910, when a painting had been submitted created by a donkey with a paintbrush tied to its tail. The phrase captured well the embrace of chance and animality that now separated Russian art from so much of the Western tradition. A certain young poet from Georgia, Ilya Zdanevich, was also insistent about Russian exceptionalism. In a noisy debate held during another 'primitivist' exhibition, *Target*, in Moscow in March 1913, he announced to his audience that an ordinary boot was more beautiful than the Venus de Milo 'because it is autonomous, because one is not aware of it'. With an image of the Venus de Milo on the screen while Zdanevich held up a boot, the audience burst into life. Shouts of 'Get the boot out of here!' and 'Travelling salesman!' to a chorus of whistles and stamping feet brought the discussion quickly to an end.[2]

In the meantime Larionov had begun to articulate a painting method he liked to call Rayonism. 'The future is behind us,' he and Goncharova wrote together in a declaration that had Russia's own sensibilities at its centre. 'We are against the West, which is vulgarising our forms.' Yet 'we are not declaring any war, for where can we find an opponent that is our equal?' By using 'rays' of energy rather than 'lines of force', by turning to 'the beautiful East', they would surmount any further discussion of Cubism and Italian Futurism with a wholly different style. 'Rayonist' (or 'Rayist') paintings would show the interaction of reflected light such as to suggest forms, as they put it, 'to the artists' will ... The objects that we see in life play no role here, rather colour, its saturation, the relation of coloured masses, depth and *faktura* ... with this begins the true liberation of painting and its life in accordance only with its own laws' (**fig. 3.2**).[3]

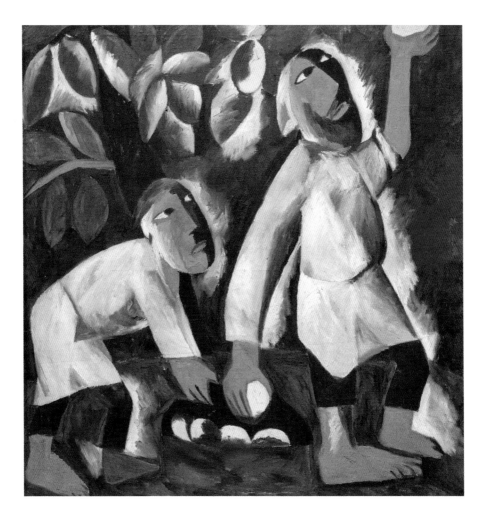

By the end of 1913 Larionov and Zdanevich had teamed up, and together they announced an intention to 'paint ourselves' – on the face, mainly, and with Rayonist lines – and appear in public as living embodiments of the new style. It could sound like Italian Futurism: 'Our faces are like the screech of the trolleybus warning the hurrying passer-by like the drunken sounds of the great tango,' they wrote; 'we paint ourselves for an hour, then a change of experience calls for a change of painting [just as] a car windshield reflects shop-windows flashing by, running into each other'. Face-painting was practiced by David Burlyuk and Goncharova too – and in Futurist theatre as much as in urban *flânerie* (**fig. 3.3**). Its anarchist overtones were unmistakable. By transforming customary human expression they hoped to project different experiences and messages – 'herald the unknown, rearrange life,

3.1 Natalya Goncharova, *Peasants Picking Apples*, 1911. Oil on canvas, 104.5 × 98 cm. State Tretyakov Gallery, Moscow

and bear man's multiple soul to the wider reaches of reality'.[4] Pastiche, provocation and the transcendence of logic now merged together in a new attitude of independence, dissension and play. Zdanevich went further: 'To wage war against the past is absurd because there is no past. To aspire toward the future is absurd because there is no future … such is the foundation of *vsechestvo* [everythingism], which makes war against the past senseless and thus overthrows Futurism.' He added, 'our time is one of cross-breeding and ephemeral styles … of speed and progress, dizzying and hasty'.[5]

For others, cross-breeding of the visual and the verbal itself became the testing ground of the new Russian art. In 1912 the poet and language historian Velimir Khlebnikov, born in Astrakhan, had teamed up with the poet and graphic artist Aleksei Kruchenykh from the Kherson region on the Black Sea, to produce an experimental book, *Mirskontsa* (*Worldbackwards*), whose pages presented word fragments, orthographic distortions and image–text conjunctions of a wholly original kind. With imagery by Larionov, Goncharova, Vladimir Tatlin and Nikolai Rogovin, a page might contain doodles, graffiti, overlapping imagery, letterforms and what appear to be 'automatic' verses or scribbles.

3.2 Mikhail Larionov, *Blue Rayism*, 1912–13.
Oil on canvas, 65 × 70 cm. Private collection

Other booklets by Kruchenykh, including *Pomade* of 1913, contained what he wished to call *zaum* or transrational poetry (from *za*, 'beyond', and *um*, 'reason'). One *zaum* verse

> Dyr bul shchyl
> ubesh shch u r
> skum
> vy so bu
> r l ez

appears as a sequence of ostensibly unrelated syllabic fragments barely stabilised by their position relative to each other on the page – subtended as it was by a Rayonist drawing by Larionov. To the *zaum* poets, language must be discordant, allusive, above all unfamiliar. It must exploit shift (in Russian *sdvig*) at the level of vocables themselves in order that new semantic spaces may be created. *Zaum* – it was becoming a principle for visual artists too – was both a reversion to savage speech and a blueprint for a language of the future, 'a new art', according to Kruchenykh, 'given by a new Russia to the entire shocked and bewildered world'.[6]

Verbal–visual interplay was further demonstrated in a book of 1913 by Kruchenykh titled *Vzorval* (*Explodity*), which presented richly textual–visual images and included a lithograph by a certain Kazimir Malevich, from a Polish family living in Ukraine, in a manner that he, Malevich, liked to call Cubo-Futurism (**fig. 3.4**). It was a manner that

3.3 Natalya Goncharova, with 'make-up for an actress of the Futurist theatre'. *Teatr v karrikaturakh*, Moscow, 21 September 1913, p. 9

3.4 Kazimir Malevich, *The Reaper*, 1913. Published in Velimir Khlebnikov and Aleksei Kruchenykh, *The Three*. Letterpress, 13.8 × 13 cm. Collection of Stedelijk Museum, Amsterdam

combined the suggestion of Futurist movement with the kind of faceting that the Paris Cubists had used to render static objects – yet was neither Futurist nor Cubist but rather a kind of prismatic style in which facets float into and across each other while ensuring how in perception they could be visually combined.

Malevich was not a poet, however, and though he understood the anarchism of the *zaum* impulse, his Cubo-Futurist drawings in hindsight look like the beginnings of a new kind of work. Indeed they were, most notably an original operatic theatre in which philosophical narrative, music and visual spectacle would all be combined. *Victory over the Sun*, with libretto by Kruchenykh, prologue by Khlebnikov, music by the musician, painter and publisher Mikhail Matyushin and stage and costume designs by Malevich, opened in St Petersburg in December 1913.[7] The opera's plot concerned the destiny of *budetlyany* – future-dwellers – but without the taint of Futurism Italian-style. Future-dwellers capture the sun, symbolising light, clarity, Platonic forms and the Mediterranean south. Normal time registers are lost. An Aviator appears who can travel through the centuries in either direction, but he eventually crashes in a spectacle of dramatic lighting, intense colour and discordant sound. With abrupt changes of stage lighting, Malevich's stage and costume designs dematerialised or 'shifted' the various characters, who bore names such as Futurist Strongman, Man With Bad Intentions and New Man, to create a mood of historical time ending and rational forms collapsing in anticipation of a new beginning (**fig. 3.5**). Here was Futurism of a distinctively Russian kind.

When Marinetti himself arrived in Moscow a few weeks later his hope – on his terms, naturally – was to bring Russian artists and Italian Futurists together in a bond of mutual enthusiasm. Later he would boast that 'all the Futurisms in the world are the children of Italian Futurism' – yet in reality he must have been disappointed.[8] The *zaum* activist Zdanevich wrote to him in mid-January 1914 from Tiflis, Georgia, telling him 'your current propaganda, your current tactics, Futurism in the form in which you propagandize it now, I not only do not accept but regard as simply destructive to art ... [It is] now more academic than the Academy itself'.[9]

In August 1914 an ill-prepared Russia entered the war in Europe in an alliance with France and Britain against Austria-Hungary and Germany (the Central Powers). No doubt the Russian government (and the tsar's family) hoped to preserve a sense of national unity in the face of rising unrest in industry and in the countryside. Socialists with

3.5 (*above*) Kazimir Malevich, *New Man*, 1913. Drawing for *Victory over the Sun*, 1913. Graphite, watercolour and ink on paper, 26.2 × 21.2 cm. State Museum of Theatre and Music, St Petersburg

3.6 (*opposite*) Vladimir Tatlin, *Corner Counter-Relief*, 1914–15. Mixed materials, 71 × 118 cm. From the booklet *Vladimir Evgrafovich Tatlin*, 1915

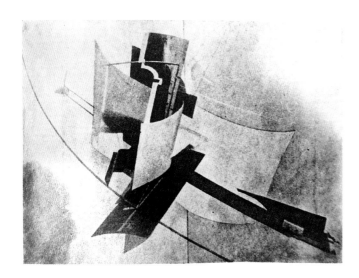

international connections sought refuge elsewhere, in the case of Vladimir Lenin and colleagues, in neutral Switzerland. In those unstable circumstances we find younger artists in Russia more determined than ever to explore the idioms, the forms, even the metaphysics, of the cultural forms of a different life. They defined and redefined their positions quickly, if necessary in mutual competition beneath which some deeper sympathies would hopefully survive. We find Malevich, for instance, by the end of 1914 and into 1915 deploying *zaum* in his paintings as a principle for form itself, in one example a fish, a sword, a wooden spoon, a ladder, scissors and word fragments, presented all at once as if suggestive of some kind of transformation, yet without any suggestion of rapid temporal flow.[10]

It was in the year 1915, however, that two exhibitions were held in which definitions of 'Futurism' took an important new turn. *Tramway V*, in Petrograd in May 1915, was subtitled by its organisers the artist Ivan Puni and the poet Ksenia Boguslavskaya *First Futurist Exhibition of Painting*, seemingly as a further attempt to distinguish Russian thinking from Italian versions further west. *Tramway V* contained, among other things, some highly original reliefs by a young artist from Moscow, Vladimir Tatlin. Tatlin had shown with Larionov, Goncharova and Malevich in Moscow, had contributed to *Mirskontsa* in 1912 and had travelled to Paris in 1914 at a moment when Cubism in that city was itself on the point of change. He had visited Picasso and had seen his constructions in wire, string and cardboard without, perhaps, altogether understanding their complex and frequently ironic style. Back in Russia in the opening months of the war, he set about making relief constructions in a manner entirely his own. We have eyewitness reports of him working furiously among piles of cast-off pieces of glass, wood and metal in an effort to find the 'true' character of one piece of material in relation to another: a method summarised later by his friend and supporter Nikolai Tarabukin as one in which 'material determines form for the artist, not the other way around'.[11] Art should no longer waste time 'picturing', but should begin to work with and from actual material things (**fig. 3.6**). In the context of *Tramway V*, Tatlin's new work spoke clearly of economic privations as well as wartime reliance upon durable materials like iron, wire and glass, in addition to wood. The new reliefs presented matter itself and 'art' in a new kind of dialogue with each other.

Young Russians found what reasons they could to not enlist in a poorly conducted and unproductive war. Tatlin's immediate group held vigorous opinions on the international state of affairs. Those around Tatlin, namely Sergei Isakov, Petr Miturich, Lev Bruni and Vladimir Lebedev, were the main participants in a Petrograd collective calling itself Apartment no. 5. The critic Nikolai Punin, also a participant, described the atmosphere:

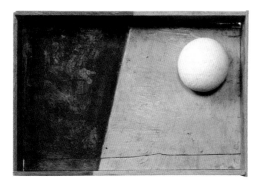

Our search was not for something new; it was for a means to capture reality, to grab it in a vice-like grip without tormenting it or being tormented by it, by its convulsions and groans ... We were looking for art that would be sturdy and simple, as simple as it could be in those years of transition and upheaval ... The war, having changed the speed of the entire world, laid underneath our lives a sinister backdrop against which everything began to seem both tragic and petty.[12]

Tatlin, to advertise his own work, now issued a booklet illustrating his reliefs, counter-reliefs and corner-reliefs alongside a self-effacing description of himself as one 'who has never belonged and does not belong to Tatlinism, Rayonism, Futurism, the Wanderers or any other group'.[13] Apartment no. 5's attitude was explicit. 'Our material is metal,' Isakov wrote at the time, 'and should be regarded in a predominantly dynamic sense', for 'there is tremendous tension, a tremendous amount of potential energy, in the way a sheet of iron is bent and a sheet of aluminium is pressing on it at an angle, in the way it is cut through by the metal corner.' In Tatlin's corner-reliefs especially that tension reached a maximum. In Isakov's eyes, the import of Tatlin's art was 'to overcome the tyranny of the machine and liberate man from technological slavery ... For isn't it the metal machine that has plunged the whole of mankind into streams of fraternal blood?'[14]

It is the background against which, at the end of 1915, Puni and Boguslavskaya presented a second exhibition, one with a different orientation from the first. As its name implies, the *Last Futurist Exhibition of Painting: 0,10* was designed to put an end to all talk of Futurism as a contemporary platform and present work by Puni, Boguslavskaya, Mikhail Menkov, Ivan Klyun and Malevich in perhaps the most notorious artistic event of that year. Puni's work could be wry and reflective at the same time: for example, a boxlike container got up as a simple landscape structured by clear regions of light and dark (**fig. 3.7**). Malevich for his part presented a new concept, Suprematism – which he explained in a lengthy text as the latest point in an evolution in which Cubism was first transcended by Futurism, which was in turn transcended by Suprematism: a manner that he liked to call 'pure art'. In a room full of Suprematist paintings could be seen rectangles, bars of colour and circular discs positioned as if floating in a non-gravitational picture space. A work identified in the catalogue as *Square* but now known as *The Black Square* was hung not against a wall but across a high corner of the room, in the manner of a corner icon from a chapel or a private devotional space (**fig. 3.8**). Though immediately controversial, a black square had in fact occurred before in Malevich's art, in the preparatory drawings for *Victory over the Sun*, in which black rectangles hover over and obscure other forms, including one drawing in which a black square is presented as a design for the opera's curtain. Back in 1913, Malevich had been obsessed with the idea of a black square suspended before the viewer as an image in the drama of history, a point of erasure and finality as well as the first format of a new visual-philosophic beginning. In this sense, the square's fullness and emptiness need understanding together, as both

ethereal lightness and the heaviest weight. Malevich wrote at the time: 'The square is not a subconscious form. It is the creation of intuitive reason. The face of the new art. The square is a living, regal infant. The first step of pure creation in art ...'[15]

The situation was in some ways typical of the modern artist's predicament. On the one hand a young, rebellious generation, here devoted to *zaum*, its sister concept *sdvig* and other formal inventions that were virtually instruments of consciousness itself; on the other, at the level of rickety state institutions, an expectation of national unity and the maintenance of some version of tradition. But by the end of 1916 the authority of the tsar and his government was in decline. A revolution in February 1917, supported by a large section of the bourgeois class, removed the tsar and his family and inaugurated a provisional government – at the same time as soviets, or factory committees, sprang up autonomously in the major cities. By the end of the summer the Bolshevik Party leader Vladimir Lenin, who in April had returned from hiding in neutral Switzerland, was ready to seize power and take Russia out of the war while hoping for support from proletarian (working-class) groups and organisations throughout Europe. In a series of dramatic events beginning on 25 October 1917 the provisional government itself was swept into the dustbin of history.

The Bolshevik Revolution propelled Russia from tsarist autocracy to a putatively classless society without passing through a period of bourgeois democracy in

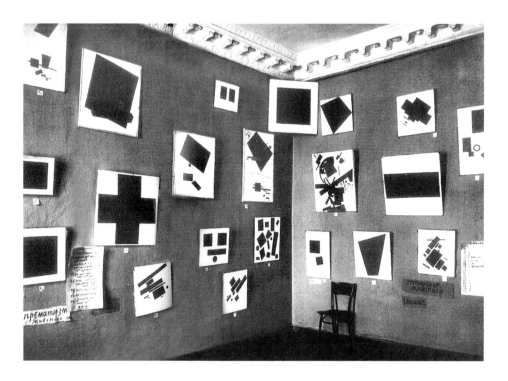

3.7 (*opposite*) Ivan Puni, *Relief with White Sphere*, 1915. Wood and paint, 34 × 51 × 12 cm. Centre Pompidou, Paris

3.8 (*above*) *Last Futurist Exhibition of Painting: 0,10*, 1915. Photograph, Stedelijk Museum, Amsterdam

between – which had been Marx's model of historical change. The establishment of a Council of People's Commissars in Russia now implied the reorganisation of every department of state. A body named the People's Commissariat of Education (Narodny Komissariat Prosveshcheniya, or Narkompros) was set up in November 1917 under the cultured and cosmopolitan Anatoli Lunacharski, with responsibility for guiding both education and the arts. In itself, such a relationship was not historically new: it signified a desire to fuse together the pedagogical and cultural life of the nation with its very consciousness, its collective will. Hopes were high for a new kind of culture, and yet opponents of the Revolution as well as more culturally conservative forces remained. The lineaments of style – or taste – were still to be decided. With so many artistic groups and networks in contention, how were priorities to be decided?

At Lenin's behest, a Plan for Monumental Propaganda was announced in April 1918 in an attempt to educate a post-Revolutionary public in the historical context of the Revolution and the names – at least – of foreign and Russian revolutionaries, including Lassalle, Garibaldi, Marx, Danton, Robespierre, Bakunin and other pioneers of modern socialism. It was only a partial success. Materials for building and constructing monuments were scarce. Several projects were only models for permanent sculptures when time and resources allowed. Some were hastily made and erected, out of scale with their urban surroundings or prone to dissolving in the rain. Others could appear comical, such as the monument to two heroes of socialism truncated at the waist, dubbed by Muscovites 'Marx and Engels in the bath' – here being unveiled by Lenin in Revolution Square in 1919 (**fig. 3.9**). At least one project tried to represent an individual in a quasi-Futurist style, only to incur public disfavour: a work by Boris Korolev in honour of the anarchist Mikhail Bakunin was erected on Turgenev Square without an official unveiling, but was labelled a 'scarecrow' in the press and was demolished by the public where it stood (**fig. 3.10**).

With the new state as sole sponsor of art and with the free market in cultural goods at an end, the question of government policy was suddenly paramount. Within Narkompros a Department of Fine Arts was set up in January 1918, known by its acronym IZO (Otdel Izobrazitelnykh Iskusstv), in which no single stylistic or aesthetic tendency was supposed to prevail. IZO's Moscow branch under the leadership of Tatlin included Cézannist painters like Pavel Kuznetsov and Ilya Mashkov in one group, and experimental figures including Malevich, Natalya Udaltsova, Olga Rozanova and Kandinski in another – 'centre' and 'left' respectively in a crude mapping of political terminology onto art. IZO's task was to organise exhibitions and carry out state commissions, but also to debate and formulate artistic policy for the new state, guided by a mission to establish 'the closest dependence of art on the social and political conditions of life' and also consider 'questions relating to the science of art' – two objectives that in fact stood somewhat apart from each other, as the following two examples show.[16] First, take the organisation known as Proletkult (Proletarskaya Kultura, or Proletarian Culture), led by the polymathic and influential Aleksandr Bogdanov, whose self-bestowed mandate was to further the artistic demands of the working class by encouraging – permitting, cajoling – that class to recognise what its intrinsic culture was. Linked quickly to similar organisations internationally, the Russian Proletkult was by and

large scathing about the already trained artists of the former bourgeoisie who had turned to experimental art. Consider the early career of Lyubov Popova. From a wealthy family and after a period of study with Le Fauconnier and Metzinger in Paris, by 1915 she had moved close to Malevich's Suprematist group by evolving a distinctive style of her own. In paintings she called *Painterly Architectonic*, the earliest from 1916, she would arrange groups of seven or eight planes of overlapping colour, densely nested upon each other with overlaps and intercuts between them. The effect is one of dematerialised colour planes woven closely together in dramatic spatial display. With their rich surface *faktura*, those in the earliest paintings of the sequence crowd the pictorial rectangle as if about to burst open with energetic force, while from 1917 it is as if that force has been allowed to breach the frame (**fig. 3.11**). This was not only not proletarian art, it was no longer Suprematism either, presenting as it did a suggestion of larger articulated units on a potentially urban scale.

A more general problem for policy arose from the events of the Revolution itself. With the Soviet government having negotiated an armistice with the Central Powers in late 1917 (a set of highly disadvantageous terms were agreed at Brest-Litovsk in March 1918), resentful and suddenly disenfranchised tsarist generals had mobilised military actions against the new government in a civil war that lasted three years, until 1921: a period known as War Communism in which Soviet power clung on to its fragile victory with the limited resources it could command.[17]

Despite the harsh conditions of War Communism, including famine in the countryside and severe deprivation in the towns and cities, several remarkable artistic

3.9 Temporary monument to Marx and Engels, Revolution Square, Moscow with Lenin at the unveiling, November 1919

3.10 Boris Korolev, *Sketch for a Monument to Bakunin*, 1919. Pencil on paper, 18.5 × 17.9 cm. Private collection

projects stand out. In the aftermath of the *Last Futurist Exhibition of Painting: 0,10* at the end of 1915, the young Aleksandr Rodchenko had begun to investigate the implications of Malevich's 'non-objectivity' but in a very un-Malevichian manner, suspending planes around a linear spine or core such as to imply something assembled – organised – but without any practical outcome in view. By the time of the Tenth State Exhibition titled *Non-Objective Creation and Suprematism* of April 1919, Rodchenko was contesting Malevich's claim to leadership in non-objective painting on his own terms. He prepared paintings of heavily textured discs and overlapping lozenges done for the most part in black – seemingly to create maximum contrast with a group of all-white paintings that Malevich had brought to the show (**fig. 3.12**). Their impulse was first and foremost reductive: to press the aesthetics of surface texture and subtlety into a cul-de-sac. 'Without doubt [Rodchenko's] black paintings are the best thing of the season,' the artist Varvara Stepanova noted in her diary, for 'in them he has demonstrated just what *faktura* is.'[18] At the same time they marked a kind of limit beyond which non-objective painting could scarcely go. Recoiling from dark *faktura*, Rodchenko now resumed his experiment with linearity per se – a radically new attitude to surface *faktura* in which line considered as a straight edge or cut in material became a component of what he could call *konstruktsiya*, constructedness or construction.

It so happened that Rodchenko's researches into linearity in that spring of 1919 were intensified by a sharpening dispute with Kandinski, who had returned to Russia from Germany at the beginning of the war and was still pursuing the 'spiritual' researches of his *Composition* series, begun in 1909. A clash was inevitable. Rodchenko and his allies viewed Kandinski's approach to line as psychological and romantic, one to which engineering metaphors such as line and strict planarity could have no application. Only when ruler and compass are put aside, Kandinski said, could line escape its mechanical confinement and find 'a truly infinite number of means of expression'.[19] Rodchenko notes the exact opposite in his diary: 'Thought of painting ten pieces, just black on white, with a ruler'; to do so 'would be exceptionally new. I really need to apply myself to the ruler, claim it as my own'. Accordingly, he produced a group of works in which lines painted against the side of a ruler or a sheet of cardboard cluster in fan-shaped groups in the surface in which they appear. His new 'laboratory method', as he liked to call it, was congruent with any number of engineering and scientific metaphors, and in that sense alone, given Russia's technical backwardness in relation to western Europe, was well suited to the task of keeping the Revolution alive. As he also noted at the

3.11 (*opposite*) Lyubov Popova, *Orange Painterly Architectonic*, 1918. Oil on board, 59 × 39 cm. Iaroslavl Art Museum

3.12 (*above*) Aleksandr Rodchenko, *Composition no. 64 (84) (Black on Black)*, 1918. Oil on canvas, 73.5 × 74.5 cm. State Tretyakov Gallery, Moscow

time, 'The surface plane is logically being discarded so as to express *constructedness*, *architecturalness* in composition; and there being no further need for it, that old favourite of painting, *faktura*, is to be discarded too' (**fig. 3.13**).[20]

In the period of War Communism it became difficult for artists to find the resources for work – at the same time as it was important that the Revolution be supported. A project by Tatlin stands out as a solution to both imperatives. His response to the announcement of Lenin's Monumental Propaganda plan was to think beyond the idea of monuments to socialist heroes and design a monument to the Revolution itself. He had seen the Eiffel Tower during his Paris visit, knew well enough the Tower of Babel image from Renaissance painting, and was aware of a much longer tradition of tower-building for military, astronomical and ecclesiastical purposes. A commission from IZO to produce a monument eventually came in early 1919. Tatlin's ally Nikolai Punin reported during the planning stage that the monument would incorporate the latest technologies for disseminating decrees and decisions of the new government. The structure would be large enough to house a motorcycle depot, cinema screens, gymnasia and reading-rooms for socialist literature, but not spaces to stand still or sit down in, according to Punin, if it was to be a centre of real dynamism.[21] Tatlin wanted revolutionary functions to determine the monument's form – in addition to plasticity and

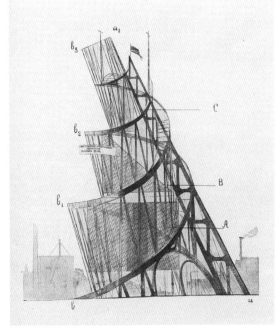

3.13 (*above, left*) Aleksandr Rodchenko, *Construction no. 89 (Light Yellow)*, 1919. Oil on canvas, 68 × 45 cm. Pushkin Museum of Fine Arts, Moscow

3.14 (*above, right*) Vladimir Tatlin, *Monument to the III International*, 1919. Sketch of the inclined axis. Page, 28 × 21.9 cm. Museum of Modern Art, New York

3.15 (*opposite*) Aleksandr Rodchenko, *Spatial Construction no. 21* (*reconstruction 1988*). Wood, 25 × 15 × 15 cm. Galerie Gmurzynska, Cologne

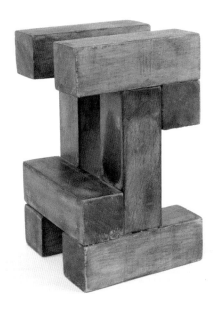

architectonic qualities that should be evident in it too. His design would comprise two spirals rising together around a central lift shaft to a height of 400 metres and would straddle the River Neva in Petrograd, out-reaching even the Eiffel Tower, while inside the vast structure would be meeting halls, one above the other and rotating at different speeds. Already built in model form by the middle of 1920, Tatlin meanwhile changed his monument's dedication, no longer to the Revolution but to the new coalition of socialist and labour parties known as the Third or Communist International (Comintern), inaugurated by Lenin in March 1919 (**fig. 3.14**). Perhaps due partly to its huge ambition, the model on its first display met with a mixed reception. Could it ever be built? Was it affordable? None other than Leon Trotski, who kept a watch over questions of art and literature even during his time as Commissar for War, was sceptical. 'He wants to construct a beer bottle for the World Council of People's Commissars,' he taunted,

> which would sit in a spiral concrete temple. But for the moment, I cannot refrain from the question: what is it for? To be more exact: we would probably accept the cylinder and its rotating, if it were combined with a simplicity and lightness of construction, that is, if the arrangements for its rotation did not depress the aim.[22]

The brilliant young poet Vladimir Mayakovski was more enthusiastic. His description of Tatlin's project as 'the first monument without a beard' was an artistic endorsement as well as the assessment of a friend.[23]

By the spring of 1920 the worst period of the civil war was over and the need to revive a collapsed economy was paramount. In March 1920 an organisation called INKhUK (Institut Khudozhestvennoi Kultury, or Institute of Artistic Culture) was set up within IZO to help define the real functions of art in the new state, and at the end of the same year a small group was formed within INKhUK around Rodchenko and Stepanova calling itself the General Working Group for Objective Analysis, set up to address the question of how to rid art of its subjective and purely romantic conceptions. That context provided for a yet more concentrated group, the First Working Group of Constructivists, to meet from March 1921 to define how scientific communism could be advanced by jumping the gap between 'laboratory work' and actual practical production. By what steps could 'art' and 'manufacture' be made to align? The methods of Constructivism would prove important to much subsequent art of the kind we still call 'modern'. Its

three essential vectors were *tektonika* (ideology applied to materials), *konstruktsiya* (constructedness) and *faktura* (the conscious and expedient handling of materials), and they received exemplification in the work of several artists.[24] Rodchenko's hanging *Spatial Constructions*, for example, were made to demonstrate how to use material efficiently. Likewise his *Equal Form* series of constructions, which used repeatable units fitting together in three dimensions yet without a conventional armature or core, mirrored closely the new methods in use in American and West European mass production (**fig. 3.15**).[25] For a nation whose capacity to produce ordinary goods was still at pre-industrial levels, revolutionary optimism combined with efficiency and practicality was a promising direction to follow.

Such principles were encouraged among very junior artists too. The Society of Young Artists, known by its acronym OBMOKhU, was set up in 1919 initially to help design agitational banners and decorations for revolutionary anniversaries and celebrations in the public space. Comprised of students from the State Free Art Studios and the art workshops known as the VKhUTEMAS – two further initiatives of the new government – OBMOKhU in its second spring exhibition of May 1921 showed the early, and formally radical, fruits of the composition/construction discussions. Konstantin Medunetski, the brothers Georgi and Vladimir Stenberg, Rodchenko and

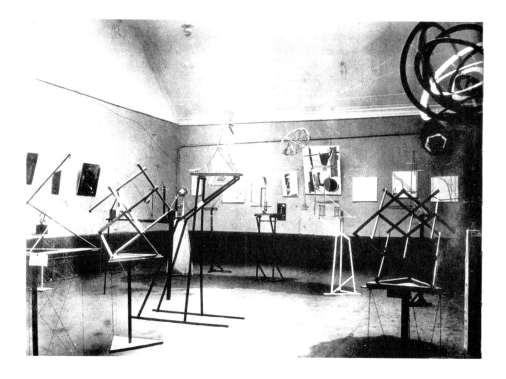

3.16 (*above*) Second spring exhibition of the OBMOKhU, May 1921. As published in *Veshch*, no. 1/2, 1922. Photo courtesy of the Rodchenko-Stepanova Archive, Moscow

3.17 (*opposite*) Boris Ioganson, *Spatial Construction (VIII)*, 1921. As published in L. Moholy-Nagy, *Von Material zu Architektur*, Munich 1929

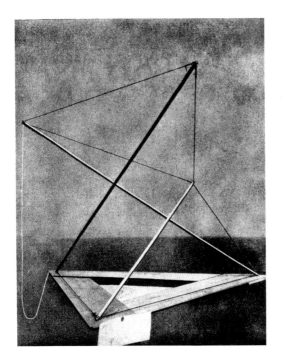

Boris Ioganson contributed self-supporting constructions made from simple spars of wood, wire, metal sheeting and the like that continued the same war against 'composition' as had animated the earlier debate (**fig. 3.16**). Rodchenko's *Hanging Forms* can be seen at top right in a documentary photograph, while Ioganson's self-equilibriating *Spatial Construction (VIII)*, extreme left, revises the original idea of *faktura* still further by making explicit the tensile and compressive properties of string and wood in a work whose balanced parts combine to form something like a flexible organic whole. Under that description such a work could also function as a vivid metaphor for an ideally organised revolutionary society (**fig. 3.17**).

One other event can be taken as a farewell to artistic 'composition' in post-Revolutionary Russia and a turn towards real manufacture. In September 1921 there took place at a writers' club in Moscow the first of two modest exhibitions titled *5 x 5 = 25*, each comprising five works by five artists (Stepanova, Aleksandr Vesnin, Popova, Rodchenko and Aleksandra Ekster). By its title alone *5 x 5 = 25* was intended to sound a note of precision and democracy at a decisive juncture. Alongside the tense simple curves deployed by Vesnin, Popova, Ekster and Stepanova, Rodchenko took the further step of exhibiting what he called *The Last Painting* – comprising three equal-sized monochrome canvases, *Pure Red*, *Pure Yellow* and *Pure Blue*, presented serially and indicating once more his ambition to reduce painting to its basic yet essential elements.[26]

Perhaps it was a signal, too, of the end of painting as an art. Now, with the civil war effectively over, the Soviet economy was badly in need of recovery. For Constructivists and others sympathetic to the aims of the Revolution, the burning question was how to put their talents at the service of industry and manufacture.

CHAPTER 4

The Dada Revolt

Soon after the European war broke out in August 1914, a significant number of those committed to pacifism or other forms of peaceable resistance rapidly made their way to neutral Switzerland. There, rage against the mechanical slaughter took a vivid form in a manner that came to be known as Dada – a word that was chosen semi-accidentally and that could be taken to mean 'play-horse' (in baby French), 'yes-yes' (in Russian), infantile babble, or nothing definite at all. During its brief flowering from early 1916 to about 1923 Dada had a consistently performative character, oscillating between cynicism and hope, energetic explosion and comedic despair. 'Life is confined and shackled,' the German poet and writer Hugo Ball wrote of the days immediately before the hostilities began.

> Economic fatalism prevails. Each individual, whether he resists or not, is assigned his interests, role and character without being asked. The church is no more than a redemption factory. Literature is merely a safety valve ... Is there a force strong enough to put an end to this state of affairs? ... [What is needed is] a league of those who want to escape from the mechanical world, a way of life opposed to mere utility. Orgiastic devotion to the opposite of everything that is serviceable and useful.[1]

Ball was already steeped in Expressionist drama from his days in Munich and Berlin. Before arriving in neutral Switzerland in May 1915 with the dancer and poet Emmy Hennings, he had already met and come to revere Kandinski while in Munich; he had studied Futurist painting, and had visited the front in Belgium. Once in Zurich, a city that would be a haven for those seeking refuge – including Lenin, Trotski and James Joyce – Ball and Hennings travelled with an itinerant vaudeville troupe called Flamingo, before placing an advertisement in the Zurich newspapers early in 1916 announcing that 'a group of young artists and writers has been formed with the idea of creating a centre for artistic entertainment'. The name given to the cabaret was Voltaire: the philosopher who, in words Ball took from a French aphorist, was 'the anti-poet, the king of jackanapes, prince of the superficial, anti-artist'.[2] The diary Ball later published under the title *Flight Out of Time* records the opening of the Cabaret Voltaire, in a cramped café in the Spiegelgasse, in Zurich's bohemian district of Niederdorf, in February 1916:

> The place was packed. Many people could not find a seat. At about six in the evening ...
> an Oriental-looking deputation of four little men arrived with portfolios and pictures under
> their arms ... Marcel Janco, Tristan Tzara, Georges Janco [all from Romania], and a fourth
> gentleman whose name I did not catch. Hans Arp [from Alsace] was there also.

The artist Richard Huelsenbeck arrived a week later. 'He pleads for a stronger
rhythm,' Ball records. 'He would prefer to drum literature into the ground.'[3] The
following month Huelsenbeck, Tzara and Marcel Janco took the floor with a *poème
simultané* (simultaneous poem); in Ball's description 'a contrapuntal recitative
in which three or more voices speak, sing, whistle, etc. at the same time in such
a way that the elegiac, humorous or bizarre content is brought out ... Noises such
as an *rrrr* drawn out for minutes, crashes, sirens etc. are superior to the human
voice in energy'.[4] Dada, as the Cabaret artists now described themselves, combined
noisy critique of an alienating and mechanical culture with a riotous mimicry of the
same: chaotic disorientation fused with violent and improbable rhythms mixed and
presented in a fiercely parodic tone. Hans Arp, having avoided being drafted into
the German army by feigning mental instability and now in Switzerland because of
its neutrality, more or less concurred: 'On the stage of a gaudy, overcrowded tavern
there are the weird and peculiar figures. Total pandemonium. The people around us
are shouting, laughing and gesticulating. Our responses are sighs of love, bursts
of hiccupping, poems, the mooing and miaowing of medieval *Bruitists*' (**fig. 4.1**).[5] Ball
attempted his own provocation. 'I made myself a special costume,' he recorded after
one notable event.

> My legs were in a cylinder of shiny blue cardboard, which came up to my hips so that
> I looked like an obelisk. Over it I wore a huge coat collar cut out of cardboard, scarlet inside
> and gold outside. It was fastened at the neck in such a way that I could give the impression
> of wing-like movement by raising and lowering my elbows ... I could not walk inside
> the cylinder so I was carried onto the stage in the dark and began, slowly and solemnly:

> gadji beri bimba
> glandridi lauli lonni cadori
> gadjama bim beri glassala
> glandridi glassala tuffm i zimbrabim
> blassa galassasa tuffm i zimbrahim

It was a *Lautgedicht* (sound-poem), a poem without words, delivered in a rising
emphatic rhythm whose successive vocables develop out of the ones before, combine
and repeat before abruptly ending; after which the lights went out and he was carried
off the stage in a cold sweat (**fig. 4.2**). And the Cabaret had a philosophical mission
too. 'The human voice represents the soul,' Ball had noted three months earlier, that
of the individual in a world in which man is swallowed up in the mechanistic process,
'a world that threatens, ensnares and destroys the *vox humana*, a world whose rhythm
and noise are ineluctable'. The Cabaret presented 'a farce of nothingness in which
all higher questions are involved; a gladiator's gesture, a play with shabby leftovers,
the death warrant of posturing morality and abundance'.[6]

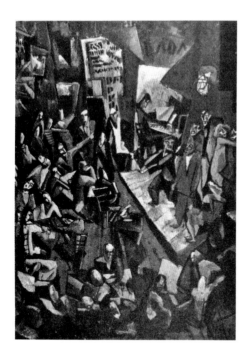

Yet Dada cannot easily be summarised. Neither Ball nor Arp could be said to be typical Dadas – but nor could anyone else. Nor could Zurich be called a typical Dada location. However, the early sound performances of the Zurich Cabaret provide one clue to a more or less constant feature of Dada activity, namely a certain indifference as to outcome, a ceding of control over how a given stage event or artwork might turn out. A willingness to accept chance seems in hindsight to be an abiding feature of the Dada method – whether in Zurich, Barcelona, Berlin, New York or Paris, or in Dada's many later manifestations in the culture of modern art. Take Arp himself, who was not always at the Cabaret because he liked to stay in his studio and 'actually make things', as his friend Richard Huelsenbeck remembered. Arp's ink drawings and wood reliefs of 1915 and 1916 echo a sense of Romantic incompletion, such as could be found in the poetry of Schiller or Novalis, as much as in the sight of detritus washed up on the shores of Lake Maggiore (**fig. 4.3**). In Arp's experiments we see forms emerging that seem 'on their way' to something rather than determined in advance. Likewise his torn-paper collages of the years 1915–17 were made 'without will', as he put it later, 'according to the law of chance'; an aspect of nature that 'embraces all laws and is unfathomable, like the first cause from which all life arises'.[7] In his early torn-paper collages he set aside the device normally used for cutting paper (a pair of scissors) and allowed the paper edges to configure as they may, their ragged, miniscule fibres clearly visible in what the viewer sees. To let paper pieces fall and settle where they may, as Arp claimed he did in certain other works, further intensified the vagaries of chance and created the look and feel not of purposeful design but of an event of nature, one whose description he was often ready to cloak in the language of medieval thought. On any account, the renunciation of control in Zurich Dada was not total randomness, rather an attempt to release life-energy from material itself, material in its own performative identity, it first having been 'selected' and the work of art then having been 'made'.

The term 'creative indifference' – *schöpferische Indifferenz* in the words of the Berlin writer Salomo Friedländer, who was also present in the Zurich Cabaret (he invented the pen name 'Mynona' for himself, or 'anonym' written backwards) – captures well the fusion of activity and passivity that Dada so dramatically explored. It was a fusion especially well captured in dance, in which the body itself becomes the medium of vitality and freedom. The experimental Choreographic Institute of Rudolf von Laban was in Zurich at that time, and its dancers – 'Mr Laban's ladies', as Ball referred to Suzanne Perrottet, Sophie Taeuber, Berthe Trümpy, Mary Wigman, Katja Wulff and others – performed *Lautgedichte* in what to eyewitnesses was a frenzied yet syncopated manner. From a dance performance of Ball's poem 'Song of the Flying Fish and the Sea Horses' there came the following vivid account by Ball himself of Sophie Taeuber's stage presence:

4.1 (*top left*) Marcel Janco, *Cabaret Voltaire*, 1917 (lost work)

4.2 (*top right*) Photographer unknown, *Hugo Ball, performance at the Cabaret Voltaire*, 1916. 71.5 × 40 cm. Collection Kunsthaus, Zurich

4.3 (*bottom*) Hans Arp, *Pre-Dada Drawing*, c. 1915. Ink and pencil on paper, 17.8 × 22.1 cm. Stiftung Arp e.V., Berlin/Rolandswerth

A gong beat is enough to stimulate the dancer's body to make the most fantastic movements. The dance has become an end in itself. The nervous system exhausts all the vibrations of the sound ... and burns them into an image. A poetic sequence of sounds was enough to make each of the individual word particles produce the strangest visible effect on the hundred-jointed body of the dancer ... a dance full of flashes and edges, full of dazzling lights and penetrating intensity (**fig. 4.4**).[8]

Ball also witnessed the summer activities in the Monte Verità community in Ascona, further south – not a Dada community so much as one for alternative politics, diet and philosophy – where he applauded Taeuber's ability not only to syncopate creatively but her skill in 'letting dance happen'.[9]

The Dada duality of activity mixed with indifference, action modified by chance, was seldom constant and seldom enunciated at the time. Only later, in the reflective journals of the participants, did the cultural implications of the Dada moment begin

4.4 Sophie Taeuber, dance performance to accompany Hugo Ball's poem 'Song of the Flying Fish and the Sea Horses', at the celebration of the opening of Galerie Dada, 25 March 1917. Stiftung Arp e.V., Berlin/Rolandswerth

4.5 Marcel Duchamp, *L'Égouttoir* (*Bottle Rack*), 1914. Replica 1959. The Art Institute of Chicago

to codify. Effects without a cause; the sympathy of things for each other; a sort of euphoric awareness of how meanings accumulate on their own: in hindsight such notions formed part of the wider culture of the time. The psychologist Carl Jung, who lived near Zurich at the time, was just then beginning his researches into what he called an 'acausal connecting principle' that suggested the possible significance of simultaneous yet disparate events.[10] 'A picture of the world takes place,' the experimental film-maker Hans Richter later suggested (he joined the Zurich Cabaret following discharge from the German army), 'in which, beside "causal" experiences, others that were previously unknown and unmentioned find a place.'[11]

Soon enough, Dada or something like it reached other cultural centres. 'Dada' was not yet a word when Marcel Duchamp arrived in New York in June 1915, in flight from the war in Europe. From a close-knit family of artists living in Rouen, Duchamp had been an outlier in the Cubist community in Paris, being from the outset more interested in machine imagery and arcane symbolism than in matters of form and planarity so important to Picasso and Braque. Much given to ironic withdrawal and wordplay in matters of art, Duchamp had taken to making machine-like drawings and paintings (as in his *Nude Descending a Staircase no. 2* of 1912, already scandalous in America from its showing at the *Armory Show*) that were mechanical and sexual at the same time. Objects, too, either bought or found in quite ordinary situations, were not originally viewed as Dada but amused Duchamp for their sly allegories as well as for being devoid of the regular markers of artistic work. A bicycle wheel turned upside down and fixed to a kitchen stool would sit in the corner of his studio and just circulate, nothing more. Designated a 'work' and dated 1913, Duchamp called it 'just a distraction: I didn't have any special reason to do it, or any intention of showing it, or describing anything. No, nothing like all that'.[12] A sense of mechanical repetition is visible too in *L'Égouttoir* (*Bottle Rack*), an object Duchamp bought in Paris in 1914 but was then thrown away by his sister-in-law before being retrieved. 'I just bought it,' said Duchamp, 'because of its very lack of appeal aesthetically' – either good or bad. 'You have to approach something with an indifference, as if you had no aesthetic emotion ...' What he was after was 'visual indifference, and at the same time the total absence of good or bad taste' (**fig. 4.5**). In New York he gained a reputation for his Frenchness, his dry yet mischievous humour, and a substantial commitment to playing chess.[13] The term 'ready-made' soon gained traction among both humourists and experimental artists of the day. 'It thrust itself upon me,' he recollected, 'as being perfect for these things that weren't works of art, that weren't sketches, and to which no art terms referred.'[14]

In New York at that time American artists were adjusting, but slowly, to what they knew about recent activities in Paris. Those who had been there had returned home with lessons learnt from others: a rich colour palette from Matisse and his Fauve group in the case of Arthur Dove and Alfred Maurer; Cubist-type faceting in the case of Andrew Dasburg; colour-and-light Orphism in the case of Morgan Russell and Stanton Macdonald-Wright. Of course, most young Americans were indifferent to the cultural rivalries between Paris, Milan, Berlin, Munich and Moscow, and they knew almost nothing about Zurich. More relevant to the generation of Dove, Dasburg and Macdonald-Wright had been the massive *International Exhibition of Modern Art*, subtitled *American and Foreign Art* and held in the hall of the 69th Regiment Armory on

Lexington Avenue, New York, in February 1913. In the *Armory Show*, as it became known, American painters had been represented by a historical survey that included Whistler, Albert Ryder and others, while in the centre of the exhibition space were arranged some 400 'foreign' works from Delacroix through to Kandinski, Duchamp himself and Maillol, representing what the organisers called an 'evolution' in the dawning of a 'New Spirit' in the larger culture of the West.[15] Among the earliest enthusiasts of European modern art in New York was the energetic Alfred Stieglitz, himself a notable photographer who managed a succession of galleries in New York over the next two decades and would give European artists as well as younger Americans important and influential shows. At his gallery 291 on Fifth Avenue, beginning in 1908, Stieglitz showed works by Cézanne, Picasso, Rousseau, Manolo, Severini, Matisse, Picabia and Brâncuşi. He also showed Arthur Dove, who was heightening and loosening his colour to limits unknown in America at that time (**fig. 4.6**); and in 1917 he would give a one-person show to Georgia O'Keeffe, whose innate sensitivity to plant and rock forms had been encouraged by two of her art instructors in Japanese art.[16]

Once in New York, Duchamp was immediately welcomed into the circle around the poet and patron Walter Arensberg and his wife Louise that included the caricaturist Marius de Zayas, the flamboyant actress and performance artist Elsa von Freytag-Loringhoven and the artists Jean Crotti, Francis Picabia and Man Ray. Grouped together in an atmosphere of discussion, partying and satire, the Arensberg circle

4.6 Arthur Dove, *Sentimental Music*, *c.* 1913. Pastel on paperboard, 54.9 × 45.7 cm. Metropolitan Museum of Art, New York

4.7 Francis Picabia, *Here, This Is Stieglitz Here*, 1915. Ink, graphite, painted and printed paper on paperboard, 75.9 × 50.8 cm. Metropolitan Museum of Art, New York

became known for its avoidance of the European war as well as for its indifference to the mores of patriotic America. 'We lived completely outside of social or political movements,' Duchamp recalled, until in the autumn of 1915 he declared his ambition as an artist to bring about 'a complete reversal of art opinion' current among the wealthy philistines of the city.[17] Tactics such as committing himself to a given action in advance, or adding minimal written inscriptions to a ready-made, further helped him detach from the postures of conventional artistic work. It was not until the rejection of a work titled *Fountain* from an exhibition of the Society of Independent Artists in New York in April 1917 that Duchamp's Dada-like attitudes became widely known. The rejected work, a porcelain urinal turned to face upwards, was initially put away behind a screen but by chance was photographed by Alfred Stieglitz and published anonymously (except for its *faux*-signature 'R. Mutt') in *The Blind Man*, a short-lived journal edited by Duchamp and two friends, a few weeks later. An article defending the porcelain 'buddha' published in that journal reminded its readers:

> there is among us today a spirit of *blague* [joke] arising out of the artist's bitter vision of an over-institutionalised world of stagnant statistics and antique axioms ... We who worship Progress, Speed and Efficiency are like a dog chasing after his own wagging tail that has dazzled him ... If there is a shade of bitter mockery in some of our artists it is only because they know that the joyful spirit of their work is to this age a hidden treasure.[18]

The playful irreverence of New York's version of Dada could be applied to Picabia and Man Ray too. The French artist Picabia, Duchamp's ally in wartime New York since 1915, had already been practising another kind of parody of the machine. For him, the objective was less anonymity, or chance, or even the scandal value of the absurd – rather the semi-humorous imbrication of the human figure with various mechanical devices and malfunctions. Just as soon as Picabia had formed a liaison with Alfred Stieglitz's gallery 291 and its magazine *Camera Work*, he had begun to devise drawn and painted portraits of his acquaintances in which a sceptical anti-mechanism was clear. The pen-and-ink drawing *Here, This Is Stieglitz Here* of 1915 presents in meticulously hand-drawn detail his friend, a fast car enthusiast as well as a photographic impresario, as a complex contraption, below a single word in Gothic type stating IDEAL and a caption 'Foi et Amour' ('Faith and Love'). The contraption in question is a car handbrake and gearstick in the rear-ground of a camera bellows that has become detached from the camera lens and flopped downwards – perhaps an affectionate joke at the expense of 291's claim that photography was one of the forms of a truly modern art (**fig. 4.7**).[19] Picabia was independently wealthy and a frequent international traveller – between Barcelona, Zurich, Paris and New York – when he began publication of his own magazine, *391*, in January 1917, that survived through the years of Paris Dada from 1919 to the first activities called 'Surrealist' in the latter part of 1924. Aside from the machine drawings and paintings of those years, Picabia was an experimental poet and writer. His verses took the form of lists of phrases, sometimes automatic or upside-down texts, in which blind adherence to arbitrary or unmotivated rules resemble a parody of artistic work, replacing carefully nuanced choice with simulated mechanical action. Once more, the urge to deindividualisation, to anonymity, eventuated in a form of work not only unique but uniquely strange. In his literary work

Picabia 'hates professionalism', his friend and ally Tristan Tzara noted approvingly; 'he writes without working'. As for his other literary productions, 'his poems have no ending; his prose works never start'.[20]

For his part, Man Ray (he was born Emmanuel Radnitzky but came to prefer a shorter name), having taken art classes in 1912–13 at the Francisco Ferrer Centre in New York where anarchism, psychoanalysis and feminism were all discussed, had quickly determined to become an outsider to all prevailing techniques and attitudes in art.[21] Meeting Duchamp shortly after the latter's arrival in the city, he found much that they shared: an interest in human-machine analogies as well as an ironic attitude to the 'correct' deployment of graphic technique vis-à-vis the human body. In Man Ray's case his experimentalism extended to photography, or rather the resources of the camera to capture near-to objects removed from their usual contexts and positioned in unusual conditions of light. His early triumphs include such images as an egg beater captured in strong raking light and photographed from below, then given a title that rehearses an analogy between man and mechanical motion (i.e. sex) from an amusing yet philosophical point of view (**fig. 4.8**). In 1920 he joined with Duchamp and the New York heiress Katherine Dreier in forming the Société Anonyme for the promotion and collection of new art, and in July 1921 moved to Paris, where we shall hear of him again.

Receptiveness to chance events in Dada took different forms according to context. The ceaseless play of contrasting and irreconcilable sensations – of noise, light, colour, intensity and rhythm – had been a central concern of the Italian Futurists but was exploited with especial ferocity in Berlin, a city mired by war and rising tides of revolution. Richard Huelsenbeck referred to Berlin in 1917 and 1918 as a city 'of mounting hunger and hidden rage'. Berlin Dada could even look like Futurism by another name: a celebration of life-forces ready to animate the social fabric and in a sense already latent within it. 'Simultaneity is against what has become and for what is becoming,' said Huelsenbeck as if he were Marinetti or Boccioni.

4.8 Man Ray, *L'Homme* (title subsequently changed to *La Femme*), 1918. Gelatin silver print, 48.3 × 36.8 cm. Private collection, New York

> The screeching of a streetcar brake and the crash of a brick falling off the roof next door
> reach my ear simultaneously and my (outward or inward) eye rouses itself to seize ... a swift
> meaning of life ... I obtain an impulse towards direct action ... I feel the form-giving force
> behind the bustling of the clerks in the Dresdner Bank and the simple-minded erectness of
> a policemen.[22]

At the time of Huelsenbeck's 'First Dada Lecture', delivered in Berlin on 22 January
1918, the mood in the city was unprecedented. 'And what is that Dada that I am
advocating this evening?' Huelsenbeck asked his audience.

> It wants to be the *fronde* [revolt] of the major international art movements ... it includes
> real characters, people of destiny with a capacity for living. People with a honed intellect
> who understand they are facing a turning-point in history ... Dadaism is something that
> has superseded the elements of Futurism or the theorems of Cubism ... Dada expresses
> nothing more than the international nature of the movement; it has nothing to do with the
> childlike stammering with which some have tried to link it.[23]

He had already met and brought together a group of artists sickened by the
wastefulness of war, among them George Grosz, Helmut Herzfelde (John Heartfield),
Johannes Baader, Raoul Hausmann and before long Hannah Höch, all of whom
were ready to demonstrate that revolutionary artistic technique and revolutionary
politics belonged together.

By the end of 1918, with the Armistice signed in November and the kaiser having
fled to Holland, a group calling itself the Spartacists, sympathetic to the Bolsheviks
in Russia and led by Rosa Luxemburg and Karl Liebknecht, led a winter uprising
against the new German government of Social Democrats under its president Friedrich
Ebert and defence minister Gustav Noske. It was crushed in January 1919 and the
Spartacist leaders were murdered in jail. In the meantime a statement by an alliance
of Expressionist artists and others calling themselves the Novembergruppe issued
a call to young artists to work for 'the moral regeneration of a young and free Germany
... [for] the collective well-being of the nation ... to fight against backwardness and
reaction'. They demanded exhibition opportunities, the liberalisation of the art schools
and changes to the collecting policies of Germany's museums. Yet the Novembergruppe
disappointed the internationalists among the Dadas, who had been sympathetic
to the Spartacists.[24] The announcement of a new German Republic at Weimar in July
1919 did little to quell the latter – including Dix, Grosz, Heartfield, Hausmann and
Höch – who turned to mercilessly satirising the new republic for its endorsement
of a culture still subservient to the market, to international capital, to the value system
of the pre-war bourgeoisie. 'You walk aimlessly along,' wrote Huelsenbeck in a fiery
declaration of 1920 while collecting his thoughts on the movement so far, 'devising a
philosophy for supper, but before you have it ready the postman brings you news that
your pigs have died of rabies, your dinner jacket has been thrown off the Eiffel Tower,
and your housekeeper has come down with the epizootic' – bourgeois conformity
suddenly thrown asunder by events.[25] By now, Grosz and Heartfield had begun to take
magazine photographs, advertising imagery, wrapping paper or packaging, and by
cutting and remixing them found new images that were licentious, provocative and

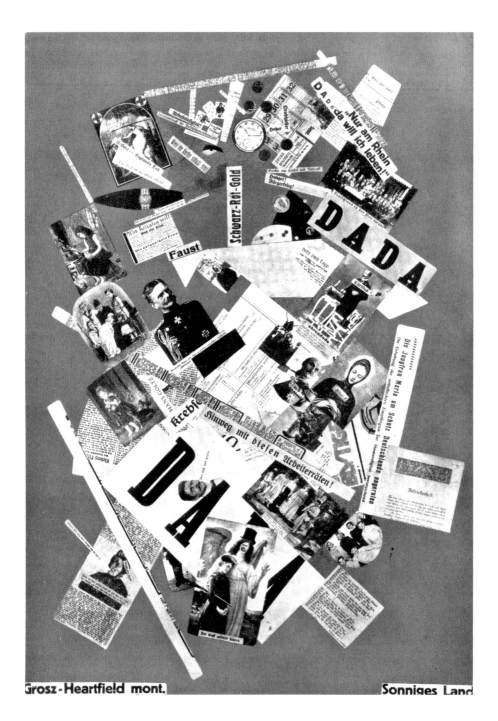

4.9 (*above*) George Grosz and John Heartfield,
The Sunny Land, 1919 (lost work). Heartfield
Archive, Berlin

4.10 (*opposite*) Hannah Höch, *Dada-Rundschau* (*Dada-Panorama*), 1919. Collage, gouache and watercolour,
43.7 × 34.6 cm. Berlinische Galerie, Berlin

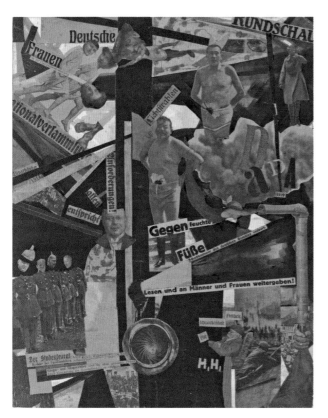

relatively anonymous; and they used the word *montieren* – 'to fit', 'to assemble' – for the new method, deployed in their jointly authored *The Sunny Land* of 1919, a visual merry-go-round of incongruously jumbled images of German bourgeois life underscored by a mocking title (**fig. 4.9**). 'We called this process "photomontage",' said Hausmann about himself and others in the group, 'because it embodied our refusal to play the part of artist. We regarded ourselves as engineers, and our work as construction: we assembled our work like a fitter.'[26] *Klebebild* (glue picture) rather than the far politer *papier collé* was the term the Berlin Dadas preferred.

The term 'photomontage' also covers the Dada contribution of Hannah Höch, who brought to the practice of the *Klebebild* a flair for paper cutting that she had previously used professionally in dress design. In 1918 and 1919 'we were living in a world that nobody with any sensitivity could accept or approve', as she put it later. Being allied with communism if not herself a member of the Communist Party, her work was at least a plea for pacifism, for a politics that in her words promised 'a better future, a more equitable distribution of wealth, leisure, and power'.[27] A powerful *Klebebild* titled *Dada-Rundschau* (*Dada-Panorama*) along with the larger and well-known *Cut with the Kitchen Knife through the Last Weimar Beer-Belly Cultural Epoch in Germany*, both dated 1919, are openly critical works. In the *Rundschau*, for example, can be seen President Ebert and Defence Minister Noske in bathing trunks, a soldier atop the Brandenburg Gate during the suppression of the Sparticist revolt, and one of the thirty-six females elected to the National Assembly in 1919, the year after women in Germany won the right to vote (**fig. 4.10**). What is distinctive about this image is Höch's renunciation of the Futurist-type visual vortex more typical of Hausmann or Heartfield's *Klebebilder* in favour of an implied stabilising grid that anchors the pictorial elements in a framework of rectangles, sections and planes. Secondly, Höch uses the device of superposition, which functions to burlesque a given image by placing the wrong head on the wrong body, slicing or inverting the head, or detaching it altogether – something the male Dadas seemed reluctant to do.

Höch's *Rundschau* and *Cut with the Kitchen Knife*, and some Dada dolls, were included in the *First International Dada Fair* or *Dada Messe*, held at 13 Lützowufer, Berlin, in June and July 1920. The *Dada Messe* was itself a collage of paintings, objects

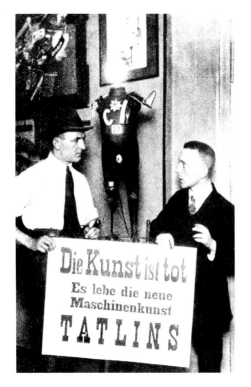

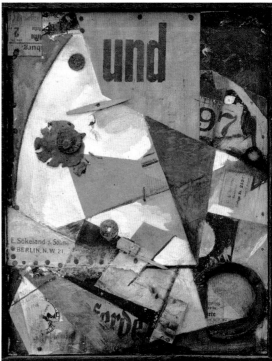

and signboards distributed with a jollity appropriate to a fairground. Or that is the impression we have from the photograph of Grosz and Heartfield holding a sign that reads 'Art is Dead: Long Live the New Machine Art of Tatlin', a direct endorsement of the Moscow Comintern for which Tatlin had recently designed a tower. Behind them in the photograph is a mannequin (no arms, one leg, a light bulb for a head) made by the pair bearing the title *Der Wildgewordene Spiesser Heartfield* (*The Petty-Bourgeois Philistine Heartfield*) (**fig. 4.11**). No doubt their placement before the mannequin was intended to translate Tatlin's seriousness into their own parodic-destructive terms. 'Art should altogether get a sound thrashing,' Huelsenbeck wrote of these events. 'Our best instrument consisted of big demonstrations at which, in return for a suitable admission fee, everything connected with spirit, culture and inwardness was symbolically massacred.' Dada's consequences 'have been drawn from the question: What is German culture? (Answer: shit), and this culture is attacked with all the instruments of satire, bluff, irony and finally violence ... Dada is German Bolshevism'.[28] A short manifesto signed by Huelsenbeck and Hausmann in the same year called for 'the international revolutionary union of all creative and intellectual men and women on the basis of radical Communism', with a list of radical demands

4.11 George Grosz and John Heartfield in front of *Der Wildgewordene Spiesser Heartfield* (*The Petty-Bourgeois Philistine Heartfield*), 1920

4.12 Kurt Schwitters, *Das Undbild* (*The 'And' Picture*), 1919. Gouache and varied material on paper, 35.5 × 28 cm. Staatsgalerie, Stuttgart

including daily meals at public expense, the conversion of clergymen to Dada, elimination of the concept of property, and 150 circuses 'for the enlightenment of the proletariat'.[29] Yet for all its rhetoric and protestation, Dada in Germany was on the point of change. In effect, the *Dada Messe* marked the climax of Berlin Dada in its politically aggressive and publicity-hungry mood.

Höch for her part had meanwhile formed a close friendship with the Hanover artist Kurt Schwitters, whose technical prowess and originality of mind she recognised as unique. Schwitters had first encountered the Berlin Dada group through the influential Der Sturm gallery network in Berlin, where he had earlier exhibited as an Expressionist painter. His new method, from the late part of 1918 – hence coinciding with the Armistice, the flight of the kaiser and the events of the aborted German Revolution – consisted of scouring the streets and waste heaps of Hanover for scraps of material, then assembling them as flat constructions within a frame (**fig. 4.12**). Schwitters' *bricolage* posture echoed those practices of 'aesthetic indifference' that had marked Dada in Zurich and New York. In another sense it resonated with Huelsenbeck's 'First Dada Manifesto' of April 1918 which announced 'the use of new materials in painting', in which everything is mixed together – 'affirmation-negation: the gigantic hocus-pocus of Being [that] fires the nerves of the true Dadaist'.[30] In fact Huelsenbeck turned Schwitters down when he applied to join Berlin Club Dada in late 1918, perhaps because of his links with Der Sturm. It may explain Schwitters' invention of a new term for his work, 'Merz' – it could be a noun or a verb – which he claimed meant 'essentially the totality of all imaginable materials that can be used for artistic purposes, and technically the principle that all of these individual materials have equal value … The wheel of a pram, wire mesh, string and cotton balls – these are of equal value to paint'.[31] Aside from references to contemporary events occasionally revealed in newspaper cuttings, Schwitters' formal virtuosity with colour, edge, scale and organisation, his revelation of the extraordinary in the ordinary, remains the great achievement of Merz and 'merzing', even today.

After the *Dada Messe*, in which Schwitters was not included, Höch pioneered a style of disruptive and disrupted imagery that was distinctively hers. We can appreciate her independence relative to the male Dadas by looking at her *Dada-Ernst* (*Dada-Serious*) of 1920–21 which both identifies gender stereotypes (male boxers and a weight-lifter, a leering eye between a young woman's provocatively parted legs) and parodies them in one jumbled, restless image (**fig. 4.13**). Throughout her subsequent career in design, painting, story writing, poetry and stage design for the avant-garde theatre, Höch remained faithful to the ethos of Berlin Dada, but on her own terms.

Dada also flourished briefly in Paris. Tristan Tzara arrived there in early January 1920, to be immediately welcomed by a group of writers close to the journal *Littérature*, including Louis Aragon, André Breton, Philippe Soupault, Paul Éluard and Georges Ribemont-Dessaignes. That Tzara was a writer among writers is of consequence in what follows, for Paris Dada – far more than its counterparts in Zurich, New York or Barcelona – was substantially a literary phenomenon insofar as experimental writing as well as visual works containing diagrams, alphabetical letters and suggestive puns occupied the centre of its attention. Picabia himself proved a star of the first Paris Dada 'season' with two small exhibitions (March and December 1920) and the publication of a short-lived magazine *Cannibale* (*Cannibal*), which came out in April

and May. A painting such as his *The Cacodylic Eye* of 1921 had a performative function too, certainly a provocative one (cacodyl is a smelly colourless liquid that combusts on exposure to the air). It was entirely painted – except for the large eye shape in the lower right-hand corner – by studio visitors invited to add a signature and perhaps a scatological remark **(fig. 4.14)**. A second Dada 'season' in the spring and summer of 1921 confirmed how, in addition to its literary dimensions, Dada was now becoming internationalised, albeit with Paris for the time being as its centre.

A talented young German artist, Max Ernst, who had already assembled a Dada group in Cologne with Johannes Baargeld and Hans Arp, held a successful show of collage-paintings, championed by Breton.[32] Straight away after his war service Ernst had begun to assault the primacy of the painted surface in art by switching to photomontage – or any mixture of media that destabilised the regular value orderings of the image **(fig. 4.15)**. Breton in his preface referred to photography itself as 'the mortal blow' to the old illustrative regime of art. Max Ernst, Breton said, has used photography 'to attain two widely separate realities ... bringing them together and drawing a spark from their contact ... disorientating us in our own memory by depriving us of a frame of reference'.[33] The exhibition marked the genesis of an idea that Breton would articulate more forcibly in the years to come; that of Surrealism.

In fact a large group show at the Galerie Montaigne that summer opened a split between Breton's immediate group, fascinated above all by psychological disorientation, reverie and the dream, and supporters of Tzara, who were mostly

4.13 (*opposite*) Hannah Höch, *Dada-Ernst (Dada-Serious)*, 1920–21. Collage on paper, 18.6 × 16.6 cm. The Israel Museum, Jerusalem

4.14 (*above*) Francis Picabia, *The Cacodylic Eye*, 1921. Oil, enamel paint, gelatin silver print and printed paper on canvas, 148.6 × 117.4 cm. Centre Pompidou, Paris

from outside France and tended to take a more anarchic and more nihilistic line. It was inevitable perhaps that the international origins of the latter group would fragment Dada's original posture of protest against the war. Not only did the Galerie Montaigne show include the Americans Joseph Stella and Man Ray and the Russian Sergei Sharshun (known in France as Serge Charchoune), but there were others, notably a group of Italians whom Tzara had drawn to Paris from some distance away. One such, the artist Julius Evola, the restless Tzara had recruited back in 1917 on one of his trips to Naples to meet the personnel of the dissenting journal *Le Pagine*, of which Evola was co-editor. Evola had come to admire Tzara's outlook and sought immediate discipleship under his wing – attracted it seems by Tzara's idea of the self as unfixed, indifferent to criticism, thrill-seeking, unaccountable and permissive. As he wrote to Tzara soon after, 'I join your movement with great enthusiasm, a movement with which all my work has long been converging ... I declare Dada to be the most important and profoundly original art movement that has appeared to date'.[34] But Evola was increasingly invoking mystics in his support, even drifting towards a kind of psychological autarchy. 'I wish to persuade no one,' Evola wrote in reference to his own Dada paintings of 1920–21; 'I stake out my case on lifeless forms; on

4.15 (*above*) Max Ernst, *La Bicyclette Graminée* (*The Grassy Bicycle*), 1921. Gouache, ink and pencil on printed paper on paperboard, 74.3 × 99.7 cm. Museum of Modern Art, New York

4.16 (*opposite*) Julius Evola, *Dada-Landscape*, 1920. Oil on canvas, 63.3 × 40.3 cm. Museo di Arte Moderna, Rovereto

nothingness'; thus a painting like *Dada-Landscape* of that time assembles arbitrary-looking forms and shapes without a hint of semantic awareness or legible allegorical drive (**fig. 4.16**). 'Dada is radical idiocy,' Evola wrote: 'I practice bad faith ... I paint my paintings for my own vanity and for purposes of self-promotion. I know what I am up to ... I am absolute.'[35] Of course, such vapidities were not compatible with Dada as a rebellious artistic force. Soon, Evola was using his Dada affiliations as stepping-stones to all kinds of national mysticism, esotericism and private spiritual ascent.

It was but one sign that the interests being pursued by Breton's group at that time were incompatible with the attractions offered by Tzara's more anarchic line. Breton's experiments with 'automatic' writing in particular, including those conducted under conditions of *séance*, were driving towards psychic exploration, fantasy and the revolutionary potentialities of the dream. In due course they would need, and find, other pathways of expression. Yet what in Zurich had begun as a protest against the European war, inclusive and internationalist as the occasion demanded, would soon run out of steam in Paris – if not in Holland, Germany and elsewhere, where Dada took on some very different kinds of life.

The 1920s:
Looking Forward,
Looking Back

The decade that followed the end of the First World War can be broadly characterised as one of recovery: not merely recovery from the hiatus of war, but recovery of past standards of stability and security, even of national redefinition against the background of rapid and destabilising change. For some artists this meant a reversion – even a partial one – to the classical standards of the European south in the form of Etruscan, Hellenic, Roman or other cultures near to the Mediterranean basin. Yet values of symmetry, balance, grace and proportion would not be transcribed unproblematically, with the result that 'the classical' during the 1920s soon became disputed territory in itself, open to adaptation and variation in diverse and complex ways. It was soon clear, for example, that looking backwards in search of new standards of stability could have many outcomes, including another look at the very fundamentals of modern visual form. For the 1920s is remarkable for the degree to which artists of a progressive kind made it their business to research – even discover for the first time – the units, the building blocks, on the basis of which everything in the visual environment was made; a form of certainty very different from the overt transcription of 'classical' standards into the new era, yet a Classical ambition in the true sense. In the remarkable German design school the Bauhaus, too, a search for the underlying fundamentals of art *and* design (including architecture) led to methods of analysing material and form in ways that would achieve pan-European and eventually world importance.

Two further kinds of recovery belong to this complex and frenetic decade. In one, artists and writers already attracted to the spontaneity and randomness of the wartime protest groups would try to recover the power of the mind itself to imagine the world afresh, a programme in which even chance occurrences might illuminate the practical and waking life, and where images might assemble together that had never been associated before. Surrealism, the movement that sprang to life in France in 1924, presented itself as the most far-reaching set of tools for the recovering of such values as surprise, ecstasy, and the mystery of the commonplace that the veneer of European civilisation had for so long concealed.

Elsewhere, however, already by mid-decade these several versions of aesthetic and cultural recovery were becoming viewed with great suspicion. In some of the major nations of Europe – Soviet Russia, Germany and Italy especially – experimentation with new kinds of artistic freedom was being deemed incompatible with the demands of economic stability, industrial progress and national prosperity in the post-war age. No sooner had the drums of the First World War begun to fade than some new forms of cultural rivalry began to take visible and often unattractive form.

Modern Classicisms

An urge to re-evaluate modern art could be detected throughout Europe following the end of the First World War. When the writer Paul Dermée announced in early 1917 that a period of artistic experiment must be replaced by one of organisation, order and method – in his words, by 'a classic age' (*un âge classique*) – he meant, not ancient Greece and Rome, but the 'classic' period of French literature of the seventeenth century, that of Racine, Molière and Corneille. To him, a work of contemporary art 'must be conceived the way a pipe or a hat is made by its maker, with all the pieces given a place strictly determined by their function and their importance'.[1]

That ambiguity, between a return to ancient Greece and Rome and a return to 'classic' national tradition was to become characteristic of many kinds of post-war compromise with 'the modern' in art. It is true that France's southern border, from the Iberian peninsula round to Italy in the east, was suffused with the remnants of Greece and imperial Rome; that for some two decades major discoveries had been made in Athens, Delphi, Samos, Corinth and in other Mediterranean excavations including Roman sites in Italy and in modern Spain. Interest in Attic, pre-Hellenic and Egyptian civilisations had been growing too. Much depended, therefore, on how the relation between the classical and modernity was understood. In certain cases it could signify a retreat. Aristide Maillol, from the village of Banyuls-sur-Mer near France's Spanish border, turned to sculpture after an early career as a painter and tapestry maker. By 1918 he was making a reputation for sculptures of standing or recumbent female nudes that captured the 'timeless' values of Mediterranean culture in a manner now claimed as evidently and patriotically French as well as belonging to the post-Armistice contemporary world (**fig. 5.1**). In fact his pensive, generally serene figures rely for their classicism not on proportion, or rootedness in myth, but on their smooth, 'correctly' proportioned bodies and nearly immobile postures – both qualities likely to reassure a viewer sceptical of more experimental techniques in art. By their supporters Maillol's sculptures were claimed to offer an ideal synthesis of ancient tradition – French, classical or otherwise – and the needs of the present. 'By birth, by race, he belongs to the French Midi': so wrote the Symbolist painter Maurice Denis, by now himself something of a classicising artist, in a monograph on Maillol of 1925. 'He comes to us from the shores of the Mediterranean whose blue depths gave birth to Aphrodite and have inspired so many masterpieces ...'[2]

The very tone of those validations is symptomatic of a certain practical and critical nostalgia now under way. The painter André Derain, known for his Fauve paintings done

while in the group of Matisse, had resisted Cubism even before the war, modulating between Cézanne on the one hand and Renaissance painting on the other, veering only occasionally towards El Greco's sombre and elongated figure style. And that conservatism could be seen as a virtue at the time. A wartime show of Derain's work at Paul Guillaume's gallery in Paris had been praised by Apollinaire for the kind of 'simplicity, freshness … and discipline' which (after all) no German artist could achieve: 'Derain's art is stamped with an expressive grandeur that one could call antique … he can be compared with Racine,' Apollinaire wrote, 'who owes so much to the ancients, nevertheless carrying not a trace of archaism.'[3] When Derain returned to art in 1918 after four years' military duty, his was seen as exemplary of a type of painting that leant unapologetically on a French 'tradition' repurposed to constitute a timeless contemporaneity – assuming such a thing could be done. In *Nu à la cruche* (*Nude with a Pitcher*), dated 1921–3, his subject gazes with a dreamlike intensity at a point somewhere below the viewer's position of sight, allowing full and unimpeded entry to the viewer's returning gaze (**fig. 5.2**). The painting's wider claim was that the fully or partially unclothed 'classical' female figure might evoke peaceable nationhood

5.1 Aristide Maillol, *Venus with a Necklace*, 1918. Bronze, 175.3 × 61 × 40 cm. Tate Gallery, London

5.2 André Derain, *Nu à la cruche* (*Nude with a Pitcher*), 1921–3. Oil on canvas, 170 × 131 cm. Musée de l'Orangerie, Paris

and territorial security in the aftermath of a highly destabilising war. In common with other artists – Metzinger, André Lhote, Roger de La Fresnaye, even Auguste Herbin – a mood was gathering in favour of recuperating traditional French values associated with agrarian life, suspicion of the machine, and a rebuilding of national morale after the physical ravages of the conflict. For remember the heavy toll suffered by the French countryside itself during the fighting; not to mention a quite different anxiety – that of Germany's possible revival and dominance once its economy had begun to recover. The phrase 'return to order' was increasingly heard among politicians and cultural commentators alike.[4]

Picasso's relationship to the classical past was more complex still. Remember that he had not been a combatant in the war, nor was he French; and that he had no need of recuperation from battle, as had Derain or Braque. Yet he had been among the earliest to startle audiences with his sudden interest in the classical south. Recall that he had started drawing in a photo-naturalist manner in 1915; had then travelled to Rome with the Ballets Russes in the spring of 1917, had visited Naples and Pompeii and seen the recently restored Roman wall frescos and statuary there. In a letter to Gertrude Stein he had spoken of 'making Pompeian fantasies' in his drawings of Diaghilev and some of the dancers.[5] By the time the company had reached London in the spring of 1919 several of his drawings and paintings had begun to display a subtle swelling in the depiction of hands, forearms, fingers and feet that cannot be called 'classical',

5.3 (*above*) Pablo Picasso, *The Source*, 1921. Oil on canvas, 64 × 90 cm. Moderna Museet, Stockholm

5.4 (*opposite*) Henri Matisse, *Nude on a Chaise-longue*, 1919. Oil on canvas, 55.7 × 33.3 cm. The Ashmolean Museum, University of Oxford

yet signified balance and solidity in a manner
that somehow evoked classical precedents;
for example, a mode of contact of feet with
the floor in Greek and Roman statuary, or the
oversize hands given to the figure of David by
Michelangelo. Graphic conventions such as
cupid lips or expressionless eyes, garnered
from Roman wall or panel painting, Picasso
now imported into his work together with a
sudden enlargement of a painting's very size
and scale. His over-life-size *Large Bather* of
1921 may be crammed into her picture space,
but there are distant echoes of any number
of Roman or Greek prototypes, from the
Parthenon figures he had seen in the British
Museum to the Pompeii frescos themselves.
A smaller painting of that year, *The Source*,
treats very differently the theme that Derain
would shortly try – that of a woman with a
water pitcher near a river or a lake. By chance
Picasso had spent the summer of 1921 living
in the village of Fontainebleau, in whose

celebrated chateau he would have seen the same composition in the painted frescos
by Rosso Fiorentino in neoclassical style. Picasso's water nymph then was twice
removed from the ancient origins of the classical style. In such a work the classical
is further signalled by the figure's drapery, but also by her unsettling solitude and
self-possession (**fig. 5.3**).

What did that mean for Picasso's 'return' to a figurative style? In the years
between 1921 and 1925 the 'classical' in his figures means ease and balance but also
a certain vacancy of expression that seems to remove them from the twentieth century
altogether.[6] Certain biographical factors also come into coincidence with his apparent
switch from Cubism to the classical. Now forty years old and with a young son born
to him and his wife Olga in that summer of 1921, he was already renowned and wealthy
enough to evoke his own ease, his own growing attraction to the Mediterranean
as a place in which to live and to look; a place of reclining females and gazes at the
distant sea. It seems no coincidence that those years mark the return of *méditerranéité*
in Matisse's paintings as well. In 1919 Matisse had moved to a small hotel on the
Promenade des Anglais, Nice, in order to pursue what he called 'true painting' in an
ambience of Mediterranean light and variable weather – to concentrate on the demands
of looking and painting itself.[7] Though never schematically 'classical', it can be said
that Matisse's paintings of semi-clothed models of the period, seated or reclining in an
often small interior, have knowingly or otherwise absorbed something of the calm and
assurance with which the classical is associated – but also a sense of remoteness from
the modern world (**fig. 5.4**). Working alone for much of the time on that ancient southern
coast, his paintings restructure his optical sensations nostalgically in preference to
offering an accurate record of a scene.[8]

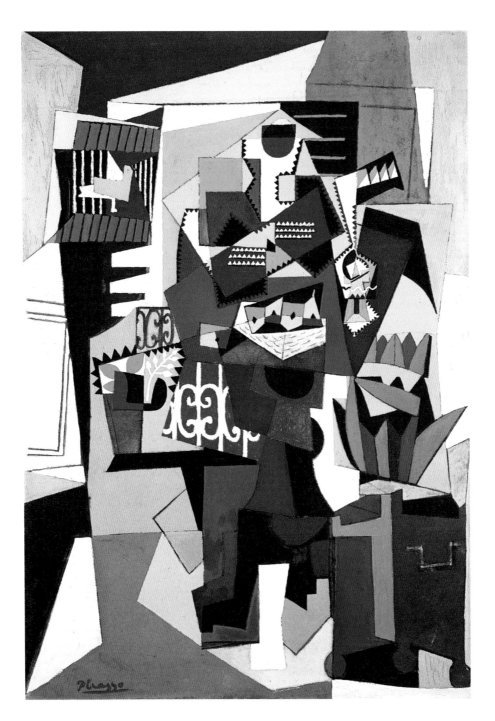

5.5 (*above*) Pablo Picasso, *The Bird Cage*, 1923.
Oil on canvas, 201.3 × 140.3 cm. Private collection

5.6 (*opposite*) Pablo Picasso, *The Red Tablecloth*, 1924.
Oil on canvas, 98.4 × 131.4 cm. Museum of Modern Art,
New York

In Picasso's case the puzzle was that just as he began to play imitative games with Greek or Roman art, he was also producing magnificent Cubist paintings, this time in a complex, even decorative variant, several of them including animals or pets such as *Dog and Cock* of 1921 or *The Bird Cage* of 1923: paintings remarkable for a tight locking together of shapes, edges, continuities and sudden disavowals – for a prismlike clarity, not in the identity of things but in their mutually adjusting geometry (**fig. 5.5**). His ability to modulate, seemingly within the same month or fortnight, between the monumentally classicising figure and the prismatic Cubist *tableau* suggests an artistic intelligence unlike that of other artists of his generation. Was his interest in classicism, then, an opportunity to shorten the historical distance between ancient and modern – or a convenient pretext for double-edged quotation and irony, the 'modern' artist's posture *par excellence*? In fact, Picasso took pains to deny that the Cubist and the classical were different – or that an evolution from one to the other had occurred. 'Repeatedly I am asked to explain how my painting evolved,' he said to an interviewer in 1923.

> To me there is no past or future in art. If a work of art cannot live always in the present it must not be considered at all. The art of the Greeks, of the Egyptians, of the great painters who lived in other times, is not an art of the past; perhaps it is more alive today than it ever was ... All I have ever made was made for the present and with the hope that it will always remain in the present.[9]

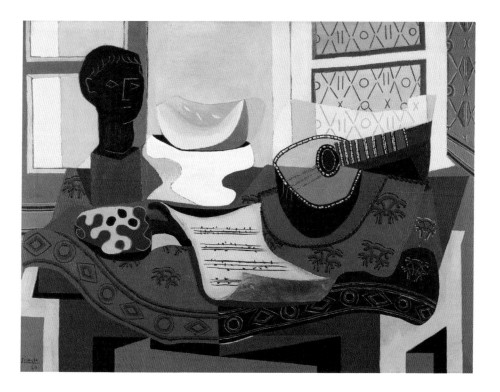

For him, Cubism and classicism gave access to the same goals: a reckoning with the simultaneity of modern phenomena and with the disturbed, sometimes claustrophobic existence lived by modern objects – the confinements imposed upon them by the spaces that they and we occupy. At least, a group of four or five ostensibly still-life paintings from the years 1924 and 1925 would show how Cubism and monumentality could be combined. Their scene is a bourgeois living room replete with tokens of culture and well-being: a musical instrument on a table, a *compotier* or raised fruit dish, a musical score or open book, a tablecloth with table legs beneath, sometimes a classical bust that gives superficial validity to the unstable assembly the viewer sees. There is usually a view through an open window behind (**fig. 5.6**). The visual language is suddenly and productively new. Complex patterning pervades the scene. Contours begin to sag and sway. In retrospect, it was a moment of relative calm before much darker, Dionysian forces erupted in Picasso's work.

For other artists in Paris, the classical could take very different forms. We saw already how the gallerist Léonce Rosenberg lent his support to Crystal Cubism; how even during the later war years some artists had begun speaking of 'objectivity', 'certainty' and 'fact'. As early as 1916 the painter Amédée Ozenfant had published a piece entitled 'Notes sur le Cubisme' ('Notes on Cubism'), hoping to rally the French spirit by appealing to its traditions of rationality and good judgement, claiming Cubism to be capable of realising a *purist* aim of 'cleansing plastic language of extraneous terms'. Cubism, he had stated, 'is a moment of Purism'.[10] Ingres, Cézanne and Seurat exemplified an attitude that guaranteed integrity, plastic harmony and balance in the French manner. 'France is repulsed by disorder,' Apollinaire stated in a lecture the following year. There was evidence of 'a new spirit' ('*un esprit nouveau*'), one that 'refers above all to the great classic qualities – order and duty – in which the French spirit is proudly shown. The new spirit is that of the very time in which we live ...'[11]

A propitious meeting early in 1918 between Ozenfant and a young Swiss architect Édouard Jeanneret (soon to call himself Le Corbusier) resulted in a collaboration that gave to both 'Purism' and '*esprit nouveau*' more precise meanings. Fleeing to the safe haven of Bordeaux during the heavy bombing of Paris in the spring of that year, Ozenfant already sensed the attitudes the two men had in common. Working side by side, the two of them produced drawings and paintings and set to work on a manifesto-like booklet they would publish in December. *Après le Cubisme* did not so much reject pre-war Cubism as propose its availability for very different ends. To them, Cubism promised

5.7 (*above*) Le Corbusier, diagram over *Composition with Guitar and Lantern*, 1920. Golding and Green, *Léger and Purist Paris*, London: Tate Gallery, 1970.

5.8 (*opposite*) Amédée Ozenfant, *Flask, Guitar, Glass and Bottles on a Green Table*, 1920. Oil on canvas, 81 × 100.5 cm. Kunstmuseum, Basel

an escape from metaphysics, romanticism and transcendentalism (as well as 'the fourth dimension') in favour of a kind of monumentality such as had been pioneered by Cézanne and by Chardin, and Claude Lorrain and Ingres before them. Secondly, Purism meant the spirit of objectivity found in technology and science – above all, the aesthetic qualities of machines and machine production. They could look to the work-time system known as Taylorism, by now widely in use in industry to promote efficiency; also the assembly line method known as Fordism after the American car manufacturer's successes in mass production. Yet clarity and pleasure were also among Purism's motives; a desire to replace the ugliness of the first machine age, that of the nineteenth century, with the beauty of the second, that of motor cars, ocean liners and industrial architecture. For the authors of *Après le Cubisme*, well-designed machine production enabled those who worked on the factory floor 'to perceive power and clarity, make him feel at one with work of such perfection that his mind alone would never have dared even to aspire to it ... [thus] instinct, trial-and-error and empiricism are replaced by scientific principles of analysis, organisation and classification'.[12] In the first issue of their new journal *L'Esprit Nouveau* in October 1920 our authors welcomed the clean monumental lines of new American grain silos. In another issue they compared the sleek design of the latest automobiles with the triumphs of Greek architecture.

Nevertheless, and for all their appeal to the aesthetic qualities of mass production, the French Purists were never prepared to go to the lengths adopted in Soviet Russia, where, little known to them, leading theorists were trying to jettison the work of art altogether as a kind of spiritual hoax. Even though Ozenfant and Jeanneret/Le Corbusier insisted that the aeroplane and the limousine 'plainly characterise the style of our times', in their own paintings they employed compositional designs regulated by a hidden groundwork of proportions and diagonals based on Pythagoras and Euclid, to suggest – if not exactly to prove – precise alignments of proportion, interval and edge (**fig. 5.7**).[13] As to the object-world of Purist painting, it remained attached to an older Cubist repertoire of bottles, guitars and wine glasses while only occasionally embracing new machinery – more often cocktail shakers and other tableware accoutrements of style-conscious Paris (**fig. 5.8**). In place of the wit and difficulty of pre-war Cubism, post-war Purism was diagram-like, even cognitively cold. To its critics, Purism presented the challenge of disentangling a truly modern classical sensibility from a merely fashionable one.

Aside from Ozenfant and Le Corbusier, the painter most attracted to aspects of *l'esprit nouveau* was Fernand Léger, in whose immediately post-war paintings a similar dialogue between the modern and the classical could become intense. Léger's attraction to Purist classicism was in several ways a surprising one. His wartime service of some four years had confronted him with machines as instruments for killing on a superhuman scale; yet we find him idolising the machine as the source of modern beauty and as the foundation of a genuinely contemporary architecture. 'The war matured me,' Léger admitted in one statement. 'I'm not afraid to say it ... I consider a machine gun or the breech of a .75 more worth painting than four apples on a table.'[14] He was convinced that the new objects of machine manufacture contained a unity of form, colour and function – his term was 'plasticity' – that exemplified modern beauty and showed the path that the truly contemporary artist must follow. In his latest paintings he represented the newly mechanised city as one in which modern men and women lived in a dynamic unity with their surroundings, untainted by distinctions of social class. 'I believe that plastic beauty in general is totally independent of sentimental, descriptive or imitative values,' Léger says in another statement; furthermore 'the tendency to utility does not impede accession to a state of beauty'.[15] A small number of his works show machine-like elements alone (**fig. 5.9**). It is no wonder that Ozenfant and Le Corbusier regarded him as one of their own. Yet there were differences in their respective ambitions. Léger became fascinated by the cinema – more accurately the medium of film – and in 1922, astonished at the machine imagery of Abel Gance's *La Roue* (*The Wheel*), began work with composer George Antheil and cameraman Dudley Murphy on his own contribution to the genre. The result was the celebrated fourteen-minute *Ballet mécanique* (*Mechanical Ballet*) of 1924, in which we see flickering geometric forms alternating with close-ups of parts of the face and body, non-narratively arranged in repetitive rhythm, amounting to a vision of the human subject and the modern machine-object as equivalent in value. 'I maintain,' Léger wrote soon afterwards, 'that before the invention of the moving-picture no one knew the possibilities latent in a foot, a hand, a hat ... Enormous enlargement of an object or fragment gives it a personality it never had before ... an entirely new lyric and plastic power' (**fig. 5.10**).[16]

5.9 (*opposite*) Fernand Léger, *Mechanical Elements* (final version), 1924. Oil on canvas, 146 × 97 cm. Centre Pompidou, Paris

5.10 (*above*) Fernand Léger, *Ballet mécanique*, 1924. Detail of image sequence. Museum of Modern Art, New York

Meanwhile, in his own efforts to unify the new urban rhythms with the lives of a building's occupants, Le Corbusier had been working on designs for a model machine-house he called 'Citrohan' – 'a house like a car', as he put it, 'a house like a machine to live in or like a tool, built by the same methods as Henry Ford was using in his car assembly-lines'.[17] The project can be taken as the first to expose one of the great contradictions of modern architecture and design – and with it, the dilemmas attending the achievement of a truly modern art: the contradiction between mechanism as a source of efficiency, cleanliness and light, and a wish for freedom from standardisation and its usual corollary, bureaucratic control. One well-publicised project connected the designer Ozenfant, the architect Le Corbusier and the painter Léger. For the huge *Exposition internationale des arts décoratifs et industriels modernes* in Paris in 1925, Le Corbusier won permission to erect a Pavillon de L'Esprit Nouveau as an expression of the new values for living and for life. According to him, the pavilion represented a 'cell' in a block of flats, 'a unit in a housing scheme', and as such a rebuff to the high-end Art Deco furnishings and personal adornments on show elsewhere in the *Exposition*.[18] Intended as an icon of the new marriage of life, art and industry, Léger's 1925 painting *The Baluster* was hung in the Pavillon's upstairs space, where it helped cross the barrier between the 'old' world and the new: an antique piece of turned wood is rhymed with steel-coloured machine forms and appears centrally alongside a shipping funnel (at left) and a closed

5.11 (*above*) Pavillon de L'Esprit Nouveau (interior) showing paintings by Léger (left) and Le Corbusier (right), 1925. Fondation Le Corbusier

5.12 (*opposite*) Gino Severini, *Portrait of Gina (Homage to Fouquet)*, 1927. Oil on wood, 31 × 22 cm. Collection Gina Severini Franchina, Rome

book (at right) **(fig. 5.11)**. And yet, whether or not Purist designers and artists intended it, one of the dilemmas of the modern period had surreptitiously taken centre stage. On the one hand the machine as an instrument of cleanliness, efficiency and light, on the other a tool of social and personal standardisation; on the one hand a handmaiden of leisure and emancipation, on the other merely an alienating device. Le Corbusier's encouragement to the 'new' citizen that he or she could 'get down to work in the superb office of a modern factory, clear and rectilinear and painted with white Ripolin paint, in which healthy activity and industrious optimism reign' was one half of that paradox.[19] The regimented housing schemes and overbearing classicising architecture that took root throughout Europe later in the decade soon became the other. 'Classical' ordering in the arts and design apparently served both ends.

In Italy, above all, classical art and architecture already formed part of the nation's history. For Italian artists based in Paris, therefore, identities could become to a certain extent confused. After giving service to Futurism, Gino Severini bemoaned what he had come to see as the aesthetic and technical disorder of experimental art, including that of Cézanne and the Cubists, and began to advocate instead for the mathematical systems employed in Egyptian and Greek architecture and believed to be applicable throughout nature – laws of number, ratio and proportion in particular. For Severini at this stage (as he argued in a small book of 1921), number was not only accuracy and measure but bestowed ethical and spiritual value.[20] Yet his country's classical heritage as well as its Mediterranean geography soon began to tell. Remaining in France while taking up a number of commissions in Italy, he watched his former colleague Marinetti's entanglement with Benito Mussolini and the Italian Fascist Party with interest verging on alarm. Founded in the same year as Severini's book, that dangerous 'turn' in Italian politics claimed to cleanse the nation of its backward-looking ways but also to supervise the progress of art and literature by promoting specifically Italian values such as family coherence, loyalty and Italy's beautiful and productive countryside. Yet Severini in the mid-1920s made a 'return' to other European traditions as well, embracing not only themes from the *commedia dell'arte* and the rituals of Italian rural life but also the tradition of Flemish painting and the techniques of the French Renaissance, above all those of the painter Jehan Fouquet **(fig. 5.12)**. For Severini and others at this stage, the relation between a modern *italianità* and those other kinds of classical tradition must be negotiable rather than imposed from above.

The interests of Giorgio de Chirico in the classical world have proved somewhat harder to define. Born in Greece of Italian parents, and after teenage years in Munich, he had spent a single year in Italy before locating to Paris in 1910, where amid the excitement of Cubism and Italian Futurism he had evolved a painting style that he called 'Metaphysical'. His travels in the south had provided him with three proclivities almost unknown in the Parisian north. In Munich he had seen works by the late nineteenth-century painters Max Klinger and Arnold Böcklin that impressed him deeply. Klinger's landscapes, for instance, he would describe as 'containing a profoundly lyrical and philosophical feeling akin to that generated by the thought of some of the Greek philosophers of Asia Minor and the thinkers of Hellenistic Greece'. They were suffused with 'a barely susceptible sense of *ennui* that breathes over everything', full of 'tranquillity and nostalgia'.[21] De Chirico's Paris paintings came to embed those affects in the spaces of a city – not a northern European city, however, but one of strongly sunlit empty piazzas in which almost nothing happens. Deserted colonnades in the midday sun, statues of Greek figures or nineteenth-century statesmen, distant towers or chimneys, occasionally a flag fluttering – such things he made 'metaphysical' by means of a flattened, tilted perspective and sharp, often naïve drawing such as a child or an agoraphobic might deploy (**fig. 5.13**). Then, after his return to Italy for call-up in 1915, a sense of anxious confinement in de Chirico's paintings begins to show.

5.13 (*above, left*) Giorgio de Chirico, *Enigma of a Day*, 1914. Oil on canvas, 185.5 × 139.7 cm. Museum of Modern Art, New York

5.14 (*above, right*) Giorgio de Chirico, *Hector and Andromache*, 1917. Oil on canvas, 90 × 60 cm. Private collection, Milan

5.15 (*opposite*) Carlo Carrà, *The Hermaphroditic Idol*, 1917. Oil on canvas, 65 × 42 cm. Private collection

He imagines claustrophobic room spaces cluttered with other pictures, inscrutable objects such as panels of biscuits laid in a row, maps, set-squares and easels, or mannequins bearing names from classical literature propped up on the boards of what is best described as a stage (**fig. 5.14**). In the closing period of the war such works proved a stimulus for artists who had taken part in Italian Futurism but now felt a certain pressure to change. Carlo Carrà, for instance, was dabbling in a kind of folk-art idiom by the time of his call-up to the Italian army in 1917, and by chance met de Chirico when both were confined to a field hospital. In what looks like an act of mimicry, Carrà quickly abandoned his folk-art manner to produce his own version of the Metaphysical style. Mimicry or not, the best of Carrà's Metaphysical works, like de Chirico's, very effectively present objects or mannequin-like figures standing on sloping, stage-like spaces or sealed inside a nearly empty room (**fig. 5.15**). Carrà spoke in this period of the need to recapture 'the original solidity of things'. His tone is one of apology for previous sins, but also of new effort, this time to 'give back to Italy that spiritual consciousness without which there can be no participation of the Europe of today'.[22]

For de Chirico, too, by this time, it was clear that the mission of an Italian artist was now to *méditerraniser* – Mediterraneanise – painting with the help of the crisp, dry outlines of southern city squares and the ghosts of Greek and Roman mythology that lingered there. Two of his wartime paintings had pictured Turin, by no coincidence the city where the philosopher Friedrich Nietzsche had succumbed to mental illness in 1888 and which for both Nietzsche and de Chirico exuded the values of a European culture permeated by the moral atmosphere of the Mediterranean south.[23] De Chirico's haughty commentary on pre-war French and Italian modernism now shared something of Nietzsche's tone: he spoke of the 'puerile confusion' of Fauvism, Cubism and Futurism, and dismissed the Impressionist painters as 'too lazy' to stay indoors and produce serious work. After a half-century of French-dominated confusion, his call was now 'to return to the craft' for those few painters 'whose brains are clear and whose eyes are clean', and who wished to take up art 'following the principles and teachings of our old masters'. Painters must make their own colours and prepare their own canvases. 'We have reached the second half of the parabola,' de Chirico says in a telling geometrical metaphor. Futurism had damaged Italian painting. Now, he wished only to be known by three words: '*Pictor classicus sum*' – 'I am a classical painter'.[24]

Yet the qualities of de Chirico's 'classical' or 'classicising' new paintings remain enigmatic. Several works of the mid-1920s introduce anonymous, oversize figures, often indeterminately gendered, who sit or recline inside cramped, room-like spaces yet lack altogether the attributes of Greek or Roman mythology or a relation to the literature and philosophy of antiquity. Their bodies contain columns, porticos, even waves lapping the Aegean or Mediterranean shore. But such figures occupy a

contemporary bourgeois interior, as if crossing the centuries between antiquity and de Chirico's time (**fig. 5.16**). Their relationship to fascist sentiment and imagery is acknowledged to be interestingly unclear. There are statements in which de Chirico seems to make a gesture of support for the nationalist leader Mussolini. On the other hand he was by no means aligned with such openly fascist support groups as the Tuscan-centred Strapaese, whose artists included Ardengo Soffici and Ottone Rosai.

In any case, there was the Novecento Italiano – the Italian 1900s – the most liberal exhibiting group of the 1920s, formed in the northern city of Milan in 1922 under the direction of artists Achille Funi, Ubaldo Oppi, Mario Sironi and others, that was flexible enough to accommodate Funi and company as well as Severini, de Chirico and Savinio, all of whom felt their *italianità* without seriously embracing fascism as a national ideal (**fig. 5.17**). Admittedly the Novecento group was guided from the start by Margherita Sarfatti, a writer and critic for Mussolini's newspaper *Il Popolo d'Italia* as well as being Mussolini's mistress. Her milder conviction was that 'returning' to Giotto and Masaccio could be a way forward for art, that 'originality and tradition are not contradictory terms' – and it may be that, to begin with, Mussolini himself partially endorsed that view.[25] At the opening of the first Novecento exhibition, in Milan in 1926, he noted that unlike those who did document the events of the new regime, Novecento artists succeeded in showing the 'severe interior discipline' of the times through such things as precision of gesture and what he called 'the social plasticity' of things.[26]

It was a compromise that could not last. By 1926 the new government in Rome had begun to advertise its wish to cement a symbolic bond between that city and Italy's imperial past. With the dictatorship officially declared in 1925, *romanità* (Romanness) became the new watchword, with Roman imperial symbolism such as fasces and classical colonnades increasingly called into use in architecture and design. While de Chirico and Severini exhibited work with Novecento in one or both of its exhibitions (the second was in 1929), Milan itself as a northern industrial culture began to lose favour, and Novecento fell from grace in the years after 1930. In that fast-moving context de Chirico's classicising *tableaux* are best regarded as they were perhaps intended – as disturbing stylisations of an ethos of the classical that a much wider Western civilisation still regarded as foundational, but whose identity remained open to interpretation. The classical had shown itself to be available for modernising recoding and political exploitation alike. The following decade would be one in which the tension between them could only grow.

5.16 (*opposite*) Giorgio de Chirico, *The Archaeologist*, 1926–7. Oil on canvas, 96 × 128 cm. Fondazione Giorgio and Isa de Chirico/private collection

5.17 (*above*) Ubaldo Oppi, *The Fishermen of Santo Spirito*, *c.* 1924. Oil on canvas, 120.5 × 101 cm. Galleria Nazionale d'Arte Moderna e Contemporanea, Rome

CHAPTER 6

Surrealism and Painting

In a decade at the end of which nations would turn to nationalist isolation, a particular artistic tendency stands out for attempting to keep the spirit of internationalism alive. Several Dada activists from Zurich, New York, Barcelona and elsewhere found a welcome in Paris after the 1914–18 war – not least Tzara, who inserted himself into André Breton's *Littérature* group early in 1920. It proved an unstable coalition. By the end of the second Dada 'season' in late 1921 a rift had opened between Tzara and the Parisian writers. By July 1923 relations between them had deteriorated further. A soirée of Dada entertainments was organised at the Théâtre Michel by Tzara and the *zaum* poet Ilya Zdanevich (known in France as Iliazde), complete with designs by Sonya Delaunay-Terk and Theo van Doesburg, music by Darius Milhaud and Stravinski, and with Nelly van Doesburg on the piano. When the time came for a performance of Tzara's play *Le Cœur à gaz* (*The Gas Heart*), a three-act parody of classical theatre with Tzara's friends playing the parts of characters known as Mouth, Eye, Nose, Neck and Eyebrow, the tension erupted. Breton and his companions invaded the Dada stage, members of the public joined the brawl, and the police were called to restore order.[1] The fun was over. It was the end of Dada's Parisian journey.

How did younger painters negotiate the fractious critical scene in Paris in those years? When the Catalan painter Joan Miró arrived in the city in March 1920, shortly after his twenty-seventh birthday, he was unaware of these conflicting currents of thought. Barcelona had its own experimental culture (it had been a home for Picabia's *391* magazine), yet Miró reported that in Paris he was 'disoriented, paralysed' by the sheer pace of its artistic life and the wealth of its museum collections – though happy to have the jolt to his awareness. He was in time to sample the Dada Festival at the Salle Gaveau in May 1920, but returned to his family's farm in Montroig, Tarragona, in June, beginning a pattern of toing and froing between Paris and Spain that would last for years – Barcelona increasingly receding, as he saw it, into sleepy provincialism in comparison with his life in France. During 1922 and 1923 Miró's network of Paris acquaintances expanded to include the young painter André Masson (they had neighbouring studios at 45, rue Blomet), the writer Michel Leiris, the poet Georges Limbour, the playwright Antonin Artaud, Tzara and others, as well as the dealers Kahnweiler and Paul Rosenberg, younger brother of Léonce. In the landscape paintings that Miró managed to complete in between his shuttling between Montroig and Paris we see a vivid intensity of detail that began to give way, sometime in the summer of 1923, to landscape visions that depart flagrantly from observed data in favour of

sparsely separated ciphers – of suns, buildings, waves, creatures above or in the land, now reduced to graphic marks that could almost be doodles on a page (**fig. 6.1**). 'I know I am following very dangerous paths,' Miró wrote to a Catalan friend in September 1923. 'I use real life only as a reference [while] the inclusion in my current painting of things extraneous to painting gives greater emotional power to the work.'[2]

Miró's paintings of this time reveal powerful crossovers between literary techniques and the exercise of the graphic imagination. We know that in his early days at the rue Blomet studio Miró discovered Apollinaire's experiments in visual poetry, while tales of Dada methodology – supplied no doubt by Tzara – were rich in ideas of arbitrariness, chance, the stimulus afforded by a subliminal encounter with visual and also verbal things. The cursive shapes of doodling or the linear patterns found in leaves, fields or natural objects – these were now of interest to Miró and to those to whom he was talking. 'I have done a series of small things on wood,' he writes to Michel Leiris in the summer of 1924, 'in which I take off from some form in the wood itself. Using an artificial thing as a point of departure like this is parallel, I feel, to what writers can obtain by starting with an arbitrary sound ... the song of a cricket, for example, or the isolated sound of a consonant or vowel'. He describes a new random technique:

6.1 Joan Miró, *The Tilled Field*, 1923–4. Oil on canvas, 66 × 92.7 cm. Guggenheim Museum, New York

I jot down a number of remarks; names of colours or simply the monosyllable *yes* when I feel that an idea should be carried out ... My latest canvases are conceived like a bolt from the blue, absolutely detached from the outer world (the world of men who have two eyes in the space below their forehead).[3]

Something akin to scribbling was becoming a technique of unsuspected potency. It was but one sign of a convergence – a radical invention in the culture of the modern – between the visual character of writing and the writerly character of painting.

Max Ernst, the Dada from Cologne whose work Breton had written about supportively in 1921, now also moved to Paris, and met the rue Blomet fraternity while lodging (illegally) with Paul and Gala Éluard in the Paris suburbs. Since his Cologne Dada days Ernst had mastered a technique of taking a page of printed imagery and painting out some areas while leaving other parts revealed – the resulting image, full of bizarre transitions and conjunctions, often framed by a line or two of his own writing (see fig. 4.15). Now in Paris, he does some larger paintings that construct an image without text – of figures that are either mechanical (*The Elephant Celebes*, 1921), sightless (*Saint Cecilia*, 1923) or dreaming (*The Wavering Woman*, 1923), collectively exploring the difficult yet fertile tension between precisely rendered images of mechanical entrapment and the inexplicable inner workings of the dream (**fig. 6.2**).

A third young painter to startle the Paris artistic community was André Masson. Having served on the opposing side to Ernst during the Great War, Masson entered the orbit of Parisian discussion by another route. Enlisted in the French army in 1914 aged eighteen, he fought in some of the fiercest exchanges at the Somme and was left for dead on the battlefield before being rescued, hospitalised and sent to recuperate at Céret, in the Pyrenees, a town already well known for the artists who worked there or came to stay. Surprisingly, Masson's Céret paintings show few signs of his wartime trauma, but on his arrival in Paris early in 1920 his works became symbolically loaded, with dark moonlit woods, a cemetery, dead birds and threatening weather. Already Masson's great talent was graphic rhythm; the fluid patterns of nature, natural wilderness, wind and water rendered somehow in the medium of ink on paper. There were also some violently erotic drawings in that medium, encouraged perhaps by reading Dostoevski or Lautréamont or de Sade – more or less the literary diet of the poets and writers whom he met at the rue Blomet studio (**fig. 6.3**). André Breton, who met Masson at his first solo exhibition in the spring of 1924, was impressed. Yet it would be wrong to assume that the war-traumatised painter and the literary ringmaster stood on entirely common ground.

Breton's preoccupation at that moment was the preparation of the *Manifesto of Surrealism* that would be published in November of that year, together with the launch of a literary-cum-artistic journal, *La Révolution Surréaliste*, in December.

What did the new term mean? In a programme note written for the Ballets Russes production of *Parade* back in May 1917, the poet Apollinaire had described the playful mix-up of Léonide Massine's choreography, Erik Satie's music and Picasso's Cubist costumes as '*une sorte de sur-réalisme*' ('a sort of sur-realism') that he hoped would be the point of departure for a whole series of manifestations of what he had also called '"*un esprit nouveau*" that is making itself felt today and that will certainly appeal to our best minds'.[4] Now, some seven years later, *sur-réalisme* was on the point of becoming redefined as an entire philosophy of art and life. 'In this day and age,' Breton states near his *Manifesto*'s beginning,

> logical methods are applicable only to solving problems of secondary interest. The absolute rationalism that is still in vogue allows us to consider only facts relating directly to our experience … Under the pretense of civilization and progress we have managed to banish from the mind everything that may rightly or wrongly be termed superstition, or fancy.

Yet the imagination is on the point of reasserting itself: 'If the depths of our mind contain within it strange forces capable of augmenting those on the surface, or of waging a victorious battle against them, there is every reason to seize them.' He adds: 'no means has been designed *a priori* for carrying out this undertaking [which] until further notice can be construed to be the province of poets as much as scholars.'[5]

Surrealism had literary foundations from the beginning. To Breton, it was Romantic literature that furnished the best examples, not least because writers had used mind-altering drugs to unburden the mind of conscious control. Breton also attributes to dreaming and the dream-state a kind of certainty; as he puts it, 'one not open to my repudiation'. The waking state is an obstacle, he says: 'The mind of the man who dreams is fully satisfied by what happens to him, [therefore] kill, fly faster, love to your heart's content … let yourself be carried along. Events will not tolerate your

6.2 (*opposite*) Max Ernst, *The Wavering Woman*, 1923. Oil on canvas, 130.5 × 97.5 cm. Kunstsammlung Nordrhein-Westfalen, Düsseldorf

6.3 (*above*) André Masson, *Drawing*, c. 1925. Pen and ink on paper, 30.3 × 24.1 cm. Galerie Louise Leiris, Paris

interference.' In Breton's formulation, Surrealism's antecedents included Dante, Shakespeare, Swift and Poe, then Victor Hugo, Baudelaire, Rimbaud, Mallarmé, Jarry, and Breton's recently deceased friend Jacques Vaché. In the *Manifesto*, visual artists appear in a detached relation to Surrealist doctrine. Only in a footnote do we find mention of Seurat, Moreau, Matisse, Derain, Picasso ('by far the most pure'), Braque, Duchamp, Picabia, de Chirico ('admirable for so long'), Paul Klee, Man Ray, Max Ernst and – 'one so close to us' – André Masson. Pages later, Breton concedes that the visual artists not only orchestrate the Surrealist score. They may even qualify to play in the same orchestra.[6]

Another clue to the relation of the verbal to the visual in Surrealism can be found elsewhere in the *Manifesto*. Breton had worked in a psychiatric hospital during the war and had tried to get trauma victims to produce a quickly spoken monologue, 'as closely as possible akin to spoken thought'. It was an experiment he now repeated with Philippe Soupault.[7] 'We decided to blacken some paper,' he tells us, 'with a praiseworthy disdain for what might result from a literary point of view … By the end of the first day we were able to read to ourselves some fifty or so pages obtained in this manner.' The result was 'a great deal of emotion, a considerable choice of images of a quality such that we would not have been capable of preparing a single one in longhand, a very special picturesque quality and, here and there, a strong comical effect'. His advice to other experimenters followed directly:

> Put yourself in as passive, or receptive, a state of mind as you can. Forget about your genius, your talents, and the talents of everyone else … Write quickly, without any preconceived subject, fast enough so that you will not remember what you're writing or be tempted to reread what you have written. The first sentence will come spontaneously, so compelling is the truth that with every passing second there is a sentence unknown to our consciousness which is crying out to be heard … Go on as long as you like.

Surrealism, Breton says in a definition that could apply to writing and painting equally, 'is psychic automatism in its pure state, by which one proposes to express … the actual functioning of thought'. Surrealism – now we hear an echo of Freud's early writings on mental life –

> is based on the belief in the superior reality of certain forms of previously neglected associations, in the omnipotence of dream .. the disinterested play of thought. It tends to ruin once and for all the other psychic mechanisms and to substitute itself for them in solving all the principal problems of life.[8]

For all that, common purpose between Breton's literary experiments and the work of painters and sculptors could by no means be assumed. The early numbers of *La Révolution Surréaliste*, edited by Pierre Naville and Benjamin Péret, ceded scarcely any space to Surrealist painting. Designed in the sober layout of a popular science magazine, the journal called for social reform from an anarchist perspective – the prisons to be opened, the army disbanded. 'We have joined the word Surrealist to the word Revolution,' it said, 'to show the disinterested, detached, even absolutely despairing nature' of the platform on which they now stood, naming as 'arch-criminals' the Pope, all university rectors, doctors of mental asylums and supporters of the right-wing parliamentary faction Action Française.[9] Writing in the April 1925 issue, edited by the actor and dramaturge Antonin Artaud, Naville declared: 'No one remains ignorant of the fact that there is no such thing as Surrealist painting.' He recommended instead the cinema, with its dynamic images of 'streets, kiosks, cars, shrieking doorways, street lights bursting in the sky'.[10]

6.4 (*opposite*) Paul Klee, *Pictorial Architecture Red Yellow Blue*, 1923. Oil on cardboard, 44.3 × 34 cm. Zentrum Paul Klee, Bern

6.5 (*above*) André Masson, *Les Chevaux morts* (*The Dead Horses*), 1927. Oil and sand on canvas, 46 × 55 cm. Centre Pompidou, Paris

In fact Naville's diatribe against the rue Blomet painters was immediately countered by Breton in the July 1925 issue *La Révolution Surréaliste*, where there appeared a defence of recent tendencies in painting that effectively changed the career of modern art forever.[11] In November 1925 an exhibition opened at the Galerie Pierre, its catalogue prefaced with written statements by Breton and Robert Desnos, of works by already well-established artists who until the publication of the *Manifesto* had perhaps not known what 'Surrealism' meant. *La Peinture Surréaliste* included Picasso, de Chirico in his first Paris period, Paul Klee, Hans Arp, Man Ray (author of the 1922 album of rayograms *Les Champs délicieux* [*The Delicious Fields*]), Miró, Pierre Roy, Max Ernst (whose collages from old zinc-engraved illustrations had already impressed the poets) and Masson. Yet the implication that 'Surrealist painting' was a collective endeavour is misleading. The American Man Ray, a relative newcomer to Paris, was primarily known for his 'rayograms' (photographs made without the use of a camera) that were not paintings at all (see fig. 4.8). Paul Klee never saw himself as a Surrealist artist (**fig. 6.4**). Picasso always resisted Breton's solicitations, and was represented by two small works, neither of which were Surrealist.[12] Miró remained detached, even though his contribution, *Harlequin's Carnival* of 1924–5, demonstrated a range of fantastically prolix imagery whose multiple small incidents could not but entertain as well as baffle the eye.

Masson, meanwhile, had been receptive to Breton's encouragement and had welcomed the inclusion of some of his 'automatic' pen-and-ink drawings in the early issues of *La Révolution Surréaliste*. Yet he had begun to realise that his facility in those drawings and his extant painting style had almost no connection with each other. True, the fluid organisation of paintings such as *La Proie* (*The Pigeon*) or *L'Oiseau mort* (*The Dead Bird*), both of 1925, betray a dark imagination trained above all on nature; yet a measure of automatism in his painting now came from a different and unexpected source. Walking one day on the beach at Dieppe, it dawned upon him how a free scattering of sand onto a canvas surfaced with glue could create a format in which, or on which, figural shapes might appear of their own accord. 'I laid out an un-primed canvas on the floor of my room,' he later recounted, 'and poured streams of glue over it: then I covered the whole thing with sand brought in from the beach ... As in the ink drawings, the emergence of a figure

was solicited, and this unorthodox kind of picture was worked out with the help of a brushstroke and sometimes a patch of pure colour' (**fig. 6.5**).[13] On the strength of these sand paintings Masson moved to the very centre of Surrealism as a visual art – even if his sympathies with Breton's leadership of the group soon evaporated, as Breton attempted to control the political priorities he wished the movement to follow. From the beginning, Breton had imagined some kind of concordance between Surrealism and the political revolution in Russia. He had not declared it in the 1924 *Manifesto*, yet he never concealed his admiration for the Clarté group of writers led by the French novelist Henri Barbusse, who were supportive of the platform of the Russian Proletkult. At some level he had always hoped that Surrealism's 'revolution of the mind' might dovetail with the class-war sympathies of the French Communist Party (PCF), founded in 1920 and still negotiating its relationship with the Moscow line.

In this he was to be frustrated. By the middle and later years of the 1920s most of the 'Surrealist' painters were winning critical and commercial reputations in their own right, and correspondingly a measure of independence from group activity – quite aside from any commitment to a political line. Picasso and de Chirico, both given special mention in Breton's footnote, exhibited with the Surrealists while neither shared his interest in *automatisme* and the dream – nor the psychic revolution that he wanted to support. Picasso's graphic manner of the mid-1920s increasingly gave way to more organic, even monstrous irregularities of form. In *The Painter and His Model* of 1927 – to take a notable example – we see two figures placed on de Chirico-like floorboards in an airless room, in modes of disfigurement the likes of which no artist had imagined or attempted before. A stick-like male figure (the painter) is attending to a lumpy, glutinous female (the model) seemingly caught, as if by a lightning flash, inside a space which belongs as fully to the hapless viewer as to themselves (**fig. 6.6**). Picasso had begun to use a cursive, nearly biological line, defining the female figure by outline while veering close to depriving her of the skeletal structure that we expect any human figure to have. In dozens of paintings and drawings from the late years of the decade he would rearrange sexual, facial and limbed parts with apparent disregard for anatomy – not for Surrealism's sake but in order, so he said, to make his figures more genuinely real (**fig. 6.7**).[14]

On the other hand, Max Ernst's discovery of *frottage* (rubbing) in the summer of 1925 sparked off a group of procedures that excited the Surrealist writers greatly. Prompted by the grain of a wood floor while staying in Pornic, Brittany, Ernst had begun to rub on the roughened surface through a sheet of paper – and then reinterpret the results in

6.6 (*opposite*) Pablo Picasso, *The Painter and His Model*, 1927. Oil on canvas, 214 × 200 cm. Tehran Museum of Contemporary Art

6.7 (*above*) Pablo Picasso, *Bather by a Cabin*, 1927. Graphite on paper, 31 × 23.5 cm. Musée Picasso, Paris

another object category altogether, adding pencil drawing or gouache as the situation demanded. Two years later he discovered how to transform *frottage* into *grattage* (scraping) by placing objects beneath a paint-loaded surface and then scraping the paint to reveal patterns and forms lying beneath. In themselves effective metaphors for blind insight, those techniques soon found their cut-paper counterpart in a series of collage novels that he now constructed, in which carefully excised and recombined fragments from nineteenth-century printed magazine illustrations were assembled to form a sequence of images constituting an entire book – even if categories such as plot or narrative could not in any obvious way apply. The 147 anarchic and dreamlike

6.8 (*above*) Max Ernst, 'And Volcanic Women Lift and Shake Their Bodies' Posterior Parts in a Menacing Way' from *La Femme 100 têtes*, 1929. Collage, printed paper, 26.5 × 20.5 cm. Nationalgalerie, Staatliche Museen zu Berlin, Sammlung Scharf-Gerstenberg

6.9 (*opposite*) Hans Arp, *Große Kopf, Kleiner Torso (Large Head, Small Torso)*, 1923. Painted wood relief, 66.6 × 57.5 × 7.5 cm. Musée d'Art Moderne et Contemporain, Strasbourg

scenes that make up the punningly titled *La Femme 100 têtes* (*The Hundred-Headed | The Headless Woman*) of 1929 are not only technically superb but hint at a wholesale revision – or parody – of gender relations still conventional at the time (**fig. 6.8**).[15]

Other artists followed their own path with respect to the border territory between literature, writing and art – for the moment tolerating Breton's leadership while becoming increasingly impatient with his efforts to impose uniformity of purpose on the group. Hans Arp, to take one example, was a poet as well as an artist and specialised during the 1920s in object-pictures that were relief-like in projecting either backwards or forwards from a plane, then titled humorously so as to cross the nature–culture divide (**fig. 6.9**). Quasi-paintings or quasi-sculptures, they dwell playfully on the mysteries of natural genesis, growth and revelation – but answer to no Surrealist formula for bridging distant realities or fathoming the obscurities of the dream.

Other artists conventionally called Surrealist took pains to contradict the lessons of automatist technique. Miró's neighbours when he moved in 1927 to a new studio in the rue Tourlaque included not only Ernst and Arp but also the Belgian dealer Camille Goemans, who brought into the group an artist named René Magritte, disappointed by his reception at a recent show in Brussels and now hoping for some appreciation in Paris. Magritte's interests were very different from those of the Surrealists mentioned so far. His special concern was to investigate the paradoxes that arise when verbal and graphic information collide. What happens when graphic denotation (picturing) is rivalled by semantic denotation (description) within the same image? What occurs when objects and their names meet, change places, mismatch, even wrestle for authority within the painted image or sign? The mind is thrown into a spin, unsure whether to seek disambiguation or just enjoy the spirit of the game. In an article in *La Révolution Surréaliste* – in fact in the last issue to be published, in late 1929 – Magritte listed a series of questions to which the rational mind cannot find an answer.[16] If an image shows one object partially obscuring another, how do we know the second object is wholly there? How does the mind understand the relation of things to each other when their images overlap, conceal each other or coincide – when their outlines touch each other to present a mosaic to sight? Once such questions are broached, the way is open to questioning the identity of quite ordinary things. A further discovery was to play with the paradoxes involved in confusing the properties of near-to objects or figures and those positioned behind. In one extraordinary painting we see, or seem to see, a curious fusion, achieved by the manipulation of outlines and perspective overlaps, both of a man's aggression against a woman as well as the women's fearful response as experienced from within (**fig. 6.10**). In another research theme, Magritte found that cognitive confusion could be generated by the superimposition of simulated cut-out paper patterns on what looks like a depth representation beneath (**fig. 6.11**). Magritte was routinely included in Surrealist exhibitions in Paris, and his works became

commercially attractive both there and much further afield.

It is the right moment to mark the arrival in Paris of another young painter who favoured simulation and paradox almost from the start. The young Catalan Salvador Dalí had met Picasso while on a short visit to Paris in 1926, and immediately revered him. Among the first of Dalí's paintings to reflect Picasso's example was an intentionally scurrilous work *The Rotting Donkey* of 1928 – the adjective could be 'putrifying' or 'decaying' – that shows a frenzied animal-person, upright and bending, hairy and soft-skinned, naked and clothed simultaneously, dancing on the shoreline of the artist's native town of Cadaqués, in north-eastern Spain. Rottenness or *putrefació* was Dalí's term for the ossified social routines of the decaying bourgeoisie (**fig. 6.12**). It was in the same year that Dalí began to use a meticulous mode of representation that looked suspiciously like a reversion to academic technique – almost a photorealist one – except that Dalí now practised it in a thoroughly ironic key. In fact he had spotted the double

values suggested by the Dutch painter Vermeer's extraordinary style: a veristic attitude to moments of shadow, atmosphere and light while at the same time endowing them with a seeming eternity. For a twentieth-century painter, here was an optic that, like that of a modern camera, could make a split-second arrest – hence a visual record – of actual phenomenological time. To Dalí, both values could be mobilised together. In his own words of enthusiasm, the sophisticated new lenses of the recently launched hand-held camera presented artists with instruments for 'the most complete, scrupulous and exciting cataloguing ever to be imagined'. The most up-to-date cameras provide 'essentially the most secure vehicle for poetry, the most agile process for capturing the most delicate osmoses that are formed between reality and sur-reality … nothing will prove Surrealism right as much as the unique capacity for surprise of the Zeiss lens'.[17]

The 'osmoses' that Dalí refers to were those that could connect painting's own simulation of reality and the 'sur-real'. Two important paintings of 1928, a big toe substituting for a reclining bather in one, a melting sunbather who fingers herself in another, were more than sufficient to advertise his talent for combining the reality-effect with both obscenity and surprise. Breton was quickly persuaded. Of a visually demanding painting *Le Jeu lugubre* (*The Lugubrious Game*) of 1929, hung in his first one-person

6.10 (*opposite*) René Magritte, *Les Jours gigantesques* (*The Titanic Days*), 1928. Oil on canvas, 116.5 × 80.8 cm. Kunstsammlung Nordrhein-Westfalen, Düsseldorf

6.11 (*above*) René Magritte, *The Spirit of Comedy*, 1929. Oil on canvas, 75 × 60 cm. The Ulla and Heiner Pietzsch Collection, Berlin

show in Paris in November of that year, Breton wrote that the artist had created 'a marvellous treasure island where masks, a lion, a giant hand, insects and other mysteries reverberate' – a kind of second existence, 'new and visibly mal-intentioned' such as can only be brought on by 'involuntary hallucination'.[18] It was in the latter phrase especially that Breton revealed Dalí to be on the brink of exchanging spontaneous hallucination with a yet more challenging and critical epistemological stance. Willed paranoia, more particularly paranoia actually practised as a critique of the real: such was the brilliant if eccentric programme that Dalí now set himself to follow. Setting aside

his naïvety about politics – he was fascinated by the personalities of powerful dictators – his virtuosic handling of the paranoid affects was enough to keep him within Breton's orbit for years.

Surrealism as a single programme for art and literature could not hope to encompass so many experiments in attitude and visual style. In point of fact political disagreements between the painters and Breton had already placed the latter's leadership in some doubt. One moment of friction had erupted in 1926. Miró and Max Ernst had been engaged – following Picasso's recommendation – to design the curtain for the Ballets Russes' performance of *Romeo and Juliet*, and on the opening night in November, Breton, Louis Aragon, the artist Yves Tanguy, the poet Jacques Prévert and a group of PCF sympathisers had positioned themselves in the audience. As the curtain rose, whistles were blown, leaflets were thrown and rioting erupted between the audience and the protesters, several of whom were later beaten up by the police, the performance having been brought to a halt. Aragon and Breton quickly republished their denunciation in *La Révolution Surréaliste*, claiming that the Ballets' aim had always been 'to tame the dreams and rebellions of physical and intellectual hunger in the interests of the international aristocracy'.[19] Breton attempted to expel from the Surrealist movement those he regarded as disloyal or half-hearted – yet in practice the process became something of a farce. His decision to write a *Second Manifesto of Surrealism* late in 1929 and wind up publication of *La Révolution Surréaliste* was the start of an effort to reshape the movement into a more unified and politicised force.

Breton's demand for loyalty was one to which not everybody in the group was willing to respond. The *Second Manifesto* accused former colleagues – Masson, Soupault, Artaud, Naville, Limbour, Desnos, Vitrac, even Aragon – of 'deviations' that included self-satisfaction, literary coquetry and what Breton called 'social abstentionism', that is, 'abandoning Surrealist demands, in their unconditional specificity, for political action'.[20] A group of the accused published a riposte titled *Un Cadavre* (*A Corpse*) in January 1930, which lampooned Breton himself for his tactics.

A different kind of crisis for the movement was the launch early in 1929 of a rival journal to *La Révolution Surréaliste*, titled simply *Documents*, under the main editorship of a Paris archivist, librarian and novelist named Georges Bataille. *Documents* bore the subtitle *Doctrines, Archéologie, Beaux-Arts, Ethnographie* and from the outset cast its net widely across the human and historical sciences to present a far darker programme for contemporary thought in which all value hierarchies would be dismantled, put into reverse or placed in dialectical opposition such as to nullify whatever mutual ranking they might have had. Otherness itself – heterology – was the overriding aim. And *Documents* by no means confined itself to the visual arts. In support of its radical heterology it published photographic images of animal slaughter, deformed anatomies, tribal practices, freaks of nature, plant life, old coins and other rarities, alongside articles on Surrealist painting from a non-Bretonian point of view. A 'Critical Dictionary' accumulated counter-definitions that were themselves disordered, including entries for Absolute, Materialism, Eye, Misfortune, Dust, Slaughterhouse, Factory Chimney, Crustaceans,

6.12 Salvador Dalí, *The Rotting Donkey*, 1928.
Oil and sand on wood, 61 × 50 cm. Musée National
d'Art Moderne, Centre Pompidou, Paris

Keaton, Pottery, Spittle, Debacle, Mouth and Formless [*Informe*], all contributing to what Bataille called a thorough-going lowering of form. 'I am trying to say without preamble,' he wrote approvingly in a *Documents* piece titled after Dalí's *Le Jeu lugubre*, 'that while the paintings of Picasso are hideous, those of Dalí are of a terrible ugliness ... Little by little the contradictory signs of servitude and revolt reveal themselves in all things. The great constructions of the intelligence are by definition prisons: which is why they are persistently overthrown.'[21]

A contest of values was under way. Breton, in turn, in his *Second Manifesto* accused Bataille of waging 'an absurd campaign', of 'wishing to only consider that which is vilest, most discouraging, and most corrupted', of substituting for Surrealism's 'harsh discipline of the mind ... a discipline which is that of the non-mind'.[22] In its favour, *Documents* in the two years of its publication, 1929 and 1930, distinguished itself by publishing fresh assessments of artists including Miró, Hans Arp, Masson and of course Picasso, whose work in the period since the beginning of 1927 had taken some unpredictable yet important new turns. Sometimes accused of having lost contact with the contemporary world due to his notoriety and wealth, Picasso was in fact the author of some extraordinary new work – and the *Documents* writers excelled themselves in describing it. The cephalopodic or 'biological' manner that he had arrived at in *The Painter and His Model* of 1927 – alarming by any measure – was now proving flexible enough to encompass the erotic as well as the agonised, the sensual as well as the wounded human form. His new subjects were either his new lover Marie-Thérèse Walter, whom he had met early in 1927, perhaps frolicking with a beach ball in summer, or it could be the seated figure of his wife Olga Khokhlova, struggling with her distress in the glare of the painter's predatory gaze (**fig. 6.13**). Yet how to describe Picasso's motivations without Surrealist cliché – or worse still, a scandalised regard? The *Documents* critic Carl Einstein proposed that Picasso was articulating '*un au-delà formel*' ('a formal beyond') that can only with difficulty be put into words. His paintings 'surpass biological conservatism' – yet are not dream-images, nor rendered in some preconceived imaginative style. Picasso's friend Michel Leiris, also close to *Documents*, proposed that in evading biological normality Picasso was by no means playing the Surrealist game – rather the reverse. His creatures are not monstrous, Leiris suggests. On the contrary, 'each new combination of forms that he presents to us is like a new organ that we can use, a new instrument that enables us to insert ourselves more humanly into nature – to become more concrete, more dense, more living'. His creations are not 'sur-human'; they are different creatures, but in the end they are 'like us, but in a different form'.[23]

Surrealism as it had flourished in Paris was, by the later part of 1930, facing many kinds of pressure to change. The collapse of the Western economy with the Wall Street Crash in late 1929 was changing the entire marketplace for works of art. There were ominous rumblings of ideological change in Soviet Russia and Germany. And thirdly, other means of expression were now pressing for recognition. Photography was coming of age, and film was in its infancy. Surrealism having fragmented violently, its 'second' life would be very unlike its first.

6.13 Pablo Picasso, *Large Nude in a Red Armchair*, 1929. Oil on canvas, 195 × 130 cm. Musée Picasso, Paris

CHAPTER 7

The Elementarist Ideal

As well as the retreats to various kinds of classicism and the many techniques of Surrealism, modern art in the 1920s contained other impulses – notably to locate those building blocks out of which everything in the visual world is made. It is in Amsterdam, in the Netherlands, that we find the first seeds of what became a new international outlook in the visual arts. A grouping called De Stijl – The Style – was inaugurated there in 1917 comprising four artists whose interests, despite their different backgrounds, briefly converged. The oldest, Piet Mondrian (by birth Mondriaan) had picked up some aspects of Cubism in Paris between 1912 and 1914, notably in some slightly faceted landscapes and still lifes. Back in Holland during the war, an interest in Theosophic spiritualism had inspired a reduction of his painterly means to broader yet suggestive colour areas derived from nature – soon to reduce still further in a notable series of paintings from 1915 that he called 'Pier and Ocean'. In these, small and mostly discrete marks of paint are vertical (the pier or shadows caused by light on water) or horizontal (the ocean) (**fig. 7.1**). The design might be encased in an oval form.

Mondrian's 'reduction' was a simplification of some kind, at the same time as another lexicon of forms was being created: accents, or units, which when positioned in relation to other accents or units made up larger wholes. To begin with, nature was still the primary resource for the painter, but the transcription was proceeding entirely differently from what had been customary in Expressionism or Cubism. Perhaps the relation of the microcosm to the cosmos could be explored this way; yet it must avoid becoming confused with what some had called – were still calling – 'abstraction': either the doctrine of Wilhelm Worringer's influential *Abstraktion und Einfühlung* (*Abstraction and Empathy*) of 1906, which held 'abstracting' to be a generalising habit of mind, the opposite pole to a close and sympathetic attitude to tangible things; or else Kandinski's intensification of colour and shape in his early paintings, aimed rather at achieving spiritual nourishment of the soul. Mondrian's reduction was different; it veered towards mathematical simplicity too. It would soon inspire others to look for those units or elements of form out of which all things in the visual register are really made.

Mondrian's meeting with the Dutch painters Bart van der Leck and Theo van Doesburg in 1916 proved a major catalyst for the launch of the De Stijl group and its magazine *De Stijl* the following year. Van der Leck at that stage described himself as 'decomposing' his earlier figure paintings in two key ways. In one example, he took his 1910 painting *Leaving the Factory*, radically simplified the factory buildings at rear, the row of resigned faces at centre and the bodies and feet below, then positioned the

results as slim rectangles on a white or cream ground in a palette of primary colours (red, yellow and blue) plus black (**fig. 7.2**). Van Doesburg, meanwhile, was decomposing visible forms too, a technique especially well suited to the design of some stained-glass windows made for private houses, in which he was often prompted to play with rotational symmetries within the larger enclosing frame. From the beginning, van Doesburg had ambitions for the group. For the *De Stijl* journal, of which he was the editor, he was keen to ensure the involvement of designers and architects as well as painters and sculptors, and thus attract international contributions and the widest distribution for his ideas. De Stijl's first manifesto, published in 1918, made it clear how the recent war was the result of excessive individualism combined with despotism, and that the objective post-war would be to create 'international unity in life, art and culture, both intellectually and materially', in which those corruptions would finally be left behind.[1]

What did this mean for the specialised enterprise of art? After the 'Pier and Ocean' series, Mondrian gradually renounced any remaining connection to visible nature, increasingly constructing his paintings by evacuating large areas of white or grey, around which gathered primary-coloured rectangles, often closer to the frame

7.1 Piet Mondrian, *Pier and Ocean 5 (Sea and Starry Sky)*, 1915. Charcoal and watercolour on paper, 87.9 × 111.7 cm. Museum of Modern Art, New York

(**fig. 7.3**). Such luminous paintings are sometimes associated with the Dutch experience of light and landscape; yet in fact his paintings from the early 1920s contain an intuitive dispersal of forms that are then presented to the viewer in the form of a task, an invitation, one to be worked at to fully understand. That task was to register the asymmetries in the design, deduce that they had no intuitive resolution, then accept that whatever perceptual equilibria seemed available would never – could never – be entirely stable (unlike those of classical art). 'Dynamic' equilibrium, as Mondrian called it, had the purpose of situating the work in the dimension of unfolding time, the equilibrium initially disequilibriating, then settling and disequilibriating again in a process that was never fixed, predictable or complete. A second feature was that his paintings (at least from 1921 onwards) were made with careful attention paid, not just to the surface forms but to the painting's edges – particularly at left and right. Mondrian carefully specified that whatever kind of simple frame might be attached, it should always sit rearwards of a painting's frontal plane, and that lines or colour areas nearing the painting's edge could either hesitate, or proceed just over the edge, in either case drawing the viewer's attention not only to the painting's evident frontality – its facingness to the viewer – but to the fact that the edge is really there. And this realisation was important since it would secure the painting's presence in the actual space and time of the viewer.

Thirdly, when Mondrian presented a long text to van Doesburg for possible inclusion in an early issue of *De Stijl*, he used the Dutch term *nieuwe beelding* to express this dynamic quality precisely. With some similarity to the German *Gestaltung*, *beelding* means not only 'construction' or 'formation' but also 'the *process* of forming', even 'the coming into being of form'.[2] Mondrian's translators have often used 'plasticising', 'plastic', even 'the making plastic' for this term, implying the ceaseless adjustment and articulation of the various visual components of the work.

For van Doesburg, meanwhile, plasticising took a very particular path. There are signs in his early writing that he believed the artist should take seriously the idea of basic 'elements': such elements as are left for him or her to work with once all perspectival, anatomical and naturalistic features have been excised. Furthermore, by 1920 he was becoming fascinated by what he knew of the Dada circle in Paris and the many provocative attitudes being explored there. On the face of it, De Stijl's commitment to deindividualising the work of art was something it and Dada shared – and van Doesburg was soon in touch with Tzara, as well as writing Dada poems himself

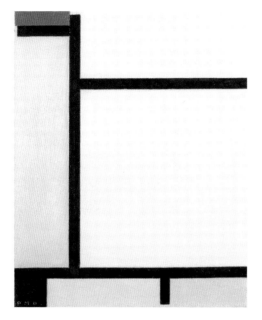

under the pseudonym (the first of several) I. K. Bonset, which he published under that name in *De Stijl*. The question then became how to reconcile – combine, interlace, place in generative opposition – the features that attracted him in Parisian Dada with an interest in the 'elemental' properties of the work of art. To be more exact, van Doesburg's mission now became to associate the anarchic, nihilistic tendency in Tzara's version of Dada not only with De Stijl but with what he was now learning of Russian Constructivism as itself a kind of 'elementarism' of line and force in the deindividualised work of art.

A coalition between Dada and Constructivism must have looked unlikely; yet to van Doesburg – with the help of I. K. Bonset and a second alias, Aldo Camini – it seemed imperative to try. The ideals of supra-individualism and supra-nationalism provided the obvious key. Nor was van Doesburg alone in his quest. In October 1921 an unlikely alliance of Dada affiliates Raoul Hausmann and Hans Arp with Ivan Puni (newly in Berlin from Russia) and László Moholy-Nagy (from Hungary) prepared 'A Call for Elementarist Art' that was duly published by van Doesburg in *De Stijl*. That statement called for 'an art that did not exist before us and cannot continue after us', an 'elementarist art ... that does not philosophise but is built up of its own elements alone'. The individual, the statement read, 'does not exist in isolation, and the artist uses only those forces that give artistic form to the elements of our world'.[3] The question was how to put those principles into practice. Suffice it to say that when a Congress of International Progressive Artists was held in Düsseldorf in May 1922, accompanied by a huge exhibition of some four hundred works, the search for a common international policy for progressive art proved impossible to achieve. Perhaps predictably, the congress's several groupings – including El Lisitski and Ilya Ehrenburg from Russia, at that time editing the magazine *Veshch* from a base in Berlin, a contingent from Holland representing De Stijl, a Hungarian group and a group combining Romania, Switzerland, Scandinavia and Germany – could reach no agreement. However, a breakaway group comprising Lisitski, van Doesburg and the Dadaist film-maker Hans Richter made a forthright statement under the label of the International Faction of Constructivists (IFdK) to affirm their refusal of 'the tyranny of the subjective' – principally Expressionism – and declare instead that art was 'a universal and real expression of creative energy that can be used to organise the

7.2 (*opposite*) Bart van der Leck, *Composition No. 3 (Leaving the Factory)*, 1917. Oil on canvas, 95.5 × 102.5 cm. Kröller-Müller Museum, Otterlo

7.3 (*above*) Piet Mondrian, *Composition with Red, Blue, Black, Yellow and Grey*, 1921. Oil on canvas, 76 × 52.5 cm. Kunstmuseum, The Hague

progress of mankind'. Such was the world-reforming ambition of the new art. Further still, 'we define the progressive artist as one who accepts the new principles of artistic creation – the systematization of the means of expression to produce results that are universally comprehensible'.[4] For a moment it seemed as if a unity of approach could be found. A further Congress of Constructivists and Dadaists was convened at Weimar in September, but this time there was no agreement except to disagree (fig. 7.4).

The difficulty of locating a universalising aesthetic so soon after the ravages of a world war comes as no particular surprise. It must be remembered, too, that there was a paradox involved in founding an anti-subjectivist art upon the efforts of individuals who were themselves locked in a degree of mutual competition for resources, publicity and reputational gain. In practice, personal temperament, economic constraint and national tradition would all play a part.

El Lisitski's research of the period is a good example. Having studied in Germany before the war, he was well placed to mediate between Constructivist and Dada groups, but from a background that was Suprematist and architectural – leading to a category of work he called 'Proun', which he defined as 'an interchange between art and architecture'.[5] A Proun positions in space a set of basic, quasi-architectural forms that have no fixed or discernible relation either to each other or to the artist/

7.4 Photo of the Weimar Congress, September 1922. Top row, at right: László Moholy-Nagy; third row, second and third from left: El Lisitiski, Cornelis van Eesteren; second row, at centre: Nelly and Theo van Doesburg; front row, second, third and fifth from left: Hans Richter, Tristan Tzara, Hans Arp

viewer. For the planes and forms within the Proun Lisitski employed a drawing method called 'axonometric' – lacking the non-parallel lines used in perspective – with the result that those planes and forms cross or abut each other without ever constituting a unitary spatial scheme (**fig. 7.5**). In front of a Proun the viewer is held in a state of creative curiosity as to up, down, left and right, as well as to the sources of the forms' colouring or illumination. Put differently, Lisitski's Proun drawings and paintings, no less than the three-dimensional *Proun Room* that he made for the *Great Berlin Art Exhibition* in 1923, can be described as not so much addressing as *producing* viewers whose mental and spatial awareness is to be kept highly dynamic and alive. 'The surface of the Proun ceases to be a picture,' Lisitski wrote in *De Stijl* in 1922, midway between the Düsseldorf and Weimar conferences. It 'turns into a structure round which we must circle, looking at it from all sides, peering down from above, investigating from below. The result is that the one axis of the picture that stood at right angles to the horizon is destroyed'.[6] Later, in a permanent structure known as *Abstract Cabinet*, commissioned by the Provinzial-Museum in Hanover in 1928, a viewer's kinetic relation to the work extended to the wall surfaces of the room itself, with sliding screens on which works of art were hung and ribbed wall surfaces that changed in appearance as the viewer moved around within the space.

Elementarism in several registers was also becoming a vital feature of the celebrated teaching and research institution, the Bauhaus. Established in Weimar, Germany, in 1919 under the directorship of Walter Gropius, its mission was to teach the integration of art, design and architecture around a philosophy of humanism, pacifism, expressive egalitarianism and modernity. Here, too, the curriculum would place emphasis upon the analysis of material, form, colour and construction by postulating 'elemental' units from which larger complexes could be made in logical – as well as intuitive – steps. The Hungarian László Moholy-Nagy had gravitated to northern Germany following war service on the Russian front, acquaintance with Lajos Kassák's artistic circle in Budapest during convalescence, and a brief period in Vienna. He had arrived in Berlin early in 1920 with some prescient intuitions concerning the role of light and dematerialised colour in painting and photography; and it must have been obvious to Gropius, whom he met in 1922, that his thinking and his painting showed an experimental attitude almost entirely free of Cubist, Expressionist or even Russian Constructivist precedent. Moholy-Nagy's appointment to the Bauhaus in 1923 had the effect of shifting the centre of gravity of its teaching towards the possibilities and demands of a technical age.

The Bauhaus quickly proved to be a hothouse of fertile ideas. When Moholy-Nagy began to teach the *Vorkurs* (Foundation Course) in 1923 in replacement of Johannes Itten, he was partnered by a recent Bauhaus graduate named Josef Albers, at this stage a specialist in the light-transmitting qualities of plain and coloured glass. The two artists had much to share. Albers now concentrated on the analysis and organisation of sensation itself. His works became geometrical grids made of sand-blasted glass and paint whose exploration of 'elemental' qualities – brilliance and dullness, the smooth and the rough, inversion and repetition, sequence and alternation – surely belonged to the ethos of a technically modern world. Moholy himself had previously made a demonstration sculpture of nickel and iron crafted into different shapes – column, spiral, base in varying qualities of shine, hardness and reflectivity –

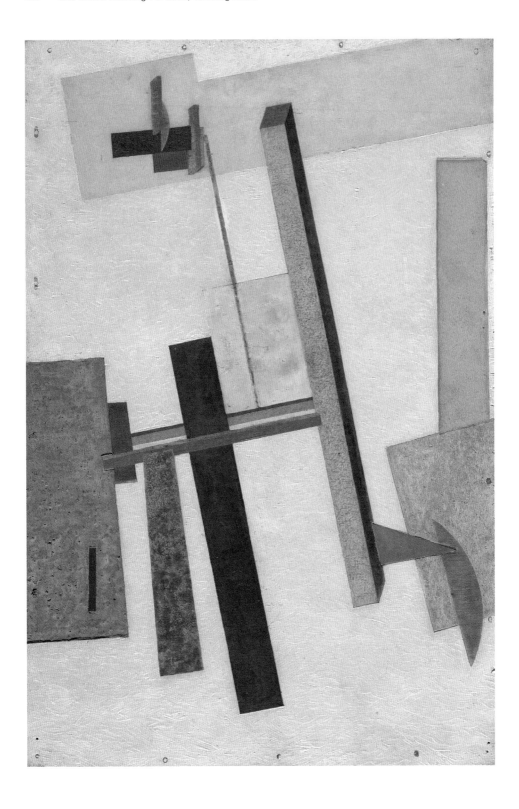

as if to demonstrate the range and effects of light-reflecting materials in their more or less elemental forms (**fig. 7.6**). His teaching, likewise, was preoccupied with the fundamental components of what he called 'optical creation', the elements of which were static/kinetic contrasts, pigment tones and intensities of light, all considered in the context of what, in a book-length manual published by the Bauhaus, he calls 'the cultural situation at the moment'. For example he pays special attention to the colourless and grey – the grey of the big city, the black and white of newspapers, of photography and film – what he calls 'the colour-eliminating tempo of life today'.[7] Working with other Bauhaus experimentalists such as Kurt Schwerdtfeger (who researched colour–light interaction), Josef Hartwig (a sculptor notable for his chess set design of 1923) and Ludwig Hirschfeld Mack (investigating colour–sound interplay), Moholy was becoming a specialist in the creation of overlapping and moving optical planes, animated by prismatic interplay and the dissolution, transition and conglomeration of radiant light. His advocacy of the photogram or camera-less image was in effect a further kind of reduction, in this case of the photo-image to the action of light on sensitised paper alone. The summa of Moholy's Bauhaus experiments was a construction known as the *Light–Space Modulator*, which he completed in 1930, having resigned from the Bauhaus two years earlier (**fig. 7.7**).

7.5 (*opposite*) El Lisitski, *Proun 2C*, c. 1920. Lithograph, 60 × 40 cm. Philadelphia Museum of Art, Gallatin Collection

7.6 (*above, left*) László Moholy-Nagy, *Nickel Sculpture with Spiral*, 1921. Nickel-plated iron, welded, 35.9 × 17.5 × 23.8 cm. Guggenheim Museum, New York

7.7 (*above, right*) László Moholy-Nagy, *Light–Space Modulator*, 1930. Chrome-plated steel, aluminium, plexiglass, wood, 151.1 × 69.9 × 69.9 cm. Photo, 1973. Busch-Reisinger Museum, Harvard University

Two other young Bauhaus artists contributed elementarist methods to students in art and design. Aside from his activities as a painter, Paul Klee's distinction as a teacher was to pay attention to the micro-processes of nature – its forces and forms alike – considered as the generative elements both of the universe and of human cognition within it. 'To begin with small things' was Klee's first lesson in how to uncover those principles upon which all else depends. In his *Pedagogical Sketchbook*, itself a miracle of compression, organised into three sequential lessons and published by the Bauhaus in 1925, Klee sets out a series of observations on line (quantitative, material, natural aspects), dimension (orientation, balance, symmetry) and earth/water/air (densities, motions, rhythms, chroma) that together constitute a lesson in analysing how the material world in its full complexity behaves.[8]

Kandinski also specialised in what may be called an elementarist pedagogy. Before leaving Russia he had taught at the State Free Studios from 1918 and had been the first director of the Moscow INKhUK, which sought to define art in 'scientific' terms – albeit in line with the imperatives of the Revolution. That orientation had been elementarist too, in the sense of pushing Rodchenko to line alone and then to a renunciation of painting altogether. In fact Kandinski's own thinking was deemed overly psychologistic, and he had left Russia for what turned out to be a ten-year appointment at the Bauhaus, beginning in 1922. Yet at once, his methodology underwent a shift from the declared subjectivism of *Concerning the Spiritual in Art* towards an analysis of the elements of art at the level of its absolutely basic foundations. In a group of brief statements published by the Bauhaus in 1923, Kandinski advocated artistic learning as a double process: first an analysis of what he called 'the basic elements' of form; then a synthesis of the results of combining them. For example, surface in this method is reduced 'to three basic elements – triangle, square, circle – and volume to the basic solids deriving from them – pyramid, cube and sphere'. The student's exercises 'must proceed logically from the simplest forms to the more complicated'. Analysis followed by synthesis becomes (as he admits) especially difficult for colour; yet he also showed

7.8 (*above*) Vasili Kandinski, analytical diagram of the painting *Little Dream in Red*, 1925, from *Point and Line to Plane: A Contribution to the Analysis of Pictorial Elements*, Munich: Albert Langen Verlag, 1926

7.9 (*opposite*) Theo van Doesburg and Cornelis van Eesteren, maquette for *La Maison particulière*, 1923. Wood, plexiglass and card, 60.5 × 90 × 90 cm (reconstruction 1982). Kunstmuseum, The Hague

how to examine colours initially in isolation, then in juxtaposition both 'purposive' and 'competitive'.[9] Kandinski gave his methods full-length treatment in his celebrated Bauhaus book *Point and Line to Plane*, published in 1926, in which each aspect of the visual sensorium is extensively analysed, beginning with the placement of a single dot on an otherwise empty surface and proceeding step by step to a full analysis of all the elements that occupy the picture plane in all their complex interactions. The twenty-five diagrams that form the book's appendix are in effect full demonstrations of the workings of Kandinski's own paintings of the time (**fig. 7.8**).[10]

Meanwhile, van Doesburg had become interested in the application of elementarist thinking to architecture, and made models that show the rules of translation between the elementary forms of painting and those of three-dimensional work (**fig. 7.9**). In the aftermath of the Düsseldorf and Weimar congresses his colleagues Richter and Lisitski had founded yet another small journal, *G* (abbreviating *Gestaltung* or 'formation') in which van Doesburg had been quick to publish a statement 'Towards Elementary Plastic Expression', in which he marked the principles of transfer of elementarist thinking from two dimensions to three – hence forming a new basis for environmental design (**fig. 7.10**). He called this progression the basis of 'a new plastic expression emanating from elementary means' – as well as a fervent rejection of what he viewed as the disorganised twists and turns of the Baroque.[11]

In the process, he had come to see how a mixing of Dada with elementarism was possible after all. To project this, he had launched a second magazine, *Mécano*, in Leiden in the spring of 1922, initially with the subtitle *International Periodical for*

Intellectual Hygiene, Mechanical Aesthetic and Neo-Dadaism, this time with his alias Bonset as editor. *Mécano*'s four issues, each differentiated by a single De Stijl colour (red, blue, yellow and white), contained poems by Hans Arp, drawings by Sergei Sharshun and various writings by Schwitters, Tzara and Ribemont-Dessaignes, with Constructivist contributions from Georges Vantongerloo and Moholy-Nagy. *Mécano* functioned to integrate the Dada ideal of purposelessness with the implications of elementarism. The experiment led him, in the early months of 1923, to a venture with the Hanover artist Schwitters, who launched his own magazine, *Merz*, that flourished from early 1923 to the end of 1924, then continued sporadically until 1927. Indeed, this outbreak of small magazine publication is a feature of all art that we call 'modern'. Cheap to produce and not subject to censorship from outside, the little magazines could create – and break – friendship circles, promote discussion and spread ideas and information fast. *De Stijl*, *G*, *Mécano* and *Merz* represented perhaps the best exploration of post-individualism in graphics, poetry and the theory of art at that time.[12]

Thus it was that van Doesburg undertook a Dada tour of Holland with Schwitters in the early months of 1923, appearing together in the Dutch cities of The Hague, Haarlem, Den Bosch and Rotterdam, where Schwitters performed his sound poem *Ursonata* (an elementarism of vocables and phonemes, semi-rhythmically projected) to audiences

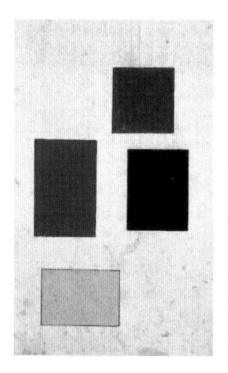

7.10 (*above, left and right*) Theo van Doesburg, *Basic Elements of Painting and of Sculpture*, 1922. Netherlands Institute for Cultural Heritage (ICN), The Hague

7.11 (*opposite*) Kurt Schwitters, *Relief*, 1923. Assemblage, 35.5 × 30 cm. Museum Ludwig, Cologne

encouraged to respond with hilarity or derision – or both. His *Merz* pictures of the time could be looked upon as carefully assembled yet randomly chosen fragments – elements – of the ruined urban civilisation of his day (**fig. 7.11**). Van Doesburg, for his part, prepared a pamphlet elaborating in marvellous detail on the spirit of self-contradiction that could join nihilism and construction in the task of finding a dynamically elementarist art. For him, Dada remained important – for it proposed a view of 'a united world, consisting of discordant and contrasting relationships'.[13] Yet as he wrote at almost the same time, the artist must 'discipline the means of expression', and do so 'by establishing laws to create a system' wherein the elements of art could be combined.[14] He meant that, by combining contrast and counter-contrast, he could create what he called 'a so to speak hovering aspect' in which a certain non-finality would be evident for a viewer to see.[15] That way, the 'system' would be active yet anticipate no fixed and final form. A diagonal introduced into a composition would provide a 'counter-movement' to the vertical–horizontal ones; then a further counter-movement would unbalance the result, from which new and no less unstable equilibria would emerge. Van Doesburg's *Counter-Compositions* are the best evidence of his adherence to what he calls 'plastic intuition controlled by a scientific idea' – in effect a dialectical method for art that he insisted would be needed in the civilisation immediately to come (**fig. 7.12**).[16]

A particular stage in van Doesburg's researches was almost complete. While supervising the building of a small studio for himself in Meudon, Paris in 1930 he finished an important painting based on the properties of the square, whose composition encapsulated both his elementarist ambitions as well as a version of the dialectical practice he had been recently advocating. *Arithmetic Composition* of 1929–30 can be described as an ordered array of squares within a square format, each square having a scale relation to every other square and to the enclosing one (**fig. 7.13**). As van Doesburg noted at the time of the painting, 'the square represents a stable element, which must be arithmeticised if it is to become animated'.[17] Thus the squares have been turned on their corner and organised into an ascending or descending diagonal in a generative relationship that stems from the properties of the enclosing square itself. The fact that a viewer cannot tell whether the sequence

is ascending or descending, approaching or receding, could be taken to be a 'counter-movement' of a further and more complex kind. Nearly a decade earlier, van Doesburg had argued that temporality in a painting should be achievable 'by mechanizing the plane of the canvas'.[18] Now, as he wrote to his friend the poet Antony Kok in January 1930, *Arithmetic Composition* was

a structure that can be controlled, a *definite* surface without chance elements or individual caprice. Lacking in fantasy? Yes. Lacking in feeling? Yes, but not lacking in spirit, not lacking the universal and not, I think, empty as there is *everything* which fits the internal rhythm: it is both the pyramid and the falling stone, both the stone skimming over the water and Echo, both time and space, the infinitely large and the infinitely small.[19]

His letter spoke of a spiritual as well as dialectical quest, a search for totality both in the present and in the society to come. On the basis of this and other works of the later 1920s with titles like *Simultaneous Counter-Composition* or *Counter-Plastic Composition*, van Doesburg believed that humanity could become 'more consciously intellectual, profound and spiritual than ever before'.[20]

For a final example of the elementarist tendency we turn to a group of artists and designers in Poland, where the question, once more, was that of the role of the artist in a post-war technical society. The problem was well summarised by the artist and designer Henryk Berlewi, who reviewed the massive 1922 Düsseldorf show for the Warsaw newspaper *Nasz Kurier* in August of that year and praised its extraordinary diversity. The contemporary challenge, he believed, was 'the unprecedented development of industrialism and the transformation along with it of social and economic conditions'. He mentioned too the disappearance of country settlements, the growth of cities, the diminishing importance of the individual and the growth of cooperative movements – all of which pointed to the fact that art was no longer isolated from everyday life, but had been 'forcefully shoved out into the streets'.[21] On his return to Poland at the end of 1923, Berlewi worked with a group of Productivists on a new magazine, *Blok*, dedicated to practical applications in the arts and design guided by

7.12 (*above*) Theo van Doesburg, *Simultaneous Counter-Composition*, 1929. Oil on canvas, 50 × 50 cm. Museum of Modern Art, New York

7.13 (*opposite*) Theo van Doesburg, *Arithmetic Composition*, 1929–30. Oil on canvas, 101 × 101 cm. Kunstmuseum, Winterthur

ideals of efficiency, economy, discipline, practicality and 'the inseparability of the problem of art and the problems of society'.[22]

Some Polish artists held that the struggle against subjectivism – individualism by another name – could be handled effectively by oil painting too. Władysław Strzemiński had been close to Malevich when the latter had worked at Smolensk near the Western Front during the Russian Civil War, yet he had interrogated deeply the legacy of Suprematism in those turbulent and changing times. Strzemiński had been part of the *Blok* discussions from the beginning, and now faced directly the challenge of what painting unhinged from both Suprematism and Productivism could be. From the beginning he insisted that 'every aspect of plastic action must be contained *within* the given work of art', that painting could best function in modern conditions by mobilising resources that were peculiar to it alone. Temporality, he argued – here he departed from van Doesburg's line, or Kandinski's or Paul Klee's – was the domain of literature and music alone. And that implied that forms interior to a painting must find a complete accommodation within the painting's limits, its edges, and the shape of its frame. In a series of *Architectonic Compositions* made between 1926 and 1930 Strzemiński believed he was showing how to banish dynamic figure–ground relationships by means of mutually adjusting colour areas within a given whole (**fig. 7.14**). In an important theoretical booklet he spelt out the case for a particularly stringent kind of elementarism based on the principle of simultaneous agreement of all the painting's parts. *Unism in Painting*, published in 1928, was at the same time another argument against Baroque instability in art. It insisted that in order for a painting to be a single painterly organism, its parts must be, as he put it in an interesting phrase, 'unanimous'.[23]

Yet if *Unism in Painting* gave an elementarist logic for painting, what could elementarist sculpture be? Katarzyna Kobro, married to Strzemiński since 1921, had trained with OBMOKhU in Russia before first gravitating, like Strzemiński himself, towards Malevich and his work in Smolensk. Yet Kobro was not hostile to temporality in her three-dimensional work. Her sculptures of the 1920s – aside from being highly advanced in relation to international norms – echoed most aspects of Unist doctrine while relaxing Unist painting's slightly rigid attitude to time. Her early *Abstract Sculpture* of 1924, for example, is believed to have been constructed on the basis of known geometrical curves and exact proportional ratios between the central sphere

and the sculpture's other units – as well as an implied invitation to circulate with the eye around and through the work (**fig. 7.15**).[24] From then onwards the task of making Unism a pan-artistic elementarism was one that Kobro addressed with determination. Her elegant and precisely designed metal sculptures from the middle of the 1920s, aside from evoking models for architecture, were graceful systems of planes and curves through which the viewer can notionally move. In her view, whereas the old solid sculpture was effectively sealed off from its surrounding space, in fact sculpture can be 'the shaping of form in space' since 'sculpture enters space and space enters sculpture'. And importantly, 'the mutual interdependence of shapes in sculpture can create a rhythm of dimension and division' (**fig. 7.16**). Furthermore, 'the unity of rhythm is achieved by means of the unity of its calculations' – by which she meant that the proportions of shapes and intervals within the sculpture should be precise (for example 1:1, 1:2, 1:4 or 8:5, the latter being a Fibonacci ratio) to the point of being relatable by the viewer.[25] She and Strzemiński together then published a booklet in 1929 bearing the title *Composition of Space: Calculations of Space–Time Rhythm* in which they explain in fuller detail how a Unist sculpture unfolds from a single plane to become, as they put it, 'potentially temporal' in the work's full articulation. Based in an elementarism of measure, shape and proportion, the task of sculpture in Unism had become 'to build a transition from individual shapes that are purely spatial and non-temporal ... up to the rhythm of the whole work of art or to the overt rhythm that unites the work into a single spatio-temporal unity'.[26]

 Importantly, and though the context was different, van Doesburg was now dovetailing elementarism and temporality too. To him, temporality implied relationships of succession, generation, contradiction and reconciliation, all considered as living yet deindividualised features of the self-announcing work of art. In the spring of 1930 he and a group of colleagues in Paris published yet another magazine, *Art Concret* (*Concrete Art*), in which his determination to establish non-subjectivist methods for art reached a kind of zenith. He and four colleagues – the typographer Marcel Wantz, Otto Gustav Carlsund (a former pupil of Léger), the painters Léon Tutundjian and Jean Hélion – announced not only that the work of art should be constructed of pure plastic elements but that the techniques should be 'mechanical, that is to say, precise rather than impressionistic'. A work should seek absolute clarity, one statement reads, and exclude from itself 'any natural form, sensuality or sentimentality ... [also] lyricism, drama, symbolism and so forth'.[27]

 They meant Surrealism, of course. Van Doesburg and his colleagues had effectively drawn the battle lines between those who conceived of the work of art as an object built systematically from elements, and those who bemoaned geometry and rational organisation as the proper foundation-stones of a truly modern art. Elementarism had done its work. Another battle of ideas had begun.

7.14 (*top left*) Władysław Strzemiński, *Architectonic Composition 3a*, 1927. Oil on canvas, 62 × 62 cm. Muzeum Sztuki, Łódź

7.15 (*top right*) Katarzyna Kobro, *Abstract Sculpture (1)*, 1924. Painted wood, metal and glass, 72 × 17.5 × 15.5 cm. Muzeum Sztuki, Łódź

7.16 (*bottom*) Katarzyna Kobro, *Spatial Composition 3*, 1928. Painted steel, 40 × 64 × 40 cm. Muzeum Sztuki, Łódź

CHAPTER 8

Germany and Russia in the 1920s

For two nations in particular, the decade following the end of the First World War was one of reversals. Germany as a nation in defeat suffered the burden of reparations payments – notably to France – and a sharp economic decline due to a slump in trade. Russia after its crippling civil war achieved limited economic stability, but at the cost of increasing isolation from the international community as the decade wore on. In both countries, specific and abrupt changes in artistic practice bear few points of comparison with the tendency in France and Italy towards retrenchment around 'classic' or 'classical' value systems. By the decade's end, and in both nations, efforts to cohere a national culture around traditional values rather than international ones were accelerating. In both, the question became whether national retrenchment and 'the modern' in art could occur together.

In Germany, by the time of the Berlin *Dada Messe* of June–July 1920 voices could be heard bemoaning the claims of artists to express the impulses of individual consciousness, as had been the tendency during the years of war. George Grosz had been discharged from military duties without seeing action, and had turned his angry and cynical eye to caricature – of fat bourgeois, complacent military types, rapists, veterans – before dabbling in photomontage with Heartfield in a Dada-like vein. Otto Dix had greeted the war with enthusiasm in 1914, remembering long after the event the craving he had felt for extreme experiences, for life on the edge. 'There was something tremendous about it,' he reflected; 'I needed to experience all the depths of life for myself'.[1] Plunging himself into military life with Nietzschean energy, the six hundred or so drawings he managed to produce during the years of conflict show grotesque scenes of squalor and death in the trenches and the mud – before exhaustion and disillusion finally supervened as the fighting came to its fruitless end (**fig. 8.1**). With the end of the war, artists as diverse as Grosz, Dix, Hausmann, Georg Scholz and Rudolf Schlichter began to turn away from those practices towards a kind of sobriety in the image – towards what they termed *Gegenständlichkeit* (objectivity) in the sense of precision of graphic outline, consistent spatial organisation, intelligible illumination, and subjects they could claim as typical of the life of the day. Their complaint about the Expressionism of Ludwig Meidner, Max Pechstein or Otto Müller – or Dix himself – was that it conveyed the anguish of personal striving but was no longer relevant to Germany's actual life.

Grosz, for example, had seen new paintings by de Chirico and Carrà on display at the Goltz bookshop in Munich and took up their methods in works like *The Diabolo*

Player and *Republican Automatons* of 1920 – carefully contrived watercolours that project a world of precision and clarity, albeit one in which supporters of the new Weimar Republic were mechanical and faceless robots, mere functionaries in the multiple compromises of the new state. In one image by Grosz, such an individual is represented with his machinery showing (**fig. 8.2**). The critic Carl Einstein noted that 'for six weeks the Futurists of the Berlin suburbs have been looking at *Valori Plastici* ... De Chirico landed in Berlin in 1919'.[2] Though no one claimed de Chirico's mannequins, studio clutter and assorted geometrical solids to be 'objective', nevertheless the Berlin artists were now seeking a certain spatial separation of things from each other, a certain clarity of point of view. Rudolf Schlichter's *Dada Roof Studio* adopts that manner to show a few top-hatted capitalists sitting incongruously together as if on a burlesque stage (**fig. 8.3**). It was the means by which German artists aligned with communism – of whom Schlichter was one – could portray contemporary realities, including factory strikes, hyper-inflation and social misery in a relatively sober light. Such was the context in which members of the *Dada Messe* group and others wrote an explosive 'Open Letter' to the backsliding administration of the Novembergruppe early in 1921, complaining of the 'slippery rhetoric' by which it had capitulated to commercial and elitist interests. The letter spoke of a commitment to 'a new objectivity [*neue Gegenständlichkeit*] born of disgust with an exploitative, bourgeois society' or else to 'a non-objective [*ungegenständlich*] optic' – what might be called abstraction – at all costs 'to replace individualism with a new human type'.[3]

Achieved either way, the turn away from Expressionism was encouraged in Berlin by the arrival in the city in late 1921 of the young Russian Lazar El Lisitski, who with the writer Ilya Ehrenburg launched a three-language journal *Veshch – Gegenstand – Objet* that functioned as an information exchange for international events in art as well as a vehicle for new attitudes to material things. De Stijl, Le Corbusier and Léger's Purism, the work of Gleizes and Lipchitz, as well as Malevich's Suprematism and Tatlin's *Monument* were among the topics discussed. The editors of *Veshch* emphasised the need 'to turn away from the old, mystical conception of the world and create an attitude

8.1 Otto Dix, *Two Riflemen*, 1917. Black crayon, 39.5 × 41 cm. Stiftung Kunstmuseum, Stuttgart

8.2 (*above*) George Grosz, *Republican Automatons*,
1920. Watercolour and pencil on paper, 60 × 47.3 cm.
Museum of Modern Art, New York

8.3. (*opposite*) Rudolf Schlichter, *Dada Roof Studio*,
c. 1920. Watercolour and pen on paper, 45.8 × 63.8 cm.
Berlinische Galerie, Berlin

of universality – clarity – reality', one requiring 'a completely changed social structure', in which paintings, poems and works of drama alike – all of them 'objects' – would need clear organisation too.[4] In October 1922 the *Erste Russische Kunstausstellung* (*First Russian Art Exhibition*), held at the Van Diemen Gallery in Berlin, presented a full spectrum of Russian artistic practices since the Revolution, further encouraging the hope that – the failure of the German and Hungarian revolutions of 1919 notwithstanding – progressive internationalism in art was a real possibility.

Of course, the term 'objectivity' could mean different things. For curators, it was less rage against bourgeois society, rather the sudden retreat from Expressionism that was significant now. In 1923, as the new republic entered a period of relative economic and social stability, the director of the Mannheim Kunsthalle, Gustav Hartlaub, began planning an exhibition reflecting what he understood to be a new mood of restraint in art. He already regarded Max Beckmann as an important figure-painter, but not as an Expressionist. He noticed how Georg Schrimpf and Heinrich Davringhausen, two artists from Munich, had resisted north German Expressionism; and that Georg Scholz from the Novembergruppe opposition had recently abandoned his satirical style in favour of coolly lit renditions of businessmen, bankers and rural landscapes showing signs of the incursion of new industries – in one work an unromantic view of suburban railway infrastructure, candidly and coolly portrayed (**fig. 8.4**). In presenting his exhibition under the title *Ausstellung 'Neue Sachlichkeit': Deutsche Malerei seit dem Expressionismus* (*'New Objectivity' Exhibition: German Painting since Expressionism*) in Mannheim in 1925, Hartlaub claimed to have identified 'a timely and coldly verificational attitude on the part of a few, and an emphasis on what is objective [*sachlich*], with technical

attention to detail, on the part of them all'. Yet in calling Davringhausen, Schrimpf and Scholz 'verificationists' who were taking the world of contemporary fact and projecting into it 'current experience in all its tempo and fevered temperature', he brought out another feature. For Hartlaub observed that 'much of the visionary fantasy of the old is preserved in the objectivism of today'.[5] What at first sight had suggested unflinching appraisal and emotional distance could at the same time appear as if a fascinated gaze had been trained upon the curious, the exceptional, and the overlooked. The critic Franz Roh even tabulated 'post-Expressionist' versus 'Expressionist' qualities in a list: thus 'cool' versus 'warm', 'pure objectification' versus 'smeared', 'quiet' versus 'loud', 'civilised' versus 'primitive', and so on. Post-Expressionism was a 'magic realism' in his eyes.[6] And what was to be said about the loneliness and distress in the allegedly *sachlich* portrayals of Christian Schad? Here was a brittle stylist whose revelations, however *sachlich*, could make the flesh creep (notice the scar on the prostitute's left cheek) (**fig. 8.5**).

What, then, was 'objectivity'? It would not be long before traditionalist critics concerned about sustaining the true German *Geist* would propose a remedy – an infusion of 'joyful optimism', even 'childlike faith' such as an energetic national community had every right to demand.[7] Unsurprisingly, many German curators in the later 1920s became wary of the term *Sachlichkeit.* Hartlaub even claimed to disown it.

It was in these years that several other claims for 'objectivity' were made, in particular for the fast-developing medium of photography. A defence of the photograph's ability to capture facts 'realistically' fell to the young Albert Renger-Patzsch. To him, photography's errors hitherto had included copying art's compositional conventions in the nineteenth century, delving into anti-composition in Constructivism or collapsing the image into photo-fragments in Dada. For him, the camera's mechanical apparatus, far from a limitation, was what made it superior to all other means of expression. The secret of a good photograph 'resides in its realism'. To Renger-Patzsch, advantages of the medium included its ability to objectify the transient beauty of plants, capture the dynamism of the modern factory or arrest rapid movement without loss of detail. Photographic technology could render the textures of wood, stone and metal, the

8.4 Georg Scholz, *Signal Box*, 1924–5. Oil on canvas, 63 × 83 cm. Kunstmuseum, Düsseldorf

sensations of height and depth, the entirety of what he called 'the magic of experience', as well as compare images, explore formal likenesses, and suggestively juxtapose images taken at radically different levels of scale (**fig. 8.6**).[8]

Yet obviously any claim that the photograph trafficked exclusively in 'fact' would be controversial from the start. Who or what should appear before the lens? In what mode of interaction with the artist/photographer would a subject be invited to appear? A Workers' Photography Movement in Germany sprang to life under a publishing empire created by Willi Münzenberg, sympathetic to the claims of the Soviet state to have created – or to be creating – a new type of proletarian culture. Münzenberg's magazine *Der Arbeiter-Fotograf* (*The Worker-Photographer*) was founded in 1926 to encourage the use, and the construction, of cameras by amateurs, the formation of local clubs and societies, and the production of images of working-class rural and urban life. It encouraged the use of the camera by everybody, but above all provided a tool with which the working class could discover its own optic – a way of looking and knowing that that class itself hardly knew (**fig. 8.7**).[9]

The battle lines of photographic 'objectivity' in Germany came to a head with the vast international *Film und Foto* exhibition staged by the Deutscher Werkbund in Stuttgart in 1929. *Film und Foto* placed on show the spectrum of devices and camera methodologies available at that time. The German section was organised – interestingly – not by an 'objectivist' but by Moholy-Nagy. Since the early 1920s he had advocated research into such 'essential' properties of the medium as the action of light on photo-sensitive paper, new camera angles and positions, new lens systems, foreshortening,

8.5 Christian Schad, *Self-Portrait*, 1927. Oil paint on wood, 76 × 62 cm. Tate Gallery, London

8.6 Albert Renger-Patzsch, *Sempervivum*, 1922–3. Gelatin silver print, 22.7 × 16.9 cm, published in *Die welt ist Schön*, 1928. National Gallery of Australia

the use of mirrors and other effects, and most radically, dispensing with the camera altogether. His Bauhaus book *Malerei Fotographie Film* (*Painting Photography Film*) of 1925 was already a milestone in the discussion of optical systems different from those of the human eye, including the use of mirrors and reflections, animation, negative photography and, of course, the photogram itself. In the same issue of *Das Deutsche Lichtbild* as Renger-Patzsch's statement of his aims, Moholy emphasised that photography should be 'productive' as much as it should be 'reproductive'; that new techniques could help define a practice capable of delivering 'the strongest visual experiences that can be granted to man'.[10]

A further project that proved distinctive in the quest for 'objectivity' in German photography was that of August Sander. His great project of photographing individuals, moreover individuals according to occupational or professional type, occupied virtually the whole of his working life. Conducted in his home district of Westerwald, near Cologne, the project that absorbed him from the early 1920s was planned as a documentary archive of 'People of the 20th Century'; yet Sander quickly discovered that 'objectivity' could best be achieved not by archival completeness – the range of his work was enormous – but by a special methodology that he brought to the task. He would encourage his sitters to choose their own backdrop, face the camera as they wanted, and adopt a matter-of-fact expression in preference to looking cheerful or grinning nervously at the lens. The results, as modest as they are unforgettable, demonstrated once again that unflinching candour before the visual fact could produce disturbing results; even that 'objectivity' and what might be called photographic 'sur-realism' sometimes went together (**fig. 8.8**).

8.7 (*above*) Photographer unknown, 'Proletarian Children', *Der Arbeiter-Fotograf II*, 1928, vol. 10, p. 7

8.8 (*opposite*) August Sander, *Rural Brother and Sister*, 1925–30 (People of the 20th Century, no. 1/1/17). Gelatin silver print, 25.8 × 18.7 cm. Sander Archiv, Fotografische Sammlung, Cologne

What other meanings of 'objectivity' might there be in the Weimar period – for example in the context of economic recovery after the national failure of the First World War? Perhaps 'objectivity' in those years can be seen as a kind of pragmatism, believed to be indispensable to the revival of industry and manufacture. Fordist methods of assembly and construction, the management of labour according to Taylorist methods of measurement: these were adopted wholeheartedly during the period. Even the ethos of the Bauhaus shifted towards the end of the decade, towards the education of artist-designers in methods consistent with assembly-line manufacture and large-scale production. Bauhaus teaching in architecture came to advocate the design of communal housing units that were efficient, streamlined and compatible with the development of new material technologies. In the wider culture of Weimar, the pragmatic attitude could even be detected in the rhythm of big city life, where sport, cinema and rapid information consumption could all be indulged in freely with what could appear to be a kind of mechanical hedonism.[11]

But the pragmatic attitude – or that part of it that rushed to embrace a modern future as achievable – also functioned in Germany to provoke alarm at the perceived decay or suspension of older nationalist, religious and cultural values; at least, such was a common perception from the early days of the new republic on. Though *Neue Sachlichkeit* had charted a middle way between the programmes of communist-leaning pressure groups and residual Expressionist yearnings for spiritual utopia, it could still attract the hostility of cultural traditionalists whose concern was the survival of a so-called national community. Germany was already decentralised into *Lände* (Lands) with their own traditions and *völkisch* (folk) cultural organisations, and to some, the internationalisation of culture in the big cities was a tendency to be resisted, if not reversed. A Kampfbund für deutsche Kultur (Combat League for German Culture, or KfdK) was founded in 1928 by an ideologue of the National Socialist German Workers' Party (i.e. Nazi Party) named Alfred Rosenberg, to mobilise support for local guilds, athletics clubs and music societies, to propagate anti-Semitism, and in the cultural sphere to spread alarm about the roots of international and 'modern' art. To take one example: the spread of mass housing design à la Bauhaus was a particular bane of the conservative politician Paul Schultze-Naumburg – 'a gigantic malignancy', he called it, 'having nothing in common with our German spirit and our German landscape'. Modern technology, he protested, was 'utterly alien' in the context of residential dwellings. 'Eating, drinking, sleeping, sociability and cosy togetherness are

extremely conservative things' – routines intrinsic to those who feel themselves 'drawn by blood to the world of our Nordic forms'.[12] In fact, since the days of Expressionism and Dada, Schultze-Naumburg had concerned himself with what he claimed was the increasing absence of 'the Nordic type' from art, as well as a corresponding increase in depictions of 'the genuine hell of inferior human beings ... primitive humans showing symptoms of degeneration, sickness and physical deformity'. His openly provocative 1928 book *Kunst und Rasse* (*Art and Race*) called for a 'Promethean defiance' of modernist internationalism and experimentation in art.[13] In the following year of 1929 the Wall Street Crash – and with it the collapse of the pragmatically operated capitalist economy – triggered a steep rise in unemployment and a sharp increase in Germany of political intolerance, violence and murder. The several 'objectivities' of the Weimar period were suddenly under threat from a different kind of force. New levels of redemptive nationalist rhetoric were increasingly to be heard, based on obscure ideals of national destiny and high culture rooted somewhere in the (albeit mythical) German past.

By the end of the 1920s an inexorable drift towards the establishment of a conservative national culture was also under way in Soviet Russia. Conditions during the period of War Communism had been such that by 1921 near economic collapse had presented a struggling Soviet government with policy dilemmas in every field. For had it not been the purpose of the Bolshevik Revolution to transform mental as much as material life, art and literature as well as the economy? In the absence of a capitalist market for art, a policy for literature and the arts had become the prerogative of the new state.

What, for example, should the Soviet state say of those who had launched the concepts *zaum* and *sdvig* into literary and visual art? Initially, certain artists had moved close to what was called 'Dada' in the capitalist West. After the 1917 Revolution the poet Zdanevich, the rabble-rouser from the *Target* debate back in 1913, had gathered around himself the poet Aleksei Kruchenykh and a younger writer Igor Terentev in far-off Tiflis, Georgia, and had inaugurated a group calling itself '41°' (the latitude of Tiflis). The two of them had produced a manifesto in 1919 claiming to 'unify left-wing Futurism and affirm trans-rationality as the mandatory form for the embodiment of art' – as well as 'cause constant trouble'.[14] Anarchism rather than Bolshevism would be their creed. Yet if trans-rationality hoped to survive through the 1920s, to what degree should the new Soviet government support them?

What could *Dyr bul shchyl*, Kruchenykh's 'Futurist' dissection from the days before the Revolution, contribute to the arts in a classless society? Lenin was immediately sceptical. Among senior members of the government it was Leon Trotski, commissar for the Red Army in the civil war, who held out for the artist's licence to experiment as a historically necessary prelude to other forms of art. He agreed with Lenin that 'Futurism' had begun as a reaction to the decay of the bourgeois-capitalist era, that unaided it could not succeed in becoming a truly revolutionary art. The Decadent and Symbolist movements had been 'mere scratches of the pen', as Trotski put it in his book of 1923, 'an exercise in craftsmanship, a mere tuning of instruments'. Kruchenykh's word forms were likewise necessary technical exercises, just as understanding form and material was a precondition of a future emancipatory art. Likewise it would be wrong to see Tatlin's *Monument* of 1919 'as a mere liquidating of art, as a mere voluntary giving way to technique'.[15] A future art would require a symbiosis of formatively self-conscious technique with the outlook of the working class.

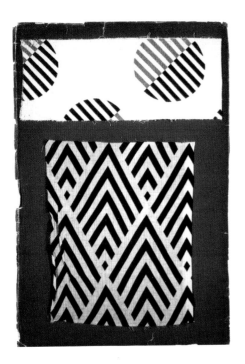

In any case, popular entertainments not likely to be eradicated included Russian traditions of circus and popular comedy. Take the Petrograd director Sergei Radlov, already celebrated for suggesting no more than a plot outline to his actors and leaving them to improvise the rest – giving rise to accidents, farcical banter and general buffoonery. In the same city, the Factory of the Eccentric Actor (Fabrika ekstsentricheskogo aktera, or FEKS), opened by Grigori Kozintsev and Leonid Trauberg in 1920, was enthusiastically absorbing ideas from Charlie Chaplin, Mack Sennett and Japanese Kabuki theatre, a cultivated artifice aimed – in one description – 'not at movement but at affectations, not at mime but at grimace, not at speaking but at shouting ... stunts aimed at a rhythmical battering of the nerves'.[16] Though known by the term Eccentrism, in effect this was *montage*, a technique applicable to any medium that combined high-voltage interruption and absurdist theatrics to produce genuinely original art. At FEKS's single production of 1922, a version of Gogol's *The Marriage*, it was promised that Gogol would not recognise his own play. In the visual arts it was a technique tried by Rodchenko, who now juxtaposed photo-fragments in a set of images to accompany Mayakovski's free-verse poem *Pro Eto* (*About This*) of 1923: images that clashed and clustered together to create abrupt pictorial surprise. Meanwhile, a young Sergei Eisenstein adopted the choppy, burlesque style of the FEKS performance, transferring it to stage adaptations and in 1924 to film. Eisenstein's 'montage of attractions' was premised on shock elements and visual rhythms suggestive of ideological connections that a film audience would be able to make for itself.[17] On this evidence there was hope that *zaum* could provide a revolutionary texture for the new revolutionary life.

At the same time, the Soviet economy was struggling hard to recover. During the years of revolution and the early part of the civil war most Suprematists, Constructivists and so-called production artists had remained aligned with the imperatives of social reform, yet how did their work square with the Bolsheviks' commitment to a revolutionary society? It is true that the confinements of War Communism found a degree of reflection in the sparse, efficient structures proposed by Constructivists, and designs by so-called Production artists in fields such as graphics, stage design, typography, exhibition design, textile design and ceramics

8.9 Lyubov Popova, *Fabric Samples*, 1923–4.
Fabric mounted on cardboard, 31.5 × 12.5 cm.
State Tretyakov Gallery, Moscow

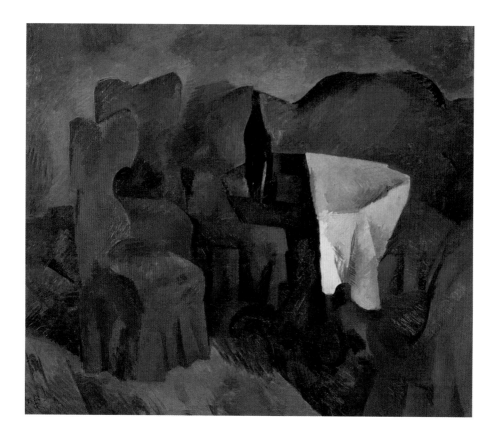

are still celebrated for their vibrancy, their sparse efficiency, their exemplary mating of practicality and style (**fig. 8.9**). 'Our cultural creative work is now entirely purpose-orientated,' the theorist Osip Brik was now able to say.[18] Yet Lenin had reintroduced an element of free-market activity (the New Economic Policy, or NEP) in 1921 with the aim of helping Soviet society get back on its feet – and dilemmas inevitably arose over the relation of art and design to the market mechanism. Involvement in NEP typography and advertising – however daring graphically – could expose artists to the accusation of political backsliding. Some Productivist furniture and clothing could be criticised for its lack of utility. Was the new art and design really flexible enough to meet the realities of manufacture and heavy industry?

Several answers were given. The leaders of the organisation known as Proletkult (Proletarskaya Kultura, or Proletarian Culture) had back in September 1918 urged for an uncompromising war on 'bourgeois culture' – in effect the traditions of West European art – thence to establish a collective and popular culture expressive of the interests of

8.10 (*above*) Robert Falk, *Furniture Upholstered in Red*, 1920. Oil on canvas, 105 × 123 cm. State Tretyakov Gallery, Moscow

8.11 (*opposite, left*) Vladimir Lyushin, *Station for Interplanetary Communication*, 1922 (lost work)

8.12 (*opposite, right*) Aleksandr Tyshler, from *Lyrical Cycle No. 4*, 1926–8. Oil on canvas, 73.4 × 55.6 cm. Pushkin Museum of Fine Arts, Moscow

the working class. 'The proletariat needs a new class art,' Bogdanov had said: 'one that assimilates and reflects the world from the viewpoint of the labour collective ... its fighting spirit, its collective will'.[19] To the party leadership, however, the idea of a Proletkult independent of government direction was unsupportable. In any case, Lenin and Lunacharski both took the view that the long history of bourgeois culture was worth examining, that there were lessons to be learnt from its so-called masterworks and from the museum and gallery networks that conserved and exhibited them. In 1921 a compromise was reached to the effect that Proletkult would continue as an independent organisation, but under the watchful eye of the Bolshevik Party. The result was that the perceived needs of the proletariat would inform Soviet policy in the arts for years to come.

Elsewhere in the visual arts, the market relaxation of the NEP years encouraged a number of different artistic groups to form. For those who still believed in easel painting, something like a revival of Cézannism now appeared at the hands of such artists as Robert Falk, Ilya Mashkov and Petr Konchalovski (**fig. 8.10**). Other groups claimed to apply artistic feeling to the tempo of modernity, to carry out what was termed art's 'creative reappraisal'. Or there were Konkretevists (Concretists) whose works addressed modernity as they understood it from recent discoveries in futuristic travel, X-rays and telegraphy, rendered in a generally futuristic style (**fig. 8.11**). A fourth group, Projectionists, were committed to somewhat ethereal abstractions designed to 'project' pathways for the organisation of energy, especially electricity and light.[20] Soon, a centrist group, the Society of Easel Painters (Obshchestvo Khudozhnikov-stankovistov, or OSt) emerged from the confusion, dedicated to developing 'a revolutionary contemporaneity and clarity in the choice of themes ... and rejecting anecdotal-narrative methods for the task'.[21] OSt's four exhibitions between 1924 and 1928 accommodated most genres and themes, ranging from fantasies of flight

and modernity by Aleksandr Labas to the imaginative theatrics of AleksandrTyshler, who by now was inventing assorted characters – seemingly ordinary citizens – caught in paradoxical or perplexing situations, often as if in a fantasy, or on the stage. His was the closest Soviet painting came to a Surrealist style (**fig. 8.12**). West European prototypes could also be detected: the Expressionism of Grosz and Dix in the work of Petr Vilyams and Yuri Pimenov, or *Neue Sachlichkeit* sobriety in paintings by Sergei Luchishkin, such as his allegorical *The Ball Flew Away* of 1926, with its depiction of cramped urban housing and a child's balloon (coloured red) drifting hopelessly away.

A more obviously West European attitude to technique was shown by the group Four Arts (standing for painting, graphic arts, sculpture and architecture), whose aim was less a mimesis of Soviet reality than what it called 'harmony with the material out of which form is constructed ... with its organisation and with its mastery'. Several Four Arts members gained international reputations and were widely travelled. Lisitski and Puni were members for a time; while extraordinary perspectival effects and luminous transparency were the hallmarks of Kuzma Petrov-Vodkin's style. Or consider the very private Pavel Filonov, independently minded and for most of the 1920s based in Petrograd, where he assembled a closely knit studio community called Analytical Art, committed to a carefully considered process of making a painting, line by line, stroke by stroke, colour by colour, such that the smallest units of its kaleidoscopic surface are linked organically with larger units, the totality of which, according to Filonov, should appear akin to a living body or a blooming flower – in short, to 'life as a whole' (**fig. 8.13**).[22]

That many of these artists remained unknown to Western audiences until much later has a tragic explanation, for, following the death of Lenin in January 1924, what had been the internationalist orientation of the Revolution began to go inexorably into reverse. A new power group including Stalin, Nikolai Bukharin, Grigori Zinovev and Lev Kamenev now supported a nationalist and isolationist posture for the Soviet Union in which travel abroad and visiting exhibitions were limited, in which support for art organisations was selective, and in which cultural debate was often abruptly curtailed. Among the new party leadership were some who looked back to pre-Revolutionary art

8.13 (*above*) Pavel Filonov, *People in the World*, 1925. Oil on canvas, 107 × 72 cm. State Russian Museum, St Petersburg

8.14 (*opposite*) Aleksandr Rodchenko, *Mosselprom Building*, 1926. Gelatin silver print, 23.8 × 30 cm. Pace Gallery, New York

in order to find prototypes for their own time. One such prototype was the Peredvizhnik (Wanderer) artists of the latter part of the nineteenth century who had travelled the country collecting motifs of peasant life and hardship and had rendered them in a quasi-documentary style. Peredvizhnik art was still much in evidence in 1917, and it stimulated certain younger artists to form an Association of Artists of Revolutionary Russia (Assotsiatsiya khudozhnikov Revolyutsionnoi Rossii, or AKhRR) in 1922 with a mission to depict 'The Life and Customs of the Workers' and Peasants' Red Army' – the title of their exhibition of that year – in works that 'set down artistically and documentarily the revolutionary impulse of this great moment of history', hence to provide 'a true picture of events' in a style they called 'heroic realism'. AKhRR's 'return' to what they claimed was a documentary style bears only minimal comparison to *Neue Sachlichkeit*. The 'objectivity' claimed by the Soviet group was that of 'the life of the working class', which, however, they tended to depict in monumentalising and formulaically optimistic terms. Meanwhile, AKhRR berated the art of the pre-Revolutionary Futurists and their Constructivist successors as 'abstract concoctions that discredit our Revolution in the face of the international proletariat'.[23]

Because of its formal conservatism, AKhRR was well funded by highly placed military interests and party officials and became a major player in the definition of Soviet cultural policy both during and beyond the 1920s. Its claims were of course disputed – first of all by Constructivists, who had abandoned painting and sculpture and taken to experimenting with the camera, or had moved into Production art.

Aleksandr Rodchenko was among the earliest to use hand-held cameras when they became available, and now produced single images in such a way, so he claimed, as to see the world anew. 'Photography is supplanting painting,' Osip Brik was able to say about his friend in 1926. Rodchenko's objective was 'to discover other, specifically photographic laws for taking and composing the shots'. One no longer needs to stand squarely on the ground and face the camera forwards, since now 'the camera can function independently, can see in ways that man is not accustomed to – can suggest new points of view and demonstrate how to look at things differently'. A fire escape could become a monstrous object, balconies seen from below could become towers of exotic architecture.[24] Even capturing the motion of an object presents no problem, said Brik, and if the photographer is unable to convey the sensation of actual movement, 'at least he can imply it'.[25] Furthermore, the camera could deindividualise its subject and present no longer the personality of the photographer but a collective and class-conscious contemporary art. Rodchenko's manipulation of the hand-held Leica camera, taken to rooftops, lowered to the ground or tilted to produce unfamiliar perspectives, launched some dynamic imagery in which the viewer could become actively involved (**fig. 8.14**).

By the end of 1927 and early 1928 the practice of both art and photography in Soviet Russia had entered a very precarious phase. The Bolshevik party after Lenin was drifting into authoritarianism and paranoia, rounding on opposition voices, fabricating often absurd accusations against them, and in extreme cases – that of Trotski and his 'Left Opposition' – removing them from the party altogether, even into exile. Surviving small journals in the visual arts such as *Novy LEF*, launched early in 1927 by Mayakovski and the playwright Sergei Tretyakov, tried to uphold the values of class-consciousness *and* experimentation in art, including the practice of what they called 'factography', the use of the camera to address the 'facts' of socialist construction but without the conventions associated with pre-Revolutionary documentary painting. In the eyes of its party-minded critics, factography was to be mistrusted from the start. Rodchenko's experimental photography was criticised for lacking an identifiable class viewpoint and for imitating such Western photographic innovators (however different from each other) as Renger-Patzsch and Moholy-Nagy. An era of extreme factionalism had begun.

8.15 Olga Ignatovich, *Untitled*, from the series
Sickle and Hammer Commune, 1920s. Photograph,
19.2 × 29.1 cm. Zimmerli Art Museum, New Jersey

In 1928 the response of 'left' artists was to regroup in a new organisation called Oktyabr (October), the membership of which included some illustrious names: Gustav Klutsis, Solomon Telingater, Olga and Boris Ignatovich, Aleksei Gan, Rodchenko, Eisenstein, Stepanova, Lisitski, Aleksandr Deineka, the Hungarian muralist Béla Uitz and for a while the Mexican painter Diego Rivera. Oktyabr's best hope was to try and square experimental practice in the arts with service to the perceived needs of the proletariat – more or less the theoretical position of the now exiled Trotski. Once more, the rhetoric is important. Oktyabr's *Declaration* of March that year expressed the group's intention to support 'rational and constructive approaches' to art (hence avoiding accusations of irrationality) but to 'reject the philistine realism of epigones: the realism of a stagnant, individualistic way of life ... with its fruitless copying of reality'.[26] Oktyabr was reduced to steering a difficult path between fanciful glamorisations of Soviet life on the one hand and the use of formal precedents already in use by the international modernist community on the other. 'We are against jingoism, factory chimneys and workers with hammers and sickles,' an Oktyabr statement of 1931 read; 'but we are also against abstract leftist photography'. They added that they wanted to show 'facts that are socially oriented and not staged, the facts of socialist construction' (**fig. 8.15**).[27] But they were too late. By then, the party's main ideological project was its Five-Year Plan for industry and agriculture, launched after much discussion in April 1929 and now in full swing. Extraordinary production targets were set for grain, coal and steel in the hope of rescuing the still struggling Soviet economy from collapse. Correspondingly, policy for art and literature was turning towards sloganising on behalf of 'shock-work' and 'socialist construction' rather than addressing the conditions of labour objectively. In the process, all quasi-independent organisations such as OSt and Oktyabr – even AKhRR's successor body, the jingoistic and self-congratulatory AKhR – faced the threat of being curtailed.

Given literature's importance to Soviet cultural life, we can conclude by noting how in that field also, the last traces of experimentalism were destined to disappear. The Russian Association of Proletarian Writers (Rossiiskaya assotsiatsiya proletarskikh pisatelei, or RAPP), formed in 1925, complained about writers even of the quality of Zamyatin (author of *We*, 1921), who seemed not to be writing what RAPP called 'the Soviet novel'. Meanwhile, an Association for Real Art (Obedinenie Realnogo Iskusstva, or Oberiu), led by the experimental writers Daniil Kharms and Aleksandr Vvedenski, came in for increasing censure too. Oberiu's stories were despairingly short, inconsequential, and for the most part indifferent to a character's fate – a kind of Dada idiom that ridiculed every literary convention it could find. 'We broaden the meaning of an object,' the authors said, 'but we do not destroy the word itself in any way. The concrete object, once its literary and everyday skin is peeled off, is the property of art' – and then, provocatively, 'proletarian literature is a maze of the most horrible mistakes'.[28] RAPP's hostility to Oberiu was immediate and cruel. In the spring of 1930 the group was denounced as 'literary hooligans'.[29] The next year Kharms and Vvedenski were sent into exile. Artistic modernity in Soviet Russia was coming to an end.

The 1930s:
The 'Low Dishonest'
Decade

To describe the 1930s as a decade of crisis may be an understatement. By 1930 it was clear to most observers that significant ideological differences had developed between ideals of shared community rooted in the experience of the proletarian or working class and those of the free competition of ideas within the context of the market mechanism. But by 1930 both communism and capitalism seemed to have faltered, and artists were divided on how to proceed. Surrealists, on the one hand, would face questions of how their interrogation of reality's deeper enchantments could be aligned with a revolutionary impulse. On the other hand, abstract artists increasingly hostile to Surrealism entered the decade with ambitions to establish rational patterns of thought, planning and construction, with the prospect of new forms of urban living to match. Yet the realities were stark. The stock market crash of 1929 introduced new fractures in the market for art, as well as widespread unemployment in most countries of the West. Secondly, it was becoming clear that regressive ideologies were at work in Germany and the Soviet Union that in very different ways threatened the intellectual independence and even the lives of artists who chose not to conform. In Italy and Spain, dictatorships were already forming that also bode ill for the practice of free thought and action in the arts. By mid-decade those fears were becoming realised, and in consequence, prospects for the continued international exchange of work and information in the arts began to dim.

With the European nations again drifting towards war, modern art itself became subject to curtailment, even defeat. At the same time the spread of European artistic precedents to the United States and Latin America helped trigger new patterns of public understanding and some different objectives for the period to come. Towards the end of the 1930s artists in the United States began to ask pressing questions about the special qualities of the nation's visual culture, and to define it accordingly. There too, however, years of economic depression lifted only to reveal a society riven by inequalities of opportunity and some major divisions in social power, aspiration, and above all race. The poet W. H. Auden wrote of a 'low, dishonest decade' while sitting in a dive 'on Fifty-second street'.[1] By the decade's end, nevertheless, and as the European nations went again to war, art in the United States enjoyed rising levels of private patronage and support.

Surrealism: Objects and Sculpture

The career of Surrealism in the 1930s shows a renewal of interest in objects –
commercial objects, domestic objects, sculptures, ordinary things. There may be
no single reason why such a 'turn' should have occurred; but consider the economics
of ownership at that historical moment. The international stock market crash of
October 1929 had made acquisitive capitalism look like a doomed economic and
social regime; meanwhile, in Soviet Russia, new policies in industry were mandating
a renunciation of personal property and the collective ownership of things. Both
capitalist as well as communist modes of social organisation had tipped the object-
world into crisis. Didn't the world have a depth, a mystery, that the quest for general
affluence was concealing?

An early sign of the crisis can be detected among the attitudes of certain painters.
'I personally don't know where we are heading,' Joan Miró said to a journalist early
in 1931, summarising two or three years of struggle with the direction of his work.
'The only thing that's clear to me is that I intend to destroy, destroy everything that
exists in painting ... Painting revolts me. I can't bear to look at my work ...' Having flirted
with the qualities of Dutch painting on a trip to the Netherlands with Salvador Dalí
in 1928 – perhaps because of it – he had developed a wish 'to assassinate painting',
to go 'beyond painting', to escape from Paris and from 'the intellectuals who have
become such cretins everywhere in the world'.[1] For Miró, 1929 had been occupied mainly
with making collages out of tar-paper, newspaper, wire and string. They were included
in an important show at the Galerie Goemans, Paris, in March 1930 titled *La Peinture au
défi* (*The Challenge to Painting*), with a lengthy preface by Louis Aragon, himself at that
moment in the process of aligning with the French Communist Party and its support
for the Moscow line. For Aragon and perhaps for Miró, the significance of collage lay
in its use of chance to escape from individualism, from the artistic 'touch' – hence
from the allure of personal 'inwardness' so beloved by the bourgeoisie. Aragon's
comment on Miró's new collages was that 'the paper is generally not completely
glued: its edges are free, it waves and flutters, [while] asphalt is one of his favourite
elements' (**fig. 9.1**). Likewise, Picasso 'did something terribly serious' when in 1926
he 'took a dirty shirt and sewed it to the canvas with needle and thread, [and] this
became a guitar by example' (**fig. 9.2**). He made another collage with nails sticking out
of the surface because 'he wanted the real offal of human life, something poor, dirty
and despised'. Such a lowering of painting to the level of ordinary matter was also
implied in the collage novels of Max Ernst. In Ernst's *La Femme 100 têtes* of 1929 Aragon

found anti-individualism in the fact that 'the painter borrows a personage from an old illustration, just as the playwright uses a flesh and blood actor whom he has not had to create from scratch'. The magic of Ernst's work is owed to this single technique 'in which nothing is drawn by the author'.[2] Miró, for his part, after his 1929 collages turned to making object-constructions which he called 'sculptures' in spite of appearing to others as 'products of a bric-a-brac store', but which, to Miró's supporters, had received the artist's alchemy and 'take on … an intense and penetrating life' (**fig. 9.3**).[3]

A further sign of widespread disaffection with painting was the show at the Galerie Loeb, Paris, in the spring of 1930 of work by Miró, Hans Arp and the younger Swiss-born sculptor Alberto Giacometti. For most of the 1920s Giacometti had made small totem-like standing figures and some Cubist heads stimulated by African, Mexican and Oceanic art, but they were thus far little known in Surrealist circles; though in fact a recent piece titled *Tête qui regarde* (*Head that Looks*) had caught the attention of the writer Michel Leiris – a review by Leiris in *Documents* for September 1929 had done much to boost Giacometti's career.[4] For the Galerie Loeb show Giacometti was exhibiting a very novel and slightly mysterious construction called *Boule suspendue* (*Suspended Ball*) comprising a simple wire framework inside which a plaster ball grazes the surface of an upturned crescent moon, giving rise to the illusion – perhaps an erotic fantasy – that the ball might gently move (**fig. 9.4**). On the strength of this and of a work titled *Homme, femme et enfant* the Surrealists now invited Giacometti to join the movement. 'They [Surrealists] are the most advanced group of people,' an excited

9.1 Joan Miró, *Collage*, 1929.
Tar paper, Conté crayon, graphite, flocked paper, wire and fabric on paperboard, 74.4 × 73.7 × 7 cm. Centre Pompidou, Paris

9.2 Pablo Picasso, *Guitar*, 1926.
Canvas, nails, string and knitting needle on painted wood, 130 × 97 cm. Musée Picasso, Paris

Giacometti wrote to his parents the following year; 'they are so keen on my works that they have given life to a new movement, and some of them [now] spend their time making objects.'[5] The Surrealists were keen indeed. Man Ray was despatched to photograph a bare-breasted woman holding another of Giacometti's works, a piece of weaponised carved wood, undeniably phallic, titled *Disagreeable Object*, that would become an icon of the growing Surrealist interest in object-fetishism and erotic desire (**fig. 9.5**). By December 1931 Giacometti was able to include both *Boule suspendue* and *Disagreeable Object* in a playful sketch of some possible and actual sculptures: they were duly published in Breton's newly launched magazine *Le Surréalisme au Service de la Révolution* (*Surrealism in the Service of the Revolution*, or *SASDLR*), by then a central discussion forum for Surrealism's evident new interest in the world of things. While some of Giacometti's 'mobile and mute' objects, as he called these projects, are eroticised, others are menacing and insectoid, creatures either caged or squirming along the floor (**fig. 9.6**). Physical things were becoming the ciphers of actual thought. Leiris had already commented that Giacometti's objects were, 'as with fetishes that are idolised, extremely alive (true fetishes being those that resemble us, the objectified form of our desire)'.[6]

The third participant in the Galerie Loeb show, Hans Arp, like the true Dada that he was, had remained loosely affiliated to both abstractionist and Surrealist factions. He had made wood-relief quasi-paintings throughout the 1920s that straddled the distinction between two- and three-dimensional art: already painting-objects that had their own kind of life (see fig. 6.9). The earliest ones had pre-dated Surrealism as a movement; and now, by the end of the 1920s, he was tired of Surrealist theorising and in the process of changing his practice in a manner that others of his generation would follow. 'In 1930,' he reminisced later, 'I went back to the activity which the Germans so eloquently called *Hauerei* [hewing]. I engaged in sculpture and modelled in plaster.' The result was a series of works he called *Concrétions* (*Concretions*) that took on a highly organic form – irregular volumes that flowed into one another as if in the process of an unfolding development. It should be added that Arp's term '*concrétion*' was very different from van Doesburg's '*concret*'. Concretion – however clumsy in English – Arp described as a 'condensing, hardening, thickening, growing together ... the solidifying of stone, plant, animal and man'; at the same time as it must appear like a process belonging to nature itself. Notwithstanding that the art object cannot literally move, 'concretion is something that has grown'.[7] And yet 'we do not want to copy nature', he said: 'We want to produce like a plant produces fruit ... directly and not by way of any intermediary.'[8] Arp's *Concrétions* were an attempt to enliven matter – bring matter to life – by means of the artist's own manipulations of actual matter and form (**fig. 9.7**).

9.3 (*opposite*) Joan Miró, *Man and Woman*, 1931. Oil on wood, chain and metal, 34 × 18 × 5.5 cm. Centre Pompidou, Paris

9.4 (*above*) Alberto Giacometti, *Boule suspendue* (*Suspended Ball*), 1930–31. Plaster, painted metal and string, 60.6 × 35.6 × 36.1. Fondation Giacometti, Paris

To some, Arp's new works had the effect of setting a precedent in the use of natural curvatures – those of the form patterns of nature that were contrary to the technical shapes of Dutch De Stijl or Russian Constructivism. In Poland, notably, several of those who had practised Unism in the late 1920s now turned towards the rhythms of human and natural movement as a basis for painting as well as sculptural art. Katarzyna Kobro and her husband Władysław Strzemiński both abandoned straight-line geometry in the early 1930s in order to nourish the look and facture of their respective arts. Kobro bent tin or steel into cursive twists and shapes in one idiom, and in another returned to the moving female as exemplary of dynamic human form (**fig. 9.8**). She refused any identification with Surrealism, however. Still wedded to the principles of utility and efficiency in sculpture, she wanted plastic form 'to become at the same time a blueprint for the organisation of the human psyche and its activities', not a narcotic against life's imperfections, 'a mere ornamentation' conveyed by what she derided as 'the entangled, freakish line in Surrealism'.[9]

Whether the work of the English sculptors Barbara Hepworth and Henry Moore can be described as Surrealist is also moot. For both, the work of shaping durable material by hand – direct carving in stone or wood – had become an expression of a form-giving attitude based in nature. A motif of nurturing motherhood had become important to Hepworth in the later 1920s, and a reclining earth female had begun to dominate the work of her friend and contemporary Moore. A small number of Moore's works from the

9.5 Model holding Giacometti's *Disagreeable Object* (1931), photographed by Man Ray, 1931. Fondation Giacometti, Paris

9.6 Alberto Giacometti, project sketches from 'Objets mobiles et muets (Mobile and mute objects)', *SASDLR* no. 3, December 1931, p. 18

9.7 (*top*) Hans Arp, *Three Disagreeable Objects on a Face*, 1930. Plaster, 4 parts, 19 × 37 × 29.5 × 19 cm. Museum Jorn, Silkeborg, Denmark

9.8 (*bottom*) Katarzyna Kobro, *Spatial Composition 9*, 1933. Painted metal, 15.5 × 35 × 19 cm. Muzeum Sztuki, Łódź

early 1930s followed Arp's and Picasso's turn towards biology – but at a safe distance, for instance in his *Composition* of 1931 that contained suggestions of hands, a breast, a head, feet, all in anatomical disarray (**fig. 9.9**). But was the English sculpture Surrealist? Perhaps the Surrealist spirit suggested to Moore the motif of piercing a hole or cavity in a sculpture, to temporalise the sculptural object as well as evoke the random pressures in matter that occur over aeons of geological time. For all that, it was seldom living biology, rather stones, fossils and animal bones that played the major part in his thinking in this decade – hardly the anguished body or the mysterious organism that counted elsewhere in Surrealist art.

What, then, could Surrealist sculpture be? The best answer comes from artists who were not dogmatically Surrealist yet whose occasional affiliations with the movement were welcomed by those who were. The cephalopodic style that Picasso had adopted in paintings such as *The Painter and His Model* of 1927 (see fig. 6.6), or his phallic-body drawings of Marie-Thérèse of the same summer, are one kind of answer, while the sculpted design of the *Nude Standing by the Sea* of 1929, with its pyramidal neck and miniscule ball for a head, is another (**fig. 9.10**). They are both related to a commission for a monument to Apollinaire to mark the ten-year anniversary of the poet's death, in November 1928. He had made two maquettes for a modest-sized sculpture in clay that looked like a self-fellating frog with female attributes, but they had shocked the commissioners, who rejected them (**fig. 9. 11**). Yet weren't all these experiments in some sense Surrealist work?

The answer is a qualified 'no'. Yet what is certain is that the practicalities of sculpture now fascinated Picasso. In Paris in the autumn of 1928 he had begun to learn welding techniques at the studio of the Spanish sculptor Julio González, and had made a single three-legged structure called *Head*, as well as a set of technically simple metal-rod sculptures that might, he thought, be possible solutions to the Apollinaire project. But there now began a characteristic double manoeuvre on Picasso's part which was to have dramatic results in sculpture, whether Surrealist or not. Acquiring the spacious Château de Boisgeloup in Normandy in June 1930, he produced a vast number of graphic studies of the human head (predominantly Marie-Thérèse) together

9.9 (*above*) Henry Moore, *Composition*, 1931. Blue Hornton Stone, 43.8 cm high. The Henry Moore Foundation

9.10 (*opposite*) Pablo Picasso, *Nude Standing by the Sea*, 1929. Oil on canvas, 129.9 × 96.8 cm. Metropolitan Museum of Art, New York

with plaster sculptures in the round that somehow fuse together female curves and swellings with a barely coded reference to the male penis (**fig. 9.12**). It was the start of an intense period of sculptural thought in clay, plaster, wood, metal and graphic media that dazzled the Surrealists without being in any programmatic way 'sur-real'. On the contrary, 'resemblance is what I am after', Picasso told a journalist later, 'a resemblance deeper and more real than the real – that [for me] is what constitutes the sur-real'.[10]

Picasso had touched upon an interesting problem, that 'sculpture' for the Surrealist literary fraternity had never really been a category at all. Recall that in Breton's 1924 *Manifesto of Surrealism* it had not been mentioned at all. At the end of the decade Giacometti had been quick to remark, apropos the Surrealist writers who admired his *Boule suspendue*, 'obviously none of them is a sculptor'.[11] Yet in another text of 1924 Breton had mentioned an ambition of his own,

> to fabricate, in so far as possible, certain objects which one approaches only in dreams and which seem no more useful than enjoyable ... I would like to put into circulation objects of this kind, which appear eminently problematical and intriguing ... Will poetic creation soon be called upon to take on this tangible character, to displace so singularly the limits of the so-called real?[12]

9.11 (*above, left*) Pablo Picasso, *Metamorphosis II*, 1928. Painted plaster, 24 × 18 × 11 cm. Musée Picasso, Paris

9.12 (*above, right*) Pablo Picasso, *Bust of a Woman*, 1931. Plaster version, 78 × 46 × 48 cm. Private collection

9.13 (*opposite*) Yves Tanguy, project sketch from 'Poids et couleurs (Weights and Colours)', *SASDLR* no. 3, December 1931, p. 27

Intriguing objects were one thing, it seemed, sculpture another. Certainly there was a tension between 'objects' made poetically and sculpture made of particular stuff. For instance, while Yves Tanguy's paintings imagined creatures floating in a remote aquatic or desert environment, imagining Surrealist objects that had equal power proved more difficult – and less convincing in the result. In a set of sketches that Tanguy published in *SASDLR* in 1931 he imagines some recondite objects made of chalk, fluff, celluloid, pearl – and in the present case a wobbly shape weighted with lead, a mercury ball and a plaster finger painted black – even though none of them was likely to be made (**fig. 9.13**). Their potency, rather, would have to be imagined. In Giacometti's case the difficulty was related: that of reconciling the tasks of 'sculpture' with the Surrealist demand for fantastic meanings. More especially, he now sought to embody in the object some semblance of human, at least anthropomorphic, presence. A very curious work known as *Cube* of 1933 is on the one hand a geometrically complex volume – at any rate, not a cube – that could impose itself upon a gallery setting as something disturbing and somewhat alive; yet on its base plane, hence invisible, was an outline of a human head (**fig. 9.14**).[13] By mid-decade Giacometti seemed to know that he had reached an impasse within Surrealism. Breton's inner circle disapproved of his apparent change of direction, and Giacometti was expelled from the movement in February 1935. Much later, he was heard to declare – unjustly, it seems now – that his work of the Surrealist period had been 'just masturbation'.[14]

Salvador Dalí, evidently not a sculptor, rode the interval between materiality and what Leiris had called 'the objectified form of our desire' in his own inimitable way. In one experiment he minutely analysed the properties that a Surrealist object would need. The result was *Surrealist Object Functioning Symbolically* of 1931 (**fig. 9.15**), which – importantly – he imagined could work as a kind of machine. He wrote a description of it in full:

A woman's shoe, inside which a glass of warm milk has
been placed, in the centre of a soft paste the colour of
excrement. The mechanism consists of the lowering into
the milk of a sugar lump on which there is a drawing of a
shoe, so that the dissolving of the sugar, and consequently
of the image of the shoe, may be observed. Several
accessories (pubic hairs glued to a sugar lump, an
erotic little photograph) complete the object, which is
accompanied by a box of spare sugar lumps and a special
spoon used for stirring lead pellets inside the shoe.

The object was photographed, published in *SASDLR*,
and accompanied by a statement to the effect that
sexual perversion – desire in a fetishised form – and
the poetic act are one and the same. Dalí also made
it clear that though Giacometti's *Boule suspendue*
had brilliantly indicated the way, it remained merely a
sculpture. Surrealist objects, he explained perceptively,
'depend solely on everyone's amatory imagination, and
are extra-sculptural'.[15]

In fact, the relevance of Dalí's work to the object-world of Surrealism extends much
further still. As a painter, he was now perfecting a technique that could make objects
visually coalesce or disappear. From around 1931 he had armed himself with a 'critical-
paranoiac' philosophy in which things are to be seen in terms of – or as – other things,
such as to contribute to 'the collapse of reality'. By now Dalí was proving a confident
polemicist too: his writings on his art are daringly inventive. Through what he called 'the
illusionism of the most analytically narrative and discredited academicism' in his own
painting, he claimed to be able to achieve 'new exactitudes of concrete irrationality' in his
art.[16] At the same time he was compiling a mental catalogue of objects and substances,
the majority of which could not easily be expressed in actual material things. One part of
that catalogue is occupied by food. The key here is the metaphor of 'taste', which had been
foundational in Western art for at least two centuries but in the eyes of this Surrealist had
degraded in the bourgeois period to become merely a convention of how to live – what
Dalí called a *putrefació* (putrefaction) of the moral sensibility. His instinct as a painter
was to objectify *putrefació* itself, in the form of precisely wrought images of melting
cheese or fried eggs, but more generally soft or glutinous objects including the flaccid
penis, rotting flesh, oozing facial pores, impossibly extended buttocks and dangerously
swollen hands. Nor was he alone in being interested in the sensations of revulsion or
disgust. Encouraged by a Spanish translation of a 1929 book by an Austrian philosopher
on the subject, he set out to uncover 'the objective laws applicable scientifically in fields
hitherto regarded as vague, fluctuating and capricious'.[17] A deployment of swarming
insects, rotting flesh and illicit intrusions into body-space provide a central motif of his
and Luis Buñuel's films *Un Chien Andalou* (1929) and *L'Âge d'Or* (1930), while for Dalí as
a painter substances more generally now assumed moral characteristics that could be
startling in their potency, in their transformative appeal. What he termed the *epoc de mou*
(epoch of the soft) had arrived, a metaphor for the prevailing moral and philosophical

9.14 (*opposite*) Alberto Giacometti, *Cube*, 1933. Bronze, 95 × 54 × 59 cm. Kunsthaus, Zurich

9.15 (*above*) Salvador Dalí, *Surrealist Object Functioning Symbolically*, 1931 (replica 1973). Wood, shoe, cardboard, fabric, hair, marble, glass, candlewax, brass, lead, gold thread and gelatin silver print on fibre-based paper, 48.7 × 28 × 10.2 cm. The Art Institute of Chicago

confusion. In a major text of 1935, *The Conquest of the Irrational*, he refers to 'the soft, extravagant and solitary paranoiac-critical Camembert' of Einsteinian space-time – seemingly an image of moral relativity. On one level claiming to relish the confusion, Dalí nevertheless advises caution with a diet consisting solely of cheese and the 'fine, intoxicating and dialectical grape of ... the imagination's caviar'. 'Don't believe it,' he concludes. 'Behind these two superfine simulacra of the imponderable hides, in better and better health from day to day, the well-known, sanguinary and irrational grilled cutlet that is going to eat us all.'[18] It sounded like a warning of a greater danger to come.

By the mid-1930s the mood in French Surrealist circles was quickly changing once more. On one level, the collapse of *SASDLR* in May 1933 and the transfer of Surrealist discussion to the journal *Cahiers d'Art* and to a lavish new publication titled *Minotaure* helped convert Surrealism from a small Parisian coterie into an international phenomenon. On another, those printed publications helped distribute ideas on the relation of sculpture to photography. For aside from Dalí's interests in the Zeiss lens, photographed objects generally could now be rendered in various modes of Surrealist *dépaysement*, or disorientation. The available techniques were by now plentiful: objects could be disoriented by oblique lighting, enlargement, repetition, perspectival distortion, contextual resituation and more. Brassaï, for instance, published in *Minotaure* in 1933 a series of photographs of insignificant objects such as a bus ticket, a bread roll, a squeeze of toothpaste, and presented them as 'involuntary sculptures' above captions by Dalí.[19]

In the Czech capital Prague, where Surrealism had already begun to take hold, the use of photography to create new objects developed in other ways. The young theorist Karel Teige had speculated about 'photo-sculpture' as early as 1922 – he had had May Ray in mind – in a search for what he called 'the hidden irrationality overlooked by the scientific system and therefore not as yet sublimated'. He called his new orientation 'Poetism', promising that it would be 'nonchalant, exuberant,

9.16 Karel Teige, *Collage no. 344*, 1948. Collage, 28.1 × 22.6 cm. Czech Museum of Literature, Prague

fantastic, playful, non-heroic and erotic' – it was that last quality especially that turned out to distinguish the Czech Republic's contribution to the Surrealist field.[20] By the 1930s photo-sculpture there was becoming a disturbingly powerful force. With Breton's *Second Manifesto* published in translation into Czech in 1930, and with the crises in Germany and Russia mounting, artists could think of the eroticised photo-object as having an emancipatory mission. Teige's colleague Jindřich Štyrský became adept at presenting sexual tumescence as if it were a waking state in a series titled *Emily Comes to Me in a Dream* of 1933. In March 1934 the Group of Surrealists of Czechoslovakia issued its own manifesto. The following year Breton and Éluard made a visit to Prague, where Breton read his lecture 'The Surrealist Situation of the Object'. Between the end of 1935 and the end of his career in the 1950s, Teige made a series of some 374 small photo-sculptures with the help of tricks and devices readily available in the medium of collage: he might isolate the curvaceous parts of the female body such as breast, belly or thigh, sometimes add photo-fragments of mechanical gadgets and surfaces, and provide a landscape reference as a context, producing new settings for the human in which life and libido seemed to merge (**fig. 9.16**). In the eyes of the Czech Surrealists, the cultivation of Eros would 'cultivate, harmonise and socialise' those vital human faculties that were vegetating, or worse.[21]

In Paris, with Surrealism's *succès de scandale* spreading internationally and with the arrival in the city of artists from the United States, South America, Britain, Spain and elsewhere, pressure for new and inclusive Surrealist exhibitions was mounting. A step in that enlargement came in May 1936 in the form of a sizeable *Exhibition of Surrealist Objects* at the Paris home of a well-regarded expert in 'primitive' art, Charles Ratton. This exhibition lasted no more than a week, yet it gained a place in the annals of Surrealism thanks to the sheer variety of work it contained. At least four types of object were on show. In one category, an object was diverted from its usual function by being given a new label or name – in essence the Duchampian ready-made. In the second, an ordinary object might be altered in some way or 'improved' by damage. In the third were objects that were inherently curious, especially if photographed Surrealistically. In the fourth were objects whose creation out of disparate elements gave rise to 'perturbation and distortion' relative to normative practical life.[22] Contributions by the regular Surrealists included Miró's *Object*, comprising a stuffed parrot, a doll's paper shoe, a derby hat, a celluloid fish and an engraved map; a *Mobile Object* by Max Ernst; Marcel Jean's *Spectre of the Gardenia*; an *Aphrodisiac Jacket* by Dalí; Duchamp's *Bagarre d'Austerlitz*; an atypical work, *Mutilé et apatride* (*Maimed and Stateless*) by Hans Arp; and Tanguy's *From the Other Side of the Bridge*. Relative newcomers to the field included Gala Dalí, Ángel Ferrant, Jacqueline Breton, the artist-poet Georges Hugnet, and Claude Cahun, who contributed a miniaturised ensemble in a bell jar. Objects by Wolfgang Paalen from Austria, Roland Penrose and Stanley Hayter from England, Óscar Domínguez from Tenerife, E. L. T. Mesens from Belgium, Alexander Calder from the United States and Méret Oppenheim from Switzerland via Berlin demonstrated the internationalism of Surrealism's new-found appeal. Oppenheim, who had been a student of Jungian thought before she met Breton's group in Paris in 1932, exhibited her notorious *Le Déjeuner en fourrure* (*Luncheon in Fur*) that cleverly merged the purely geometrical swirl pattern of fur (the Jungian motif) with the *frisson* generated by interrupting commonplace domestic crockery with natural-looking growth (**fig. 9.17**). Oppenheim, or rather her Surrealist object, became a celebrity.

Tragically, her new status as a remarkable artist troubled her self-identity and helped precipitate a depression that lasted for nearly twenty years.[23]

The third Galerie Ratton category, objects and substances given a new appearance through photography – is worthy of particular comment. As an eyewitness, the artist Marcel Jean describes agates and crystals, carnivorous plants, Transylvanian stibnite, limonite, a lump of bismuth, and a stick of calcite from the Musée de l'Histoire Naturelle. He tells of items such as fetishes, a shellfish-encrusted book, a star-shaped biscuit signed 'Raymond Roussel' (a poet and novelist much admired by the Surrealists for his expertise in word games), as well as various Eskimo, Hopi Indian, Réunion and Oceanic artefacts, displayed for the revelations they seemed to promise to hidebound Western patterns of thought – all the more so once they were rendered photographically in a number of *Cahiers d'Art*. An example was a group of mathematical objects recently rescued from a Parisian mathematics institute and reckoned among the most Surrealistic exhibits of all. Presented with their technical mathematical descriptions intact, these models of complex curvatures demonstrated the strange poetry existing within the most rigorously rational form. In Man Ray's memorable photographs of them for *Cahiers d'Art*, with their perspectives pulled out of true and their lighting adjusted, it was as if the rational universe was one of spirits and presences too (**fig. 9.18**). Breton in his commentary on the show went further, citing both Hegel and the paradoxes of post-Euclidean mathematics in order to validate Surrealist transcendence of the distinction between the irrational and the real. He may or may not have been speaking for the majority of those exhibiting in claiming that such 'dream-engendered objects represent pure desire in concrete form'.[24] Dalí put the matter in his own inimitable way. 'If the truth be told,' he quietly said, 'no one cared less about geometry than Plato did … he was really the Dame aux Camélias [i.e. tragic prostitute] of Mediterranean thought … who without realising it inaugurated brilliantly the first great official brothel of aesthetics.'[25]

The Charles Ratton show was merely one symptom of Surrealism's wider international career. By the spring of 1936 Surrealist groups had been formed in Belgium,

9.17 (*above*) Méret Oppenheim, *Le Déjeuner en fourrure* (*Lunch in Fur*), 1936. Fur-covered cup, saucer and spoon, cup 10.9 cm diameter, saucer 23.7 cm diameter, spoon 20.2 cm long; overall height 7.3 cm. Museum of Modern Art, New York

9.18 (*opposite, left*) Man Ray, *Surface reglée* (*Rule-governed surface*), 1936. *Cahiers d'Art* nos 1–2, 1936. Collection Jean-Claude Vrain

9.19 (*opposite, right*) Eileen Agar, *Angel of Anarchy*, 1936–40. Plaster, fabric, shells, beads, diamanté stones, 57 × 46 × 31.7 cm. Tate Gallery, London

England, Spain, Yugoslavia, Denmark and Japan, in addition to the Czech Republic. Another was the *International Exhibition of Surrealism* in London, held in June 1936, which was followed by the *Exposition Internationale de Surréalisme* in Paris in January 1938. In all of these later Surrealist groupings the number of women participants is remarkable, as is their feeling for the mysterious life of objects, found or adjusted objects in particular.[26] A notable instance is the young Eileen Agar, a protegée of Herbert Read and Roland Penrose for the London exhibition in 1936. She had recently, in partnership with Paul Nash, become a devotee of beachcombing on the south coast of England, picking up barnacled objects, stones and driftwood in her search for the buried marvels of the sea. Agar was never an obedient Surrealist, of course. An object titled *Angel of Anarchy* was lost in transport in 1937 but redone later in the version we now have (**fig 9.19**). We see a gender-fluid bust, decorated with bark, beads, diamante stones and feathers, then blindfolded with Chinese silk, as if a symbol of the uncertainties and instabilities of the decade. For the time being, Paris would retain its place at the centre of Surrealist activity as still younger artists arrived to join the fray.[27] But political events were moving fast. To name but one calamity: in July 1936 a Civil War had erupted in Spain. A countdown to further crises had already begun.

Battles over 'Abstract' Art

The public success of Surrealism in the late 1920s created difficulties for those who, at the same time, wished to lay the foundations of a rational, systematic art, one free of the tangles of the inner life but devoted instead to universalism and objectivity. In Paris, for example, the reception accorded to De Stijl was still unfavourable. When a group comprising van Doesburg, Mondrian, Vilmos Huszár, César Domela and Friedrich Vordemberge-Gildewart showed work in the city at the end of 1925, they had faced the accusation that their work was emotionally disengaged, that it involved 'suppressing all natural and human meanings'. Such Neo-Plastic work, the critic Christian Zervos said, 'reveals a total disdain for images born of sensuous passion for life'.[1] Van Doesburg had not been deterred, however, throwing himself into a project for the redecoration of the Aubette dance hall in Strasbourg with Hans and Sophie Taeuber-Arp. It proved ruinous financially, but that had not altered his ambitions to secure altogether new principles for art and architecture.

The statements issued by van Doesburg's Art Concret group in 1930 had made forthright claims against the Surrealists. Among his colleagues in that endeavour, it was the painter Jean Hélion whose methods perhaps came closest to van Doesburg's own (**fig. 10.1**). Hélion had abandoned his earlier figurative painting to experiment with the combinatorial possibilities of simple elements (here yellow squares, black rectangles) as well as simple oppositions (empty against full, dark against light, closed against open). The target for all the Art Concret signatories had been 'the Baroque' – a byword for 'corruptions' such as 'Fauvism, animalism, sensualism, sentimentality, and that super-Baroque testimony of weakness, phantasy'. The language was confrontational. 'We are not interested in providing "Luna-Park" sensations,' said one Art Concret statement, 'nor sadistic or sexual attractions designed to tempt a snobbish and surfeited bourgeoisie.' In the new art, mathematics would reign supreme. 'Everything is measurable, even spirit … we are painters who think and measure …' Says another, 'unlike pastry-cooks who do things intuitively … we use mathematical data, whether Euclidean or not'. 'Cultural value is bestowed by mathematical, or rather arithmetical control …' Painting must be done 'by the intellect'; and so on. 'The method leading to universal form is based on calculations of measure and number': this from *De Stijl*'s final issue of January 1932.[2]

It was not only Breton's Surrealist affiliates who objected to the mathematical turn. The *Documents* writers who supported Arp, Miró, Masson and Picasso from an ethnographical or phenomenological standpoint took exception too. For *Documents*,

the defeat of individualism would come not from measurement but from a determined
inversion of all humanistic and Enlightenment values in whatever form they occurred.
Georges Bataille's accusation that 'the whole of philosophy has no other purpose than
... to give a frock-coat to what is, a mathematical frock-coat' was just another metaphor
crafted to mock the aspirations of Enlightenment rationality and cast opprobrium
on artworks based on geometry and arithmetic. Artists were mathematical amateurs,
Carl Einstein claimed in responding to a 1929 Zurich exhibition titled *Abstrakte und
Surrealistische Malerei und Plastik* (*Abstract and Surrealist Painting and Sculpture*) –
an ambitious attempt by the curator Wilhelm Wartmann to reconcile Surrealism and
geometry and perhaps even synthesise them. The geometrical works were standardised
and hygienic, 'empty cocktails of the absolute'. On the contrary, Einstein appealed to a
new generation 'to revive the psychogram and the ideographic curve' in the manner of

10.1 Jean Hélion, *Complex Tensions*, 1930. Oil on
canvas, 90 × 89 cm. Galerie Louis Carré, Paris

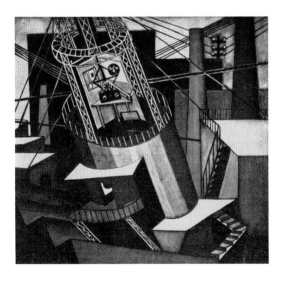

such pioneers as André Masson and Joan Miró.[3] In any case, he added, even professional mathematicians have renounced total certainty. Not only an intangible notion like infinity was tainted (and good riddance, given its religious heritage), but the laws of causality were suspect too. In Einstein's support no less a figure than Hans Reichenbach, a pioneer of probabilistic mathematics shortly to be active in Berlin and Vienna with the Logical Positivists, supplied a statement to *Documents* urging that nature can no longer be deterministically known, even in principle. Scientific prediction, Reichenbach says in his piece, 'should rather be compared to an endless game of dice'.[4]

In fact the antagonism between rationalism and Surrealism was only just beginning, and the conflict could take many different forms. It has never been easy to tell, of course, whether artists who appealed to mathematical precision in their work were proposing analogies; whether terms such as 'fourth dimension' or 'infinity' were metaphors or facts, nor whether the laws of number were being used with the necessary epistemological finesse. Yet those artists could always refer to operations of recursion and repeatability that had been used to good effect in art before. The Constructivist Rodchenko had used them in his *Equal Form* sculptures of 1921–2. Lisitski, Klee and Georges Vantongerloo had all toyed with geometry and mathematics during the 1920s; not to mention van Doesburg's own efforts to animate geometry dialectically in the later part of that decade.[5]

Several organisations flourished in Paris wishing to cleave to a rationalist line. In early 1929 a group called Cercle et Carré (Circle and Square) had coalesced under the leadership of the Uruguayan artist Joaquín Torres-García and the Belgian painter and poet Michel Seuphor, devoting itself to the defence of efficient and humanistic art and architecture conducted in a spirit of internationalism – yet in a variety of non-figurative styles. Cercle et Carré had attracted Kandinski, Mondrian, Le Corbusier, Dadas like Arp and Schwitters, the Purist Amédée Ozenfant, the Futurist Luigi Russolo and others for whom artistic community in itself had begun to take on importance. Yet Cercle et Carré was short-lived. Its sole exhibition, held at the Galerie 23 in the rue La Boétie in April 1930, featured works by some forty-five artists of whom, nevertheless, a significant number were women. Vera

10.2 Vera Idelson, *Design for Ruggero Vasari's play Machine-Anxiety*, 1925. *Der Sturm*, vol. 16, no. 1, 1925. Marquand Library of Art and Archaeology, Princeton University

Idelson, to take an example, was a stage designer and painter whose work had included remarkable designs for Ruggero Vasari's play *L'Angoisse des machines* (*Machine-Anxiety*), performed in Paris in 1927 – itself a bitter satire on the world of mechanisation and dehumanisation in the electronic and industrial age (**fig. 10.2**).[6] In fact Cercle et Carré did not attract much favourable attention at the time. 'Your journal is truly appalling', an irate van Doesburg wrote to Seuphor immediately, 'without any basis, documentation or direction'. Reviews of the group's exhibition were mostly negative. It was spurned by *Documents*, for example. Carl Einstein mocked 'those pedants of the circle and the square [who] obstruct all inventiveness … The know-alls must give up their fetish of unification and place some limits on their so-called laws'.[7] Cercle et Carré's stylistic and formal diversity was probably its downfall, and in the autumn of 1930 it was disbanded.

Yet rationality and internationalism remained keenly felt objectives in those increasingly turbulent times. Surrealism having burst onto the scene in France with ambitions to forge political links with the politics of the Comintern (Breton's own position in the 1920s), rationalists could now point to the crisis in Soviet Russia that was revealing the corruptions rampant in that troubled regime. They could claim that Surrealism had little to offer the fast-expanding European cities and the needs of their inhabitants for modernity in architecture and design – for rational ambition in all the main departments of life. Meanwhile, ideological fault lines had become visible in many European nations following the world economic crisis of 1929–30. Versions of nationalist isolationism were emerging everywhere. Germany, Italy and Spain as well as Soviet Russia were all turning away from international collaboration. Even in France, the home of experiment in the visual arts, right-wing and pro-fascist groups were wreaking violence on exhibitions of which they did not approve.[8] Against such a background, strength in numbers must have been a motive for the formation of the largest interwar group devoted to non-figuration, moreover one that proved to have a genuinely international appeal.

Van Doesburg had the idea first. 'It is absolutely impossible to arrange exhibitions or publications by limiting the participants too strictly,' he had written to his friend the Czech painter František Kupka in February 1931. 'We must unite on a larger basis …' His proposal was to invite artists to join a new group 'even if their tendency is not our own'.[9] Tragically, he died of a long-standing asthma-related illness, aged forty-seven, the following month; but undeterred, his friends and supporters held a meeting, in fact in his studio, which led to the launching of a new organisation the following year called Abstraction-Création. Guided initially by a committee comprising Arp, Gleizes, Hélion, Herbin, Kupka, Léon Tutundjian, Georges Valmier and Vantongerloo, Abstraction-Création used a secondary title, 'Art Non-Figuratif', to signify a more focused commitment to 'pure plasticising' in art while remaining free of such anecdote and literary narrative as the Surrealists continued to propose.

Abstraction-Création might be described as a partial success. At its peak it could boast over four hundred members under the rubric of a 'non-figuration' capable of accommodating two related impulses: 'the progressive abstraction of forms from nature' as well as non-figuration 'achieved purely via geometry, or by the exclusive use of elements commonly called abstract such as circles, planes, bars, lines, etc.'.[10] In the second of its five annual *cahiers* it took the further step of supporting artists

at a time when 'free thought is being fiercely contested, in so many ways and on all levels ... everywhere', as well as upholding the principle that in matters of art 'consideration of race, ideology or nationality is odious'. To its credit, Abstraction-Création hoped to respond to 'the cultural demands of the era' – referring to the beginnings of state control of the arts in Germany and the conservative turn in artistic policy in the USSR.[11] Abstraction-Création also vowed to resist the pressures of unprincipled commercialisation – the wild fluctuations of the art market – in the democracies.

Notwithstanding its early success, Abstraction-Création proved large and unwieldy, perhaps precisely because it was unwilling to follow a single practical or theoretical path. 'Abstraction' as an idea had been poorly articulated at the start, in trying to embrace both the simplification of nature *and* pure geometry. For practical reasons, some artists who had been invited to join could not, among them Lisitski, Malevich and Tatlin. Others declined. Some who did join sailed close to Surrealism, for example Gérard Vulliamy, Kurt Seligmann or the English former Vorticist Edward Wadsworth. Others had mystical inclinations, including Auguste Herbin, Abstraction-Création's *directeur* from 1934 and a fine artist of liberal dispensation whose notable career extended far beyond the organisation's demise in 1936. Herbin viewed his paintings of the period as manifestations of pure freedom from any principle other than to advance a pacifist and optimistic humanism, while remaining responsive to intuitions of cosmic and social change. Looped, motionful shapes articulate the majority of his *non-figuratif* works of that time (**fig. 10.3**). 'Movement embraces, envelops, dominates, penetrates everything,' he wrote in the first Abstraction-Création *cahier*. 'Nothing is isolated or independent ...'[12] Herbin's career as an artist raises questions about the scope of the term 'abstraction' that still resonate today.[13]

Before leaving Paris we must review the 1930s career of a pioneer of 'abstract' art, Vasili Kandinski. Following the closure of the Bauhaus in 1933, Kandinski and his wife Nina (née Andreevskaya) moved from Berlin to Neuilly-sur-Seine in the Paris suburbs. He immediately renewed his friendship with (among others) Hans Arp and at once embarked on a new phase in his career. Now, thanks perhaps to the example of Arp's recent *Concrétions*, a rich vocabulary of squirming and embryonic forms came visibly to the fore. In *Relations* of 1934, for example, we see diminutive embryonic forms, wriggling

energetically with what seems like mutual awareness in a setting of vibrant and ceaseless change (**fig. 10.4**). Kandinski's position was interestingly uncertain. He was no longer the *enfant terrible* of modern art, as he had been at the time of the First World War – but once again in a foreign country, and not doing well commercially. Yet his work was conceptually very new. For one thing, his biology-inspired manner was not a return to representation; rather, it hinted at another principle of form. In his own words, his new paintings 'leave behind the outer skin of nature but not nature's laws'.[14] For another, he deemed the terminology of 'abstraction' to be no longer helpful. Through conversations with Arp and then with his nephew Alexandre Kojève, a Hegel scholar with a growing reputation in Paris, Kandinski now developed an understanding of 'the concrete' in art as meaning something aesthetically compelling at the same time as remaining an object or image complete in and for itself.[15] By the end of the 1930s Kandinski had altogether renounced the term 'abstract' for his work at the same time as steering clear of any association with Surrealism. In 'concrete' art, Kandinski would say in a pair of short statements of 1938–9, the artist 'frees himself from the object [and] offers

10.3 (*opposite*) Auguste Herbin, *Mouvement continu, mouvement inverse, mouvement interieur* (*Continuing movement, inverse movement, interior movement*), 1937. Oil on canvas. Musée d'Art et d'Histoire, Cholet

10.4 (*above*) Vasili Kandinski, *Relations*, 1934. Oil with sand on canvas, 89 × 116 cm. Kreeger Museum, Dumbarton Oaks

a kind of parallel with symphonic music by possessing a purely artistic content' such that 'in every truly new work of art a new world is created that has never existed'. By his paintings he wished to affirm that 'next to the already known world a new, previously unknown one is uncovered which says "Here I am!" and for which I prefer the term *concrete art*'.[16] Kandinski's period in Paris until his death in 1944 proved to be one of the high points of his career.

Beyond Paris, what some still wished to call 'abstraction' took a variety of forms. In Poland, Strzemiński's *Architectonic Compositions* had attempted to provide a rational basis for visual articulation in graphics, typography and architecture, but the experiment had reached an abrupt end around the year 1930. Katarzyna Kobro's *Spatial Compositions* sculptures, conceived as models for functional cognitive organisation in a democratically organised society, also showed signs of faltering around 1931; and we should ask why. Following the crash of the New York stock exchange in autumn 1929 the Polish economy had nosedived, with the national mood turning to one of caution verging on despair. By 1932 Poland's industrial output had fallen to half of its pre-crash level, and by 1933 one-third of the Polish workforce was unemployed.[17] With an increase in tension between Germany and Russia, and with French cultural loyalties dangerously suspended between the two, Poland's geopolitical position was complex. Some artists felt pressure to move away from Soviet solutions – Constructivism and Production art – in the direction of national affirmation and a strengthening of the national will. For others, such as Strzemiński, it was the right moment to make connections internationally – and to turn his Unist paintings from being architectonic structures to being declaratively organic works animated by rhythmic articulations, in effect fields of energy within a unitary perceptual frame (**fig. 10.5**). After 1932 he turned to the demands of some smaller-format paintings called *Seascapes* that evoke the motions of water, wind and sky by means of curvilinear line drawing. In common with Kandinski's new work, they were probably indebted to the new biological vocabulary of Hans Arp.

They were also the years when Strzemiński brought to fruition an important project that helped Poland become a centre of European attention in matters of art. With the help of the poet Jan Brzękowski in Paris, as well as Henryk Stażewski, active in Abstraction-Création, gifts of works were solicited from artists including van Doesburg,

10.5 (*above*) Władysław Strzemiński, *Unistic Composition 12*, 1932. Oil on canvas, 50 × 38 cm. Muzeum Sztuki, Łódź

10.6 (*opposite*) International Collection of Modern Art, Łódź. Installation view, 1932. Muzeum Sztuki, Łódź

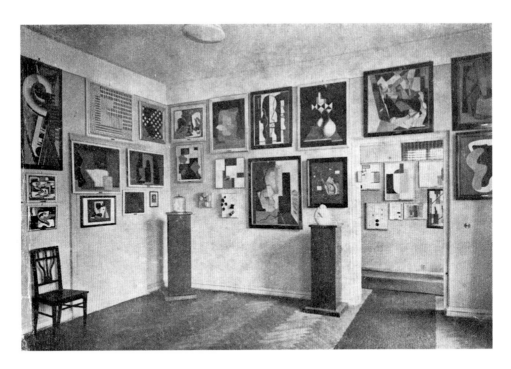

Jean Gorin, Ozenfant, Léger, Taeuber-Arp, Vantongerloo, Gleizes and Picasso, in addition to Stażewski himself and other Polish artists in Paris and elsewhere – but none of them Surrealists. Support for the venture was immediate. On its opening with the assistance of the civic authorities in Łódź in February 1931, the International Collection of Modern Art in that city became the earliest public collection devoted specifically to international modern art in Europe (**fig. 10.6**). Yet history had cruel events in store. Poland was invaded by the Nazis in September 1939 and the enterprise of *art non-figuratif* in that country was for the time being at an end.

A nation in which 'abstract' art took permanent root was Switzerland – by 1930 already secure in its reputation in graphics and design and increasingly engaged in the wider European debate about modern art. The closure of the Bauhaus in Germany in 1933, and the return to Switzerland of artists of the order of Johannes Itten, Paul Klee and Camille Graeser was part of the pattern; yet the practice there of a geometrical modus operandi from the mid-1930s was one not duplicated in any other European country. Swiss neutrality helped, and, as in the Netherlands, national forms of religious and ethical Puritanism probably played a part. Meanwhile, certain Swiss museum curators were making efforts to launch international debate about the seemingly incompatible claims of fantasy – the Surrealist paradigm – and rational-cum-geometrical principles in the search for a truly modern style. An exhibition at the Kunstmuseum in Lucerne in the spring of 1935 bore the title *Thèse-Antithèse-Synthèse* (*Thesis-Antithesis-Synthesis*) that took Purism, Constructivism and 'abstract' art as its thesis, Dada and Surrealism as its antithesis and, in common with *Abstrakte und Surrealistische Malerei und Plastik*, the Zurich show of 1929, declared its aim to be to examine the two tendencies and explore possible reconciliations between them.

In the logic applied to the experiment by the critic Anatole Jakovski, the two main tendencies stood in need of a kind of referee. 'The immemorial squares of Mondrian,' Jakovski wrote, and Miró's 'protoplasms of desire' are just the extremes and could surely be reconciled in a new art still to come.[18] The previous year he had curated a show in Paris of Swiss artists under the auspices of Abstraction-Création, comprising Hans Erni, Hans Schiess, Seligmann, Taeuber-Arp and Vulliamy, and had argued that the works of some of them, at least, constituted just such a synthetic trend.[19] Sophie Taeuber-Arp, for example, by this date already had a long pedigree in Dada, in painting, puppet-making, furniture design and interior architecture, and was represented in Paris by spare yet precise paintings whose exact yet delicate linear balances could not but evoke the performative feats of an acrobat, a dancer or a performing troupe, yet without the remorseless logic of De Stijl (**fig. 10.7**). Or take the works of Gérard Vulliamy from around this time – which presented agonised dancing rhythms in wave forms of a seemingly microbiological kind (**fig. 10.8**). Both showed evidence of how geometry and fantasy could be combined.

Yet Swiss artists enamoured of geometry alone were on the point of developing their methods much further. The young artist and designer Max Bill had been a Bauhaus student under Josef Albers and Paul Klee from 1927 to 1929, and in the early 1930s studied De Stijl, especially van Doesburg's treatment of rational yet ambitiously temporalised form. A single phrase from the latter's 'Towards Elementary Plastic Expression' of 1923 – his reference to an artist's need 'to revise his means, to establish laws creating a system' – prompted Bill to experiment with systems that first established elemental rules, then built a kind of dynamic structure upon them. In a serial work *Fifteen Variations on a Single Theme* of 1935–8, Bill would explore the arrangements that can be derived from an equilateral triangle governed by a rule requiring any n-sided figure to provide a single side for a new figure of (n + 1) sides – beginning from 3 and working upwards. In such a 'system', applicable to curved as well as straight-line constructions, each interval, relationship and sequence, given certain entry and exit conditions, could be reckoned as accountable and verifiable, and in that sense 'true' (**fig. 10.9**). The new systematic method first came to light in an exhibition *Zeitprobleme in der Schweizer Malerei und Plastik* (*Contemporary Problems in Swiss Painting and Sculpture*) at the Zurich Kunsthaus in the summer of 1936. Presenting no fewer than forty-one artists of all styles and manners, its purpose was to show the vitality of Swiss modernism as an already highly creative field, to position Zurich in rivalry to Paris as a centre of artistic power, and to propose clarity and democracy as guiding aims for art in the face of mounting European totalitarianism and a possible slide towards war. Bill's

written contribution was a text titled 'Konkrete Gestaltung' ('Concrete Forming'), which proved to be a breakthrough in the search for an organised and sequential method by which an artwork could be formed. '*Konkrete*' works, according to Bill, were constructed of colour, space, light and movement 'according to a technique and to laws of their own in a clear and specific way ... to become objects, visual and intellectual tools'.[20]

Bill's thinking here lacks a precise formula, but it proved flexible enough to hint at the range of possibilities open to artists for whom 'Konkretion' as a concept could be systematic as well as generative. His newly formed friendship with the Belgian sculptor and painter Georges Vantongerloo demonstrates how. Having been instrumental in the founding of De Stijl, Vantongerloo had been in at the start of both Cercle et Carré and Abstraction-Création. For much of the late 1920s and 1930s he strove (as no other modern artist did) to use Euclidean geometry – and later algebra – as tools to help him shape the character and presentation of his work. Some of Vantongerloo's structures even had algebraical titles. In practice that extreme position did not work, and with the help of further dialogue with Max Bill he switched, around 1938, to a language of less regular curvatures that gave him freedom from numerically based systems as well as access to some fabulous new simplicities of plastic form, some of them suggestive of cosmic patterns, radar, microscopic traces and the like (**fig. 10.10**). 'I am free,' he would soon be able to say; 'I have rights and no duty ... I respect everyone without distinction, and I try to be and remain myself.' As to the use of these sentiments, 'one need only open one's eyes and remain simple to perceive their truth'.[21] For Vantongerloo, Konkretion could in fact transcend the divisions between 'rational' and 'irrational' art,

10.7 (*opposite*) Sophie Taeuber-Arp, *Equilibrium*, 1932. Oil on canvas, 41.7 × 33.5 cm. Stiftung Arp e.V., Berlin/Rolandswerth

10.8 (*above*) Gérard Vulliamy, *Phantasmagoria*, 1933. Oil on canvas, 89 × 146 cm. Private collection

10.9 (*above*) Max Bill, *Fifteen Variations on a Single Theme*, 1935–8. Lithograph, 16 parts, each 32 × 30 cm. Haus Konstruktiv, Zurich

10.10 (*opposite*) Georges Vantongerloo, *Variante*, 1939. Oil on masonite, 52.5 × 40 cm. Institut Valencià d'Art Modern

the temperament of the artist permitting. Bill too would write in a later version of his important 'Konkrete Gestaltung' text that rationality and the organic were part and parcel of each other. Concrete form-giving, he said, 'when true to itself, is the pure expression of harmonious measure and law ... it organizes systems and *gives life to these arrangements* through the means of art'.[22]

In the later 1930s Bill's compatriot Richard Paul Lohse, a young graphic artist and designer, was also experimenting with curvilinear as well as straight-line systems, becoming committed to forms of political activism both inside and exterior to his art (**fig. 10.11**). Lohse's founding with Leo Leuppi of the organisation Allianz in 1937 played a central part in the success of Swiss modernism in the later 1930s, in the 1940s and beyond.

In England, the practice of 'abstract' art was frequently tempered by a native scepticism and the pull of national tradition. Modern art had been virtually a non-event in that country since the collapse of Vorticism in the later stages of the First World War. Few steps had been taken there beyond the imitation of either a Post-Impressionist or a Fauvist manner by artists such as Matthew Smith, Ivon Hitchens and Winifred Nicholson, and then not until the later 1920s. Only Ben Nicholson, a frequent traveller in mainland Europe, had taken seriously the principles of flattened colour and straightened line that could be learnt from seeing good Cubist paintings, as he had done in Paris just after the war. Nicholson's *1924 (first abstract painting, Chelsea)* of 1923–4 had been one such learning exercise. In it, he gives up any reference to table-top objects, even if he still holds the viewer above a table-like space, as if looking down on what appear as various textures and plane surfaces below (**fig. 10.12**).

It was not until the beginning of the 1930s that English artists began to consider their position in relation to the full gamut of French, German, Russian and Dutch art by that time considered modern. Paul Nash was a landscape painter of a dry yet affecting sensibility who had painted harrowing scenes of the Normandy trenches at the time of the First World War, after which he became a strong admirer of de Chirico's work when it was shown in London in 1928; and he saw new art at Léonce Rosenberg's gallery in Paris in 1930, after which he began to consider its implications for his own manner. Yet in a well-titled article 'Going Modern and Being British' of early 1932 Nash expressed the problem in terms of a choice, one of 'internationalism versus an indigenous culture; renovation versus conservatism; the industrial versus the pastoral; the functional versus the futile'.[23] To him they were not stark alternatives however, and he determined to try and place them in some kind of coalition. Other artists joined him; and thus it was that a group calling itself Unit One came into existence in early 1933 after a series of meetings

in London with the support of the Mayor Gallery, which in April of that year presented
a show that included Nash himself, Nicholson and others alongside works by Braque,
Léger, Herbin and Willi Baumeister as well as Arp, Ernst and Dalí.[24]

It should be mentioned here that, in contrast to galleries like the Mayor, most British
institutions were still very hesitant in the face of modern European art. The Royal
Academy of Art was stuck in an antediluvian past. The Tate Gallery, whose mission was
to collect art made after 1900, had only just reconciled itself to Post-Impressionism.
The opinions of the British public were untested and unknown. It was in this context

10.11 (*above*) Richard Paul Lohse, *Verwandlung von
gleichen Figuren* (*Transformation of Equal Figures*),
from the Portfolio *5 Constructions + 5 Compositions*,
1940. Lithograph in four colours, 32 × 30.5 cm.
Lohse Foundation, Zurich

10.12 (*opposite*) Ben Nicholson, *1924 (first abstract
painting, Chelsea)*, 1923–4. Oil on canvas, 55.4 ×
61.2 cm. Tate Gallery, London

that Nash published press articles to explain Unit One's commitment to what he called 'the contemporary spirit', first in a letter to *The Times* and then in an article in the BBC magazine *The Listener*, in which he expressed the need 'to find again some adventure in art'. More fully explained, the adventure was to be 'first the pursuit of form; the expression of structural purpose in search of beauty in formal interaction apart from representation' – this was non-figuration – yet also 'the pursuit of the soul, the attempt to trace the "psyche" in its devious flight, a psychological research on the part of the artist parallel to the experiments of the great analysts' – an approximation to Surrealism. Nash believed that if applied in combination, the two impulses offered both a stimulus to research as well as opportunities 'for expanding the strength of a national art'.[25]

The following year Unit One held their only London exhibition as a group – it then toured to six provincial cities and towns. Simultaneously the critic Herbert Read published statements by the Unit One artists in a book, together with a preface of his own in which he became in effect a spokesperson for the group as well as a staunch advocate of *both* the resources of geometry in pursuit of purity of design *and* the free imagination as it was being expressed in British Romantic poetry as well as in contemporary Surrealism.[26] The Unit One artists followed the compromise inventively. Several found

poetry in jetties or breakwaters (John Armstrong), sea-front furniture (Paul Nash) or beach landscapes (Tristram Hillier) (**fig. 10.13**). For the sculptor Henry Moore it was animal bones and ancient stones found in a field, no less than an approximately human presence, that endowed his work with an echo of the past as much as it transmitted 'the contemporary spirit'. Wadsworth and Nicholson were members of Abstraction-Création, and their exceptionalism is striking. Wadsworth retained a sense of local fish and fauna or the forms of nautical machinery (**fig. 10.14**). At the time of the *Unit One* exhibition Ben Nicholson was strongly attracted to Mondrian's attitudes and on the point of using ruler and compass to more precisely map the geometry of some newly carved shallow pictorial reliefs – as well as to radically simplify their colour to all-white. And yet, though the white reliefs that he made from 1934 are the most austerely 'abstract' works in the British modernist canon they are never given entirely to formal geometry. Rather, they betray their nature references through irregularly carved textures, variable reflective properties and what can resemble window-like circular openings onto spaces beyond. They may even be said to reflect indigenous handcraft traditions and archaic painting styles (**fig. 10.15**).[27]

To Nash himself as an artist, 'the contemporary spirit' was to be found precisely in a duality of psyche and form; in a relationship between the very old and the very new. The

10.13 (*above*) John Armstrong, *The Jetty*, 1931. Oil on canvas, 50.8 × 76.2 cm. Huddersfield Art Gallery

10.14 (*opposite, top*) Edward Wadsworth, *Dux et Comes IV*, 1932. Oil on canvas, 38.4 × 58.4 cm. Victoria and Albert Museum, London

10.15 (*opposite, bottom*) Ben Nicholson, *White Relief*, 1935. Painted wood, 101.6 × 166.4 cm. Tate Gallery, London

location of Nash's paintings was mostly southern England, on the South Downs or near the ancient Neolithic remains at Avebury and Stonehenge, where could be found geometrical rings of massive stones, earth mounds built as cemeteries, and alignments of landscape forms whose origins were unknown. In a painting titled *Equivalents for the Megaliths* Nash positions various elements from modernising architectural construction (a gridded window, a steel beam, two conspicuously unclassical columns) in a grassy field, as if on a stage. A hill fort is visible in the scenery far behind (**fig. 10.16**). The effect may be described as uncanny, even 'metaphysical' in de Chirico's sense, translating both 'structural purpose' and 'psyche' from a local context into what could pass as a national, or nationally resonant, image.[28]

The brief career of Unit One demonstrated how England's pastoral traditions, its native pragmatism and its basic scepticism about abstract thought, could be nourished, at least, by the main streams of European modern art. Yet from around 1935 that impetus began to falter and decline. The initially adventurous journal *Axis*, formed in Oxford in 1935, now became notable for its resistance to 'abstract' art and theory alike. The title of one of Nash's own statements in *Axis*, 'For, But Not With', spoke for many of his generation to the effect that they could not, as artists, do without some enduring nature references in their art – in Nash's words, 'the hard cold stone, the rasping grass, the intricate architecture of trees and waves, or the brittle sculpture of a dead leaf'. What he called 'the immaculate monotony' of Abstraction-Création's support for

10.16 Paul Nash, *Equivalents for the Megaliths*, 1935.
Oil on canvas, 45.7 × 66 cm. Tate Gallery, London

geometry had become a shared anathema.[29] Also in *Axis*, the poet and writer Geoffrey Grigson vigorously spurned any project that moved too far from the 'fullness and complexity' of observable fact. In his caustic assessment of the Unit One painters and sculptors, Wadsworth exhibited 'a simplifying and concentrating of a cold curtailed fancy', Nicholson 'an image of infinity … floating and disinfected' such as could only be redeemed by what Grigson called a 'bodying out' of form with the resources of nature. The work of Mondrian and his school 'leads to the supersession of art by an ideal death', he suggested. 'And this needs to be remembered now in England if leading English abstractionists are to turn their backsides to *Minotaure* and run off to Nowhere through the dry spaces of infinity …'[30]

Viewed in retrospect, what may be called the 'geometrical' tendency was never likely to gain hold in England while such scepticism remained in play. As if to confirm Grigson's misgivings, Surrealism arrived in England in the summer of 1936 in the form of a large *International Surrealist Exhibition*, opening in June at the New Burlington Galleries and organised by the artist and writer Roland Penrose (later to become Picasso's biographer) in collaboration with André Breton and Herbert Read. It was an exhibition in which, of course, nature references abounded; an absolute counterpart to a smaller and less sensational show titled *Abstract and Concrete* that had opened in Oxford in February of that year and then toured the country (including London) in an effort to show unity between British and European devotees of a broadly 'abstract' art. In fact, by 1936 *Axis* magazine had lost interest in either. In retrospect, the limited impact achieved by *Abstract and Concrete* can be viewed as a reminder of the relatively greater importance attached to Romantic literature in the national imagination. It is even likely that the much larger public success of the *International Surrealist Exhibition* helped turn English art at the end of the 1930s even further towards a fully romanticised vision of nature and the national past.

In one sense, that mood change was just one version of a tendency in several European nations whereby the very idea of an international modern art was viewed by many as incompatible with the gathering ideological divisions – and soon enough the likelihood of another war.

CHAPTER 11

Art and Politics in the 1930s

The 1930s mark a terrible caesura in the concept of a modern visual art. In several nations, and in the face of extremely rapid ideological and social change, narrow and self-serving political elites took control of both practice and policy in the arts. Authoritarian regimes in Soviet Russia, Germany and Italy began to constrain, ostracise and *in extremis* eliminate those artists it wished to control.

The Soviet government's Five-Year Plan for industry and agriculture, launched in April 1929, was designed to enable the nation to catch up with, and even overtake, the nations of the West. The cooperation of visual artists, writers, musicians and producers in other media was considered essential, with the result that by the end of 1929 otherwise separate art groups were thrown into competition with each other for the approval of the Bolshevik Party – which then dispensed its own judgement on whether 'socialist competition and shock-work', the attitudes deemed essential to the plan, were being achieved. In late 1930 the Narkompros chief Andrei Bubnov (Lunarcharski's successor) carried out a review. The centrist painting group OSt was required to banish a perceived 'decorativeness' in its work relative to the tasks of the Five-Year Plan. AKhR was accused of spending more time talking than producing viable work. The Oktyabr group needed to curb its 'excessive *LEF*-ism': it quickly conceded, admitting that 'left' tendencies like Constructivism were 'the greatest ideological danger to young artists', that in the struggle for socialism experts were unnecessary, that amateur art groups must be given a part to play.[1]

Such recantations were obviously made under pressure. Artists with strong ties to western Europe were especially vulnerable. Kazimir Malevich was detained by the secret police in the autumn of 1930 and imprisoned for two months on account of recent trips to Poland and Germany. As a Ukrainian national (he was born in Kiev to a Polish family) his loyalty to the Soviet state was perceived to be in doubt; and from now until around 1933 his paintings showed peasant figures, in work groups or sometimes alone, frequently faceless (and notice what appears to be a prison camp in the rear of this painting) – as if a kind of Suprematist figuration could encode both the wishes of the state as well as the goals of artistic transcendence that Malevich really stood for (**fig. 11.1**). It was a compromise that partly worked – until death in 1935 at the age of fifty-seven brought this artist's career to a premature close. We are left to speculate what Suprematism might have become if the state had not intervened.

For painters willing to heed the dangers of 'formalism', the task was to depict the alleged enthusiasms of those engaged in the Five-Year Plan. Serafima Ryangina's *Brick*

Burners of 1934 shows an all-female team operating heavy factory machinery in a persuasive documentary style (**fig. 11.2**). The viewer would be unlikely to comment, of course, either on the veracity of the image, or on the place occupied by women within a world constructed and administered entirely by men.

In the early years of the 1930s nothing was stable in Soviet policy for the arts except a growing campaign to denounce 'abstraction', 'formalism', 'Trotskiism' – such phrases were interchangeable, at best imprecise. Then, in a sudden policy reversal at the beginning of 1932, a switch to top-down organisation was announced for industry and the arts, at once revising the policy of proletarian levelling and reverting back to that reliance upon such 'experts' as the party would define. On 23 April 1932 the party's Central Committee published an edict to the effect that 'existing proletarian literature and art organisations are becoming too narrow and are hampering the serious development of artistic creation'. A decision had been taken that all 'writers and artists who support the platform of the Soviet government and who aspire to participate in socialist construction … be integrated into a single Union'.[2] As well as quelling competitive wrangling in the arts, the party now aimed to formulate a new framework for the arts with the help of slogans selectively adopted from Marxist–Leninist theory. Late-night meetings involving Stalin, Maksim Gorki and others in late 1932 and 1933 eventually led to the phrase 'Socialist Realism', under which rubric the party would guide all artists and all forms of art in a direction contrary to West European and American practices in 'modern' art. The new policy and its slogans were formally announced at the All-Union Congress of Soviet Writers in Moscow in 1934 at which Gorki, Karl Radek, Nikolai Bukharin and others launched their own tirades against 'bourgeois' writers in Europe and America, among whom James Joyce, regarded as an extreme case, was accused of weaving 'an intricate cobweb of allegories and mythological allusions, the phantasmagoria of the madhouse … a heap of dung crawling with worms, photographed by a cinema apparatus through a microscope'.[3] From 1934 until the end of the decade and beyond, Socialist Realist art would be governed by

11.1 Kazimir Malevich, *Man in a Suprematist Landscape*, 1930. Oil on canvas, 98 × 79 cm. Albertina, Vienna

a party-led rhetoric of *partiinost* (party-mindedness), *ideinost* (correct ideological content) and *narodnost* (people-ness) under the rubric that artists, writers and other producers in the arts must be 'engineers of human souls'.[4]

In the event, these maxims were not always consistently applied. The 'single Union' referred to did not in fact materialise until the end of the decade – while a body known as MOSSKh (Moscow Section of the Union of Soviet Artists) stood in as the official body for the visual arts, run by artists but under the always watchful eye of the party. Meanwhile, certain 'leftist' techniques of photography and photomontage continued to be used, most notably by Gustav Klutsis and Rodchenko, the latter of whom was employed to make a photographic record of the White Sea Canal project connecting the northern Arctic Ocean and the Baltic Sea, in which hundreds of thousands of political prisoners and other convicts were forced to build a canal that in the event proved too shallow to use. Rodchenko's tilted-camera photos, his layout and design work for the early issues of the multi-language propaganda magazine *USSR in Construction* (published from 1930 to 1941) cannot be faulted in terms of their technique; yet their concealment of the terrible work conditions and the fact that thousands died illustrates the harsh dilemmas faced by artists for whom all choices were either compromising or bad (**fig. 11.3**).

Two examples will show the distortions to which the idea of truth or realism was subjected in Soviet Russia during the 1930s. An alleged 'documentary' style was already the specialism of the painter Isaak Brodski, by no means a modern artist in the West European sense yet one who stood out for his skilful conversion of journalistic photographs – of Lenin working or making speeches, of military figures and party officials, of revolutionary events – into paintings having a kind of veracity to the fact (**fig. 11.4**). Yet such paintings surely fell far short of providing an account of the 'profound contradictions' of monopoly capitalism or the petty-bourgeoisie that Radek had urged at the Writers' Congress. In practice, the drift of party policy after 1934 supported the formulaic portrayal of forthright workers, spirited athletes and contented families, and the spread of an easily legible and patriotic style. The most celebrated case is the massive steel-plate sculpture *Worker and Collective Farm Woman* by Vera Mukhina, erected on top of the Soviet pavilion at the foot of the Trocadéro Gardens in Paris

11.2 (*above*) Serafima Ryangina, *Brick Burners*, 1934. Oil on canvas. Regional Art Gallery, Chelyabinsk

11.3 (*opposite*) Aleksandr Rodchenko, *The Baltic White Sea Canal*, 1933. Photogravure, 22.2 × 15.2 cm. Museum of Modern Art, New York

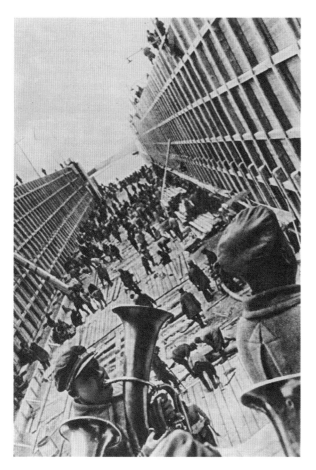

for the 1937 World's Fair (**fig. 11.5**). The striding factory worker raises a hammer in rhythm with a ballet-shoed *kolkhoznitsa* (collective farm woman), who holds aloft her sickle. However impressive in scale, the work exemplifies the bureaucratic confinement in which Soviet artistic production was by now entrapped, and from which it would take a further quarter-century to recover.

The situation in Germany bears comparison. With the declaration of a Third Reich in March 1933, followed by the consolidation of the Nazi Party in a series of rigged elections and the banning of political opposition, disagreements soon emerged about the direction that state-controlled art in Germany should follow. One version of the answer was to try and define which qualities of the Nordic (north German and Scandinavian) tradition best embodied what was now referred to as the German national 'soul'. Some members of the National Socialist hierarchy entertained an admiration for art of the recent past. Hitler himself (a former art student) is said to have held the sculpture of Ernst Barlach in high regard, while Emil Nolde's glowingly intense paintings of northern coastal communities – at prayer, at family meals, on the land – were admired by the influential Joseph Goebbels, now in charge of a new Reichsministerium für Volksaufklärung und Propaganda (Reich Ministry for People's Enlightenment and Propaganda), who viewed Expressionism and even on occasion *Neue Sachlichkeit* with favour: the latter he referred to on one occasion as 'the German art of the next decade'.[5]

On the other hand Alfred Rosenberg, author of *Der Mythus des 20. Jahrhunderts* (*The Myth of the Twentieth Century*) of 1930, had already claimed that German art and culture was that belonging to the *Volk* (people) and evolved according to its own irreducible laws without need of what he viewed as the sterile corruptions of 'modern', foreign-inspired art. German culture was that of the peasant and the artisan, he said, wholesome and warm-hearted, responsive not to the urban individual but to the rural collectivity. Meanwhile, Hermann Göring, as Prussian minister for the interior, took the position of harassing artists known to have communist sympathies and launched an intense campaign against the internationalist tendencies of the Bauhaus before ordering that institution's closure in April 1933, it having briefly relocated to Berlin. In the same month, initiated by local museum directors but supported by officials

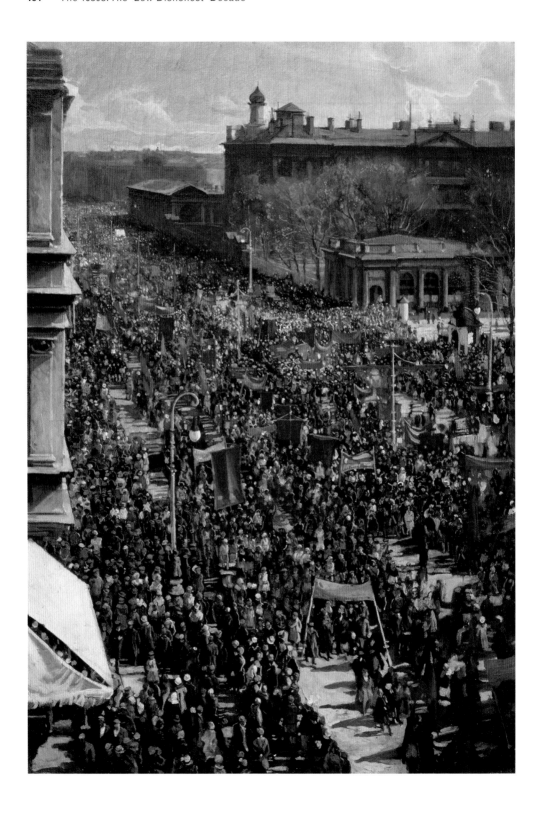

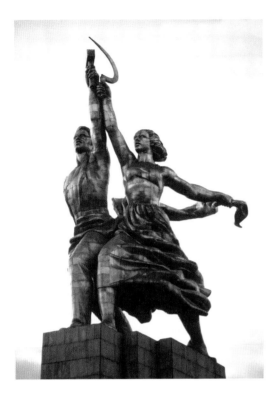

and members of Rosenberg's ideologically rabid Kampfbund für deutsche Kultur (Combat League for German Culture), a series of exhibitions was opened across the country designed to discredit internationalism and modernism in every form. They included *Kulturbolschewistische Bilder* (*Bolshevik-Culture Paintings*), opened in Mannheim; *Regierungskunst 1918–1933* (*Government Art 1918–1933*) in Karlsruhe; *Schreckenskammer* (*Chamber of Horrors*) in Nuremberg; and *Kunst, die nicht aus unserer Seele kam* (*Art That Did Not Come from Our Soul*) in Chemnitz – to mention only the earliest of a longer series that continued throughout the decade. In all of them, techniques of disparagement were adopted that included displaying works by Die Brücke, Expressionist, Dada, *Neue Sachlichkeit*, Bauhaus and assorted left-wing artists in shabby corridors and other marginal spaces, often over abusive slogans. Names of Jewish dealers and alleged purchase prices were frequently shown. An exhibition entitled *Entartete Kunst* (*Degenerate Art*) in Dresden in September 1933 set the tone for the more particular accusation that works by 'modern', mostly Expressionist artists were *entartet* – the term meaning 'malformed, substandard, unworthy, abnormal or diseased'. The artists in the show included Grosz, Erich Haeckel, Karl Hofer, Kandinski, Kirchner, Klee, Nolde and Max Pechstein.[6]

It was not long before the wider party became uncomfortable with the rift between Rosenberg's powerful Kampfbund and Goebbels' no less determined antagonism to *völkisch* culture underpinned by his sympathy for Expressionism. Their differences were deemed a stain on party unity. Goebbels, in any case never an internationalist, capitulated, and was soon leading the opposition to modern art in Germany in both its international as well as its German forms. Artists of already high repute internationally were removed from teaching positions (Beckmann and Baumeister from their posts in Frankfurt, Dix from the Dresden Academy, Paul Klee from the academy in Düsseldorf), expelled from membership of the prestigious Prussian Academy of Fine Arts (Käthe Kollwitz) or else banned from exhibiting on stylistic and/or racial grounds. Previously celebrated German figures would soon be ostracised too (Barlach, but also Kirchner,

11.4 (*opposite*) Isaak Brodski, *May Day Demonstration on 25 October Prospect*, 1934. Oil on canvas, 285 × 200 cm. State Tretyakov Gallery, Moscow

11.5 (*above*) Vera Mukhina, *Worker and Collective Farm Woman*, 1937. Stainless steel, 24.5 m high. Paris World's Fair, 1937

who committed suicide in 1938). Even Nolde, whose work continued to fascinate some members of the Nazi hierarchy, was forbidden to exhibit from 1934. Museum directors with inappropriate political loyalties were rebuked or dismissed for having stocked their collections with 'un-German' art. In fact, the official art of the Nazi state now became neither *völkisch* nor Expressionist – rather the production of oversize oil paintings by artists of an academic bent depicting some approved Nazi theme: the racially pure family, the individual's rootedness in the land, physical prowess in sport or military preparation, or fawning images of the Führer as the embodiment of Germany's destiny and will. Though Hitler had often expressed admiration for classical art – for 'Hellenism and Germanness together' – in practice his taste was for high-finish renditions of both female and male flesh.[7] On 18 July 1937 a well-funded *Große Deutsche Kunstausstellung* (*Great German Art Exhibition*) opened in the grand premises of the Albert Speer-designed Haus der Deutschen Kunst in Munich. Here could be seen appropriate thematic paintings and bombastic sculptures: no longer art, merely expressions of the commissioning priorities of the Nazi state.

A day later, on 19 July, in an attempt to solidify the new relation between the German people and its art, a large *Ausstellung 'Entartete Kunst'* (*Degenerate Art Exhibition*) was opened in Munich in the dingy premises of the former Institute of Archaeology. Located nearby the official exhibition, the *Degenerate* exhibition was intended only to mock and decry. Here were gathered some 650 works by no fewer than 110 artists of national or international repute from all the groups and branches of practice associated with the term 'modern'. Works were defamed by the attachment of misquotations from the artists, prices paid and critical judgements given, in cramped rows in rooms appropriate to a warehouse or a reserve collection. In one part of room 3 were arranged works by Schwitters, Klee, Hausmann and a marble figure by Rudolf Haizmann in a mock-Dada manner, against a background wall drawing copied crudely from a painting by Kandinski of 1921. At the top of the same wall were scrawled George Grosz's words, 'Nehmen Sie Dada ernst! Es lohnt sich', 'Take Dada seriously! It's worth it' (**fig. 11.6**), while for the (dis)information of the vast numbers who attended the show a catalogue was provided by the Reich's propaganda directorate of which the following is typical. The exhibition was to appeal 'to the sound judgement of the people and thus to put an end to the drivel and claptrap of all those literary cliques and hangers-on, many of whom would still try to deny that we ever had such a thing as artistic degeneracy'. It meant 'to expose the common roots of political anarchy and cultural anarchy and to unmask degenerate art as art-Bolshevism in every sense of the term', while alongside were reproduced Hitler's own denunciations, from his speech at the 1933 Reich Party Congress or that given at the opening of the *Große Deutsche Kunstausstellung* nearby.[8] It was clear that the free practice of art in Germany was now prohibited, and that lives and livelihoods were in danger. An emigration of artists from the German cities soon began. The Bauhaus master Lyonel Feininger returned to America in 1936; Beckmann managed to reach Amsterdam in 1937, thence to America after the coming war; Schwitters fled to Norway in 1937; Meidner to England in 1938; Johannes Molzahn to America in 1938, and so on. Grosz had departed for America in 1932. Klee had returned to Bern in 1933, and Kandinski had left for Paris in the same year. With the staging of the two exhibitions in Munich in 1937, the practice of modern art in Germany was at an end.[9]

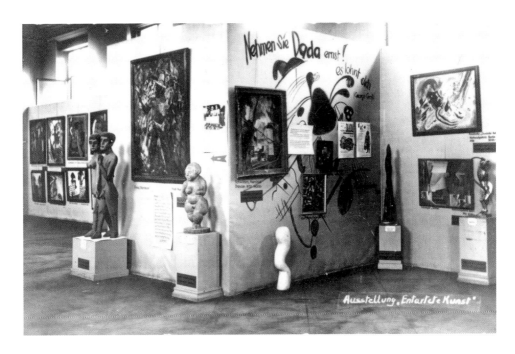

In Italy in 1932, the tenth anniversary of the fascist government was marked by a propaganda event in Rome, the *Mostra della Rivoluzione Fascista* (*Exhibition of the Fascist Revolution*), which traced, through documents and installations, the relatively unhindered ascent of the regime. The *Mostra*'s main purpose was the legitimation of fascist power in Italy as an authentic expression of Italian history and destiny against the backdrop of its imperial past. In its design and presentation the *Mostra* was by turns bombastic and overbearing at the same time as it was relatively inclusive of what Mussolini called 'modern and audacious' style – in the architecture of Giuseppe Terragni and in the design work of Fortunato Depero and Enrico Prampolini, the latter a pan-European figure who had belonged to Cercle et Carré and was a member of Abstraction-Création in Paris.[10] A certain Futurist dynamism was also part of the whole, notably a number of grandiose wall reliefs inspired by photomontage, double-coded to evoke both dynamism and simultaneity. At the same moment Mario Sironi, the most fascist-leaning member of Novecento, whom Margherita Sarfatti described as 'the most audacious modern among our painters and so in a certain sense the most classical', was exploring allegories of the new Italian life in the medium of large-scale mural painting, his figures now garbed in a hybrid of ancient and modern dress (**fig. 11.7**).[11] Sironi's *Manifesto della pittura murale* (*Manifesto of Mural Painting*) of the following year, signed by Carrà, Massimo Campigli and Achille Funi, insisted that the instructional value of the new art of *italianità* was not based on content – for Sironi a communist concept – but on style; one of sobriety, unambiguous gesture and grandiose

11.6 *Entartete Kunst*, Munich 1937, room 3 (Dada wall): '"Nehmen Sie Dada ernst! Es lohnt sich (Take Dada seriously! It's worth it)" George Grosz'

national will, hence a link between contemporary figuration and a deeper Italian past.[12] In 1933 and in a similar spirit, Sironi invited some thirty artists, many with Futurist or Novecento credentials, to decorate the walls of a large building in Milan for that city's fifth Triennale in order to demonstrate a 'rediscovery of the classical'.[13]

That particular occasion renewed tensions between the relatively inclusive Novecento manner and the increasingly hard-line demands of fascism's cultural ideologues in Rome. And yet, unlike their counterparts in Moscow or Berlin, no direct sanctions were applied to artists working in Futurist or abstract modes until later in the decade. Private galleries remained free to exhibit according to their standards so long as they respected limits of other kinds. The Galleria del Milione in Milan, notably, gained a reputation for showing abstract art in the sense of rational form and construction. For example, the artists Mauro Reggiano, Oreste Bogliardi, Gino Ghiringhelli and Fausto Melotti claimed sympathy for a 'Mediterranean climate of order and equilibrium' without in any obvious way descending into a formulaic *romanità*. As Melotti expressed it for his one-man exhibition at Milione in 1935, 'we are favourably disposed towards the classical, but clearly this does not mean arches and columns' **(fig. 11.8)**.[14] The young Lucio Fontana – already an exception to every rule – at this stage showed versatility in both figurative and non-figurative styles. The appearance of all these artists at the second and third Rome Quadriennale exhibitions in 1935 and 1939 at the Palazzo delle Esposizioni passed without comment of an openly ideological kind. Yet with the passage of Italy's racial laws of 1938–9, which banned Jews from many professions and restricted their rights to own property, convergence with German policy was under way. Mussolini and Hitler had already formed a pact against Republican Spain and

11.7 Mario Sironi, *The Shepherd*, 1932. Oil on canvas, 90 × 80 cm. Civico Museo Revoltella, Trieste

11.8 Fausto Melotti, *Scultura no. 11*, 1934. Plaster, 80 × 70 × 12.1 cm. Fausto Melotti Foundation, Milan

had settled their differences over Austria. Now, accusations of Jewish sympathy or 'Bolshevism' in Italian art began to appear.

We must pause to consider the fate of Italian Futurism in the decade of ideological conflict and eventual war. Back in the early 1920s Marinetti had shared with the anarchist-turned-socialist Mussolini a ferocious patriotism. Given the choice between an internationalising Bolshevism and German-type revolution on the one hand and a rhetoric of national revival on the other, both of them had chosen the latter. 'We are not Bolsheviks because we have our own revolution to make,' Marinetti declared in 1920. 'We want to free Italy from the Papacy, the Monarchy, the Senate, marriage, Parliament. We want a technical government without Parliament, vivified by an *eccitatorio* [animating council] of very young men.'[15] Yet by the end of the 1920s changing ideals had forced them apart. Mussolini wanted the Papacy on his side and a kind of monarchy for himself. Marinetti would still describe his old comrade as 'a marvellous Futurist temperament' – but was receiving few if any plaudits in return.[16] In the meantime, a second generation of Futurist painters had launched a renovated version of the early Futurist style.

This 'second' Futurism was called by Marinetti and his co-author Mino Somenzi *aeropittura* (aero-painting), an approach to painting and sculpture that rewrote some early Futurist aspirations in the context of aeroplane flight. Boccioni at the end of his 'Technical Manifesto of Sculpture' of 1912 had called for 'an environmental sculpture ... that comes to model the atmosphere which surrounds objects'. Meanwhile, Marinetti had sensed the exhilaration of aeroplane flight – had claimed that aerial speed suggested 'the destruction of the old syntax inherited from Homer ... That is what the whirling propeller told me, when I flew two hundred metres above the chimney pots of Milan'.[17] In the 1920s Fedele Azari, Mino Rossi and Depero had taken to flying. Aerial photography was also helping set the pace for an assault on the sensations of speed, of simultaneity and of 'the entirely new reality' that differed so markedly from earthbound perspectives.[18] This and similar phrases from the 1929 'Manifesto of Aero-painting' translated the very sensations of flight into fertile metaphors for qualities that had been vital to Futurism from the start: poly-dimensionality, dynamism, the transfiguration of the real by means of light, speed, and rapid change (**fig. 11.9**). Flying, wrote Gerardo Dottori in 1931, means 'opening and aerating the imagination, cleansing it of the inevitable waste of the past which hinders the free and rapid spreading of the wings'.[19] Unsurprisingly, Mussolini's regime took an ambivalent view of this second Futurism of the air. On the one hand the iconography of modern flight was adventurous and even militaristic, and Futurism's rhetoric offered a dynamism potentially attractive to the state. Yet by the mid- and later 1930s Italian fascism had turned to military adventurism in Ethiopia premised on displays of discipline and order, and aero-painting would be reckoned un-Italian, anarchic, internationalist and – to use a term that could cut both ways – 'avant-garde'.[20]

It brings us to Spain, where a republic had been established by popular vote following elections in April 1931 and the departure of King Alfonso XIII. Yet the new republic was unstable, and following its disestablishment of the Catholic Church and its secular reforms in education it faced opposition from conservatives and traditionalists almost immediately. With the appearance of a Spanish fascist movement, La Falange, in November of that year it became clear that the prospects for national

stability were nil. Civil war erupted in the summer of 1936 between Nationalists (including La Falange) under General Franco and the Republican government, whose supporters included liberals, anarchists, communist groups and Basque and Catalan loyalists. A non-intervention pact signed by Hitler with France, Britain, Soviet Russia and others was flouted when German and Italian troops arrived to support Franco and besiege the capital, Madrid. Volunteers belonging to the so-called International Brigades arrived to protect the city and its inhabitants. The international situation was suddenly perilous. What role could be played by artists sympathetic to the Republic?

For Spanish Surrealists, the challenge was to find ways of reacting to anguish and pain with such tools as they had – principally the techniques of surprise and the 'revelation of the marvellous'. The Catalan Salvador Dalí had watched the earlier rise of

11.9 (*opposite*) Fedele Azari, *Perspectives in Flight*, 1926. Oil on canvas, 120 × 80 cm. Private collection, Rome

11.10 (*above*) Salvador Dalí, *Autumn Cannibalism*, 1936. Oil on canvas, 65.1 × 65.1 cm. Tate Gallery, London

Nazism in Germany with a fascination that had disturbed his Surrealist friends. Some ill-judged remarks made by him about Hitler suggested that he viewed the fascist personality as no less complex and interesting than the paranoid one. His painting *The Weaning of Furniture-Nutrition* of 1933–4 had showed a hollowed-out Hitlerian wet-nurse (identifiable by a swastika armband) sitting on a beach next to a piece of furniture having the same shape and volume as her missing anatomy. The Paris Surrealists insisted that the swastika be removed. Dalí, ordered to appear before a Surrealist tribunal in January 1934, from a kneeling position mumbled a speech about Hitler having 'four balls and six foreskins' before being abruptly silenced by Breton.[21] Yet the Surrealists had not expelled him – after all, the transgression of civilised norms had interested them all from the start. Likewise, Dalí's 1934 series of forty-two etchings for Lautréamont's *Les Chants de Maldoror* (1868–9) showed his fascination for extremity at any cost – including the terrors and turbulence of Spain's current life. *Autumn Cannibalism*, painted in 1936 during the intense early period of the civil war, shows an immensely doleful scene in which a female and a male figure, both apparently eyeless, have arms around each other's shoulders and are making a nourishing meal out of the female's flesh – her left and right breasts respectively (**fig. 11.10**). They are situated somehow on a chest of drawers, on a Catalan beach, themselves draped in bits of drooping foodstuffs, while in the background lies a blood-soaked area of land and a white-painted church in the foothills of some mountains. It is in the couple's gruesome kiss, however, that we see

11.11 André Masson, *Les Coqs rouges*
(*The Red Roosters*), 1935. Oil on canvas,
65 × 46 cm. Eric Fitoussi Collection

11.12 André Masson, *Acéphale* no. 2,
January 1937. Cover illustration, 15 × 18 cm.
Bibliothèque Kandinsky, Centre Pompidou, Paris

a kind of masochistic connivance in the violence; as if Spain's destiny was driven by tragic but ineradicable impulses. The painting's proposal seems to be that the civil war was a malady of the whole nation, as horrific as it was inevitable.[22]

André Masson, not a Spaniard but with a fascination for the ambience of the south, reacted to some fascist demonstrations in Paris in February 1934 by fleeing to Tossa de Mar, on the coast north of Barcelona, and by turning his existing obsession with creatural violence – animal appetite, rape, entrapment – to Spain in his own way. The *Documents* writers Michel Leiris and Georges Bataille, who each visited him in Spain during the spring of 1935, found him working on a series of paintings of flying or creeping insects in a confused orgy of contestation – or scrawny red cocks fighting under the midday sun – that seem to allegorise the mood of the country in that year (**fig. 11.11**). Masson's paintings meshed with his visitors' own preoccupations. Bataille was by this time developing a concept of spontaneous popular uprising derived from his reading of Nietzsche – a kind of swelling, energetic discontent that can erupt without plan or policy in a people's quest for freedom from the logic of organisation. In fact, Masson was already on the point of a brief (though untypical) collaboration with Breton to which they gave the name Contre-Attaque (Counter-Attack); it in turn led Bataille to a Nietzschean project with Masson in the form of a short-lived review named *Acéphale* – subtitled *Réligion, Sociologie, Philosophie* – that opposed both the bureaucratic edicts of Comintern Marxism and the conciliatory postures of the Popular Front government in France, and with a particular proposal. The headless figure that appeared on the cover of *Acéphale* – drawn by Masson – is an incarnation of Bataille's Nietzschean ideal. In his ecstatic readiness, the figure carries a flaring heart in one hand and a dagger in the other. The labyrinth of his intestines is visible at his middle, and at his crotch there is a skull (**fig. 11.12**). When the situation in Spain became truly explosive, Masson and other figures were forced to physically retreat. With the eruption of civil war in July 1936, Masson joined the Iberian Anarchist Federation (Federación Anarquista Ibérica, or FAI) before returning to Paris in November.

Allegorical constructions – whether of animals, the burning landscape or a headless figure – distinguish artistic reactions to the Spanish war because they built, inevitably perhaps, on the myths and icons of Spain itself. Back in Paris, Masson immediately began work on some *corrida* images for a painting show at the end of 1936. By now Masson and Leiris had also begun work on a text-and-image book *Miroir de la tauromachie* (*The Bullfight as Mirror*), finally to appear in print in 1938, which reflected Spain's intensifying disorder. Masson's images reflect Leiris's view of the bullfight as a spectacle in such a way as to build out of the current Spanish conflict an allegory of the human predicament in general.[23]

Leiris's reflections also shed light on Picasso's own responses to Spain's Civil War, and on his celebrated painting *Guernica* in particular. The events of 26 April 1937 are well known. The war for Republicans in the north was going badly, and they had dropped back to the militarily insignificant small Basque town of Guernica, where there began a devastating air attack at four in the afternoon by members of Germany's crack Condor Legion, supported by a smaller number of aircraft from Mussolini – clearly at Franco's arm's-length control. The town was destroyed, and its fleeing population was strafed from the air. International outrage was swift. The Republican government immediately asked Picasso to prepare a mural painting for its pavilion (already in the design

stages by Josep Lluís Sert) for the forthcoming Paris World's Fair in June. Positioned amid other assertive national pavilions at the Fair, the hope was to establish visually, and at scale, the credentials of a free Republican Spain. Other works would embellish the pavilion: outside, a totemic sculpture by Alberto Sánchez titled *The Spanish People are Following a Path That Leads to a Star* – a work of the so-called 'telluric' tendency among Spanish sculptors (**fig. 11.13**); inside, a *Mercury Fountain* by Alexander Calder and a mural painting (since lost) by Miró titled *The Reaper, or Catalan Peasant in Revolt*. Picasso's painting was to fit a space some three-and-a-half metres high by nearly eight in width and would have to be conceived and completed in a matter of weeks.

In one sense we know too much about the painting, for it was preceded by dozens of sketches and once started in a large space in the rue des Grands-Augustins, Paris, was photographed by Dora Maar in seven of its changing states. In most respects it is clear what the finished painting shows (**fig. 11.14**). The central triangle contains a shrieking wounded horse, down on one knee, nearly trampling on an already decapitated warrior who clutches a broken sword, even in death. Two women to the right are horrified witnesses to the sudden destruction. There are flames and collapsing buildings: the scene is both in and out of doors. To the left a screaming mother holds a dead or dying child. The black, dark grey and white tonality – reserved for particular occasions in Picasso's painted work – gives the painting the air of being a news report, a scene of violence captured in flash photography at the instant in which it occurred.

But what of the bull who looks outwards, as if towards us, while three out of four female figures in the painting and the horse (itself a cipher for the female) look towards it? Why a bull at all, as a cipher of a tragically conflicted Spain? Critics have noticed that there are no overt symbols of Republicanism in *Guernica* – a raised clenched fist having been present at an early stage of the painting but since removed. What, then, does the bull represent? A clue comes from a remark made by Picasso's widow

11.13 (*above*) Alberto Sánchez, *El pueblo español tiene un camino que conduce a una estrella* (*The Spanish People are Following a Path That Leads to a Star*), 1937. Plaster, 184.5 × 32 × 33 cm. Museo Nacional Centro de Arte Reina Sofía, Madrid

11.14 (*opposite*) Pablo Picasso, *Guernica*, 1937. Oil on canvas, 349.3 × 776.6 cm. Museo Nacional Centro de Arte Reina Sofía, Madrid

Jacqueline Roque in 1973. Picasso was 'very sensitive to extremely ancient forms', she said, 'forms that have persisted from civilization to civilization ... the skull, the bull of the Sun, the horse of death ... the last two are in *Guernica*'.[24] She is referring to the bull of the Mithraic cult of the sun, whose sacrifice by slashing the throat was practised as a release – of blood, of intense emotion; and the bull-fight is the modern equivalent of the Mithraic sacrifice. In both, the ritual begins with a display of bovine dominance, even if the presumption is that the bull will surely die. In *Miroir de la tauromachie*, too, the rhythms of the bullfight exemplify the human need for what Leiris calls 'certain violent spectacles [that] turn around a crisis first knit up and then unraveled'; for certain 'exceptional occurrences that ... show us to ourselves because of some affinity or secret analogy' that has acquired, 'with perhaps unequaled intensity, the allure of crucial experiences, of revelations'. And such revelations, Leiris says, can lead us towards what he calls 'tangency to the world and to oneself'.[25] Leiris's closeness to Picasso's thinking leads us to say that *Guernica* stages an 'exceptional occurrence' as much as a public statement of resistance to this and every war. Composed as an academic tableau in the eighteenth-century style, the painting's contemporaneity is meanwhile carried by Picasso's most flexible and durable idiom, that of Cubist shapes, jagged edges and twisting forms, all unequally lit. Connecting a specifically Spanish understanding of national tragedy with the expectations of a wider international public, Picasso in *Guernica* succeeded in transforming a single event of destruction into a parable, on one level deeply paradoxical, applicable to any warlike event at all.

Republican Spain's submission to superior forces in April 1939 was followed by an escalation of tension between Nazi Germany and Soviet Russia in the summer, capped by a Non-Aggression Pact in August between the two totalitarian nations. It was predictably unreliable. Germany invaded Poland in September and triggered the opening skirmishes of the Second World War, a conflict from which only one major power remained relatively aloof. It is to America that we next turn.

Modern Art in America

To convey the character of modern art in America in the 1930s it is necessary to go back. At the end of the First World War the United States was becoming – had become – a nation of rampant industrial and commercial expansion, in this respect and for many, the envy of the world. With the global financial crash of 1929 and the beginning of the Great Depression, that status began to falter. By then it was clear that not only economically but in their artistic cultures, American cities were becoming increasingly separated from the life of the countryside.

It is part of the reason why a manner known as Regionalism evolved in America, devoted to recording the conditions and sensations of rural life. Regionalist painters such as Thomas Hart Benton, Grant Wood and John Steuart Curry took to representing the experiences of small-town farmers, rural communities and culturally conservative townships of the Mid-West, and sometimes their histories. For example, Benton himself devoted much of the 1920s to a vast project of some seventy paintings to be called *American Historical Epic* – in practice a total of eighteen was reached by the end of the project in 1928. In them, we see historical themes such as a slave-master whipping his cargo during the voyage to the New World, the exploration of the Wild West, the appropriation of indigenous people's lands – yet peopled with stereotypes close to those of a picture book or a child's film (**fig. 12.1**). Comparisons with El Greco or European Mannerism miss the point. Benton later reflected that Regionalist art was conducted 'in terms comprehensible to Americans as a whole'; that he and his colleagues had succeeded in distancing themselves 'from the hothouse atmosphere of an imported and, for our country, functionless aesthetics' (European modern art); that 'we felt we were on the way to releasing American art from its subservience to borrowed form'.[1] Clearly, Regionalism was in part an act of resistance, perhaps retrenchment. Benton, Wood and Curry were giving their viewers what they considered to be 'honesty' and 'truth' in a visual register supposedly American to the core. 'The Modernists were men of the strongest antisocial propensities,' wrote the critic Thomas Craven in a diatribe against French and other European artists celebrated by other Americans since the *Armory Show*. The European moderns had taken pride in their aloofness, said Craven, and in such an atmosphere 'art turns inwards, feeds upon itself, takes refuge in abstractions'.[2] To Benton and colleagues, modern America contained a world of local history and custom by comparison with which the technical wizardry of European modern art was remote and unimportant – even supposing they knew very much about it.

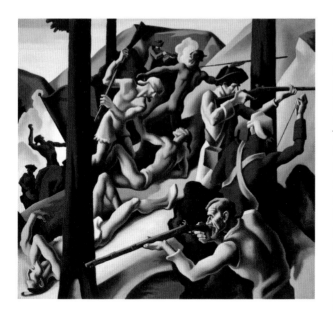

A second and specifically American defence against 'borrowing' from the Europeans can be seen in the manner known in the 1920s and early 1930s as Precisionism. The painter Charles Sheeler had been quick to recognise that the new manufacturing landscape was enough by itself to convey a sense of modernity – one, moreover, in which America was becoming a model for much of the world. It had already attracted him in his photography, which he had practised in an austere style while in the circle of Paul Strand, Edward Weston and others close to Stieglitz at the time of the First World War. Nearly xenophobic in his zeal, Sheeler subsequently took to celebrating American manufacturing creativity in an idiom that projected the new America as cleanly defined and vital, for the money economy if not obviously for the benefit of all. Whether the deck architecture of an ocean-going liner, the functional precision of brand-new railway rolling stock or the visual drama of the massive Ford Motor Company Plant at River Rouge, Michigan, in its heyday, to Sheeler and other Precisionists such as Charles Demuth, Ralston Crawford, Niles Spencer and (for a time) Georgia O'Keeffe, here was a proud civilisation of sight, sound and sensation that no truly American artist could ignore (**fig. 12.2**).[3] Whether this manner deserves to be called 'classic' or 'classical' remains moot. So too does the austere new architectural idiom that spread quickly in America at the same time. The painter Georgia O'Keeffe throughout the 1920s and 1930s was also attracted by the imposing high-rise buildings of the new American city. The symmetries and near symmetries found in animal bones, rocks and desert plants for which she is better known project a similar Precisionist vision from which human life and activity is for the most part excluded (**fig. 12.3**).

The question of whether this art was 'modern' in the sense of being experientially or cognitively new is a real one. From the *Armory Show* right up until the beginning of the 1930s the flow of ideas and visual protocols across the Atlantic had been consistently one way, and Regionalist and Precisionist artists were not mistaken in thinking that 'borrowed form' was a set of qualities by which American art was at that

12.1 Thomas Hart Benton, *Struggle for the Wilderness*
(from the *American Historical Epic* cycle), 1924–6.
Oil on canvas, 182.8 × 213.3 cm. Nelson-Atkins
Museum, Kansas

point endangered. In the 1920s the remarkable development was the championing of modern European initiatives by American patrons and collectors from some of the east coast's wealthiest families. Several such families had crossed the Atlantic in the nineteenth century, and their offspring remained enthusiastic about a search for the original and new.

Two philanthropic-cum-artistic projects of the 1920s stand out. Katherine Dreier, the heiress to an iron and steel fortune who studied painting in New York and Paris and exhibited two works of her own in the *Armory Show*, met Duchamp and Man Ray through her contacts in the Arensberg circle during the years of the First World War. In 1920 she founded with them a collecting and exhibiting organisation they called the Société Anonyme (in French the term *anonyme* also means 'corporation') and proceeded to hold exhibitions and discussions in modest premises at 19 East 47th Street until 1928 when the Société was dissolved through lack of further funds. Dreier's tireless energies – she organised a large *International Exhibition of Modern Art* at the Brooklyn Museum in 1926 – led her to hope that a permanent home might be found in New York to contain her collection of modern French, Spanish, Russian, German and American art on a permanent basis: indeed, the subtitle its founders gave to the Société in 1920 was 'Museum of Modern Art'.[4] That may have been a piece of Dada irony – yet by the middle of the 1920s enough enthusiasm had been registered in New York for another project to unfold that would change the face of Western art for ever. Three other wealthy

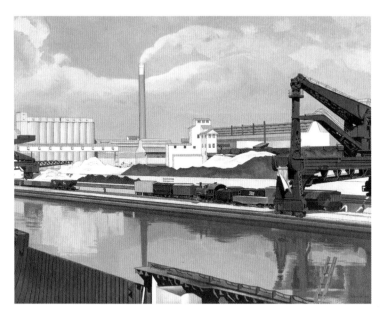

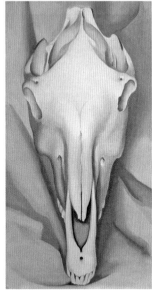

12.2 (*above, left*) Charles Sheeler, *American Landscape*, 1930. Oil on canvas, 61 × 78.8 cm. Museum of Modern Art, New York

12.3 (*above, right*) Georgia O'Keeffe, *Horse's Skull on Blue*, 1930. Oil on canvas, 76.2 × 40.6 cm. Arizona State University Art Museum, Tempe

12.4 (*opposite*) A. H. Barr, 'Torpedo' diagram of the Permanent Collection, Report to Trustees, 1933. Museum of Modern Art, New York

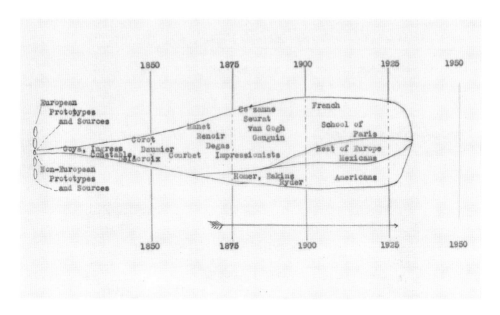

New York women, Lillie Bliss, Mary Quinn Sullivan and Abby Aldrich Rockefeller, laid plans for what would become an actual Museum of Modern Art (MoMA) – no irony attached – 'a permanent public museum in this city [New York] which will acquire, from time to time (either by gift or purchase), collections of the best modern works of art'.[5] Subscribers were sought, a director with art-historical training was duly appointed, and the Museum of Modern Art was opened in rented rooms at 730 Fifth Avenue, New York, on 8 November 1929.

What were the values of the museum to be? Aside from 'the modern' in art, some ordering of style, historical precedent and country of origin would need to be employed. What balance between art, architecture and design would be encouraged in the museum's projected programme of some ten to twelve exhibitions per year? Alfred Barr, twenty-seven years old at the time of his appointment as director and an enthusiast of modern European art from his days as a graduate student at Harvard, had travelled widely in Europe in the middle years of the 1920s and pondered the relation – if any – between modern art in Europe and the various manners being practised in America. His answer became visible with the opening exhibition *Cézanne, Gauguin, Seurat, Van Gogh* in the winter of 1929/30. Here the proposal seemed to be that modern art was a virtually autonomous European phenomenon in which American artists played no part at all. The assumption that modern art was also French, or sprang from the geography and ambience of France, was underscored by a diagram Barr drew for the benefit of his Trustees in 1933. It showed a torpedo-like shape with the Post-Impressionist foursome squarely at the torpedo's centre and the period between 1900 and the end of the 1920s, labelled 'French School of Paris', positioned tellingly at the leading (that is forward) end. In a smaller compartment beneath appear 'Rest of Europe' and 'Mexicans', while 'Americans' are tucked into the bilges down below (**fig. 12.4**). Even during the years of the Depression that followed, the museum would prioritise the dazzling innovations of the European modernists at the expense – or so it seemed to the museum's

detractors – of those documentary impulses that would want attention to be paid to the facts of mass unemployment among the urban poor, the devastation of American agriculture and the experiences of American workers and lower-income households either in the countryside or in the bustling cities themselves. To the wealthy (and white) cosmopolitans of America's east coast, the culture of black Americans was also not remotely on the museum's collecting and exhibiting agenda at that time.

A third and somewhat different philanthropic project was that of Gertrude Vanderbilt Whitney, heiress to the massive railroad and shipping fortunes of the Vanderbilt family, acquired in the Gold Rush years of the 1860s. A sculptress by inclination, Whitney's project was to amass by the beginning of the 1930s a collection of some six hundred works by artists who aspired, not to be 'modern' in the European sense but to be both American and 'contemporary' together. Anxious to have an existing institution accept her collection as a bequest, Whitney offered it to the prestigious Metropolitan Museum of Art in 1929, only to be turned down.[6] That refusal was for the best, however, in that Whitney now set about forming an independent institution to promote American contemporary art, with the eventual consequence that the Whitney Museum of American Art opened its doors on 19 November 1931 at West 8th Street in downtown New York, with a commitment to hold a series of biennial *Exhibitions of Contemporary American Painting* in the city beginning the following year.

Cultural philanthropy on such a scale had no equivalent in Europe at the time, and it planted in America a spreading enthusiasm for both 'modern' and more widely 'contemporary' artistic innovation in any of the ways it could be defined. Broadly, the distinction between the two terms was that a certain graphic economy combined with a degree of risk in matters of technique characterised the self-consciously modern artist, while 'picturing' could characterise the work of those who saw themselves as 'contemporary'. It followed that for the relatively few American 'modern' artists of that generation the role of 'picturing' in American art came under special and often exacting review.

The prime example is Stuart Davis. In the early 1920s he had taken effortlessly to American commercial imagery in a series of paintings in which he responded to the colour and immediacy of commonplace packaging – Lucky Strike cigarettes for example – with no less enthusiasm than a previous generation had greeted a river or a tree. Packaging and typographic forms 'are of enormous interest to me', he wrote in his journal at the time. Such things 'symbolise a very high civilization ... I want direct simple pictures of classic beauty expressing the immediate life of the day'.[7] Such paintings were followed by still lifes containing ordinary household things – mouthwash bottles and light bulbs among them – depicted with humour and delight. Quickly recognised for his painterly skills, Davis was awarded a monthly stipend by Gertrude Whitney for 1926/7 and made contact with other likely supporters in what was becoming a fast-expanding art scene in New York. His so-called *Egg Beater* paintings are from this time: they show a formal command of the small-format table-top picture, in this case a composition based – very loosely – on the shapes of three commonplace objects fastened to a kitchen table: an egg beater, an electric fan and a rubber glove (**fig. 12.5**).[8] He then embarked for Paris, where he met the writer Gertrude Stein and exchanged studio visits with Fernand Léger, the latter encouraging him to combine a flexible, movement-filled compositional method with a progressive political position

in art. Back in NewYork by 1930, Léger's advice, combined with the shock of theWall Street Crash, had the effect of guiding Davis to his proper idiom: a visual language based on the signs, images and forms of the urban scene that the ordinary citizen can easily and happily share.To him, the Regionalist impulse then flourishing in the Mid-West was unproductive. Benton's narrative style, he said, was betrayed by a cartoon-like rubberising of form that translated human action into stereotypes. Davis would call the latter's depiction of Negro and other figure types 'a caricature ... a third-rate vaudeville character cliché, with the humour omitted' – a derision already supported by the sheer brio and modernity of Davis's own work.[9]

With the election of Franklin Roosevelt in 1932 on a ticket to deliver a 'New Deal' for Americans, the contest between conservative Regionalism and savvy cosmopolitan modernism became intense. A Public Works of Art Project (PWAP) was set up in the winter of 1933/4 to help artists stay in employment; it led in turn to a scheme under theWorks Progress Administration (WPA) known as the Federal Art Project, or FAP. In operation from August 1935, the aim of the FAP was to commission artists to design and execute mural paintings for public buildings. Would the model for such commissions be the manner of Léger and now Stuart Davis, that of an articulate

12.5 Stuart Davis, *Egg Beater No. 2*, 1928. Oil on canvas, 74 × 91.4 cm. Amon Carter Museum of American Art, FortWorth

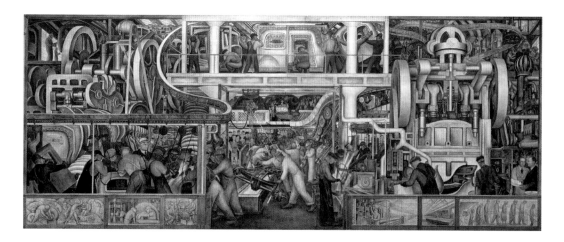

celebration of modernity, or would it be that of the Regionalist school? Or would it be the mural style already well practised by Mexican artists and much admired by left-wing and Communist Party affiliates in America? A fourth example would be the public art projects being carried out in the Soviet Union. And what role would be played by black artists from the southern states, hitherto disenfranchised but increasingly seeking validation in what was known as the Harlem Renaissance, so named following the migration of many talented and ambitious southern artists to New York. The challenge was to find the terms on which an imagery for New Deal America could find embodiment on the scale of a mural panel or a ceiling, or on a public building's exterior.

Mexican muralism had sprung to life at the conclusion of that country's long and many-sided civil war of 1910–20. The civil war over (or suspended) by 1921, the Mexican Minister of Education José Vasconcelos had persuaded the artist Diego Rivera to return home from Paris to work in the government's mural painting programme. In the 1920s the reforming government of Álvaro Obregón encouraged a degree of alignment with the cultural ambitions of the Russian Revolution such as public works and slogans that memorialised the events of revolutionary struggle, as well as appealing directly to agricultural workers and militant cadres to support land and tax reforms. Rivera set to work immediately, joining the Mexican Communist Party the following year and embarking on a series of confidently scaled mural projects arising from Mexico's own revolution. After a short spell in Moscow at the turn of the 1930s (where he participated in the Oktyabr group) Rivera relocated to North America and completed three mural schemes in the San Francisco area (including for the city's stock exchange) before accepting a commission to undertake a scheme in the northern city of Detroit. The economic downturn of the early 1930s was a period of crisis for the United States' automobile industry, sparking a struggle of unionised labour for pay and conditions that became a major theme of Rivera's work (**fig. 12.6**). It was by such examples that mural

12.6 (*above*) Diego Rivera, *Detroit Industry Murals*, automotive panel, final assembly (south wall), 1932. Fresco, 540 × 1372 cm. Detroit Institute of Arts

12.7 (*opposite*) José Orozco, *Modern Migration of the Spirit*. Panel 18 from *The Epic of American Civilization*, 1932–4. Fresco, 323.9 × 320.7 cm. Baker Library, Hood Museum of Art, Dartmouth College, New Hampshire

painting in fresco or on wall-mounted
canvas came to be admired by Americans
supportive of a class-conscious art
beholden to collectivist and proletarian
ideals. At the same time, those murals
could look overly literal to cosmopolitan
modernists enamoured of cognitive
adventure and the visual spectacle of the
modern city itself.

Rivera's compatriot José Clemente
Orozco was always more deeply steeped
than he in the older traditions of Mexican
art: the heritage of Mayan, Olmec and
Aztec civilisations but also the Mexican
traditions of the Baroque and the
grotesque; sufficiently at least for those
alert to European developments to notice in them something of the wild provocations
of German Expressionism. Moving to New York for the years 1927 to 1934, Orozco
in 1930 embarked on two major works, a cycle on the theme of Prometheus for Pomona
College, Claremont, California, and a scheme for the International Style building at
the New School of Social Research, New York, on the theme of universal brotherhood.
These were followed by a commission for Dartmouth College, New Hampshire, named
The Epic of American Civilization – an ambitious cycle of interconnected scenes
acknowledging the travails but also the necessities of human striving, with panels
bearing titles including *Ancient Human Sacrifice*, *The Pre-Columbian Golden Age*,
The Departure of Quetzalcoatl (the ancient Mesoamerican deity), *The Machine*, *Anglo-
America*, *Gods of the Modern World* and *Modern Industrial Man* – in effect a development
of the Prometheus theme of unbound creative energy, here represented by a rebel
figure who has destroyed religious icons, cultural monuments and military hardware
and rises up defiantly to begin the struggle for a new kind of life (**fig. 12.7**).[10] Among
other results, the very presence of such murals in institutions in the United States
was more than sufficient to present a challenge to the inclusiveness – political, artistic,
aesthetic – of any east coast institution purporting to be a Museum of Modern Art.

With such murals already complete by the time the FAP commissioning scheme
began, it was inevitable that the politics of public art would now become contested
by artists and critics alike. Theoretically, an artist of any alignment could win or lose
a FAP commission according to several criteria: the nature of the institution or building
for which a scheme was being designed, the readability of a proposed scene, and its
suitability to the architecture of the building. No prior stylistic criteria were imposed
by the FAP itself. Davis himself had completed a mural commission for the men's
lounge at Radio City Music Hall in New York in 1932, and was clearly capable of adapting
his post-Cubist manner to the demands of a larger format. It was not until 1936, however,
that he began work under the FAP on a mural design for one of the social spaces of a
new low-income housing scheme in Brooklyn, New York (it was completed only later). In
the meantime he became consumed by political activity on behalf of artists as editor-in-
chief of, and contributor to, a small yet important campaigning journal named *Art Front*.

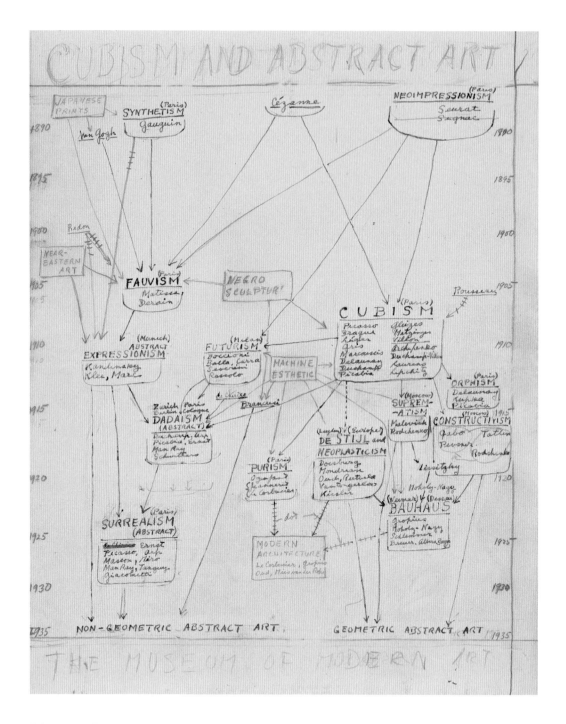

12.8 A. H. Barr, Sketch for the frontispiece of
Cubism and Abstract Art, 1936. Museum of Modern
Art, New York

In the Depression years the east coast art community was in turmoil. The many thousands of artists who congregated in and around New York not only benefited from the WPA/FAP scheme but were prepared to mobilise in order to contest, where necessary, the policies and preferences of the fast-developing Museum of Modern Art. *Art Front* ran from November 1934 to December 1937 and promoted vigorous discussion not only of American Regionalism – for the most part dismissive of African American culture – but also the increasing dominance of German-style corporate monopolies taking hold in America, the press empire of William Randolph Hearst in particular. *Art Front* published articles by or about Léger, Le Corbusier, Jacques Lipchitz, de Chirico, Picasso, Dalí, Isamu Noguchi and others whose working attitudes would become inspirational for some younger Americans. It also represented cultural figures aligned with the Communist Party of the United States of America as well as independent Marxist commentators on art.[11] *Art Front* also mounted campaigns against war and fascism, supported a municipal art gallery for New York, and agitated for the establishment of an artists' union to create employment rights and opportunities. Davis himself, perhaps the most articulate exponent of a left-wing yet self-consciously modern manner in art, declared at the American Artists' Congress of February 1936 that 'Fascism is plunging us headlong toward a devastating new World War'. As artists, he said 'we have faith in our potential effectiveness precisely because our direction naturally parallels that of the great body of productive workers in American industrial, agriculture and professional life'.[12] And he repeated his accusation that Benton, Curry and other Regionalists had produced only cheap dramatism, 'executed without the slightest regard for the valuable, practical and technical contribution to painting' made by Europeans and others since the turn of the century.[13]

At the same time it was clear that MoMA's enthusiasm for modern European art was one-sided. Alfred Barr betrayed his own instincts on the question by the priorities enshrined in two massive exhibition projects of 1936–7. For the first, *Cubism and Abstract Art*, held in the spring and summer of 1936, his decision was to exclude American artists altogether from the show and to present instead the significant stylistic links, as he saw them, within modern art in France, Germany, Italy, Russia and Spain from the first stirrings of the Cubist experiment through to two distinct types of 'abstract' art that were distinguishable by the mid-1930s (**fig. 12.8**).[14] The first strain of 'abstract' art was broadly geometrical and suggestive of mathematical purity and proportion; the second came closer to natural, even biological form. The distinction was fundamental, as Barr saw it, to Western culture as a whole, with Apollo, Pythagoras and Descartes on the rational side and Dionysus, Plotinus and Rousseau on the more instinctual. He had a view about the future path of modern art too, hazarding the judgement that in 1936 'the geometrical tradition in abstract art ... is in decline [while] the non-geometrical biomorphic forms of Arp and Miró and Moore are definitely in the ascendant'.[15]

The neglect of American artists by the Museum of Modern Art was not in fact quite total. Immediately following the *Cubism* show a display was mounted of works completed in the first year of the FAP scheme. *New Horizons in American Art*, in the autumn of 1936, was led by Holger Cahill, director of the FAP and himself a principled opponent of modern art in Barr's meaning of the word. Cahill took the opportunity to rail against the 'polyglot stylistic language' with the help of which 'the modern artist seemed determined to lose art itself in the theoretical mazes conjured up by his own

ingenuity'.[16] In practice, however, *New Horizons* was a display of relatively well-tried narrative and pictorial styles, predominantly by artists from the northern states, leavened only by a small number of studies for mural schemes that alone showed awareness of the dynamism of the modern urban world.[17]

It was, therefore, a further sign of growing tension between American artists and the Museum of Modern Art that Barr's second large exhibition, *Fantastic Art, Dada, Surrealism*, in the winter of 1936/7, presented yet another European invention that could only serve to remind Americans of the relative brevity of their cultural past. Barr described the exhibition as one that stands 'as it happens, diametrically opposed in both spirit and aesthetic principles' to *Cubism and Abstract Art*, and shows 'the deep-seated and persistent interest which human beings have in the fantastic, the irrational, the spontaneous, the marvellous, the enigmatic, and the dreamlike'.[18] With texts by the French poet and artist Georges Hugnet on Dada and Surrealism, the show selected examples from the fifteenth century right up to recent European Surrealism, alongside caricature and cartooning, children's art, paintings and drawings by psychopathic patients, and fantastic architecture.

It is not a surprise, therefore, that there now emerged a strong commitment on the part of a group of young Americans to define an 'abstract art' of their own. To them, the economic and social circumstances of the Depression era were no obstacle to building upon what they could learn from Crystal Cubism, De Stijl and Russian Constructivism. It was a conviction that drove Burgoyne Diller, Harry Holtzman, Ilya Bolotowski, Balcomb and Gertrude Greene, and others to meet for discussions during the winter of 1935/6 and eventually launch, in January 1937, American Abstract Artists (AAA), an organisation committed to holding a series of Annual Exhibitions of abstract art and spreading information about its activities through successive catalogues.

In many ways AAA can be regarded as a continuation of the Paris organisation Abstraction-Création that became defunct in 1936. The first AAA exhibition took place in April 1937 at the Squibb Galleries, 745 Fifth Avenue, and of the thirty-nine participants several were either recent arrivals from Europe or had a European past: Josef Albers from Germany (latterly of the Bauhaus but since 1933 head of Black Mountain College in North Carolina), Arshile Gorky from Turkish Armenia, Willem de Kooning from the Netherlands and Carl Holty from Germany (he had studied in the studio class of Hans Hofmann in Munich), while Ibram Lassaw had been born in Egypt of Russian parents. By its work and polemics AAA established relatively quickly the possibility that a credible American abstract art could be generated on home soil – in short, that contrary to Regionalist and populist claims, 'abstract' art could in no sense be any longer regarded as 'un-American' (**fig. 12.9**).[19]

Gorky, to take his example, was by this date busy on an FAP commission to execute murals at Newark Airport, New Jersey, at that time regarded as the hub of American

aviation. He had arrived in the United States, aged sixteen, in 1920, had been quick
to make friendships in New York, and by 1927 had settled into a studio within walking
distance of a notable collection of European modern art amassed by a certain Albert
Gallatin, American-born but of Swiss descent, on free-entry display at New York
University in Union Square. Several important works in Gallatin's Union Square
collection were 'geometric' in Barr's terms, including Léger's *La Ville* (*The City*)
of 1919 and Picasso's *The Studio* of 1927–8, as well as works by Mondrian, Hélion,
Delaunay and Gris; they surely helped Gorky's understanding of the Cubist table-top
still life, the essential testing ground of so much experiment in European modern
art. Gorky also saw some 'biomorphic' works of Picasso and Hans Arp in Gallatin's
collection, and by the later 1930s was mastering a complex idiom that bound him
both to his memories of rural Armenia as well as to a conception of painting as
itself an organism, one with a lifeworld of its own (**fig. 12.10**).[20] At the same time,
his completion of a commission of ten panels for one of Newark's lounges shows his
indebtedness to the style of Léger as well as the position being taken at the time by
Stuart Davis. Gorky's chosen theme for the scheme was *Aviation: Evolution of Forms
under Aerodynamic Limitations*, made ready for installation in 1938 on the second floor

12.9 (*opposite*) Josef Albers, *Proto Form B*, 1938.
Oil on fibreboard, 70.8 × 61.3 cm. Hirshhorn Museum
and Sculpture Garden, Smithsonian Institution,
Washington

12.10 (*above*) Arshile Gorky, *Xhorkom*, *c*. 1936–8.
Oil on canvas, 100 × 130 cm. Private collection

of the airport's Administration Building (**fig. 12.11**). In sequences of tumbling avionic and mechanical forms his panels trace the stages of modern aviation from airfield activity to flight itself – but without need of narrative or a moral crusade. The scheme provided evidence that large-scale American and European modern art could function very effectively together.[21]

Another twist in the fate of modern American art must be mentioned. During its second season of 1937–8 the AAA accepted as members the Swiss-born Fritz Glarner, who followed Mondrian's Neo-Plasticism, and the American sculptor David Smith. Smith had already noticed welded metal sculptures by Julio González and Picasso in *Cahiers d'Art* and had begun to practise welding himself. After a trip to Europe in 1935–6 with his wife the artist Dorothy Dehner, where he saw new work by Picasso, Lipchitz and others, his commitment to welding intensified. He quickly became adept at crafting complex pictorial constructions, most often containing humanoid, animal or landscape references rising energetically from a narrow base (for this idiom particularly, Smith would become celebrated in the 1940s and 1950s) (**fig. 12.12**). Other artists admitted to AAA at the time included Charles Shaw, Suzy Frelinghuysen and Albert Gallatin himself, all of them familiar with modern European art through travel and in many cases first-hand acquaintance with French, German and other artists in their home environments. By the early 1930s Gallatin had himself begun to paint passably good Crystal Cubist pictures, and with G. L. K. Morris, Frelinghuysen and Shaw had become

known as the Park Avenue Cubists for their competent Europeanism as well as for their social capital within the city.[22] It was a background against which Gallatin as curator now made an important terminological commitment – to sidestep Barr's distinction between different types of 'abstract' art by adopting the concept of 'concretion' already in use in France, Holland and Switzerland to designate an anti-illusionistic manner in art that emphasised values of materiality (even *faktura*) and 'plasticity' instead. The difference was by no means inconsequential. A show titled *Five Contemporary American Concretionists* opened in March 1936, just days before MoMA's *Cubism and Abstract Art*, and showed works by Shaw, Morris, John Ferren, Charles Biederman and Calder that Gallatin now claimed as 'examples of concrete plasticity and simplification', and to which the usual languages of 'abstraction' did not apply.[23] Hans Arp had been the forerunner here: by 'concretion' he had meant the rootedness of forms in real matter, generally clean-edged and with a certain organic look and feel about them, with 'plasticity' as their essential term. In 1937 Gallatin and Morris co-founded a magazine *Plastic/Plastique*, edited by themselves in America and by Sophie Taeuber-Arp, Hans Arp and César Domela in Europe. For its short life *Plastic/ Plastique* functioned as a platform for transatlantic communication about concretion in art, and also as a bridge connecting Europe with America.[24]

By the latter part of the 1930s the Regionalism championed by Benton, Curry and Wood lost traction as the American economy began to revive. Increasingly confident demonstrations by the likes of Gorky, Graham, Diller and Stuart Davis seemed to many to match more closely the vigour of American urban culture in an age dominated by jazz, dancing, motor cars and the powerful resources of narrative film. Davis's Brooklyn housing project mural was finally finished in May 1938 and remains the most complete expression of this colourful, polyrhythmic and multi-referential version of European simultanism, now attuned to match the optimism rather than the anxieties of the age (**fig. 12.13**).[25]

At the same time, the steady influx of black Americans from the southern states to New York – the so-called Harlem Renaissance that had been under way since the mid-1920s – had opened new and difficult questions about the relation of the African American experience to that of the enfranchised cultures of the north.

12.11 (*opposite*) Arshile Gorky, *Mechanics of Flying*, 1936–7. Oil on panel, 275 × 332.5 cm. Newark Museum, New Jersey

12.12 (*above*) David Smith, *Construction on a Fulcrum*, 1936. Bronze and iron, 35.6 × 43.2 × 7.6 cm. Private collection

The painter Aaron Douglas settled in Harlem in 1924, and with other black artists, writers and musicians he initially struggled – by his own testimony – with his Negro identity in the predominantly white metropolis. Was he to dilute or modify that identity for reputational gain? The experience of a visit to the celebrated Barnes Collection in Philadelphia, where he saw West African and Oceanic art as well as European modern art that had taken lessons from them, led Douglas to a practice that openly investigated, and confidently placed in view, the inner trials as well as the dynamics of African American history.[26] His paintings of the 1930s, including a major four-panel scheme for the Harlem Public Library at 135th Street, powerfully and confidently showed the rhythms, struggles and energies of what the black community itself still referred to as Negro life (**fig. 12.14**). In common with others, such as the young Romare Bearden, the priority was less to integrate into white culture than to picture the African American experience in all its richness and resilience.[27]

In the meantime, European Surrealism had taken root in America following MoMA's massive 1936/7 show. The Julien Levy Gallery in New York had begun to show Dalí and other figures, and in November 1938 gave a show to a Mexican artist of rare but uneven gifts. Frida Kahlo had begun painting following a serious motor accident in 1925 and had absorbed the energies of Mexican rural traditions expressed in such things as votive images, small metal *retablos* and decorative forms. André Breton, who first recognised her talent while visiting the exiled Leon Trotski in Mexico in April 1938, understood at once Kahlo's self-positioning at the point of intersection – as he put it – 'between the political (philosophical) line and the artistic line, beyond which we hope they may unite

12.13 (*above*) Stuart Davis, *Swing Landscape*, 1938. Oil on canvas, 224.8 × 443.9 cm. Eskenazi Museum of Art, Indiana University

12.14 (*opposite*) Aaron Douglas, *The Negro in an African Setting*, from *Aspects of Negro Life*, 1934. Gouache with touches of graphite on illustration board, 372 × 406 cm. Countee Cullen Branch, New York Public Library

in a single evolutionary consciousness'. Her painting *Self-Portrait on the Borderline between Mexico and the United States* of 1932, for example, shows the artist standing at the junction between ancestral Mexican culture and what she imagines to be the heavy industrialising reality of the United States. Kahlo's work, Breton wrote apropos the Julien Levy show, 'is a ribbon around a bomb' (**fig. 12.15**).[28] His meeting with Trotski, meanwhile, resulted in an important statement of the modern artist's ideological self-positioning. It was a meeting of unlike minds: 'His understanding of artistic problems was average, at best,' Breton later said of the exiled revolutionary.[29] Yet against the background of the 1936 Moscow show trials in which Stalin's left-wing opponents were summarily removed, and with the rise of fascism in Germany and now the outbreak of civil war in Spain, the two men contrived a text for artists that represented what both had always looked for: a fusion of radical freedom of the imagination with revolutionary politics inspired by the intellectual tradition of Marx. Published in English in the New York journal *Partisan Review* over the names of Breton and Diego Rivera (thus expediently concealing Trotski's authorship), the more or less overt theme of 'Towards a Free Revolutionary Art' was the need for an unhindered association between artists and the political tradition of anarchism.[30]

The timing of the Breton–Trotski statement was apposite on two levels. The disastrous Munich Agreement of September 1938 that allowed Hitler to appropriate Czechoslovakia was followed in April 1939 by the capitulation of the Spanish Republic as France, Britain, Italy and Soviet Russia jostled for alignment in readiness for what looked like inevitable conflict. And with those developments the contrast between the war-mobilising economies of Europe and the American domestic recovery became more and more stark. On 10 April of that year the spectacle of the massive New York World's Fair was launched at Flushing Meadows, Queens, as if to supercharge the recovery in America's technical, commercial and cultural life and of course broadcast it to the world. Perhaps predictably, the fair's exhibition of 'contemporary' American art was a disaster. Stuart Davis, for example, complained of its 'tonal and formal conservatism ... an inability to visualize the reality of change' that corresponded 'to the complacent and uneventful outlook of a very tame house cat'.[31]

At the same time, most young American artists continued to feel abandoned by those who might patronise and support them. On the one hand there was the culture

12.15 (*above*) Frida Kahlo, *Self-Portrait on the Borderline between Mexico and the United States*, 1932. Oil on canvas, 31 × 35 cm. Private collection

12.16 (*opposite*) Museum of Modern Art, West 53rd Street, New York, in 1939. Photograph

of museum directors and trustees that still favoured the European heritage over indigenous American art, and on the other was the principle of federal funding for contemporary art. It was the same conflict that had riven art in America throughout the decade: between the patronage of European modern art with the aid of wealthy commercial families on the east coast and the achievement of genuinely American contemporaneity in art under the aegis of the state. The immediate answer was that power still lay with the growing profession of curators and those wealthy philanthropists who endorsed the importance of the European heritage. In the spring of 1939 two further exhibition spaces were opened in New York, both of them demonstrations of that wealth. On 10 May the Museum of Modern Art transferred to an imposing and well-appointed new building on Fifth Avenue at West 53rd Street, designed by Philip Goodwin and Edward Durell Stone in the International Style (**fig. 12.16**).

The second was due to the endeavours of the artist Hilla von Rebay. Born in Alsace to wealthy parents, she had met many European artists before moving to New York in 1927. There she became acquainted with the mining magnate Solomon R. Guggenheim, whom she persuaded to form a collection of what she called 'non-objective' art of a type to which she and her partner Rudolf Bauer, also an artist, had become devoted, predominantly one of 'spiritual' exploration in the manner of the early Kandinski.[32] The upshot of Rebay's friendship with the Guggenheim family was a fast-growing collection of art by Seurat, Robert and Sonya Delaunay, Léger, Moholy-Nagy, Mondrian, Kandinski, Severini, Calder and others, mostly purchased during the later 1920s and early 1930s despite the ravages of the Wall Street Crash. Installed initially in a former automobile showroom on East 54th Street, the Museum of Non-Objective Painting became the home of some 725 works expressive of 'spiritual' qualities efficiently transplanted from endangered European territory to American soil – it would eventually become the Solomon R. Guggenheim Museum. The meanings of that transplantation were of course multiple: it provided a sudden injection of modern European values into the heart of transatlantic culture, at the same time as it could look like a timely salvage operation at a moment of crisis in Europe itself. Three months to the day from the museum's opening on 1 June 1939 came the eruption, first in Europe and later America, of the Second World War.

The 1940s:
Transatlantic Exchanges

With the start of another war, the tectonic plates of Western life and culture were put under tremendous strain – practically, ideologically, artistically. With modern artistic life at a standstill in Nazi Germany and Soviet Russia and heavily compromised in Spain, in Italy, and in occupied France, personal displacement, geographical confinement or lack of opportunity for discourse and/or exhibition became the order of the day. Some sought opportunities for migration to safer shores. In one pattern, artists in all media fled from Germany to the relative safety of the United States. Several took teaching posts at colleges or research institutes on the east coast, where they promoted the adoption of De Stijl, Constructivist and Bauhaus methodologies in their new surroundings. For them, the mission of modern art, architecture and design was to help reshape the emergence of a stable, progressive and peaceful world order. In another migration, Surrealist artists from Paris fled war-torn Europe to the east coast of America and predominantly New York, where they mixed with a young American but expanding art community already there. The result of that intermingling was a period of confident new energy in American art that took its place alongside the more rational principles that pre-war Europe had been able to supply.

The period after 1945 was one of recovery as well as further division throughout the West. The dropping of atomic bombs on Hiroshima and Nagasaki in August 1945 signalled an end to the war in Japan but sparked a competition between Moscow and Washington to develop thermonuclear weapons of unprecedented destructive power. With British war leader Winston Churchill's 'iron curtain' speech in Fulton, Missouri, in March 1946, in which he referred to the carving out of an eastern 'bloc' of European nations subservient to the Moscow line, signs were fast accumulating that the ravages of the war had given rise to a decidedly uneasy peace. While totalitarian nations continued to regulate those cultures that they could control, a degree of competition began to emerge between the art communities of Paris and New York, the one insisting on a rewriting of the rules of European humanism, the other turning initially to ancient myths and archetypes as the basis on which an art of true contemporaneity could be born.

Geometries of Hope

The migration and dispersal of European artists at the beginning of the Second World War rearranged the national geographies of modern art. Some sought refuge in London, a city not known for its commitment to the modern movement in the later 1930s, yet one still able to offer a haven to those displaced by the international crisis. Piet Mondrian reached London in September 1938 intending to sail for America as soon as possible. When war broke out the following year he was invited to accompany Barbara Hepworth, Ben Nicholson and others to the safety of Cornwall. The prospect was anathema to him: 'The country [i.e. countryside] upsets me,' he wrote to Hepworth in September 1939.[1] With news of the occupation of Paris in June 1940 and fears of a German attack on London, he still resisted. Yet encouraged by financial support from friends in New York including Frederick Kiesler and Harry Holtzman, and after setting aside his London friendships, Mondrian crossed the Atlantic in late September 1940, albeit with few paintings completed during his English stay.

Mondrian was already a figure of some interest to artists in New York. Familiar to many from MoMA's *Cubism and Abstract Art* show, his work was in Gallatin's collection (thanks to Jean Hélion's urging) and in MoMA's collection too. Neo-Plasticism was already being studied closely by younger artists such as Burgoyne Diller and Holtzman, two founder members of the American Abstract Artists. Other AAA figures such as G. L. K. Morris and Fritz Glarner were also admirers. Yet for some, it was not in its application to plane painting that Mondrian's example was most strongly felt, but in the possibilities Neo-Plastic thinking held for the modality of relief. Relief painting – the projection of geometric features forward of the ground plane of a picture into real space – had been attempted in the period 1938–40 by AAA members Balcomb Greene and Vaclav Vytlacil as well as by Diller and Holtzman. Diller, to take his example, made a series of works by positioning wooden spars in front of the ground plane, some spars projecting far enough forward to cast shadows on the surface behind. His works showed an obvious sympathy for the spirit of modern architecture and planning, and reached a well-enough considered compromise between Mondrian's example and actual design (**fig. 13.1**). The work of the independent-minded American Charles Biederman can be compared. Not an AAA member, Biederman had followed Mondrian's methods devotedly while in Paris in the mid-1930s, but was back in New York by 1937 and finding the Dutchman's obsession with the plane surface restrictive. To begin with, he turned to van Doesburg's methods as well as the Russian Constructivists, the latter for their pioneering use of the relief form. But he then disaffiliated himself from

both those paradigms and retreated to Chicago in 1941, then to Minnesota, to work on a lengthy (and influential) written critique of both De Stijl and International Constructivism, after the publication of which his work began to blossom on its own terms (**fig. 13.2**).[2]

By the time of the third AAA exhibition at the Riverside Museum, New York, in March 1939, it could be said that geometrical painting and relief in the traditions of Constructivism, De Stijl or the Bauhaus had become almost the dominant tendency of the group. Yet by the time of their fourth exhibition, in June 1940, the AAA had become frustrated by the lack of recognition accorded to it either by the prestigious Museum of Modern Art or by the more 'spiritual' programme of Hilla von Rebay at the Museum of Non-Objective Painting. In April, some fifty AAA members held a demonstration on the pavement outside the Museum of Modern Art and handed out copies of a circular titled 'How Modern is the Museum of Modern Art?' – the cover was designed by a young painter called Ad Reinhardt. The museum responded by declaring the circular a work of art, hence 'killing the protest with kindness', in the recollection of AAA member Ilya Bolotowski.[3] It is true on the one hand that MoMA's priorities in the early stages of the war were largely informational and related directly to the war effort. Yet equally, the AAA's attachment to De Stijl and Constructivist principles looked somewhat reductive, as if stepping beyond them was not proving easy. It was as if European traditions would need to find new sources of sympathy in order to survive.

As to Mondrian, his presence in the city was that of a modern master at the end of his career. Yet on his arrival he was bowled over by the pace of the city's culture and its music rhythms especially. Boogie-woogie dance music was having a late revival, swing

13.1 (*top*) Burgoyne Diller, *Construction*, 1938. Painted wood, 37 × 31.9 × 6.7 cm. Museum of Modern Art, New York

13.2 (*bottom*) Charles Biederman, *#27, Giverny*, designed 1952 (fabricated 1971). Painted aluminium, 99 × 83.8 × 10.1 cm. Weisman Art Museum, University of Minnesota

bands were popular, and the European countryside was a distant memory. Of some significance, then, is that his *Broadway Boogie-Woogie* of 1942–3 was a major departure from Neo-Plastic first principles, in that it abandoned firmly stated linearity in favour of unequal rectangles of colour suspended upon what could easily look like the street plan of New York itself. That is its superficial appearance. In fact the painting's micro-rectangles, suspended at irregular intervals along what used to be linear strips, not only in effect destroy those linear strips but wrestle anew with the problem of the ground plane itself – the problem of the construction of the painting as non-illusionistic in any sense. An unfinished work, *New York City I* of 1941, shows that Mondrian had tried another solution, that of weaving continuous red, yellow and blue lines above and below one another as if reaching for a purely optical depth – perhaps even a flickering movement between parts. Then in *Victory Boogie-Woogie*, left unfinished at the time of his death in January 1945 (though titled in anticipation of victory in the war) we see another attempt to achieve a dynamic variation on the principles governing his much earlier work. In diagonal format, the work contains coloured paper squares placed experimentally in positions that give real presence to the near white rectangles that lie in between **(fig. 13.3)**. Together, this group of works exemplifies what in a late statement Mondrian described as his final escape route from Cubism:

> To move the picture into our surroundings and give it real existence has been my ideal since I came to abstract painting ... The attitude of the Cubists to the representation of volume in space was contrary to my conception of abstraction which is based on belief that this very space has to be destroyed.

Boogie-woogie music, he says, 'I conceive as homogeneous in intention with mine in painting: destruction of melody which is the equivalent of the destruction of natural

13.3 (*above*) Piet Mondrian, *Victory Boogie-Woogie*, 1942–4 (unfinished). Oil, charcoal and pencil on canvas, 127.5 × 127.5 cm. Gemeentemuseum, The Hague, on permanent loan from the Institute Collections, Netherlands

13.4 (*opposite*) Anni Albers, *Monte Alban, Oaxaca*, 1936. Silk, linen and wool, 146 × 112 cm. Busch-Reisinger Art Museum, Harvard University

appearance; and construction through
the continuous opposition of pure means –
dynamic rhythm'.[4] For all that, Mondrian's
lifelong commitment to the straight
line, the interval and the right angle did
not prove easy to sustain in New York
after 1945. A retrospective of his work
at the Museum of Modern Art in that
year was not enough to stimulate much
further experiment with the ethics of the
dynamically equilibrated plane.

What then of the Constructivist and
Bauhaus inheritances? Here, the migration
of Europeans to the United States brought
important artists to a culture increasingly
finding its way. Anni and Josef Albers
arrived in America in 1933 to take teaching
posts at Black Mountain College, North
Carolina, where a spirit of experiment
and enquiry helped generate, in their work and that of their students, an acute
consciousness of the relation of form and material to temporality; that is, to rhythm
and pattern that could appear to unfold in time. Soon after their arrival in America,
the Alberses began making frequent visits to the ancient architectural sites of Mexico –
Mitla, Tenayuca, Uxmal and Oaxaca – where they found a richness of formal intelligence
in the sequences, symmetries, subtle irregularities and rhythms characteristic of an
almost forgotten civilisation; rhythms rendered all the more striking when captured
on the plane, even in a snapshot photographic print. Anni Albers in those years was
proving herself to be a virtuoso weaver of intersecting grids, layered patterns and –
sometime later – the meandering but space-occupying line, in a medium in which thread
itself was an active ingredient, and by a method she called 'listening to the dictation of
the material'.[5] When displayed frontally on a wall, Albers' woven panels could address
a viewer with the same – or greater – complexity as the most carefully temporalised
structures of abstract painting (**fig. 13.4**). Josef Albers himself observed in a lecture
of 1939 that the pre-Columbian culture they saw in Mexico contained 'form problems
very little known in the Western tradition' and which could be made 'alive again in
abstract art'.[6] True to those principles, his own work of the early war years internalised
such rhythms and restated them in their fundamental forms, mobilising temporalities
by doubling, inverting and respatialising some simple geometries of the plane (**fig. 13.5**).
In this way these Bauhaus refugees adopted their European experience to produce
formats expressive of the tangible traditions and energies of the 'new world'. The
Alberses retained their influential positions at Black Mountain until moving to Yale
University in 1949.

Other Bauhaus figures had been welcomed before the war. Walter Gropius and
Marcel Breuer both took up posts at the Harvard School of Design in 1937. The same
year architect Ludwig Mies van der Rohe, last director of the Bauhaus, accepted a
post at the Armour Institute of Technology (later the Illinois Institute of Technology)

in Chicago, after the war to become a leader of the Chicago School of modernist architects and planners. László Moholy-Nagy, after a lacklustre interval in London between 1935 and 1937, accepted a post at a contemporary design school established by a group of businessmen in Chicago. Moholy had called it the New Bauhaus: American School of Design, and it later became the Chicago School of Design (later still to be incorporated into the Illinois Institute of Technology). Until his untimely death from leukaemia in late 1946 Moholy produced an enormous number of colour photographs, many of them time-exposed to reveal extraordinary patterns of human movement; also stationary and mobile sculptures in single-sheet Plexiglas (bent by heating in a kitchen oven) as well as experimental colour- and light-dependent works (**fig. 13.6**).

An intriguing case of Bauhaus principles adopted in American art is that of Irene Rice Pereira. She found her feet as an artist while working at the innovative Design Laboratory set up in New York by the WPA Federal Art Project in the mid-1930s, an initiative for training designers and artists along Bauhaus lines. As an artist and teacher Pereira was absorbed in the properties of materials, in hope for 'universal' standards for aesthetic work, and in the prospect of a fusion of art and design. Around 1940 she began experimenting with the optics of painting on plastics and glass, following earlier experiments by Moholy-Nagy and Albers. Positioning a glass sheet in front of a background plane, rectilinear markings on the front plane would cast shifting shadows and reflections on the plane behind – a situation both optical and relief-like at the same time. Increasingly well regarded by curators (including Alfred Barr, who purchased two of her works for MoMA), Pereira during the early 1940s was one of the foremost female figures in the rapidly expanding New York scene. At a one-person show at Peggy Guggenheim's Art of This Century in January 1943 her experimentalism was widely noticed.[7] And she was now beginning to show independence of Bauhaus precedents in art. Works like *Reflection* of 1943 or *Glass Painting: Reflection* of the same year reveal a layered spatial organisation that originated in research into perceptual and cognitive unities that unfold only gradually in time. For one thing, she had begun to explore the theories of Gestalt psychology, particularly Gestalt's founding proposition that perception begins with the whole unit (optical, musical, social, ethical) in relation to which other, subordinate units find a subordinate place. For another, she had become interested in C. G. Jung's theories of the archetype and of the personal and collective unconscious. The result was that, by 1945 or 1946, she had found a way to make the constructional organisation of a layered glass painting a kind of embodiment of the Jungian mind. A painting such as *Transversion* of 1946, with its two layers of glass floated above a rear-ground plane, reads like a complex demonstration – if a somewhat literal one – of 'surface' psychological constructs emerging from a chaos of richer

13.5 (*opposite*) Josef Albers, *Penetrating*, 1943.
Oil, casein, tempera on Masonite, 54.3 × 63.2 cm.
Guggenheim Museum, New York

13.6 (*above*) László Moholy-Nagy, *Double Loop*, 1946
(replica 1971). Plexiglass, 41 × 56.5 × 44.5 cm.
Pinakothek der Moderne, Munich

patterning deep beneath (**fig. 13.7**).[8] The gradual shift in Pereira's work from Bauhaus-type analysis towards depth psychology may reflect a growing sense, at least in New York, that by the mid-1940s the more rational European inventions in art were acquiring the status of traditions that had run their course.

In the case of the Constructivist wartime migration, the pattern is no less rich and varied. First-generation Russian Constructivists, persecuted inside the Soviet Union since the early 1930s, had not been able to leave the country. Others had proved more fortunate. Take the brothers Naum Gabo and Anton Pevsner. In fact their version of Constructivism had differed from that of the First Working Group around Rodchenko in 1921. At that time they had claimed to be Constructivists *as artists*; had objected to the orientation of Rodchenko's group towards utilitarian construction in the discussions leading to Production art. Leaving Russia in 1922 for Berlin, Gabo taught briefly at the Bauhaus in 1928, and after some lean years arrived in London in the winter of 1935/6. There, he had joined a small circle of enthusiasts who orchestrated

13.7 (*above*) Irene Rice Pereira, *Transversion*, 1946.
Ceramic fluid and porcelain cement on two planes of
corrugated glass over oil on hardboard, 34.3 × 40 cm.
Phillips Collection, Washington

a publication the following year whose very title is revealing. Edited by Lesley Martin, Ben Nicholson and Gabo, *Circle: An International Survey of Constructive Art* was a compendium of statements by figures from art, architecture, town planning and material science in favour of 'constructive' (that is, broadly modern-movement) approaches, including Mondrian (at that point still in Holland), Hepworth, Moore and of course Gabo himself. *Circle* was among other things a challenge to the ethics and politics of Surrealism. 'Construc*tive*' art and design, in its own way utopian, offered visions of a culture built upon material elements in rational, articulate relations based on Enlightenment humanism rather than Marxism–Leninism – not on the eradication of art. Yet at the onset of war in 1939 *Circle*'s optimism had been forced into retreat. Gabo, who by that time had already decided to leave England for America, was unable to travel since the ship on which he was due to embark was sunk in mid-Atlantic and he had to settle in St Ives, Cornwall – with some reluctance. 'I am resigned to make the most of this abode,' Gabo wrote despairingly to a friend in June 1941, unable to work productively apart from some time spent in drawing.[9]

In fact the remote coastal community was not altogether unconducive. Gabo soon began to make new works with spiralling or twisting forms, achieving a delicate transparency with clear Perspex and thin cord, materials relatively untried by sculptors and not easy to obtain in wartime. In one sense they continued the project of achieving space without solid volume that he and Pevsner had launched back in 1920 (**fig. 13.8**). In another sense such works were responsive to the rough beauty of his new location where wind, waves and cloud formations presented dramas of rhythm and mobility

13.8 Naum Gabo, *Linear Construction in Space No. 1*, 1942–3. Perspex with nylon monofilament, 34.9 × 34.9 × 8.9 cm. Tate Gallery, London

13.9 Ben Nicholson, *1945 (still-life)*, 1945. Oil paint and graphite on canvas, 83.6 × 66 cm. Tate Gallery, London

that could not but leave their mark. By contrast, Ben Nicholson, pioneer modern artist of mid-1930s Britain, took a step backwards towards Cubist table-top pictures now organised around precise, interlocking profiles of cups, bottles, table-legs, objects on a nearby ledge (**fig. 13.9**). In the meantime, Gabo's brother Anton (now Antoine) Pevsner, since 1923 living and working in Paris, was working tirelessly at 'open' sculptures made not by using transparent materials but by evolving 'developable surfaces', as he called them, in effect linear units arranged fan-shaped so as to make curving, interconnecting planes that created open, developing spaces rather than an enfolded one. His *Developable Column of Victory*, for example, fashioned in bronze and oxidised tin, was made in anticipation of the end of the war and by implication was suitable for positioning – at scale and in public – as a symbol of defiance in a culture both optimistic and communitarian.

Indeed, both brothers took seriously the possibilities of scaling up various of their wartime projects and placing them in spaces where people and traffic circulate – a vision for the post-war world that germinated even while the war in Europe was raging. 'My constructions, in the main, are meant … for an open space in the new towns,' Gabo wrote to Herbert Read in the middle of the war. 'I am trying to forestall an eventual demand and prevent a probable accusation of ignoring the needs of the community.'[10] When his *Linear Construction in Space No. 1* was presented in the London journal *Horizon* in July 1944 Gabo wrote, again to Read: 'I have chosen the absoluteness and exactitude of my lines, shapes and forms in the conviction that they

are the most immediate medium for my communication to others of the rhythm and state of mind I would wish the world to be in'.[11] Pevsner's attitude was similar. Invoking the victory of good over evil, order over chaos, the brothers' optimism won them admirers once the war was over; but their acceptance was uneven. On reaching the United States in November 1946 Gabo found that a hostility to Russians and Russian artists was becoming tangible, and for a while few public or other commissions came the way of either brother. When they did, the majority were for commercial and corporate plazas in which the distinction between business values and those of the community was blurred. For instance, a version of Pevsner's *Developable Column of Victory* was positioned outside the Eero Saarinen-designed General Motors Technical Centre in Warren, Michigan in the mid-1950s, as if to celebrate the triumph of the motor car (**fig. 13.10**).

Nevertheless, Pevsner's *Column* can profitably be compared with the unashamedly triumphalist memorial by the Russian artist Evgeni Vuchetich, situated in Treptower Park in Berlin to mark the liberation of the city in 1945 by the Soviet army (**fig. 13.11**). The airy optimism of the one compared with the ponderous symbolism of the other lends weight to the claim of both Gabo and Pevsner that their experiments with space and rhythm represented the best hopes for the historical re-emergence of true Constructivist thinking once the period of Socialist Realism in Russia was over. Yet when both artists were given a prestigious joint exhibition at the Museum of Modern Art in 1948 they were celebrated, not as artists of public projects but in terms of sculptural art alone. For his part, Gabo in a lecture at Yale University that year held out vigorously for a fruitful relationship between artists and the task of constructing forms and environments for a restructured contemporary world – and for freedom to work without harassment from 'the blind forces trying to make us do what we do not believe is worth doing'.[12]

For other consequences of pre-war European methods in art we move to South America. The Uruguayan artist Joaquín Torres-García had been active in Paris in 1929–30 in the group Cercle et Carré and in the discussions around *Art Concret* and Abstraction-Création; but had returned to South America after the financial crash and set about

13.10 (*opposite*) Antoine Pevsner, *Developable Column of Victory*, 1944–6. Bronze and oxidised tin. Photograph of work outside General Motors Technical Center, Warren, Michigan. Library of Congress

13.11 (*above*) Evgeni Vuchetich, *Soviet War Memorial*, 1949. Treptower Park, Berlin

galvanising his home culture by teaching, writing and doing new artistic work. En route for South America in Madrid in 1933 we hear him urging that, 'by the law of epochs', art in a time of evident historical transition must become anti-romantic – above all that it must escape from the clutches of a then fashionable Surrealism. The individual will count less and less, he said, in a period in which order and moderation must become the main principles of art. What he called a 'concrete realism … with a constructive base' must be made to prevail.[13] Arriving in Montevideo in 1934, he began to lecture on the need for the South American nations to throw off their colonial status and meld the principles of a much older pre-Columbian culture with whichever lessons Europe could still usefully supply. The first step in 'repositioning the South' – as he put it – would be an attitude of 'Constructive universalism' as an antidote to the 'full decadence and disorientation which is Surrealism'. A classical monumentality based on the ancient cultures of the Americas should be submitted to rules of structure such as to achieve a consonance between abstract means and an awareness of the continent's much deeper past (**fig. 13.12**).[14]

In practice it took until 1944 before the true impact of Torres-García's energies came to fruition, in the Argentine capital Buenos Aires. The Uruguayans Rhod Rothfuss and Carmelo Arden Quin founded with two others, Gyula Kosice and Tomás Maldonado, a group calling itself Arturo, with a short-lived journal that made clear their opposition to both Expressionism and Surrealist automatism: the subtitle of *Arturo*'s single issue

13.12 (*above*) Joaquín Torres-García, *Constructive Painting 16*, 1943. Oil on board, 43.2 × 64.1 cm. Patricia Phelps de Cisneros Collection

13.13 (*opposite*) Tomás Maldonado, *Development of a Triangle*, 1949. Oil on canvas, 80.6 × 60.3 cm. Museum of Modern Art, New York

was *Invención contra automatismo* (*Invention against Automatism*), with the group committing itself to 'invention' – but with awareness, with 'cold calculations, patiently prepared and applied'.[15] In fact, it was not long before two emphases could be discerned within the now energised Argentinian community. In one, a group led by Maldonado stayed close to the spirit of van Doesburg's impersonal Elementarism and called itself the Asociación Arte Concreto-Invención (Concrete Invention Art Association), supportive of articulate pictorial relations and a socially collective orientation to real things (**fig. 13.13**). The same approach in the medium of relief might involve first abandoning the picture frame and positioning small groups of simple coloured forms forward of a background plane in a demonstration of clear formal articulation at either pictorial or (potentially) architectural scale.

The second Argentinian tendency, called Madí, was assembled around Rothfuss, Arden Quin and Kosice and came to life in the summer of the same year. For Madí supporters, the priority was for cross-media experiment that might embrace performance, music, theatre, fiction and dance, even a hint of European Dada. In the visual arts Madí was open to rotating or movable forms, variable contours, even curved or concave surfaces located somewhere between painting and sculpture.[16] Rothfuss had already campaigned to 'break the frame', in a polemic in *Arturo* in 1944. If art no longer needed to imitate nature, he had argued, the artist can feel closer to it – to the point of discarding the conventionalism of the rectilinear frame. In fact, whatever frame there might be must receive its structure from the artwork's own composition. Conversely, decisions about the frame could begin to formulate the entire work of art.[17] In that way, speculations about the frame suggested rewriting relations between painting and sculpture (**fig. 13.14**). Arden Quin gave a private lecture on 'The Mobile' in 1945, in which he shared Rothfuss's principle that the square form and the right angle are not sacrosanct – but went further in stating that any return to the rectangular order 'we cannot accept under any circumstance'. An impulse to radical cultural change was intrinsic to both Arte Concreto-Invención and Madí, at a moment when Argentina was about to be engulfed by the doomed presidency of Juan Perón. For Quin, the idea of the jointed object with movable parts created an analogy with history itself in always imminently changing, in never staying still. Crediting the Italian Futurists as well as the work of Calder and Moholy-Nagy, Quin announced that 'our aim is to assert Plurality and Playfulness, to work with angles of all kinds, to use mass and void in a dialectical game: shine; transparency; real movement'.[18]

The work of the Hungarian-born Kosice was crucial to Madí's influence and success. Editor of the magazine *Arte Madí Universal* between 1947 and 1954, his own earliest

sculptures were assembled with joints allowing a degree of movement between parts –
either by suggestion or by changes that the viewer could make to the piece. 'Our aim
was not to establish geometrical order' – here Kosice repeats the Madí formula – 'nor
to search for an objective expression of reality signifying rationality', but rather a deep
reflection, as he put it, 'on man's condition of existence on planet earth' (**fig. 13.15**).[19]
From the outset Madí art was kinetic, and its works pointed to a tendency that would
develop internationally in the years to come.

A notable case is the arrival of Concretion in Cuba, pioneered from the early 1950s
by the Romanian-born Sandú Darié, an arrival from war-torn Paris some years before.
Darié's earliest works in this vein were brilliant readings of Mondrian's experiments,
relief-like as well as fully kinetic, and he and the Argentinian groups were soon
in mutual contact.[20] A full international dialogue about Concretism was by now well
under way. In another example, Maldonado, on his first trip to Europe in 1948, met
Georges Vantongerloo and Max Bill, two artists who were already relaxing a previous
confinement to straight-line geometry and exploring the enchantments of more complex
and curvilinear form. What Maldonado learnt from them confirmed his adherence to
rational and impersonal procedures in art but opened him to the possibility that form
could be rhythmic and generative, and suffused with the dimension of time.

Bill, for his part, following his 'Konkrete Gestaltung' announcement of 1936, had
been instrumental in founding the Allianz ɹroup in Switzerland in 1937 and in planning
and realising various Allianz exhibitions: in Basel in 1938, in Zurich in 1942 and 1944,
and after the war in Zurich with the large *Allianz: Vereinigung moderner Schweizer*

13.14 (*opposite*) Raúl Lozza, *Relief no. 30*, 1946. Oil, alkyd, pine resin, wax and acrylic on wood and metal wire, 41.9 × 53.7 × 2.7 cm. Museum of Modern Art, New York

13.15 (*above*) Gyula Kosice, *Röyi no. 2*, 1944. Wood joined with bolts and wing nuts, 12 × 64 × 15 cm (variable). Museum of Fine Arts, Houston

Künstler (*Allianz: Association of Modern Swiss Artists*) in 1947. Switzerland's neutrality throughout the war, combined with the reputation of its culture for precision and clarity, lent to its younger artists a sense of real opportunity. Earlier concepts of 'concretion' now began to reopen themselves to a residue of the Dada spirit. Bill himself would write in the Zurich journal *Werk* in 1949 that concepts of space and energy then being uncovered by contemporary cosmologists could stimulate the modern imagination in ways that anyone with a taste for paradox could surely enjoy. His palpable excitement at the popularisation of topology, space–time curvature, field theory and much else stemmed from the possibilities of convergence between the application of the most rigorous rationality and a sense of 'nature' in its most hard to predict, irregular forms (**fig. 13.16**). It was an outlook he shared with Vantongerloo.[21] Such cosmological phenomena are 'projections of latent forces that may be active or inert', Bill proposed; 'in fact that music of the spheres which underlies each man-made system and every law of nature it is within our power to discern'.[22] 'Konkrete Kunst,' he could now claim, 'is real and intellectual, a-naturalistic while being close to nature. It tends towards the universal and yet cultivates the unique. It rejects individuality, but for the benefit of the individual.'[23]

This important conceptualisation was in large measure shared by Bill's compatriot Richard Paul Lohse, who himself conceived of Konkrete Kunst in ultimately social terms. Untrained as an artist but well acquainted with Paris Cubism, Lohse had been active in the struggle against fascism before the war and was coming to theorise the links between visual form and the development of cognitive and democratic freedoms. He had already examined the work of Mondrian and van Doesburg closely and had come to believe that systematicity *as such* must underlie any credible modern and democratic art. Thus Lohse's own *Konkretion* paintings, launched in 1943, begin from the specification of an 'element' on which the total work is based before then unfolding in arrangements of self-coherent entities called 'groups' that exist in relatedness to each other in ways that the viewer could imaginatively explore (**fig. 13.17**). By the end of the 1940s Lohse was developing a conception of a social-political mission for art in which a 'system' would function not as a completed structure but as a demonstration of rational, egalitarian relations taking shape in pictorial form.[24] Lohse's

13.16 (*above*) Max Bill, *Endless Ribbon*, 1953 (conceived 1935). Granite, 111.7 × 134.7 (with base) × 116.8 cm. Baltimore Museum of Art

13.17 (*opposite*) Richard Paul Lohse, *Konkretion III*, 1947. Oil on fibreboard, 79.5 × 114 cm. Lohse Foundation, Zurich

aesthetic-cum-social thinking was nothing if not ambitious. A later statement from the critic Hans Heinz Holz argued that his project succeeded in purging International Constructivism and De Stijl of any such remaining excesses as 'ideas of the artist' or 'a feeling for form'. He further explained that though Lohse gave his work the validity of a mathematical deduction, his paintings in their final appearance made evident how those objectives had been achieved – how their systems of relations had 'come into existence through the construction process' in a manner both processual and optimistic.[25] Lohse himself spoke eloquently of systems that 'make possible' combinatory orderings; of the 'bringing-to-visibility' of process; of how 'necessity and succinctness' are achieved as kinetic and flexible qualities in the relations between forms. In fact Lohse claimed that his new serial and modular paintings stood 'as parallels to expression and activity in a new social reality'.[26]

The years after the end of the Second World War were a time of both opportunity and reckoning for those still basically aligned with De Stijl, Constructivism or the Bauhaus. Others, scarred by the experience of war, could not easily identify with what they took to be cool calculation alone. Wasn't there room for scepticism about 'progress' defined in terms of reason and patient experiment, essentially the ideals of the European Enlightenment? The art historian Robert Goldwater, an American expert in ethnic and 'primitive' art, was at that moment detecting a growth of interest in art 'in which emotion has not been subjugated, in which uncontrolled feeling breaks through'.[27] We shall see next how, in both Europe and America, 'control' and 'uncontrol' in modern art were becoming opposing and highly contested terms.

Art between Paris and New York

Another kind of exodus of European artists to America took place between the summer of 1939 and the fall of Paris in June 1940. The route was from the French capital to the unoccupied south of France, or clandestinely across northern Spain to Lisbon, thence by ship to South America or New York. Several Surrealists, sheltered by a Committee of Aid to Intellectuals organised by an American, Varian Fry, assembled in Marseilles and waited in an atmosphere of despair leavened mostly by creative tomfoolery.[1] As a German, Max Ernst was interned as an alien in May 1940 and reached New York only in July 1941. The young English Surrealist Leonora Carrington, by now Ernst's partner, suffered a breakdown and made a nightmarish journey to join him via northern Spain and Portugal which she related in a book *En Bas* (*Down Below*) in 1944.[2] Wolfgang Paalen, who had left Europe for New York in the spring of 1939, managed to organise an *International Surrealist Exhibition* in Mexico City in February 1940 that brought together major Surrealist works with pre-Columbian objects, drawings of the mentally disturbed and other artefacts. Breton's own passage to New York, via the French colony of Martinique in the company of the anthropologist Claude Lévi-Strauss, enabled him to pause there and meet the poet Aimé Césaire before continuing via Guadeloupe and Santo Domingo, this time with the Massons. The experience of Caribbean occult culture, poetry and – to the European view – extraordinary vegetation lent to wartime Surrealism a degree of nature mysticism unknowable in pre-war France.

 In this way New York in 1940 and 1941 became the meeting ground of a highly charged European Surrealist sensibility and an initially resentful young American generation whose own artistic identity was by no means yet formed. By then, modern European masters of the status of Picasso, Matisse, de Chirico, Arp, Miró and Dalí had growing reputations on the American scene; and the Museum of Modern Art had staged *Picasso: Forty Years of His Art*, including *Guernica* and fifty-nine studies for the painting, between November 1939 and January 1940 before travelling the show to eight other cities across the country.[3] Shows of Miró and Dalí followed at MoMA during 1941 and 1942, while its support for young American artists remained negligible. With the presence in the city of Ernst, Magritte, Tanguy, Victor Brauner, Kurt Seligmann, Paalen, Roberto Matta and Gordon Onslow Ford, it is not surprising that the young Americans did not always know how to respond. Several were already congregating in Lower Manhattan. Gerome Kamrowski had arrived from the Mid-West in 1938 and began associating with William Baziotes, himself from Pittsburgh via the WPA scheme. The Italian American Peter Busa had been in the city since 1933, had trained at Hans Hofmann's school, worked

under the WPA and knew the painter Jackson Pollock – from Wyoming, and a student of Benton – who also had experience with the WPA. In 1940 Robert Motherwell was still an art history student at Columbia University, but with a growing urge to do his own painting. By the winter of 1940/1 the Americans were putting their WPA experience behind them and getting to know the *emigré* Surrealists in a spirit of enquiry and experiment. Soon, a dialogue between the two communities was under way.

Two events may be singled out. In the winter of 1940/1 Baziotes brought Pollock to Kamrowski's loft on Sullivan Street to experiment with some new methods of paint application that in retrospect appear close to Surrealist automatism. The result, a small three-person collaborative painting measuring some 48 by 65 centimetres, shows a degree of trial and error in the techniques of applying paint (**fig. 14.1**). *Untitled* is also free of those linear Cubist facets that had been foundational in European painting for a generation: its form-language is that of irregular, organic shapes that could exist on either a cosmic or a microcosmic scale – and shares only with Arshile Gorky's *Sochi* paintings of those years a recognition of nature in its most primal and mutable states (**fig. 14.2**). More widely, it was in questions of attitude – of posture, of concentration, even mood – that the Europeans and the Americans were beginning to explore a degree

14.1 William Baziotes, Gerome Kamrowski, Jackson Pollock, *Untitled: Collaborative Painting*, 1940–41. Oil and enamel on canvas, 48.9 × 65.4 cm. Private collection and Weinstein Gallery, San Francisco

of common ground. The Englishman Gordon Onslow Ford gave a series of well-attended lectures at the New School of Social Research in the spring of 1941 in which he spoke of de Chirico, Ernst, Miró, Magritte, Tanguy, Brauner, Seligmann, Paalen, Matta (and himself) in terms that urged those present to find 'the marvellous' locked inside what he called 'the ignored powers of man and the unknown aspects of nature'; of the need, as well as the opportunity, 'to tear down the veils one by one that hide the reality of our incomprehensible universe'.[4] To some of those present, this could also mean ancient cultures far less industrialised than their own. It is no accident, then, that the American Museum of Natural History now became as important a resource for artists in New York as the latest issues of *Minotaure* or *Cahiers d'Art*. By the time of America's entry into the Second World War early in 1942, following the bombing of Pearl Harbor by the Japanese in December 1941, young Americans and a community of European Surrealists were living in proximity as well as in mutual conversation.

In 1942, the first year of America's commitment to the war, the question for the aspiring American artist was how to make use of the European experience while finding a persuasive – in some sense – style of his or her own. Roberto Matta, in New York since 1939 and relatively settled in his own convictions about nature and the instinctual zone, provided some essential training for certain of the Americans. Coming late to the Surrealist conversation, he nevertheless already possessed

14.2 (*above*) Arshile Gorky, *Garden in Sochi*, 1941. Oil on canvas, 112.4 × 158.1 cm. Museum of Modern Art, New York

14.3 (*opposite*) Roberto Matta, *Like Me, Like X*, c. 1942. Oil on canvas, 88.3 × 108 cm. University of Iowa Museum of Art

what a close observer described as 'a common feeling for original violence'. With Matta, wrote Marcel Jean, 'invention is derived from a sort of automatism' – he was referring to how material accidents and the unforeseen interplay of colours in Matta's practice generated suggestive shapes from which explosive landscapes would often emerge **(fig. 14.3)**.[5]

One of Matta's earliest American tutees was Robert Motherwell. The two of them spent the summer of 1941 in Mexico where Motherwell, according to his own testimony, found a way of using ink and paper in a more instinctual manner than his erstwhile New York mentor Seligmann had been able to suggest. The following year Matta himself began a series of Saturday-morning classes in his studio involving Motherwell, Busa, Baziotes, Pollock and Kamrowski, all at a formative stage in their careers. According to Matta, Surrealist automatism and what he called his students' first-hand 'sense of America' – the scale and diversity of the country – fitted together like hand and glove. Busa, up to that time a devotee of Léger and Picasso and with WPA experience behind him, recalled that it was less Surrealism than Matta's own presence among them that provided a key – his insistence that they *not* try to 'make art', rather tie the making of art to the experience of 'life', the felt conditions of the moment – the inverse of Dalí-like illustration of a psychological scene. It helped that Matta's counsel was of a general rather than particular sort: to follow Breton's pleas for 'total emancipation', but with possibilities contained within the painting medium itself, its fluidity and lyricism, its propensity to provoke accident and error, even abject failure if that is what the situation suggested. Other precepts soon entered the conversation and stayed there: 'breaking down the barriers between art and life'; 'everyone holding on to *art* and not willing to take up anti-art or the destruction of art'; in Pollock's words 'destroying yourself and working your way out of it'. Or as Busa reports Pollock saying: 'Don't control accident. Use it. Let it be yours!'[6]

Meanwhile, a new network of art dealers and museum curators, critics and newspaper reviewers was taking form. The Guggenheim heiress Peggy Guggenheim had learnt about French and British Surrealist art at the time she opened her gallery Guggenheim Jeune in London in January 1938. During her years in Europe in the later 1930s, and with Marcel Duchamp's advice (aided by Herbert Read and Theo van Doesburg's wife Nelly), she had amassed a collection of European modern art which at the outbreak of war was stored clandestinely in the south of France before being shipped to New York in the spring of 1941. Herself arriving in New York in the company of Max Ernst (they would marry in December that year), Guggenheim began planning

a gallery to house her collection as well as show the work of mostly younger European artists. After further purchases in America, Guggenheim's Art of This Century gallery opened in a suite of rooms at 30 West 57th Street at the end of November 1942. With a printed catalogue of her collection completed thanks to a collaboration with Ernst and Duchamp, her gallery spaces were moulded by the celebrated designer Frederick Kiesler in highly unconventional style. Aside from a single 'daylight gallery' of conventional layout, Kiesler's two larger rooms, an Abstract Gallery and a Surrealist Gallery – the former with diamond-shaped display mountings and the latter with curved panelling, movable screens, dynamic lighting and curvilinear seating areas – were designed to animate the exhibits, often literally, and intensify the viewer's experience by techniques of defamiliarisation, variation and surprise (**fig. 14.4**).

To begin with, Art of This Century exhibitions bore the stamp of Guggenheim's friends and advisers, notably Ernst, Breton, Duchamp and Howard Putzel, a gallerist based in California. A Duchamp *Boîte-en-valise*, boxes by Joseph Cornell and *Bottles* by Laurence Vail made up the first show. The second, titled *Exhibition by 31 Women*, of January and February 1943, remains perhaps the largest all-female exhibition in all of modern art.[7] Despite mixed reviews and low commercial success, it nevertheless marked a rise in the visibility of ambitious women in a culture generally dominated

14.4 (*above*) Art of This Century gallery, Abstract Gallery, installation view looking south, 1942, including works by Kandinski, Vantongerloo, Vordemberge-Gildewart, Charles Howard, Calder, Ozenfant, Pevsner. Photograph by Berenice Abbott. Guggenheim Museum, New York.

14.5 (*opposite*) Jackson Pollock, *The Moon Woman*, 1942. Oil on canvas, 175.2 × 109.3 cm. Guggenheim Collection, Venice

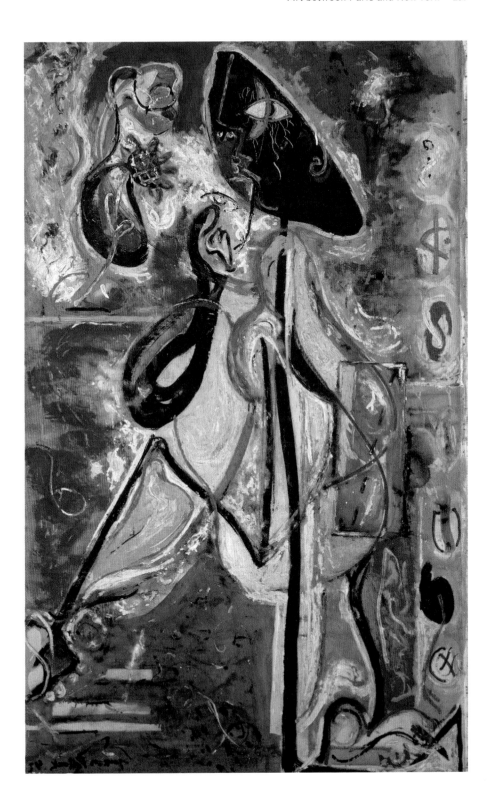

by men. It was an ascent not easily sustained. For one thing, the WPA's Federal Art Project having terminated the previous December, Americans were now more dependent than before on the patronage of curators, dealers, collectors and of course critics. For another, interest was growing in the work of the young American men. Meanwhile, Peggy Guggenheim's network of art advisers was evolving. In March 1943 Matta replaced Ernst as main intermediary between the gallery and the Surrealists, just in time to help select works for an exhibition devoted to a medium, collage, scarcely practised in America thus far.

The *Exhibition of Collage* of April 1943 had consequences that could not have been foreseen. A mixed exhibition was prepared of mainly European exponents of a medium whose origins stretched back to Cubism and Dada. Perhaps it was on Matta's suggestion that requests for work were also made to the artists of his Saturday group. To Motherwell, the encouragement to use pasted paper as well as paint was a revelation, one that stayed with him throughout a long career. Baziotes' contribution was likewise a success. Pollock's was a work mentioned in a press review as being made of 'burnt matches'. Though now lost, Motherwell remembers Pollock working on this and other pieces 'with a violence that I had never seen before'.[8] In this sense the show marked a shift in Art of This Century exhibitions away from the European Surrealists towards support for the young Americans. Conversations in the studios about Americanness in art were by now proving infectious. Peggy Guggenheim's adviser Howard Putzel persuaded her – as did, surprisingly, Piet Mondrian, recently arrived in New York after his stay in London – to accept for her Spring salon exhibition of 1943 a medium-sized painting by Pollock entitled *Stenographic Figure*, and to offer him a solo exhibition for November. Meanwhile Guggenheim commissioned Pollock to complete a 5.5-metre-wide mural for the entrance to her private apartment, to be finished in time for the opening of the show. Pollock had watched Orozco and Benton working at the New School of Social Research in 1930 and had taken part in the murals workshop set up by David Siqueiros in New York in 1936, so his interest in mural painting was already known. In the event, his Art of This Century show of November 1943 proved a breakthrough, containing as it did at least two large upright paintings, *The Moon Woman* and *Male and Female*, which confront archetypal themes – of Jungian and therefore ancient pedigree – rendered with an energy and directness that in America was altogether new (**fig. 14.5**). They were qualities recognised by James Johnson Sweeney of the Museum of Modern Art, who wrote in the show's catalogue:

> Pollock's talent is volcanic: it has fire. It is unpredictable. It is undisciplined. It spills out in a mineral prodigality not yet crystallised. It is lavish, explosive, untidy … What we need [in America] is more young men [*sic*] who paint from inner impulsion without an ear to what the critic or spectator may feel.

Sweeney's reference to Pollock's 'independence and native sensibility' added impetus to a growing conviction that young American painting was finding its way.[9]

The collision of modern energy with symbolism and archaic myth was a strategy located by others too. In 1940 a group of New York artists had formed a Federation of Modern Painters and Sculptors, some of whom advocated a direct artistic response to the military and political crisis in Europe. By the time of the federation's *Third*

Annual Exhibition in 1943, however, its most vocal members were speaking up for the importance of archaic myth, though of a non-Jungian kind. Mark Rothko and Adolph Gottlieb's contributions were attacked in print by the critic Edward Alden Jewell of the *New York Times*, who then offered them a chance to assuage the critic's 'befuddlement' in his actual column. Rothko and Gottlieb, assisted by Barnett Newman, took the opportunity to explain. Gottlieb's *Rape of Persephone* 'is a poetic expression of the essence of the myth ... with all its brutal implications', they wrote, while Rothko's *The Syrian Bull* 'is a new interpretation, involving unprecedented distortions'. For 'art is timeless', the artists said, and 'has as full validity today as the archaic symbol had then'. They asserted two requirements that they felt their paintings must possess. The first was that 'only that subject-matter is valid which is tragic and timeless'. The second was a technical preference, 'for the large shape because it has the impact of the unequivocal. We wish to reassert the picture plane [by means of] flat forms because they destroy illusion and reveal truth'.[10] Their current work – Pollock's too – was bringing the contemporary easel painting nearer to the visual scale of ancient totems, magical communitarian images and elemental forms (**fig. 14.6**). It was Rothko

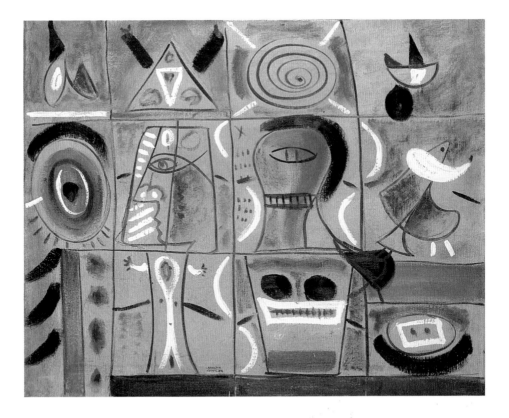

14.6 Adolph Gottlieb, *Nostalgia for Atlantis*, 1944.
Oil and tempera on canvas, 50 × 62.5 cm.
A. and E. Gottlieb Foundation, New York

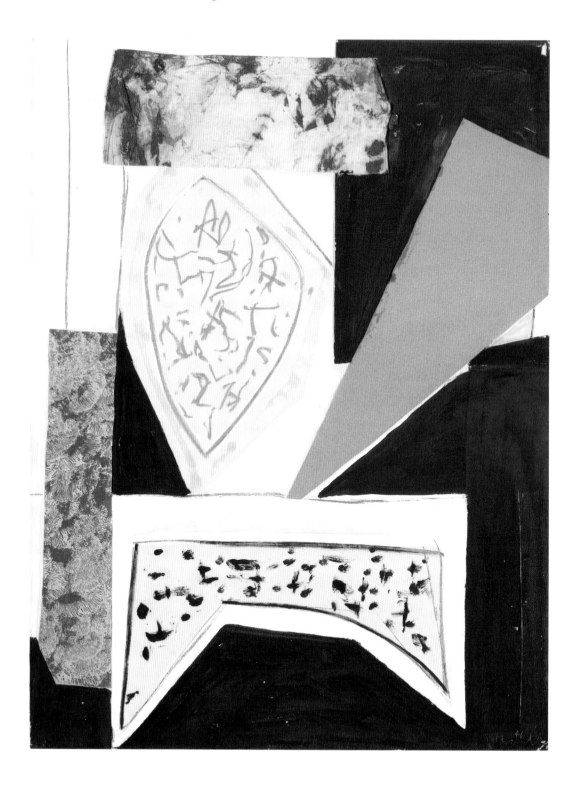

and Newman's prerogative to add a further dimension whose essence, if not its final embodiment, was religion. The tragic (Rothko) and the cosmically singular (Newman) were to them valid contributions to a world seeking – yet at that moment conspicuously lacking – a transcendent faith.

To many observers the precise character of the new American painting remained for the moment something of a puzzle. Howard Putzel posed the problem succinctly in a show he called *A Problem for Critics* at his own newly opened 67 Gallery in June 1945. For a body of work by Gorky, Gottlieb, Hofmann, Pollock and Rothko, shown alongside pieces by Arp, Picasso, Masson and Miró, he proposed the term 'new metamorphism' – a clumsy label which did little to embed the appetite among many young painters for (in his words) 'totemic, early Mediterranean and other archaic images'.[11] The critic Clement Greenberg, whose essays and art reviews would hold New York in thrall for half a century before beginning to lose their appeal, suggested 'Surrealist "biomorphism"'. He had offered '"biomorphic" Surrealism' in reference to an Arshile Gorky show earlier that year.[12] In fact neither term survived the changes that American art was about to undergo.

Only the more cerebral Motherwell was adhering closely to recent developments in European art. Technically, his discovery at the Art of This Century *Collage* show had been that paper–paint combinations were permissible at any size or scale. By the time of his solo show at Art of This Century in October–November 1944 he could present himself as at ease with a dialogue of paint and paper across a range of intensities, ranging from the brutal to the delicate. We hear Motherwell the writer at this stage trying to bring into alignment the corruptions of fascism, the crises of capitalism and the extraordinary plastic inventiveness of French and especially Spanish modern art, as well as Mexico's attempts to maintain an imaginative humanism in some form.[13] His answer was to build his fluency as an artist upon the 'sensations', as he calls them, arising from more or less intuitive interaction with real materials in the picture plane. 'The sensation of physically operating on the world is very strong in the medium of the *papier collé* or *collage*,' he would write in 1946. 'One cuts and chooses and shifts and pastes, and sometimes tears off and begins again [so that] shaping and arranging such a relational structure obliterates the need and often the awareness of representation.' The work in its very process acquires authenticity 'because all the decisions made in regard to it are ultimately made on the ground of feeling' (**fig. 14.7**).[14] Clement Greenberg had already responded to Motherwell's 1944 show with an important endorsement. 'He [Motherwell] has already done enough [at the age of twenty-nine] to make it no exaggeration to say that the future of American painting depends on what he, Baziotes and Pollock and only a few others do from now on.'[15] His verdict had already launched a much larger narrative in which America was not only supplanting the European tradition but in so doing, was extending it.

Such was Greenberg's importance as a commentator that something of his outlook must be explained. His position at the end of 1940 had been that capitalist democracy

14.7 Robert Motherwell, *Collage*, 1946. Oil and pasted coloured paper, Japanese paper and fabric on paperboard, 40 × 30 cm. David Winton Bell Gallery, Brown University

itself must fall if fascism is to be defeated: more or less a Trotskiist position to the effect that capitalism is itself fascism, 'that in order to keep democracy there must be a socialist revolution'.[16] Yet by 1945 that perspective had dwindled, and his mind had turned to the progress, even the evolution, of modern Western art regarded as a whole. He had come to think that the fall of Paris in June 1940 might also have signalled the end of the School of Paris, that European modern masters of the order of Kandinski and Klee stood not only at the end of their careers but at the end of a tradition of Cubist art that must be transcended if Western culture was to remain vital and new. It was one reason why he supported a version of biomorphism – one that filled out the flat silhouette of Cubism and so 'restored the third dimension, [and] gave the elements of abstract painting the look of organic substances'. And one or two American artists – Gorky and Pollock among them at that time – 'have accepted just enough of Surrealist cross-fertilization to free themselves from the strangling personal influence of the Cubist and post-Cubist masters ... They advance their art by painterly means without relaxing the concentration and high impassiveness of true modern style'.[17]

'High impassiveness' might also be a description of Greenberg's own critical tone. It was as if, in suggesting that French-based art had declined since 1940, he had forgotten that in Paris and the other belligerent nations art had practically come to a standstill. The war period up until the liberation of Paris in August 1944 was one of enforced closure of museums, of inactive gallery networks and the dislocation of individuals either into uniform or into situations of isolation from their usual habits of work. Art had had to continue by other means. Some who had not emigrated, such as Hans (now Jean) Arp and Sophie Taeuber-Arp, had moved initially to the unoccupied south, where Jean completed a modest body of work that was eloquent of dirt, waste and make-do resources, and where Sophie explored the delicate interplay of chaos and formative structures in her flexible yet always inventive style (she was to die tragically in a domestic accident in 1943) **(fig. 14.8)**. In Paris a residual Surrealist community had remained, including writers who could speak on its behalf. They took their cue from Breton, who in 1939 had insisted that in the event of war Surrealists must in no sense 'hide the sickness of the world under a carpet of flowers'; that they should condemn as tendentious any image 'in which the painter or poet offers us a stable universe'. The work of art must be 'a happening' – '*une œuvre d'art-événement*', he had said, 'with perceptible bifurcations and breaks in time, no longer a ridiculous search for formal

perfection but the power of revelation alone'.[18] In wartime itself, occupied Paris became a city of frustration and ambiguities. A pamphlet *Le Surréalisme encore et toujours* (*Surrealism Again and Always*) was published in 1943 and included a collective drawing by Brauner, Breton, Wifredo Lam and Jacques Hérold as a sign of their continued resistance. Picasso himself remained in the city and produced works of darkness and sorrow: skulls, a morose Dora Maar, darkened or makeshift interiors, and the great *L'Aubade* (*Dawn*) of 1942, showing two women in a threadbare room, one reclining in anguish while the other holds a lute but does not play. In early 1945 Picasso began work on a painting based on news of a Spanish family massacred in their home; it would reflect the current news and imagery of the concentration camps. Titled *The Charnel House* and related in its *grisaille* effects to *Guernica*, the painting's successive states were photographed by Picasso's friend and ally Christian Zervos and show perhaps better than the finished work the horror of those events, by no coincidence in a swirling – perhaps even 'biomorphic Surrealist' – post-Cubist style (**fig. 14.9**).

Among the artistic fraternity who remained in occupied Paris a spirit of dissent was also kept alive by a group calling itself La Main à Plume (The Hand to the Pen), to which Picasso belonged together with Arp, Georges Hugnet, Paul Éluard, Raoul Ubac, Gérard

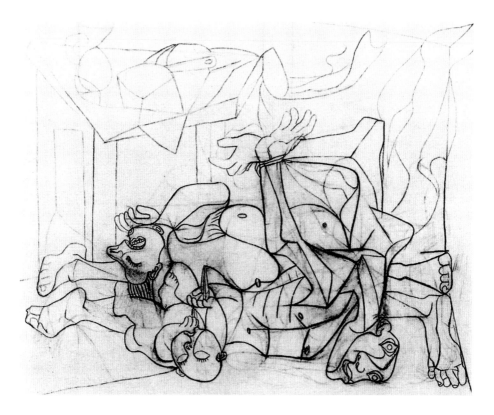

14.8 (*opposite*) Jean Arp, *Drawing on Packaging Paper*, 1942. Oil on packaging paper, 64.5 × 49.5 cm. Stiftung Arp e.V., Berlin/Rolandswerth

14.9 (*above*) Pablo Picasso, *The Charnel House*, 3rd state, May 1945. Photograph by Christian Zervos

Vulliamy, Édouard Jaguer and others. It was into this orbit that the painter Jean Fautrier was drawn. Fautrier had grown up and trained as an artist in London, had worked as a ski instructor in the 1930s, and returned to Paris in wartime in the hope of resuming activity in art. Having presented two sculptures at a vestigial *Salon d'Automne* in 1941, he was befriended by writers including Éluard, Jean Paulhan and Francis Ponge before being arrested for suspected Resistance activity. He was released, but then chose to live alone in lodgings near a mental hospital on the wooded outskirts of Paris (**fig. 14.10**). It was here, within earshot of screams from the woods where the Nazis took prisoners for torture, that Fautrier devised a method of working up a kind of paste (*pâte*) out of which to make smudged, facelike entities that appeared to arise somehow from the rough paper surfaces it was pressed into. He called them *Otages* (*Hostages*) (**fig. 14.11**). When exhibited at the Galerie Drouin in October 1945, Ponge described them as 'tumescent faces, crushed profiles, bodies stiffened by execution, dismembered, mutilated, eaten by flies'.[19] And Ponge's litany of foul sensations meshed with a phenomenology already familiar to Fautrier's literary and artistic colleagues. Disgust was already something of a totem for those Surrealists who had followed Dalí and Buñuel's interests almost a decade earlier. Sartre had immersed himself in the revulsion felt by his anti-hero Roquentin in his novel *La Nausée* (*Nausea*) of 1938 – had captured there the sensations of filth, rotten profusion and decay presented by the natural world no less than by the human one. The publication of Sartre's magisterial

14.10 (*above, left*) Jean Fautrier, *Large Tragic Head*, 1942. Bronze on marble base, 38.5 × 21 × 21.5 cm. Tate Gallery, London

14.11 (*above, right*) Jean Fautrier, *Head of a Hostage no. 22*, 1944. Oil on paper pasted on canvas, 27 × 22 cm. Galerie Limmer, Freiburg-am-Breisgau

14.12 (*opposite*) Alberto Giacometti, *Trois hommes qui marchent (petit plateau)*, 1948. Bronze, 72 × 32.7 × 34.1 cm. Fondation Giacometti, Paris

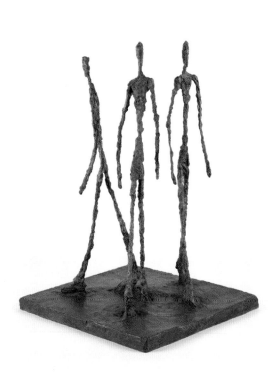

L'Être et le néant (*Being and Nothingness*) in 1943 had pursued the same themes. His philosophy of existence – existentialism – proposed that as humans we are condemned to decide who we are, that we must accept the responsibility of defining our essences from a starting point of zero. Or let us mention the remarkable *L'Eau et les rêves* (*Water and Dreams*) of 1942 by the mathematician turned philosopher Gaston Bachelard, who trained his attention upon fluid and viscous substances *per se*, including their interaction with the human hand and eye. Bachelard had described an earth–water mixture – effectively Fautrier's *pâte* – as 'truly intimate materialism in which shape is supplanted, effaced, dissolved'. The eye 'has become tired of looking at solids', Bachelard proposed: 'It needs to dream of deforming'.[20]

In sculpture, too, *pâte* and deformation had become the instruments of a new sensibility. Alberto Giacometti spent the war years in his native Switzerland where, having abandoned Bretonian Surrealism, he worked relentlessly on drawings, mostly of his brother Diego, as well as on small finger sculptures in clay that, after his return to Paris, became the emaciated, sometimes grimacing heads and figures for which he would soon become celebrated. In them, flesh becomes so to speak pummelled and battered, as if to reduce humanity to zero, a victim rather than an agent of contemporary history (**fig. 14.12**). Giacometti's near contemporary Germaine Richier was also able to remain in Zurich throughout the war, where she too found a method of moulding clay that rendered the human figure as if watchful, near the limits of its survival as a kind. Animals such as a toads, grasshoppers and insects stand in for human presences in her wartime work, while after the war Richier's flesh-damaged figures appear startled, even trapped, by the circumstances of their time (**fig. 14.13**).

Direct correspondences with American art were few and far between. Yet the qualities of the School of Paris were generating comparative judgements in America. A test case was that of Jean Dubuffet, who during wartime was picking up the threads of old friendships with the writers Georges Limbour and Jean Paulhan, and through them new ones, for instance Ponge and Éluard. After studying art during the later stages of the First World War, Dubuffet had got to know Masson (by now in America), had studied the images in Hans Prinzhorn's *Bildnerei der Geisteskranken* (*Artistry of the Mentally Ill*) of 1923, and had worked in a family wine business before returning to Paris,

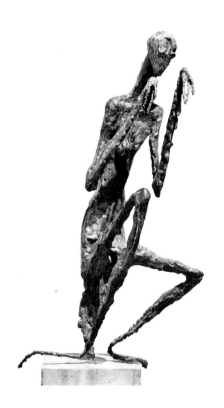

where his new friendship circle urged him to develop his interest in the art of the marginalised, the untutored and the dispossessed, as well as in children's drawings. Around 1944 Dubuffet's focus expanded to include graffiti and shapes scratched on an urban wall. It was seeing Fautrier's *Otages*, however, that led Dubuffet to his first *haute pâte* (high impasto) paintings, shown to acclaim at the Galerie Drouin in May 1946. Here, human forms were smeared, scraped and scratched in a manner disregarding correct anatomy, proportion or easy legibility. Images of startled women and men – many of them ostensible portraits – were brought about by 'making the surface speak its own language', as he wrote in a sequence of dictionary-like 'Notes' at the time the paintings were being done (**fig. 14.14**).[21] Figures and objects would be 'transferred' into the painting surface and in the process 'changed into pancakes, ironed flat'. He presented them under the curious title *Mirobulus, Macadam et Cie: Hautes pâtes*, referring to Joseph McAdam, the inventor of asphalt – Dubuffet used bitumen on his canvases – as well as 'and Company', suggesting a manufacturing collaboration between the *mirabilis* (the marvellous) and the sticky base. In the meantime, he had been on a trip to Switzerland in the company of Jean Paulhan, Le Corbusier and the Swiss writer Paul Budry to see at first hand works by psychiatric patients.[22] It was the beginning of a vast collection of images and objects to which, together with his own manner of painting, Dubuffet gave the name *Art Brut* (Crude Art). Both they and it are sometimes referred to by the unsatisfactory term Outsider Art.

If earthiness, mess and crudity were the marks of Dubuffet and Fautrier's work in wartime, it was the scratch, the scrape and the stain that became the modus operandi of the German-French artist Alfred Otto Wolfgang Schulze – he called himself Wols – whose relatively short career also exemplified the Paris existentialist style. Wols had been a student of Moholy-Nagy at the Berlin Bauhaus in 1933 and had lived on the fringes of Surrealism in Paris before the war, photographing lowered *matière* such as rotting food, torn poster hoardings and rain-soaked gutters before being interned as an enemy alien in 1939. Confined to years of poverty near Marseilles during wartime, he had been able to make small ink-and-watercolour drawings of a dystopian micro-world of spicules and squirming quasi-organisms, before returning

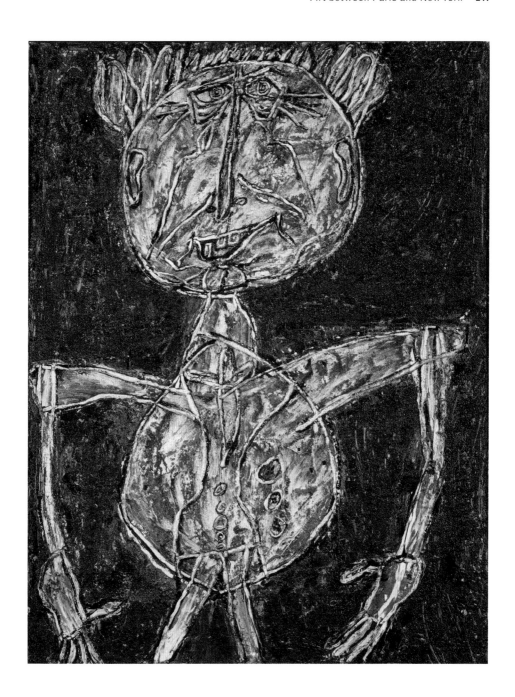

14.13 (*opposite*) Germaine Richier, *Praying Mantis*, 1946. Bronze, 168 × 72 × 72 cm. Museu Berardo, Lisbon

14.14 (*above*) Jean Dubuffet, *Limbour Crustacé* (*Limbour as a Crustacean*), 1946. Oil and sand on canvas, 116.2 × 88.9 cm. Hirshhorn Museum and Sculpture Garden, Smithsonian Institution, Washington

to Paris in 1945 where he was introduced to the gallerist René Drouin, who took an interest in his plight and helped him with canvas and materials. Urged by Drouin – and by Sartre – to work on a larger scale, Wols produced works with a patina of scratched markings like those of an overused work surface already spoiled by neglect and random domestic stain. When forty of his paintings were exhibited at the Galerie Drouin in May 1947 they too were applauded for the depth of their disquiet, for their sense of damage and despair (**fig. 14.15**). Sartre later wrote of Wols's dishevelment, his poverty, his rheumatic disorders, the 'short-term adventure' into which he seemed to throw himself – that is, 'to kill himself convinced that one cannot express anything without destroying oneself', in the pursuit of which, all the same, 'he constructed palaces with his own excretions as a matter of course'.[23]

How are we to judge the relationship between the School of Paris and the emerging New York School? On the evidence just presented they did not deserve to be compared. Almost nothing of the European experience of war (the camps, the casualties, the compromises) was duplicated across the Atlantic. For Mark Rothko the period 1945 to 1948 was a time of renunciation of archaic imagery in favour of large-scale blocks of colour floating on an indeterminate ground (for the time being Gottlieb held on to his archaism). Motherwell was having his first successes in large-scale oil painting. Clyfford Still, out in California, was giving his canvases the look of ragged landscapes seen from high above – or else tattered cosmic wall surfaces rent by massive energetic change (**fig. 14.16**). Meanwhile, Barnett Newman was beginning to simplify the incident in his paintings at the same time as cautioning himself about the dangers of reduction to geometry alone. The result was a set of works of which *Onement I* (a later title) of 1948 is an example. A raggedly painted cadmium red vertical bisects two darker areas that never quite cohere into an uninterrupted ground – not geometry, therefore, but a declaration of unity by other means (**fig. 14.17**).

Furthermore, American painting remained little known in Paris, which meant that opportunities for comparison were rare. This did not deter Greenberg, however, whose enthusiasm for both Pollock and Dubuffet led him to an assessment of the two artists as if they were rivals for leadership in the evolution of Western art in the post-war world. Conveniently for him, both artists had solo shows in New York early in 1947. Pollock's

14.15 (*opposite*) Wols (Wolfgang Schulze),
Composition IV, 1946. Oil on canvas, 65 × 54 cm.
Pinacoteca di Brera, Milan

14.16 (*above*) Clyfford Still, *1948-C*, 1948. Oil on canvas,
205.4 × 174.6 cm. Hirshhorn Museum and Sculpture
Garden, Smithsonian Institution, Washington

fourth exhibition at Art of This Century in January–February revealed that he too had renounced the archaic references of his wartime work. A group of new paintings called *Sounds in the Grass* of 1946, in fact quite modest in scale and painted with carving or swirling motions of the brush, hinted at imagery related to creatures mysteriously present yet living largely out of sight; images that (to judge by Pollock's titles) were of 'eyes', 'shimmering substance', 'earth worms' or 'croaking movement' (**fig. 14.18**).

Meanwhile at Pierre Matisse's gallery on East 57th Street could be seen Dubuffet's Art Brut paintings that mimicked the tone of work made by children and graffiti scratchers. 'He maintains every part of the surface flush with the canvas and exactly inside the frame,' Greenberg wrote approvingly. Dubuffet 'paints the primitive and the childlike at a remove, portraying it ... from the height of culture, and as a state of mind, not a way of art'. His *Grand Paysage Noir* 'bears resemblance at points to a sort of thing many painters over here have been trying to do with Klee's heritage: even, all-over treatment, scratches in bark, runes, graffiti scraped into limestone' (**fig. 14.19**). Pollock too, he notices, 'remains essentially a draftsman in black and white who must as a rule rely on these colours to maintain the consistency and power of surface of his pictures'. Yet in the comparison between them, Pollock's all-overness is 'of more variety than the French artist, [he is] able to work with riskier elements – silhouettes and invented ornamental motifs – which he integrates in the plane surface with astounding force'. Dubuffet is skilful and pleasing; yet Pollock has 'more to say in the end'. For the critic, the comparison even pointed to a verdict about national identity. 'Sophistication' on the French side had to be set against a more brutal, more complete positivism on the

American. Pollock is 'American and rougher and more brutal ... [he] points a way beyond the easel, beyond the mobile, framed picture, to the mural, perhaps – or perhaps not. I cannot tell'.[24] A year later Greenberg would propose that 'when it comes to the Zeitgeist', Americans are 'the most advanced people on earth' on account of being the most industrialised, while it was the artist's alienation from that ambience that was 'the condition under which the true reality of our age is experienced'.[25]

With or without the comparison, it could be said that by the beginning of 1947 artistic energies were running high on both sides of the Atlantic – from which, certain questions were likely to follow. How would painting culture intensify and yet diversify, on one side of the Atlantic and on the other? Which other nations would vie for attention after the devastations of a lengthy war? How could the more rational traditions in art develop in such unstable times? On what terms could a fast-reviving School of Paris match the resources and ambition of New York?

14.17 (*opposite, left*) Barnett Newman, *Onement I*, 1948. Oil on canvas, 69.2 × 41.2 cm. Museum of Modern Art, New York

14.18 (*opposite, right*) Jackson Pollock, *Earth Worms*, 1946. Oil on canvas, 97 × 68 cm. Tel Aviv Museum of Art

14.19 (*above*) Jean Dubuffet, *Grand Paysage Noir (Large Black Landscape)*, 1946. Oil on hardboard, 155.1 × 118.6 cm. Tate Gallery, London

The 1950s:
Climates of the Cold War

The first full post-war decade can be described as one of tensions and extremes. In Europe particularly, the massive task of urban recovery and reconstruction confronted all citizens with two sharply different phenomena: on the one hand economic constraint combined with the spectacle of wartime damage and disrepair, particularly at the city's fringes; and on the other the arrival in the urban centre of advertising for goods and services on an altogether expanded scale – and by mid-decade the spread of television that brought the commercial world indoors and closed off neighbours from each other. Meanwhile, and at the level of superpower ideology, tensions between the democratic victors in the war and the Soviet-dominated Eastern bloc escalated the nuclear arms race to dangerously new levels. How were artists to respond to the new world order? In Europe, a scramble for new definitions of human value became paramount – in art, the adoption of broadly 'expressive' techniques appropriate to apprehensions of existential change.

In America, anti-Soviet opinion led to the persecution of writers, actors and others for alleged communist sympathies – though visual artists were seldom harassed directly in that way.[1] At the same time the much touted 'American dream' of prosperity 'for each according to ability or achievement', supported by a surge of technological innovation and corporate power, led to disillusion among those either sceptical of or excluded from those developments. In both Europe and America – the latter relatively free of urban destruction on a European scale – artists and writers took to plundering the objective world of garbage and redundancy for cues to experiences of authenticity, even the 'reality', of the post-war age.

Towards the end of the 1950s symptoms emerged of a shift in sensibility away from the culture of heavy industry towards one dominated by sign systems and information flow. New technologies of computation were now in prospect. In education, and on both sides of the Atlantic, rising levels of prosperity were accompanied by increased opportunities for art school training and a degree of social mobility from the countryside into the fast-expanding and newly developed cities. In all the arts, as earlier generations of modernist pioneers were coming to the end of their careers, a culture of youthfulness, renewed energy and protest was being born.

Informel International

There is no completely satisfactory term for a genre of practice known as *art informel* (literally 'informal art') that flourished internationally in the later 1940s and 1950s. Applied to paintings, the term refers to work that appears casually executed, unpolished, even 'expressionist' in origin or affiliation. By turns crude as well as lyrical, *informel* art could evoke attitudes of celebration as much as despair. Moreover, it was deployed not only in Paris and New York but across a wide spectrum of experiment throughout North America, Europe and Scandinavia during this time. *Art informel* claimed a sharp differentiation from the rational methods and philosophies that descended from Soviet Constructivism, De Stijl and the Bauhaus.

We saw the German-French artist Wols – who up until his death in 1951 created dystopian micro-worlds of squirming creatures that seemed to imply that their maker had become dystopian too – scratching and smearing a painting or drawing surface as if creeping messily over territory unfamiliar to both him and it. Other artists in Paris also adopted what may be called a 'creatural' style. The earliest paintings of Georges Mathieu – from an aristocratic French family and with no training in art, who arrived in Paris in the mid-1940s – contained smudged, quasi-organic shapes that a later commentator described as 'uterine', as 'sorts of algae indefinite in their contours which drift at random among vaguely amoebic forms ... magma whose life is to be divined'. Mathieu's paintings distilled somewhat around 1947 so as to resemble spider-like webs, 'cellular conglomerations, fibrous textures which one may see surging, little by little, from the original limbo ... an ill-defined organic world, moving and horrible ... at the confines of being and non-being' (**fig. 15.1**).[1] A third figure, Camille Bryen, already well connected among Paris artists, was also reckoned to be an exponent of something akin to a creatural style. As a young artist in the mid-1930s he had practised automatism with candle smoke and soot; had met Wols at around that time; and formed a lasting friendship with Hans Arp, whose Dada playfulness corresponded closely with his own. By the early 1950s Bryen's painting was being described as a performance of grimacing, masticating, digging at the canvas, requiring a scraping and shredding of paint and surface without guidance from a plan or a sketch, and with a degree of purposiveness no more coherent – at least to those who watched him work – than that of a marauding aquatic organism such as a sea anemone, or a swarm of ants (**fig. 15.2**).[2]

It was in 1947 that Mathieu and Bryen, aided by the young critic Michel Tapié, staged a defence of *informel* or 'creatural' abstraction by attacking the geometrical tendency that had been widespread before the war and was now showing signs of

resurgence. To them and to La Main à Plume, it was manifestly inappropriate that former members of Abstraction-Création should mount a show in the last weeks of the war against a backdrop of national demoralisation at the hands of an occupying power.[3] Likewise, a series of *Salons des Réalités Nouvelles* had been launched in July 1946, hoping for a Constructivist or Concretist revival in contemporary art.[4] On what terms could such optimism be justified? One La Main à Plume writer, Édouard Jaguer, published a declaration 'Les Chemins de l'abstraction' ('The Paths of Abstraction') in the autumn of 1946 that gave expression to the need for the dangerous and the raw – for the artwork to refuse any cosy return to bourgeois life and order. 'Faced with such cheerful or austere mosaics,' Jaguer said about the latter-day Constructivist and Concrete artists, 'we remain indifferent, notwithstanding the optical pleasure they give. These decorations have no connection with our apocalyptic age.' About the works of *géométrisme* generally, Jaguer said, 'we cannot recognise ourselves in them'.[5]

When Mathieu, Bryen and Tapié joined forces in December 1947 it was for a show they were mounting at the Galerie du Luxembourg titled *L'Imaginaire* – by no coincidence the title of a Sartre book of 1940. It was to be the basis of what Mathieu called '*psychic* non-figuration', a manner of 'absolutely free creation' in which form, inspiration and content were inseparable, and in the face of which the champions of *géométrisme* would have to retreat.[6] Moreover, the fifteen artists of *L'Imaginaire* were not all French, or from France. Those who were included Jean-Michel Atlan, who had been arrested during the war as a Jew and for his work in the French Resistance. After pleading insanity he had been confined to an asylum. His paintings throughout a short career were of twisted, anguished figures – often seemingly animals – wrestling with the confines of the picture frame as if it were a prison (**fig. 15.3**). Yet *L'Imaginaire* also included the Spaniard Picasso, the Alsace-born Hans Arp (now Jean and French-passported), the Germans Wols, Victor Brauner and Hans Hartung, the Swiss-born Vulliamy, and the Canadians Fernand Leduc and Jean-Paul Riopelle. Internationalist in its ambition, the project was effectively a showcase for the new informal style.[7]

At the same time, that internationalism masked a diversity of responses both to the recent war as well as to the conflicts and difficulties of the peace. The Canadians Leduc and Riopelle were from a group of French-speaking writers, dancers and

15.1 Georges Mathieu, *Red Decadence*, 1948. Oil on canvas, 115 × 75 cm. Fondation Georges Mathieu

15.2 (*above*) Camille Bryen, *Crinane jaune no. 41*, 1953. Oil on canvas, 100 × 81 cm. Musée d'Art Moderne, Saint-Étienne Métropole

15.3 (*opposite*) Jean-Michel Atlan, *Realm*, 1957. Pastel on coloured paper, 25.1 × 32.7 cm. Museum of Modern Art, New York

musicians in Montreal who were rebelling against the authority of the Catholic Church in Quebec. Both were supporters of a vehement manifesto of 1948 titled *Refus Global* (*Total Refusal*), written principally by the Canadian painter, poet and writer Paul-Émile Borduas, who denounced Christian civilisation for its decadence and commercialised America for its superficiality. *Refus Global* was a cry of anguish and at the same time a call for passion, spontaneity and unpredictability in art and everyday life, 'a resplendent anarchy' capable of reinvigorating the social body.[8] The painters of *Refus Global* called themselves *automatistes* – practitioners of that very spontaneity who in the later years of the 1940s were prepared to align themselves with the remnants of Surrealism à la Breton and the spirit of the *informel*. After a time in Paris, Leduc and Riopelle returned to Canada before migrating again in furtherance of their individual careers.

Interestingly, it was Canada's very geography that from the mid-1950s became relevant to Riopelle and also Borduas – the latter by now in New York and increasingly conscious of the *nordicité* (northernness) of Canadian culture in relation to that of the United States. Breton himself referred to Riopelle as the *trappeur supérieur* (superior trapper) of contemporary painting, while Borduas's work soon took on the winter-white tonality of the northern expanses such as to set him apart from other *automatistes* of his time (**fig. 15.4**).[9]

It was another version of northernness entirely that came to nourish the *informel* from the direction of Europe's own northern territories, and from Scandinavia. In the later 1940s Denmark was a nation still struggling to emerge from an uneasy form of

constitutional occupation by the Nazis, in which free artistic activity had been heavily proscribed. In fact, young Danish artists had been aware of artistic trends in Paris even before the war: a group of Danish painters known as Linien (Lines) had admired Kandinski, Klee and Miró, yet also looked to Nordic nature mythology and the creatures who dwelt there – in rivalry to the Nazi ideologues who were claiming Nordic culture as their own. Egill Jacobsen from the Linien group had leant heavily towards an energetic style: 'To paint more expressionistically than the German expressionists' was his declared ambition at the time of a Linien exhibition in Copenhagen in 1937. Likewise the paintings of Carl-Henning Pedersen, who scratched out animalesque images in the 'naïve' manner associated with children's art, reached for fundamental and authentic forms. Such a plundering of primal imagery, with paint rapidly and messily applied, produced a genre of animal–human fusions that aimed to preserve the Nordic imaginary from the grasp of Denmark's invaders. In 1941 Pedersen and his colleagues coalesced in a fresh group called Høst (Harvest). Its magazine *Helhesten* (*Hell-Horse*) was largely the work of the youngest member of the group, Asger Jørgensen. He later called himself Asger Jorn.

Jorn's first impulse at the end of the war was to establish international connections, and to this end he travelled to Paris in early 1946 in order to cultivate links with Atlan, Jaguer and others from La Main à Plume. In the meantime, writers close to pre-war Surrealism in Belgium, notably Christian Dotremont, had also gravitated to La Main à Plume and particularly its orientation to revolutionary Marxism. From these Brussels–Paris connections emerged so-called Revolutionary Surrealism groups in each city, one of whose main dilemmas was to reconcile their adherence to Marxism with the implications of appalling war atrocities in Russia, details of which were now gradually becoming known. For the moment they hung on to their Marxist convictions – but now clashed with Breton, recently back from New York, who wished to sever any remaining alliance between Surrealism and Marxism in the form the Soviets now endorsed it – a top-down command structure that was effectively a dictatorship. In their

15.4 (*above*) Paul-Émile Borduas, *Gouttes bleues* (*Blue Drops*), 1955. Oil on canvas, 127 × 102 cm. Montreal Museum of Fine Arts

15.5 (*opposite*) CoBrA exhibition at Stedelijk Museum, Amsterdam, 1949. Installation: Tonie Sluyter and Aldo van Eyck in room 6. Aldo and Hannie van Eyck Foundation

statement *contra* Breton, Jaguer and other Surrealists insisted that 'there was no point to the Surrealist experiment unless its development was based on dialectical materialism'.[10] Some complex networking now ensued. Jorn had meanwhile made contact with the Dutch painter Constant Nieuwenhuys (known as Constant) in Amsterdam over plans for a radical art magazine and a further extension of the Danish initiative. Two other Dutch artists, Karel Appel and Guillaume Cornelis van Beverloo (known as Corneille) entered the conversation with the launch of yet a further magazine, *Reflex*, in which Constant in September–October 1948 published a vigorous 'Manifesto' reiterating some Dada-cum-revolutionary motifs – exasperation at bourgeois society, a refusal of church and state authority, and a determination to 'begin again' from the basic impulse to make things in the manner of 'primitive' cultures, children and the insane.[11] No more than a month later, and following an unproductive meeting convened by the Revolutionary Surrealism group of Paris, an already energised coalition of Jorn, Dotremont, Appel, Constant, Corneille and Joseph Noiret rebelled against any further dissection of the Surrealism–Marxism relationship and determined to work together under a new label CoBrA, signifying *Co*penhagen, *Br*ussels and *A*msterdam.

Under Dotremont's organisation in Brussels, CoBrA's ambition during its brief but fiery existence was above all to *despecialise* painting and poetry, deaestheticise it, at the same time reinscribing CoBrA's new-found freedoms at the centre of European and international art. It was an ambition that secured the enthusiasm of Willem Sandberg, poet and young director of the Stedelijk Museum, Amsterdam, who undertook to host in November 1949 the first, largest and best CoBrA exhibition ever to be held. Under its title *International Exhibition of Experimental Art: CoBrA* and under the design direction of the architect Aldo van Eyck, the show was experimental in its staging. Paintings were hung at various heights rather than 'on the line', larger paintings standing directly on the floor (**fig. 15.5**). A poetry 'cage' was constructed at the centre of the exhibition where writings of the poet members were posted. At the opening, Dotremont read a text reviling the civilisation that had produced the atom bomb, adding that 'in the light

of this situation a good fat smudge of paint acquires its full significance'. 'It is like the scream from a painter's brush,' he said, 'gagged as it is by formalism.'[12] The Dutch press was scandalised by the show, and CoBrA's international reputation quickly spread.

As a group, CoBrA's life was brief – unlike the achievements of its participants. As with other rebellious art fraternities, rebelliousness itself worked to destabilise its sense of community. Furthermore, CoBrA insisted on no firm conditions of affiliation, and in practice artists could be more or less close to its principal aims. Such figures included Pierre Alechinsky (Belgium), who remained close to the centre of the group – but also Karl Otto Götz (Germany), Atlan and Jacques Doucet (France), Josef Istler (Czechoslovakia), Stephen Gilbert and William Gear (Scotland), and Shinkichi Tajiri (United States), who did not. It was in the Belgian city of Liège in October 1951 that the second and final CoBrA group exhibition was held. To the regulars of CoBrA were now added works by Giacometti, Lam, Jean Bazaine and Miró together with others sympathetic enough to merit inclusion. Among the latter was the Dutch sculptor Lotti van der Gaag, whose clay sculptures, made in a dishevelled warehouse studio in the rue Santeuil, Paris, were in their own way improvised – *informel* – and offered close points of connection with the animalesque imagery of Jorn himself and several of his Dutch colleagues (**fig. 15.6**).

CoBrA's creatural imagery was most intense in the work of Appel, Constant and Jorn. In Appel's case it was his fascination for young children reduced almost to the instinctual life of animals that permeated nearly all his work (**fig. 15.7**). Jorn's creatures, by contrast, are animal–human hybrids, most often rendered as fearful, wounded, avaricious – bestial in the sense of sustaining life instinctually by every means that nature could provide. A painting of Jorn's such as *The Eagle's Share II* of 1951 is a presence rendered terrifying by its frenetic mood and night-time colouration but also by its seeming readiness to burst through the limits of the picture frame – against the threat of which the viewer would have no defence at all (**fig. 15.8**). We know that Jorn regarded his creatures as human too. Looking back beyond Bosch and Breughel's allegorical fantasies, he aimed to paint 'in the style of ancient Indians, the Vikings, the "primitives"'. As he put it forcefully, 'we must portray ourselves as human beasts'.[13] His paintings evoke the creatural world of the Norse legends in which animals and humans converge spiritually, and whose appearance on ancient rock carvings and in folk literature revealed a convergence of images and words. 'In the north,' as Jorn pithily put it, 'we are on the cold edge not only of civilisation

but also of existence, of truth and of life itself: the naked domain of fantasy.' He refers to Scandinavia generally as neither west nor east – rather 'the dream centre of Europe'.[14]

Such examples show that *informel* art was practised according to cultural geography as much as to personal temperament – that the two factors often coincide. Back in Paris, the more typical practice was to deploy animalesque methods in the context of a wider crisis, that of the philosophical commitments of European humanism. Bryen himself had by the early 1950s become known in Paris for his conviction that that culture was at an end, that its belief in progress and its optimistic subjectivity had become impossible to uphold. A book published by him and the playwright Jacques Audiberti in 1952 introduced the term *abhumanisme*, the prefix *ab* insisting on a replacement of what they called 'humanist chauvinism' with a kind of base materialism opposed to any anthropocentric ordering of values. Audiberti himself likened Bryen's paintings to mould, fungus or the growth patterns of a viral disease. Varying only slightly the metaphors of creatural life, he says of them that they 'plunge into the poisonous vegetation of the depths, or soar out of the abysses of a gnat's rotten tooth towards the blink of our eye and the fist of our hand'. Bryen's paintings 'throb and settle under the horizontal shower of our look' to the point where we see 'the work of art dehumanising itself, freeing itself from man's signature'. Painting was an 'abhumanist hypothesis'; and Bryen was its *abhomme*.[15]

By this time, leading figures in Paris had become aware that the *informel* was being practised in America too. Now it was Tapié, with Mathieu's advice, who convened a show called *Véhémences confrontées* (*Opposing Passions*) in March 1951 that attempted to present *informel* as a truly international style. With Bryen, Mathieu and Wols representing France, work was obtained by Hans Hartung from Germany, by Giuseppe Capogrossi from Italy, by Riopelle from Canada, and by Pollock and de Kooning from

15.6 (*opposite*) Lotti van der Gaag with *Clay Sculpture* (lost work), rue Santeuil, Paris, 1951

15.7 (*above*) Karel Appel, *Composition with Animal Figures*, 1951. Oil on canvas, 67 × 142 cm. Karel Appel Foundation

New York. *Véhémences confrontées* was designed not only to present a programmatic 'other' to geometric and social-realist styles of art. What in Tapié's book of the following year he would call '*un art autre*' ('a different art'), was in his eyes traceable ultimately to Dada – 'the great break', as he called it – as well as to the exhaustion of European humanism after the recent war. In that exhaustion, Tapié argued, 'life has become *estranged from form*' – witness the work of the many painters who now act 'without need of form', who proceed 'with a casual indifference to conventional wisdom, acting without form in a spirit of profound anarchy'. For form was no longer worth studying if doing so worked to the detriment of what he called 'an intoxication with life itself … an openness to mystery'.[16]

Tapié's verbal flourishes were themselves somewhat formless; but his insistence on *art autre* as a catchphrase for the new art had a purpose: to establish an international

compass for a loose yet expressive style that would embrace the American contribution above all (Tapié organised Pollock's first one-man show in Paris in 1952). He also hoped to scorn the efforts of a rival critic, Charles Estienne, to promote French artists exclusively as a reborn School of Paris under the term *tachiste*. A *tache* is a splodge, spot, mark or stain; hence *tachisme* was an art of matter, 'of the substance of [the artists'] paint, taking the form of *taches*'.[17] Yet it was Tapié's *art autre* that dominated Paris, supported by the claim that Paris still commanded the international scene. Those claims were of course disputable. Hartung, for instance, from Germany but a French resident since before the war, had practised a form of gestural abstraction in the 1930s and had become adept at organising sequences of strokes and stripes across horizontally extended canvases such as to create dancing rhythms. He would soon progress to creating mobile forms in larger swathes of paint in crisp, floating groups that withdrew from the *informel* manner to become more deliberate, calculated and precise (**fig. 15.9**). Mathieu, likewise, was already moving his 'organic' imagery in the direction of a method he now called *tubisme*, that is, paint applied by squeezing the paint tube with the thumb as the hand traverses the canvas in rapid ideographic curves (**fig. 15.10**). In fact Mathieu now adopted the practice of completing relatively large paintings in public, drawing considerable crowds and 'performing' a work in a matter of seconds. In doing so he rapidly became celebrated in Europe and New York as a showman-artist with a talent the equal of any.

Further, what Tapié could not have grasped was the extent to which *art informel* across the Atlantic was taking its own course. His description of Pollock's manner as 'magic, thaumaturgy, transcendence', as 'violence born of a gesture whose limits are vertiginous, beyond comprehension', was a poor verbal substitute for the sort of integration of self and nature that was becoming the model for artistic subjectivity in New York.[18] Pollock's interest was no longer in insectoid or suppurating nature, rather in the endowments of the American deep past – such as the culture of American Indians, whose mode of life could be viewed as the 'primitive' of the American mind.[19]

15.8 (*opposite*) Asger Jorn, *The Eagle's Share II*, 1951. Oil on Masonite, 74.5 × 60 cm. Museum Jorn, Silkeborn

15.9 (*above*) Hans Hartung, *T.1954-12*, 1954. Oil on canvas, 38 × 100 cm. Collection Fondation Hartung-Bergman, Antibes

15.10 (*top*) Georges Mathieu, *Black Spot*, 1952. Oil on canvas, 200 × 299.7 cm. Guggenheim Museum, New York

15.11 (*bottom*) Jackson Pollock, *Number 1*, 1949. Enamel and metallic paint on canvas, 160 × 260.4 cm. Museum of Contemporary Art, Los Angeles

That version of 'integration' had been visible in Pollock's paintings since early in 1947, when techniques of pouring and dripping liquid paint were first used on a scale suitable for achieving a balance between the consequences of paint discharge and the rhythms of the body while painting. At least up until his *Autumn Rhythm* of 1950, Pollock's testimony was that his body rhythms were not distinct from those of the natural world but equal to them and belonged among them – as if to exemplify a perpetual 'becoming' in nature whose energies permeated the human organism as much as what lay beyond it. Outside and inside the body were in some sense the same. 'When I am painting I am not much aware of what is taking place,' Pollock famously said: 'It is only after a sort of "getting acquainted" period that I see what I have done.' 'The painting has a life of its own. I try to let it come through' (**fig. 15.11**).[20] When Hans Hofmann suggested to Pollock that he try to work directly from nature, his reply – 'I *am* nature' – showed a wish to be immersed in pattern and flow; to make the *work* of the work of art be not entirely his, yet not beyond his direction either. For him, the release of paint from a spatula, stick or brush was a new kind of semi-controlled volition, while refusing that element of randomness that for some Surrealists had been true spontaneity. The titles of so many of Pollock's works in the first year of 'dripping', 1947 – *Sea Change*, *Watery Paths*, *Vortex*, *Full Fathom Five* – were metaphors for informality, fluidity and rhythm as the very substrate of human activity. Other metaphors were galactic or other-worldly. Some observers could connect Pollock's fluid energy fields with the much larger force of America's atomic bomb. 'The present painting has a spattered technique,' wrote the veteran New York critic Henry McBride of a paint-on-paper work of 1949, 'but the spattering is handsome and organized and therefore I like it. The effect it makes is that of a flat, war-shattered city, possibly Hiroshima as seen from a great height by the light of the moon'.[21]

At the same time, and on the individual level, the new artistic culture of New York could be one of indecision, even despair. Versions of French existentialism were reaching the city, and European philosophers were being read.[22] Increasingly, artists felt the need for discussion – even for some identity as a group. First, a studio school was established in 1948 at 35 East 8th Street by Baziotes and others called Subjects of the Artist, for both art instruction and the discussion of ideas. Though unsuccessful financially (it lasted only a semester), the habit of debate was established, and led to a conference in April 1950, of which a record has been preserved.

At Studio 35, as the conference was called, an exchange of opinions was first conducted on the naming of the group, their differences from French and European artists, the American identity of the new art, and much else. 'Americans are interested in process above all else,' Motherwell proposed on day one of the debate; 'In "finishing" their paintings the French assume traditional criteria to a much greater degree than we do'. De Kooning concurred: French artists' works 'have a particular something that makes them look like a "finished" painting ... They have a touch which I am glad not to have'.[23] Indeed, he had recently brought to perfection a method of embedding traces of organic movement and vitality in a buckled, disaster-strewn paint surface – including the first in a series of *Woman* paintings for which he would subsequently become well known (**fig. 15.12**). Other artists contributed differentia of their own. Americans inhabit an emotional rather than an intellectual position, Motherwell offered in a published statement that year, 'a kind of dumb, obstinate rebellion at how

the world is presently organised'.[24] American art is 'lyrical, often anguished, brutal, austere, and "unfinished"', he would also say. 'The problem [in America] has been to project an experience, rich, deeply felt, and pure, without using the objects and paraphernalia, the anecdotes and propaganda of a discredited social world'. Or again, decisions in American painting are made 'on the grounds of truth, not taste'.[25] As for a group name, an initial consensus was to do without one. Motherwell's suggestion of 'New York School' was descriptive, and on those grounds several used it. Others preferred 'Abstract Expressionism', which despite its unsuitability has gained wide currency since.

At the start of the 1950s the ambitions of the New York School could not be exaggerated; nor the reach of *informel* generally on a nearly global scale. An example is that of Pollock and Mathieu in far-off Japan – a country devastated less than a decade earlier by America's atom-bomb attacks on the cities of Hiroshima and Nagasaki. The self-taught painter and businessman Jirō Yoshihara, born in 1905, was already knowledgeable about Western art before he saw works of Pollock and other Western painters in a show in Tokyo and Osaka in 1951. When news of Mathieu's new work, shown at the *Salon de Mai* in Paris in 1952, reached a younger circle of artists in Osaka they began to avidly explore relations between Western and Eastern attitudes in their field. In that spirit Yoshihara brought a group of Japanese artists together under the label Gutai – meaning literally 'body-tool' – whose members now explored ways

of handling material that both deepened and purified sensibilities already latent in the culture. The painter Kazuo Shiraga took lumps of paint and spread them around with his feet – in Yoshihara's words 'a method which enabled him to confront and unite his chosen material with his own spiritual dynamics'. In another case, Saburō Murakami would break through a sequence of forty-two paper screens in a single action of his body (**fig. 15.13**). Shōzō Shimamoto might fire paint at a canvas using an acetylene gun. In his turn Yoshihara paid respects to both Mathieu and Pollock in a 'Gutai Manifesto' that he published in 1956. The Westerners' works are 'the loud outcry of the material, of the very oil or enamel paints themselves', he said. Gutai aimed to achieve a Japan-inspired Concretism in which material is 'brought to life' with an intelligent simplicity.[26] Those attitudes remained for the time being largely in Japan. It took some forty years for Gutai's special manner to be fully recognised in the West.

In the meantime – that is, by the mid-1950s – New York was fast becoming a cosmopolitan centre of art, and within its increasingly hothouse atmosphere came pressure for various kinds of change. By around 1956 or 1957 the early success of Pollock and his generation was beginning to fade – among artists if not in the popular imagination.[27] By then, some new variations on *informel* attitudes were being tried: for example an injection of irony on the part of Larry Rivers, or a kind of emotional distance in works by Robert Rauschenberg and Jasper Johns. Other variants on the essential sobriety of *informel* were being tested by Franz Kline and Philip Guston –

15.12 (*opposite*) Willem de Kooning, *Attic*, 1949. Oil, enamel and newspaper transfer on canvas, 157.2 × 205.7 cm. Metropolitan Museum of Art, New York

15.13 (*above*) Saburō Murakami, *Laceration of Paper*, 2nd Gutai Art Exhibition, 1956. Photographer Kiyoji Otsuji. Tate Gallery, London

15.14 (*above*) Philip Guston, *The Mirror*, 1957. Oil on
canvas, 172.8 × 153.6 cm. The Guston Foundation

15.15 (*opposite*) Grace Hartigan, *The Massacre*, 1952.
Oil on canvas, 200 × 320 cm. Kemper Museum of
Contemporary Art, Kansas City

the latter of whom achieved a rare concentration of smeared paint marks that, contrary to an earlier New York tendency to work up a kind of open field, now tended to cluster in the centre of paintings with an intensity that has never proved easy to describe. One critic saw the earliest of those works as exuding a brooding, darker mood – a 'grey melancholy'.[28] By mid-decade Guston's works had come to possess a particularly compelling force on account of their scale and size but often because they took on the aspect of an intimate presence, a looming concentration of energy facing a viewer who, in looking, comes to see an aspect of a head looking back (**fig. 15.14**). Guston's works of the mid- and later 1950s embody deliberate yet provisional acts of making which seem to be constantly reflecting on – presenting difficult questions about – the very steps by which they were made.

By now, too, the masculinism of Pollock, de Kooning, Motherwell and others was becoming supplanted by the achievements of several younger women. Social-cum-professional networks like Studio 35 or the Eighth Street Club had been virtually men only. Yet artists such as Mary Abbott, Perle Fine and Mercedes Matter were by the early 1950s already working in an *informel* manner, even though their standing with the dealers and critics remained generally low. Perhaps a disadvantage lay in the fact that they had come to art careers in the later 1930s and 1940s and reached maturity after the already well-established men. They were also hampered by stereotypes that downplayed their creativity and ambition, yet they were all painters of originality and considerable scale. The slightly younger Grace Hartigan began her *informel* paintings after seeing Pollock's exhibition at Betty Parsons in 1948, after which her works quickly achieved confidence enough to refer to real events by working up contemporary derivations from the old masters. One such is her *The Massacre* of 1952, which she began by sketching from Delacroix's *Massacre at Chios* (1824), with which it shares both grandeur and an epic scale (**fig. 15.15**).[29]

By mid-decade the critical fortunes of Hartigan and others in her milieu were
beginning to grow, not least because of a reversion among several women to
a particular kind of interest in 'nature'. The women's work would take on qualities very
different from the expansive scale references of Pollock or Newman, or the 'creatural'
references more common in European *informel*. Helen Frankenthaler, who met
Greenberg in 1951 and had been encouraged by him, discovered a technique of staining
unprimed canvas with washes of thinned paint, effectively creating what became
called a 'field' – both a literal description of the up–down and lateral spread of painted
markings as well as the sense of air, water and movement that pervades her expansive
images. It was this ability of several women to address the interspace between body
and mind, between consciousness and memory, that marks much of the best painting in
New York in the later 1950s. Pollock's wife Lee Krasner, overshadowed from the start
by her husband's reputation (boosted further by his death in a car accident in August
1956), now turned to her own considerable resources. She had trained with Hans
Hofmann, and with her innate calligraphic talent now started again with a series
called *Earth Green*, in which autobiographical references appear as well as natural

15.16 (*above*) Perle Fine, *Summer 1*, 1958–9. Oil on
canvas, 144.8 × 177.8 cm. The Levett Collection,
Florence

15.17 (*opposite*) Joan Mitchell in her studio at 77,
rue Daguerre, Paris, September 1956. *Life Magazine*,
13 May 1957

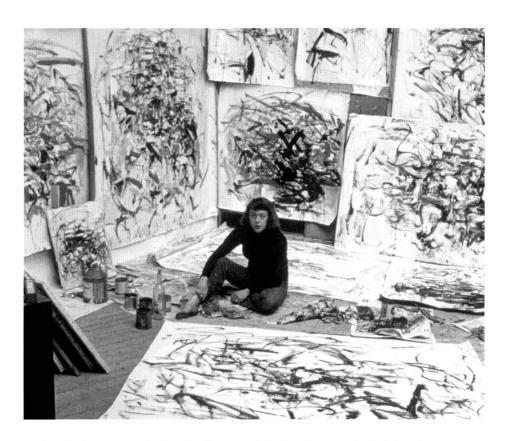

and bodily forms in works like *The Seasons* of 1957 or *Cornucopia*, 1958. In other artists, the range of landscape evocations ran from the lyrical translations of Perle Fine's best work, such as her superbly achieved *Summer I* of 1958–9 (**fig. 15.16**) or *Image of Winter* of 1959, to Joan Mitchell's anxious uncertainty before nature, combined as it often was with a willingness to import a narrative in order to key the work to actual life. Mitchell was by now producing superb translations of different kinds of sensation – spatial, chromatic, rhythmic – into clusters and collisions of paint. By the time *Life* magazine ran an article celebrating the 'ascendance' of five women painters in May 1957, a group of highly talented artists had begun to achieve the public recognition they deserved (**fig. 15.17**).[30] In 1959 Mitchell moved full-time to France, where she associated with an expatriate art community in Paris including Shirley Jaffe, Sam Francis and Jean-Paul Riopelle.

If *informel* reached a reputational high point during the 1950s, nevertheless its very seriousness and subjectivity were beginning to reveal gaps in its ways of accounting for experience in the post-war world. The commercial city had largely disappeared from its view. Eclecticism and irony had escaped its notice. Extraordinary new commodities were beginning to demand understanding. In the cities of the West, such agendas were pressing for attention too.

CHAPTER 16

London in the 1950s

It is to London that we now turn. Britain had entered the war period with a commitment to 'the modern' that was tentative at best; therefore to join the wider stream of artistic developments after the war it was necessary to start from a low base. Aside from the efforts of those associated with Unit One, *Axis* magazine or *Circle* in the 1930s, or who had belonged to Roland Penrose's circle of enthusiasts for Surrealism, the wider British public remained unversed in questions of modernity in art. A Council for the Encouragement of Music and the Arts (CEMA) had been set up early in the war under the guidance of a group of establishment figures, the majority with relatively little idea of artistic developments further afield; its slogan 'The Best for the Most' signalled support for rural communities and urban populations in a spectrum of artistic genres. When CEMA was joined by the economist and Bloomsbury-connected John Maynard Keynes in 1943, its populist aspirations gave way to a different orientation, to twentieth-century art not only of national but of international origins. In June 1945 CEMA became the Arts Council of Great Britain whose principles, as Keynes expressed it in a BBC announcement, included acknowledgement of the fact that 'the work of the artist is, of its nature, individual and free, undisciplined, unregimented, uncontrolled', and that 'he [*sic*] leads the rest of us into fresh pastures and teaches us to love and enjoy what we often begin by rejecting'. At the same time Keynes issued a warning against subservience to metropolitan standards and fashions. As he put it in a flourish, 'Let every part of Merry England be merry in its own way'. He added: 'Death to Hollywood'.[1]

The paternalism of this gesture was of a piece with the national isolationism still prevalent in the country's art museums. No British institution could match the collection or the programme of New York's Museum of Modern Art or its Museum of Non-Objective Painting. London's Tate Gallery, whose pre-war hesitations about 'modern foreign art' are now legendary, had added little to its holdings of early twentieth-century art and only hesitantly of work by living British artists of the order of Stanley Spencer, Graham Sutherland, Eric Ravilious and David Jones, figures still relatively unfamiliar to the larger public of the day. When a small exhibition *Braque and Rouault* was presented at the Tate in 1946, objections were raised by mostly older visitors on the grounds that the works 'violate nature'.[2] Meanwhile, the monarchically sponsored Royal Academy of Art remained 'if not retrospective at any rate stagnant', led at that point by the accomplished horse painter Sir Alfred Munnings, a fierce opponent of modern art in any of its forms.

Yet signs of interest were emerging. The 'stagnant' accusation was one issued by the critic and poet Herbert Read in his introductory address to an exhibition *40 Years of Modern Art 1907–1947: A Selection from British Collections* staged in February 1948 at a new institution, the Institute of Contemporary Arts (ICA), in its first premises, a disused Academy Cinema in London's Oxford Street. The ICA was the initiative of Read, Penrose and E. L. T. Mesens. It had initially been discussed as a scheme for a 'Museum of Modern Art'. Moreover, the ICA would not collect art; rather it would be 'cooperative, experimental, creative, and educational ... and for the benefit of the community'.[3] Metropolitan interest in modern culture was slowly rising. The Victoria and Albert Museum had shown *Picasso and Matisse* in the winter of 1945/6; the National Gallery had shown Paul Klee in 1946; and the Tate Gallery mounted shows of Van Gogh and Chagall in 1946 and 1947 respectively. With the resumption of art and design education throughout the nation, young aspirants wanting a glimpse of modern European art were now arriving in London for the first time.

The Scottish-Italian Eduardo Paolozzi arrived as a student at the Slade School of Art in 1944 with almost no acquaintance with modern art. In any event, he rejected the Slade curriculum in favour of drawing at the Science Museum, South Kensington, or browsing the second-hand bookshops on Charing Cross Road. Leaving for Paris in 1947 without graduating, he spent two years absorbing the residues of Paris Surrealism and in the process made the acquaintance of Giacometti, Léger, Tzara, Hélion, Brâncuşi, Arp and Duchamp, among others. He sought out and saw Dubuffet's *Art*

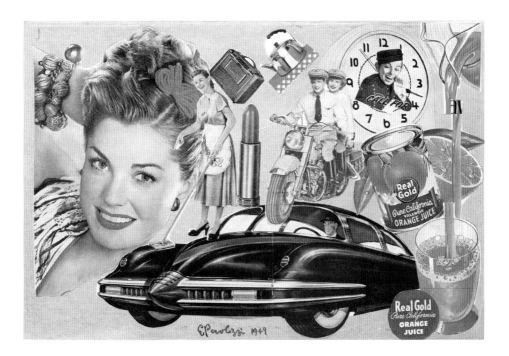

16.1 Eduardo Paolozzi, *Real Gold*, 1949. Printed papers on paper, 28.2 × 41 cm. Tate Gallery, London

Brut collection and admired it greatly. And in Paris there was an opportunity to extend his activities as an image scavenger or *bricoleur*, culling fragments from magazines and pasting them in telling or humorous conjunctions in what soon began to look like a new version of *dépaysement* – Surrealist disorientation. He appropriated glossy advertising images from magazines sent to the American artists he met, many of them in Paris courtesy of the recently passed GI Bill.[4] Soon, several collages and at least five extraordinary scrapbooks were complete, crammed full of sci-fi images, food and health advertisements, fragments from comics and technical illustration, in a manner that since the days of Dada had been all but excluded from contemporary art. Shiny non-sequiturs – a new car, little spacemen, sex, washing powder and warfare – were all now represented in a fantastical yet visually thrilling mix: images that Paolozzi would later call 'a catalogue of an exotic society, bountiful and generous, where the selling of tinned pears was transformed into multi-coloured dreams, where sensuality and virility combined to form ... an art more subtle and fulfilling than the orthodox choice of the Tate Gallery or the Royal Academy' (**fig. 16.1**).[5] Here was America as projected by the major corporations in the era of the hydrogen bomb and the diplomatic stand-off between the United States and the Soviet Union.

Back in London in 1949, Paolozzi was busy connecting animal and machine forms in sculptures and collage scrapbooks in ways that other British artists were becoming increasingly keen to follow. His first welded metal sculptures gave spiky, insect-like or creatural likenesses to crouching or standing figures not dissimilar in attitude to those of Germaine Richier at the time. A group of British sculptors in this vein were exhibited at the British Pavilion of the 1952 Venice Biennale and described by Herbert Read in just such terms. 'These new images,' Read wrote,

> belong to the iconography of despair, or of defiance ... Here are images of flight, of ragged claws 'scuttling across the floors of silent seas', of excoriated flesh, frustrated sex, the geometry of fear ... Their art is close to the nerves, nervous, wiry. They have found metal, in sheet, strip or wire rather than in mass, their favourite medium ...[6]

Some creatures were nimble too, for instance a metal *Crab* by Bernard Meadows or a well-regarded piece *The Inner Eye* by Lynn Chadwick – witness its four legs tapering below a torso with a central hole from which an eye of watchfulness (or surveillance) seems to peer (**fig. 16.2**). In more technical terms the 'geometry' Read refers to arose from the works' non-totemic quality: often more akin to a cage and produced by declarative methods of joining, hence quite different from the carving methods favoured by sculptors of a generation before.

Meanwhile, another of Paolozzi's obsessions was being put to the test. A number of artists, architects and writers who converged upon the ICA and known initially as the Young Group set up lecture occasions to stimulate discussion of what was to become a flood of new ideas. In April 1952 Paolozzi gave an impromptu slide lecture at the ICA in which he showed colour advertising, technical and machine images, without much commentary and in no apparent order. The occasion was greeted with 'disbelief and some hilarity', in Paolozzi's own recollection.[7] Exemplary of those images was one that featured the word 'Bunk!' – the title by which Paolozzi's lecture has come to be known – showing a swimsuited Charles Atlas holding aloft a new Cadillac aside a diagram

of the erect male member with a pin-up over the scrotum; or one now known as *I was a Rich Man's Plaything*, with its *Intimate Confessions* cover, an aeroplane, a Coca-Cola ad and a toy gun firing the word 'Pop!' (**fig. 16.3**). The hilarity audible in Paolozzi's audience was a sign that such images were parodies – to a degree affectionate ones – of the new American culture and its insertion into a slowly recovering yet hopeful British post-war world.

Those present at the 'Bunk!' lecture, including Paolozzi's close friends the sculptor William Turnbull and the photographer Nigel Henderson – but also Richard Hamilton, Victor Pasmore, Toni del Renzio, John McHale, architects Alison and Peter Smithson and the writer Lawrence Alloway – were soon known collectively as the Independent Group (IG), and it was from their shared and disputed enthusiasms that several important projects at the ICA were subsequently made. The exhibition *Parallel of Life and Art*, launched in September 1954, comprised 122 panels of photographically reproduced images from various sources and took to a further limit the mixing and association of categories – here medical, scientific, anthropological, metallurgical, geological and archaeological as well as art. In curatorial terms, too, the display reached for new principles. Images were hung on walls, suspended from or near the ceiling, and at radically different scales of magnification, all without information labels – for which the viewer had to consult a hand list that assigned every image to a group, among them Anatomy, Nature, Primitive, Stress Structures, Football, Science

16.2 Lynn Chadwick, *The Inner Eye*, 1952. Wrought iron with glass cullet, 230 × 107.9 × 76.7 cm. Museum of Modern Art, New York

16.3 Eduardo Paolozzi, *I was a Rich Man's Plaything*, 1952. Printed papers on card, 35.9 × 23.8 cm. Tate Gallery, London

Fiction, Medicine, Geology, Metal, Ceramic, even Architecture, Calligraphy and Art
(**fig. 16.4**). The organisers contributed separate but converging obsessions of their
own. Henderson was a photographer already adept at scale enlargement, high-speed
photography, images 'stressed' by being pulled out of shape in the printing, and what
he called Hendograms, a version of Moholy-Nagy's photogram technique. Henderson's
interest was to use the camera 'to expand our field of vision' beyond limits previously
explored, even those of recent publications such as György Kepes' *Language of Vision*
of 1944 or Moholy-Nagy's *Vision in Motion* of 1947.[8] Together with his friend Paolozzi
(also an organiser of the show), Henderson's primary enthusiasm was for the curious
and incompatible in combination.

For the other two organisers, the architects Alison and Peter Smithson, *Parallel
of Life and Art* exemplified their belief in a continuity between art and architecture
by showing how form, texture and intrinsic patterning – the material world 'as found'
by the camera or the human eye – was a keystone of both. Their term 'as found' pointed
to what already existed in a nearly natural state, in contrast to the 'found object'
of Surrealism, which for the most part signified a manufactured thing. The Smithsons'
new design projects were for the human living space itself. 'We were concerned with
the seeing of materials for what they were,' they later reflected; 'the wood-ness of wood,

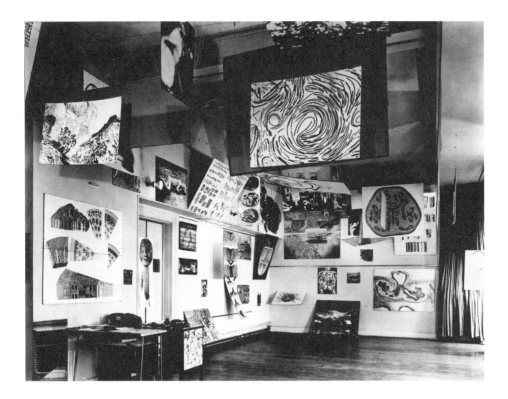

16.4 *Parallel of Life and Art* exhibition, Institute
of Contemporary Arts, London, 1954. Installation
photograph

the sandiness of sand. With this came a distaste of the simulated, such as the new plastics of the period – printed or coloured to imitate a previous product in "natural" materials', and a preference for 'the items in the detritus on bombed sites, such as an old boot, heaps of nails, fragments of sack or mesh and so on'.[9] It was an emphasis that led their Independent Group colleague Reyner Banham to anoint the 'as found' attitude in design and architecture 'The New Brutalism'.[10] What had begun in literary Paris as a fascination for encounters with 'found' objects had become in the grimy yet resurgent ambience of London after the Second World War an aesthetic of importance and originality.

It should be noted that 'materiality' as applied to collage – in the Independent Group as much as in Picasso or Max Ernst a generation earlier – signified both a paper surface *and* an image that may be printed on it. It was another of Paolozzi's circle, John McHale, who well understood this binary character, and with the writer Lawrence Alloway collaborated on a new project of October 1954, *Collages and Objects*, which presented over eighty works from Picasso, Braque, Gris, Ernst, Dalí, Magritte, Miró and Penrose to Paolozzi, Turnbull and McHale himself, whose *Transistor* collages addressed some quite recent advances in electronic communication by arranging diagram-like some simple units of glued and coloured paper. The very idea of incongruity was by now an active one among the Independent Group, who in a series of talks given the following year reprised a Dada attitude that happily conflated one thing with its contrary, its opposite, even its outright negation. In so doing they elevated the idea of contradiction to the status of a principle.[11]

Yet McHale's own work was about to change. Leaving in the autumn of 1955 for a fellowship programme at Yale University under Josef Albers, his attention became diverted by the sheer profligacy of American advertising, its news and lifestyle magazines, its science and technology enthusiasms. Back in London a year later, McHale set about constructing humanoid presences in cut and torn paper (often on a painted surface) in a demonstration of the cruel interface between the individual as willing consumer and technology victim alike. In the earliest of such works McHale presented a kind of brutish mechanical analogy for the human, engine-parts for the head and neck, cakes and cutlets for the interior, a ticker-tape emerging from the mouth – ill-assembled robots already ruined by the technology that had made them (**fig. 16.5**). Others in the series resemble lumbering cyborgs of uncertain appetites: men – yet not quite men – managers and politicians, those who are both the organisers and victims of the brave new world of atomic bombs and supermarket shopping, of 'communications' and television. McHale's creatures are sensing and digesting machines whose mechanical subjectivity has been opened to the general view. True to the IG's non-Aristotelianism, the contraries of inside–outside, mind versus body, subjective perception versus objective state are combined. As McHale would write in his later and much anthologised essay 'The Plastic Parthenon', the products of this increasingly technological diffusion 'become less viewable as discrete, individual events, rather more as related elements in a contextual flow'.[12] McHale's wife-to-be the painter Magda Cordell also refashioned the human figure, flattening it in the manner of an X-ray diagram, while similarly exposing it to the intrusive, inspectorial view (**fig. 16.6**).

For Paolozzi, some comparable principles applied. From around 1956 his method was to collect small-gauge toy cars and machine parts and press them into clay, then

16.5 (*above*) John McHale, *Machine-Made America II*, 1957. Collage, *Architectural Review*, no. 724, May 1957. British Library

16.6 (*opposite*) Magda Cordell, *Figure 59*, 1958. Oil and acrylic on Masonite, 243.8 × 152.4 cm. Albright-Knox Art Gallery, Buffalo, New York

bend the impressed clay into shapes suitable for wax moulds, out of which bronze, collage-like surfaces would emerge. We have Paolozzi's notes from a 1958 lecture at the ICA, delivered against a quickly changing flow of slide images of crashed cars and aircraft, men with mechanical arms and other odds and ends. The notes contain concrete poems, sketches and jottings amounting to a bricolage of the urban and the ancient, the adult and the naïve, the human and the mechanical, scribbles and Zen prose. He dwells upon robots, ancient cities, fantastic weapons and primitive fetishes, hinting repeatedly that the key to our jumbled universe is to be found in the world of the child's toy. His nearly life-size sculptures of the period are clearly parodies of a process in which, as he puts it, 'giant machines with automatic brains are at this moment stamping out blanks and precision objects, components for the other brains which will govern other machines'. Speaking of his obsession with the metamorphosis of the figure, he proposes the end result to be 'a parade of politicised robots gone criminal' (**fig. 16.7**). Such 'hollow gods' are brutal and mysterious, 'with the head like an eye ... the legs as decentred columns or towers, the torso like a tornado struck down, a hillside or the slums of Calcutta'.[13] They are automata that we revere, even in their dangerous yet ruined state.

Another group of London artists had been exhibiting together since the start of the 1950s and were frequent visitors at the ICA. Victor Pasmore, Mary and Kenneth Martin, Robert Adams, Adrian Heath and Anthony Hill were based in the Fitzrovia area of central London, and a series of weekend exhibitions had taken place in that district that presented reliefs, paintings organised geometrically, analyses of texture and shape, and mobiles, all made for the most part in a spirit of what Kenneth Martin called 'organizing real space ... an art of environment'. Pasmore echoed the theme: 'As he creates environment,' he said, so the artist 'creates experience', escaping the confines of literature to create a mobile and multidimensional kind of space.[14] Here was a nearly Constructivist attitude based on analysis, relationship, the modelling of modes of thinking as well as the made environment. Word of those exhibitions soon enough reached Paris, and in May–June 1954 an international exhibition *Artist versus Machine* had presented works by the Fitrovia group as well as containing some architectural projects from France and two reliefs by the American artist Charles

Biederman. Relations between the Constructionists (as the Fitzrovia group became known) and the Independent Group at the ICA were mostly hostile – except for Lawrence Alloway, who was catholic enough in his interests not only to review the exhibition but also to prepare a booklet, *Nine Abstract Artists*, which the bookshop Tiranti published to coincide with another show, mainly of Fitzrovia artists, at the Redfern Gallery in London in early 1955.

Nine Abstract Artists has proved a useful guide to many of the positions being taken in London at that time. Alloway recognised that Hill, Pasmore and the Martins were theorists of art: that each in their own way was reckoning with the demands of Pythagorean plane geometry yet keen to enrich that foundation by extending it to three dimensions, into rhythm, and into the viewer's experience of time. Hill at this stage would establish interlocking rhythms by means of parabolic shapes and square corners that push–pull against each other in sets of quickly shifting *gestalts*, dancing as if in counterpoint, but with minimal means. The Martins, meanwhile, looked for subtly rhythmic pulsations built of bronze or white-painted plastic forms – in Mary Martin's case, articulations of grouped relief surfaces that can be read either as wall structures or as possible relations between modern-movement buildings seen from the air (**fig. 16.8**). In Adrian Heath's work, too, we see temporality operating inside the painting itself, to the point where almost rectangular forms hinge and lever relative to each other like the pieces of jointed machinery. Going further than the 'dynamic symmetry' formulae of Mondrian or the dialectical

sequencing proposed by van Doesburg, Heath looked to an extraordinary book published by the Australian painter John Power in 1932 in which 'moving formats' are discovered inside the works of old master paintings which he, Power, claimed could still be used today.[15] As rectangles tilt and reposition themselves in Power's diagrams, so Heath finds a method in which near-rectangular painted elements look as if they are about to move (**fig. 16.9**).

On the other hand the three non-theorist members of *Nine Abstract Artists* –Terry Frost, Roger Hilton and William Scott – remained engaged with the question of how to negotiate figural references in the work of art in an age when a 'modern' figuration seemed no longer easy to achieve. All three of them had seen active service in the war and had afterwards been well supported by the dealer network at a stage when

16.7 (*opposite*) Eduardo Paolozzi, *Jason II*, 1956–8. Bronze, 107.3 × 25 × 13.2 cm. National Galleries of Scotland

16.8 (*above*) Mary Martin, *Spiral Movement*, 1954. Paint on wood, 61 × 61 × 7.6 cm. Arts Council Collection, London

their sensibilities were beginning to form. It took Roger Hilton until 1953 or 1954 to discover his own casual yet rigorous manner in which suggestive shapes lie embedded *in* a paint surface rather than upon it; and Scott at this stage was doing approximately the same. Hilton would manage a fine balance – or tension – between the respects in which a painting might 'picture' a figure and the no less clear sense in which a painting's forms might not 'picture' anything at all, or very little. 'If we are interested in solids [in art],' Hilton wrote in *Nine Abstract Artists*, 'it is the picture which is the solid. It is for us real paint on real canvas'. And: 'A picture is a thing, no longer something looked into but something which energises and activates' (**fig. 16.10**).[16] Terry Frost, for his part, belonged to a group of artists who either worked in, or regularly visited, St Ives, the Cornish fishing village umbilically connected to London by the train line out of Paddington to the west; and for these, landscape and the objects in or upon it were part of what the artist should reckon with and learn to see. By mid-decade Frost was learning to translate his experiences of the coast by reducing the shapes of boats bobbing in the harbour to a rhythm of stacked colour forms in counterpoint (**fig. 16.11**). As Alloway put it in *Nine Abstract Artists*, painters in St Ives incorporate such references 'because the landscape is so nice nobody can quite bring themselves to leave it out of their art. The generalised horizon-line or a particular rock, a mine or a climb, is always present to a greater or lesser degree of abstraction'.[17] For Patrick Heron, on the other hand, a more complex (and richer) phenomenology of interlocking colour forms was the manner he preferred to try. He had met Braque

16.9 Adrian Heath, *Interlocking Forces*, 1950. Oil on canvas, 45.7 × 35.6 cm. Private collection and National Museum of Wales, Cardiff

16.10 Roger Hilton, *June 1953*, 1953. Oil on canvas, 91.4 × 71.1 cm. Stedelijk Museum, Amsterdam

on visits to Paris in 1948 and 1949, and had learnt from him that the wandering, variable line in the Cubist's later paintings could be put to use as a graphic gesture, interweaving objects and intervals while holding strictly to the picture plane, whether in a still life, an interior or a portrait (**fig. 16.12**). Heron had been in Paris again in 1952 where he had met Nicolas de Staël and Pierre Soulages, from the first of whom he had learnt that patches of colour could create spatial sensations without being referential at all.[18] As an astute organiser and articulate critic, he recognised the qualities of a group of British artists (of which he was one) that he presented under the title *Space in Colour* at the Hanover Gallery in July–August 1953 – in his terms a celebration of how colour creates space as the primary quality of visual art. Good painting, he wrote in the catalogue,

> creates a sensation of voluminous spatial reality which is so intimately bound up with the flatnesses of the design at the surface that it may be said to exist only in terms of such pictorial flatness ... [moreover] colour is the indispensable means for realising the various species of pictorial space.[19]

Throughout the rest of his career Heron operated as a painter in the mid-zone between suggestiveness and pure pictorial flatness in the work of art. In June 1956 a show titled *Tachiste Garden Paintings* at the Redfern Gallery demonstrated his mastery of an aesthetic rooted in colour, intrinsic to the natural world and to the materiality

16.11 Terry Frost, *Green Black and White Movement*, 1951. Oil on canvas, 109.2 × 85.1 cm. Tate Gallery, London

16.12 Patrick Heron, *Portrait of Sir Herbert Read*, c. 1952. Oil on canvas, 76.2 × 63.5 cm. National Portrait Gallery, London

of paint alike (**fig. 16.13**). In such an aesthetic, necessarily, the London environment of commerce, industry and advertising was nowhere to be seen.

Those projects together tell us that by the mid-1950s London's artistic culture was changing fast. For some in the later 1940s and early 1950s, the human figure and its predicament had been important; and here the work of Francis Bacon must be mentioned briefly. He had found his true interests as an artist only gradually. After time in Berlin in the late 1930s his models in art had become Van Gogh but more relevantly Picasso, especially the radical figure paintings of the later 1920s which were generally not widely known. These latter had suggested the grotesque style of Bacon's breakthrough triptych *Three Studies for Figures at the Base of a Crucifixion* of 1944, in which animal–human hybrids squirm and scream as if in agonised confinement. By the early 1950s he had found a picture format in which male figures – vulnerable, damaged, often naked – would be glimpsed as if unawares inside an evenly lit room. When two figures are together, the mood is of sex and violence combined (**fig. 16.14**). Bacon would always insist that his paintings were neither 'figurative' nor 'non-figurative' – rather 'a kind of tightrope walk' between the two.[20] No other painter dared imitate Bacon's manner or even try to, and his work still divides opinion today. Yet it is worth noting that other painters of the isolated figure were beginning careers in London at this time, among them Frank Auerbach, Lucian Freud, Michael Andrews, Leon Kossoff and Ron Kitaj, who would later become dubbed the 'School of London', notwithstanding the many divergencies among them.[21]

For those in London unpersuaded by such kinds of figuration, other questions predominated. For one thing, by mid-decade a generation of European modern masters were at the end of their careers. Klee, Kandinski, Bonnard and Matisse were all dead. Picasso and Braque were elderly, though still working vigorously. How was a figure painter to 'go on' in such a situation? Surely the better challenge was to reckon with the achievements of the new American art, or of Paris *art informel* at the time. Here, the record of the ICA in the mid-1950s is remarkable. A version of Michel Tapié's *Véhémences confrontées* (retitled *Opposing Forces*) was staged there in 1953 with works by Pollock, Sam Francis, Henri Michaux and Mathieu. Dubuffet and Mark Tobey had exhibitions at the ICA in 1955, and Mathieu a solo exhibition there in 1956, complete with a TV demonstration of his 'tubism' technique in action. The year 1956 in London was certainly an important one. Firstly, a sample showing of artists of the New York School arrived in force at the beginning of the year. It was in the final room of *Modern Art in the United States* at the Tate Gallery that works by Pollock, Rothko, Baziotes, de Kooning, Gorky, Kline, Motherwell, Hartigan, Stamos, Still, Tobey and Guston could now be seen as a group; and to the London art community the immense ambition of the Americans could not be other than clear. Here was a loose-knit community of artists – not representative of America so much as predominantly New York – in which both scale and articulate gesture were being impressively combined. At the same time, some critical questions would soon be asked about the vigour of the New York School. What were the social meanings of its reach and confidence – including the arrival of the exhibition in London at the very start of a longer European tour? What relations might obtain between the ambitions of the new art and America's increasingly commercial dominance throughout

16.13 Patrick Heron, *Autumn Garden*, 1956.
Oil on canvas, 180 × 90 cm. Private collection

16.14 (*above*) Francis Bacon, *Two Figures*, 1953.
Oil on canvas, 152.5 × 116. 5 cm. Private collection

16.15 (*opposite*) Aubrey Williams, *Death and the
Conquistador*, 1959. Oil on canvas, 83.5 × 133.8 cm.
Tate Gallery, London

the West? At a time of high levels of international tension between the United States and Soviet Russia, what part might such exhibitions have been intended to play?[22]

It should be noted that London as a European capital was also beginning to become a world city at this time – but on terms different from those of its colonial past. The year of Indian Independence, 1947, saw the founding of the Progressive Artists' Group in Bombay and the search among its members for creative relationships between Indian and Western developments. Francis Souza, a founding member, arrived in London in 1949 to be immediately exposed to conflicted attitudes among the critics and dealers in the post-war city. Likewise the arrival in London of artists from the Caribbean, themselves with ancestry in West Africa and the experience of the Atlantic slave trade, created harsh dilemmas for the artists themselves. The Guyanese painter Aubrey Williams, to take but one example, who arrived in 1952 and studied art at St Martin's School of Art, found himself interested in German Expressionist stylisation as well as the new American art, but also in elements of pre-Columbian art from his Guyanese past. How was he to reconcile those several traditions inside his work – and more especially make those cultural references understood? 'I have all the five races inside me,' he later said, 'the dominant one is West African – Ghanaian or Nigerian. Flowing through me are all these things [and] the question is to which pole I give my identity direction' (**fig. 16.15**).[23] Williams did in fact find a welcome at the New Vision Centre Gallery, near Marble Arch, run by the artist Denis Bowen. This modest institution played an essential role in establishing a resonance between London as an artistic culture and a generic *tachiste* manner in art, particularly the postures and attitudes of the CoBrA group, but also provided display opportunities for work addressing the political crisis fomented by the East–West arms race as well as creating openings for younger artists. With strong

links to art schools in the north of England as well as experimental groups in mainland Europe, the New Vision Centre was for a while essential to the vitality of the London scene. Bowen's own *tachiste* paintings addressed with some urgency the disturbing international news agenda of the day (**fig. 16.16**).[24] Williams, for his part, having achieved a measure of recognition in the city, became progressively ignored by dealers and curators in the decade that followed.

The year 1956 in London was not to end without a further enterprise involving some dominant art groupings already there. Early in the year an initiative was developed to try and fuse together the interests of the Fitzrovia community and the Independent Group in their joint concern to connect art to the viewer's experience of the city itself. A first step was a meeting between the artists of the *Artist versus Machine* exhibition and Paule Vézelay, representative of the Paris-based Groupe Espace, who came to London with a mission to establish a large-scale art and architecture project of some kind. The meeting went badly, and the Fitzrovia artists, now joined by the architects Colin St John Wilson and Theo Crosby and some members of the Independent Group, determined to plan an event of their own around London as a city and the making and experience of a contemporary, futuristic art. After arguments and indecision, the upshot was a multi-part exhibition staged finally at the Whitechapel Gallery in London's East End in the autumn of 1956 entitled *This Is Tomorrow*.

Here, and confusingly to some, was an arrangement of twelve different small group displays, each with a uniquely arranged room space and a catalogue of its own. Given its fragmentary presentation – made worse by the desire of individuals to make signature contributions rather than collaborate – *This Is Tomorrow* was in effect a collage of unresolved deliberation, far-fetched speculation and audience provocation. The Fitzrovia artists organised an abstract and Constructivist display in Group Five. The Martins were in Group Nine. Most of the other groups were dominated by IG interests – and one in particular has survived well in the historical record. This was the coalescence

16.16 (*above*) Denis Bowen, *Cold War*, 1957. Oil on canvas, 185 × 123 cm. Gallery Different, London

16.17 (*opposite*) Richard Hamilton, *Just what is it that makes today's homes so beautiful, so appealing?*, 1956. Collage, 26 × 24.8 cm. Kunsthalle, Tübingen, Zundel Collection

of art and graphics in Group Two, that of Richard Hamilton, John McHale and John Voelcker, that played effectively on the combination of contemporaneity and ruination that characterised, as they saw it, the contemporary city as experienced from within. The group's most notable contribution was perhaps its catalogue, containing a small collage by Hamilton showing a hybrid interior of contemporary lifestyle choices (interior design, glamorous dressing), domestic technologies (vacuum cleaner, tape recorder) and gender stereotypes, including a body-builder holding a sign containing the word 'Pop' (**fig. 16.17**). Bearing the ironic title *Just what is it that makes today's homes so beautiful, so appealing?* – and with a host of ready associations with 'lollipop', 'pop-gun', 'popular', 'pop music' – the 'Pop' that found its way into Hamilton's collage was destined to become accepted currency for an art that dwelt in the ordinary stuff of a commercial culture, eventually to elevate it into a new genre of art.

In the Vernacular: Beat and Assemblage

One of the regularities of modern artistic change is for artists to attend to objects or situations conventionally deemed unimportant, at just the moment when gathering social change triggers a re-evaluation. The realm of common objects – 'the vernacular' – underwent just such a recovery in the period after the Second World War. In common with other recoveries, this one could be double-edged: a critique of accepted value-codings on the one hand while being an ironic celebration of those same codings on the other. What became known as Beat culture exemplifies the pattern. In America, it can be traced to Columbia University, New York, where in the mid-1940s three would-be writers, Jack Kerouac, Allen Ginsberg and William Burroughs made friends with a poet and Times Square junkie named Herbert Huncke who used the term 'beat' to refer to the predicament of being low in the world, materially poor, rejected by society yet at the same time streetwise, wide-eyed and perceptive. It was the kind of awareness that in the spring of 1951 fuelled a three-week Benzedrine-driven writing stint by Kerouac that produced the novel *On the Road*, based on road trips to California and Mexico, which reads as a celebration of random travel, humility before the unpredictable, the sanctity of ordinary places and things.[1] 'This is the beat generation,' announced an article in the *New York Times Magazine* towards the end of 1952. 'It involves a sort of nakedness of mind, and, ultimately of soul, a feeling of being reduced to a bedrock of consciousness ...'[2]

On America's west coast the conditions of a Beat culture were less confining than in cities further east. From as early as 1942 Jermayne MacAgy, acting director of the San Francisco Museum of Art, curated a pioneering programme of exhibitions that included Pollock, Motherwell, Gorky, Rothko and Still. Meanwhile, the California School of Fine Arts, situated in the North Beach area and led from 1945 by Jermayne's husband Douglas MacAgy, was an important catalyst. MacAgy encouraged perspectives that were innovative and contemporary. One was New York School-type painting, taught by Still and for a time Rothko as well as the younger Richard Diebenkorn. A second was the more anarchic attitude adopted by the no less influential Clay Spohn, a stalwart of the California WPA programme who was attuned to European Dada as well as an exponent in America of what came to be called 'assemblage': the joining together of material retrievable from trash cans or garbage dumps, then placed within the context of a gallery exhibition or even the hallowed sanctuary of a museum. Schwitters and other artistic scavengers were important to him. 'I would pick up little pieces of cast-off parts of machinery,' Spohn recalled, 'and then get some wire and a piece of metal and put it all together and make an object of it ... I gathered up a lot of stuff from the brush of the

vacuum cleaner, stuff from the carpet, and called it "Bedroom Fluff"'.[3] The result, the forty-two items of Spohn's Museum of Known and Little-Known Objects (the majority now lost), staged his conviction that all objects inhabit a cycle of rising and falling relative value – an important truth behind the much touted imperative of the instantly 'new' (**fig. 17.1**). For Spohn and those who followed him, repurposing the discarded was at the same time an assertion of essential artistic freedoms such as spontaneity and independence of choice.

The San Francisco area also played host to a poetry revival in the early 1950s at the hands of Kenneth Rexroth, Robert Duncan, Lawrence Ferlinghetti and others that provided fertile conditions for visual artists too. The poet Robert Duncan, who had written a brave defence of homosexuality at a time when such discussions were rare, had met the artist Burgess Collins (who had trained under Spohn) and established a *ménage* that became a creative partnership lasting some thirty years. Collins – or Jess as he preferred to be known – specialised in creating marginal categories that he called 'Paste-Ups', 'Assemblies', 'Translations' or 'Salvages', in which *objets trouvés* of any kind – photographs, thrift-shop objects, cut-up newspapers – were reworked such as to encourage abrupt disjunctions, hallucinatory scenes, even the frisson of absurdity, and in that way reveal a new and remarkable image.[4] A large Paste-Up of 1951 took dozens of images from male pin-up magazines and recombined them in a spirit of provocative play (**fig. 17.2**). In December 1952 Jess set up the King Ubu Gallery (named after Alfred Jarry's provocative pastiche *Ubu Roi* of 1896) with Robert Duncan and Harry Jacobus at 3119 Fillmore Street, San Francisco as a venue for poetry readings, performances and exhibitions for and by the west-coast Beat community, including an exhibition of junk assemblages called 'Necro-Facts' by Jess himself. One further Paste-Up included

17.1 Clay Spohn, *Mole Samplers – Mouse Seeds, Bedroom Fluff*, 1949 (lost work). Photograph by Carl Hultberg

images of a fashion model, a foot, a lobster, and quips from society gossip. Another transformed an image sequence from the popular *Dick Tracy* comic into provocative nonsense. Jess was an ardent fan of Max Ernst's collage novels of the late 1920s and early 1930s – but in a fresh situation in which a whole new material culture and a new aspirational society was available to plunder and distort.

The spirit of interplay between media extended to the ownership and management of galleries themselves. Artist-run and unprofitable, they supplied the infrastructure for a blossoming San Francisco scene. The King Ubu Gallery having closed in 1953, the Six Gallery ran at the same address from late 1954 to 1957 under the direction of the painter Wally Hedrick **(fig. 17.3)**. He had attended the California School of Fine Arts under the GI Bill on discharge from war service in Korea, and made a series of works in those years that were assemblages of broken radio and television sets, washing machine parts and other junkyard scrap, often covered with a thick impasto of gesso and paint.

17.2 (*opposite*) Burgess Collins (Jess), *The Mouse's Tale*, 1951. Collage and gouache on paper, 119 × 81.2 cm. San Francisco Museum of Modern Art

17.3 (*above*) Wally Hedrick in his studio at the 'Ghost House', San Francisco, 1952. Photo by Nata Piaskowski

17.4 (*above*) Bruce Conner, *Untitled* (back view), 1956–60. Mixed materials on Masonite, 162.2 × 126 × 10.5 cm. Walker Art Center, Minneapolis

17.5 (*opposite*) Bruce Conner, *Child*, 1959–60. Mixed media, 87.7 × 43.1 × 41.7 cm. Museum of Modern Art, New York

Some of these lash-ups might contain flashing lights or moving parts if an electric component could be persuaded to work.[5] The Six Gallery was also the site of a particular event that caught the period mood. On 7 October 1955 Beat culture became fixed in the public memory on a lasting basis. A poetry reading to accompany a show of sculptures by Fred Martin heard readings from six poets, including Ginsberg, who had recently arrived with Kerouac from New York. To the accompaniment of rhythmic chanting by Kerouac, Ginsberg delivered his epic poem *Howl* to a rapt audience in passionate, incantatory style, voicing accusations against America (both 'moloch' and 'machine') as well as urging celebrations of the body, nature and the freedoms of a visionary art.[6]

By mid-decade, however, the visionary impulses underlying Beat America were beginning to slightly fade, as 'assemblage' itself became the term more widely used for any manner of tarrying with the broken, the damaged or the marginal amid the glamour of the new. By the time Bruce Conner arrived in San Francisco in 1957 the spectacle of overload by the advertising industry was becoming a matter of intellectual and artistic concern (by no coincidence it was the year of Vance Packard's analysis of manipulative marketing, *The Hidden Persuaders*, and of Roland Barthes' seminal essays on sign systems, *Mythologies*). Conner, true to the straight-talking experimentalism of west-coast culture, set about making assemblage constructions that dealt a no-holds-barred challenge to the double standards of the culture that surrounded him. A large two-sided work known as *Untitled*, worked on intermittently for years before it was completed in 1960, contains a barrage of erotic pin-ups, medical diagrams of the body, images of war torture, clips from *Good Housekeeping*, a photo of James Joyce and a US army sticker stating 'Warning: You Are In Great Danger' – as if to address the viewer as much as the culture from which the fragments came (**fig. 17.4**). *Untitled* at the same time contained all the personal investment of a private noticeboard, its viewer caught midway between alienation and inclusion and now faced with the challenge of reconciling a position between the two.

The same double-edged assemblage method was used in Conner's more disturbing work, *Child*, exhibited for the first time in 1959 (**fig. 17.5**). At first glance the piece is a gruesome rendition in wax, nylon, metal and twine of a mutilated child strapped to its high-chair and left there by its abuser – until we recall the wider context, that of a certain

Caryl Chessman who was in the news at the time. A convicted robber and larcenist, Chessman was in San Quentin jail awaiting execution for an alleged rape (in legal terms a non-lethal kidnapping) while powerful voices were being raised against the sentence being confirmed by the US courts. *Child* was made during a lengthy period of legal indecision. Tellingly, the work reads as an image of Chessman himself, as if bound by captors and himself psychologically mutilated by a culture that had effectively kidnapped *him*. Conner had meanwhile proclaimed himself president of a group of dissenting San Francisco artists calling itself the Rat Bastard Protective Association that included Wallace Berman, Jay DeFeo, Wally Hedrick, George Herms, Michael McClure and others, all zealous of their outsider status and committed to political and artistic protest. This collective was short-lived too. Conner soon left the west-coast city for Mexico and a new period of work in experimental film.[7]

Matters were necessarily different on the east coast. Even while *informel* in New York was approaching its crescendo, artists coming late to that banquet were picking up other clues in the public culture of the day. The young Robert Rauschenberg had spent the early part of 1948 in Paris, also thanks to the GI Bill, experimenting with free-painting methods but in a manner more concerned with chance and randomness than with angst or despair. He then returned to enrol in the experimental art school Black Mountain College, North Carolina, at that time still under the leadership of Josef Albers. Rauschenberg's interest in imprinted marks (vehicle tyres on paper, woodcuts, handprints, X-ray photographs) dates from this time, as does his sympathy for his friend John Cage's explorations in sonic randomness, intervals between sounds, inclusiveness, even silence. Rauschenberg's sensibility came into further focus during a journey to Italy and North Africa in the winter of 1952/3 with the painter Cy Twombly. There, he picked up on the special qualities of aging newspaper scraps, old engravings and graphic exotica from the several cities they visited. Perhaps recalling Albers' encouragement to his students to pay close attention to materials and things 'in combination', Rauschenberg would assemble these scraps side by side in seemingly casual proximity – and without comment – thus to uncover a way of noticing things that would inform his entire career. Near-flatness, the squashed, folded or imprinted mark of one surface upon another, is visible in the majority of his photographs of that time (**fig 17.6**). In them, the distinction between two dimensions and three begins to fall

17.6 (*above*) Robert Rauschenberg, *Rome Flea Market (V)*, 1952. Gelatin silver print, 38.1 × 38.1 cm. Rauschenberg Foundation, Florida

17.7 (*opposite*) Robert Rauschenberg, *Interview*, 1955. Combine: mixed materials, 184.8 × 125.1 × 63.5 cm. Museum of Contemporary Art, Los Angeles

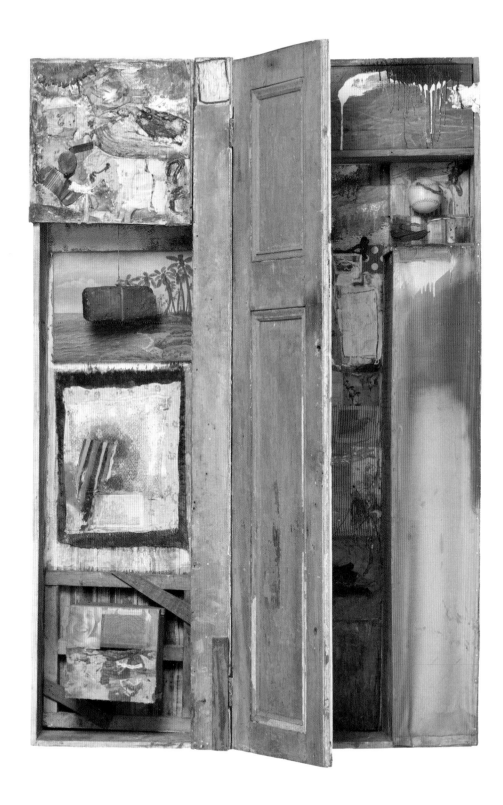

away. Apparent happenstance would become the hallmark of most of his future work.

It is the quality that marks the celebrated series of Combines and Combine Paintings that Rauschenberg began in 1954 and continued for about a decade. Such Combine Paintings as *Charlene* and *Collection*, both from that year, eschew painted canvas in favour of upright panels on which, to cite a later critic who speculated on their structure, 'objects are scattered ... data is entered ... information may be received, printed, impressed, whether coherently or in confusion'. In Leo Steinberg's further words, the panels are of the kind 'to which anything reachable-thinkable would adhere ... whatever a billboard or dashboard is, and everything a projection screen is'; a typical Rauschenberg surface 'stands for the mind itself – dump, reservoir, switching centre', as in an internal monologue. The resulting picture plane 'is for the consciousness immersed in the brain of the city'.[8] The same principle informs the Combines themselves – free-standing objects either resting on the gallery floor or functioning on stage for the Merce Cunningham Dance Company as a screen or door that dancers could pass through. Several Combines and Combine Paintings suggest physical movements such as climbing a ladder or opening a door (**fig. 17.7**). In fact, both wall-mounted and free-standing objects have a further quality that through the late 1950s and early 1960s became distinctive of Rauschenberg's work. Their imagery was so profuse and dispersed as to seem to evade, or not quite reach, any particular area of thinking and feeling – let alone a politics – and yet do so in a way that was widely apprehended as something interesting and new. It was perhaps not until the Irish artist and writer Brian O'Doherty examined them closely that the meaning of Rauschenberg's style of non-commitment became clear. Rauschenberg's fragments, as O'Doherty put it, are 'the casual information of the man who scans the paper, gathers fragments of news on TV and radio, flips through an art book now and then'. The Combines and Combine Paintings not only welcomed accidents in their making but encouraged what O'Doherty called 'the city-dweller's scan ... a glimpse of lapsing histories, half-chewed processes, sputtering feedback from nutty dissociations, all contained in the crowded arc of one rapid perception ... not just the vernacular object but something much more important: the *vernacular glance*'.[9]

17.8 (*above*) John Chamberlain, *Essex*, 1960. Automobile parts and other metal, 274.3 × 203.2 × 109.2 cm. Museum of Modern Art, New York

17.9 (*opposite*) Jasper Johns, *Gray Alphabets*, 1956. Beeswax and oil on newspaper and paper on canvas, 168 × 123.8 cm. Menil Collection, Houston

Before long, the full scope of what the curator William Seitz called 'the vernacular repertoire' would be celebrated in the exhibition *The Art of Assemblage* at the Museum of Modern Art, New York, in the later part of 1961. Itself an assemblage of sorts, the exhibition encompassed put-together techniques running from the nineteenth century, through Cubism and onwards to the Beat fraternities of San Francisco, the latter represented by a mordant burnt offering by Bruce Conner titled *The Last Supper*, 1961. Necessarily, the show contained a spectrum of attitudes to the vernacular form: from crisis-ridden works by Ed Kienholz (*John Doe*, 1959) and George Herms (*The Poet*, 1960), aestheticised metal sculptures by John Chamberlain (**fig. 17.8**) – crushed and twisted automobile parts garnered from the junkyard – to softer, sensuous assemblage works by Robert Motherwell, Anne Ryan and Louise Nevelson. To Seitz, the vernacular repertoire included 'beat Zen and hot rods, mescalin experiences and faded flowers, photographic bumps and grinds, the trash can, juke boxes and hydrogen explosions', extending to topics often 'fearfully dark, evoking horror or nausea ... the confrontation of democratic platitudes with the Negro's disenfranchisement; the travesty of the Chessman Trial'.[10]

As Seitz noted, several artists of the vernacular incorporated into their works flags, shields and other symbols of national power and authority with seeming irony, not only flouting enforceable regulations regarding sacred insignia of the state, but in the process reducing them to banal images while raising them upwards into the circuits of a contemporary art. Such double-edged manoeuvres enshrined a kind of conceptual provocation found in much of modern art. In the case of Jasper Johns' work of the 1950s, the motivation was less to flout conventions than to reach for the inert, even unexciting materiality of ordinary things – materiality that only gets elevated into value by the culture that things belong to. What happens to familiar objects when that value is stripped away? The task underlying Johns' deployment of targets, maps, numerals, the American flag, was to suspend rather than add to their social aura. Encaustic, newspaper fragments, grey or white paint: such inexpressive – even Beckettian – substances drove his early work as it were downwards, beneath where even the vernacular resided (**fig. 17.9**).[11]

In Europe, assemblage art tended to be smaller in scale than its American counterpart, as well as more reflective of the poverty and damage that had been experienced in the war. The Parisian group christened in 1960 as Nouveau Réalisme (New Realism) by the critic Pierre Restany began as a collaboration between Restany and the young Yves Klein in the context of an exhibition in Milan. A declaration signed by Restany and eight artists in October of that year announced their orientation towards what he described as 'the real perceived in itself and not through the prism of conceptual or imaginative transcription'. What would be seen as a European flavour was suggested by the final part of the group's announcement, that 'if man succeeds in reintegrating himself into the real, he identifies the real with his own transcendence, which is emotion, sentiment, and above all poetry'.[12] Technically, the Nouveaux Réalistes worked in various ways. Armand Fernandez (since 1957 known as Arman) had been represented in Seitz's *Art of Assemblage* show by two early works he called 'accumulations', collections of the same or similar objects crammed into a shallow-spaced box and presented in a basically pictorial mode. A work named *Arteriosclerosis* of 1961 was a boxed accumulation of forks and spoons such as might be seen in a waste pile outside a derelict or ruined building. The macabre *Tamerlane's Memorial* of the same year places discarded dolls' heads in a shallow wooden drawer, a clear evocation of the brutalities perpetuated in Europe a mere fifteen years before (**fig. 17.10**). Yet other artists in the Nouveau Réaliste grouping, for instance the poster-tearing Jacques de

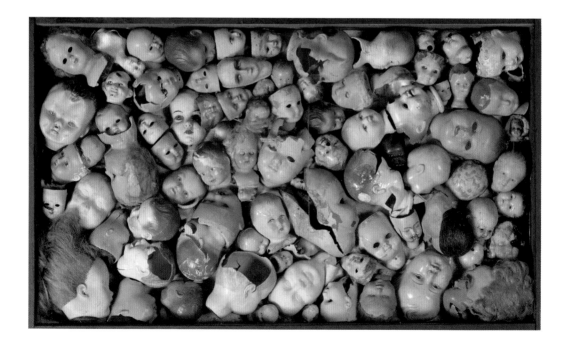

17.10 (*above*) Arman, *Tamerlane's Memorial*, 1961. Mixed materials, 6 × 100 × 10.8 cm. Kunsthalle, Hamburg

17.11 (*opposite*) Daniel Spoerri, *Kichka's Breakfast I*, 1960. Various materials, 36.6 × 69.5 × 65.4 cm. Museum of Modern Art, New York

la Villeglé, Raymond Hains and François Dufrêne (as well as Mimmo Rotella, who did not sign the manifesto but joined the group in 1961), were as much interested in the fascination exerted by urban ruination as in the political meanings of ruination itself (see fig. 18.1). Daniel Spoerri's confrontation with the ordinary took place in the domestic sphere. When he took the table-top remains of a meal event, stuck the pieces down and raised the whole to a vertical plane, he created a pictorial entity that would invite the viewer to understand the most humble remains as 'art' (**fig. 17.11**). The elevation of normally horizontal things to a vertical plane was a formal change adopted for much vernacular material in its transformation into art.

For some, ruination did not necessarily need to be tragic. The Swiss Jean Tinguely, normally resident in Paris, where he took to making machines that clanked and rotated by the power of electric motors, arrived in New York in early 1960 with plans for a truly massive construction that would perform its own destruction. On an overcast evening in March 1960 his *Homage to New York* was made ready in the sculpture garden of the Museum of Modern Art, and at the appointed time – in Seitz's description – 'vibrated and gyrated, painted pictures, played music, and magnificently but inefficiently sawed, shook, and burned itself to rubble and extinction'.[13] At once spectacular and absurd, this and other self-destroying devices clearly shadowed widespread contemporary fears about the possibility of nuclear annihilation (**fig. 17.12**). Nouveau Réalisme continued as a coherent grouping (enlarged by the later membership of César, Gérard Deschamps and Niki de Saint Phalle) until it was dissolved in 1970.

The range of European approaches to vernacular images can be illustrated by examples from Germany and the United Kingdom. When the German artist Wolf Vostell made his first visit to Paris in 1954 his attention was drawn to a newspaper headline at a kiosk in the boulevard Saint-Germain that stated '*Peu après son décollage une Super-Constellation tombe et s'engloutit dans la rivière Shannon*' ('Shortly after take-off a Super-Constellation fell and sank in the River Shannon'). He associated the air disaster with an event from his childhood, when in 1940 he had witnessed bombs and aircraft falling from the sky 'like a flock of birds'.[14] The word *décollage* (unglueing, loosening, also an aircraft's take-off) at once became for Vostell a phrase linking technology, destruction and decay. It evoked the contrast now in front of him between the physical destruction of post-war Germany and the condition of contemporary Paris – to a German, a reasonably intact city. There were relatively few physical ruins, rather

'there were more ruined posters than readable ones in every Paris street and Metro [and] I established an immediate analogy between the pulverised aeroplane and the torn posters'.[15] Henceforward Vostell used the term *dé-coll/age* (as the dictionary writes it) for his method of confronting head-on the conflicts of the culture at the level of the street, producing works for which, inspired in part by his friendship with the young composer Karlheinz Stockhausen, he would use crowd provocations, broadcasting equipment, mechanical diggers and flamethrowers to fashion images of ruin that bristled with multiple references to the culture of the day. Vostell's *Marilyn Monroe II* of 1963 is a *dé-coll/age* of images of the recently dead film star with two television sets positioned behind so as to constitute, in his own words, 'a chaos of visual consciousness and acoustic environment' **(fig. 17.13)**.[16]

There is no doubting that such forms of intercourse with the vernacular were designed to rob art of its 'spiritual' mission, its nobility of purpose, above all its consonance with polite feeling – the reassurance that all was well with the world. Tarrying with the vernacular could indeed take some explicitly political forms. The path taken by the Situationist International (SI) was the most explicitly ideological

17.12 (*above*) JeanTinguely, *Study for an End of the World no. 1*, 27 September 1961. Photograph. Louisiana Museum of Modern Art, Humlebæk

17.13 (*opposite*) Wolf Vostell, *Marilyn Monroe II*, 1963. *Dé-coll/age* on paper (with 2 television sets behind), 160 × 120 cm. Museo Vostell, Malpartida

grouping in Europe, from the time of its formation in 1957 to its demise about a decade later. To the SI's key exponent, the French theorist and artist Guy Debord, a critique of the 'spectacular' – as he called it – city must begin by exploring new attitudes to the city itself. Inspired by Constant's ideas of the Imaginist Bauhaus, Debord advocated a form of travel within the city that he called *dérive* (literally 'drift'), an unmotivated passage through the spaces of the city that put on one side ordinary consumption routines to become instead a celebration of arbitrariness, thereby to constitute a type of pure revolutionary play. Debord's cut-up maps, overlaid by quotations and blotches of dripped colour, were his own contribution to the SI's relentless drive to overturn – *détourne* (literally, reroute) – behavioural routines inasmuch as they followed the regular signposts of marketing, the clichés of 'good' and 'bad' neighbourhoods, or the most time-efficient pathways between one momentary destination and another.[17]

The prolific CoBrA artist Asger Jorn was also toying with methods of radically collapsing the distinction between high culture and low. A colleague of Debord's in the early SI, Jorn turned to vernacular imagery with a vengeance towards the end of the 1950s. In May 1959 he held an exhibition at the Galerie Rive Gauche in Paris that he called *Modifications*. The term referred to his actions on old flea-market paintings whereby he would paint over their once dignified surfaces such as to blot, deface or ridicule the values they once enshrined – tastes and aspirations of the self-enriching bourgeois class insofar as these were embodied in compositional resolution, technical competence and references to property or social status. A second series by Jorn, known as *Nouvelles défigurations* (*New Disfigurations*), was shown at the same gallery in 1963, once more defacing the surfaces of 'high' art by effecting a transformation of the politically redundant into something vital and highly charged. *Two Penguins* of 1962 presents a well-fed and pompously dressed individual now debased by some casual over-painting (**fig. 17.14**). Mutilation *was* creation, for Jorn. In a text he provided

for the earlier exhibition he asked: 'Why reject the old if one can modernize it with
a few strokes of the brush? ... Painting is over. You might as well finish it off. *Détourne.*
Long live painting.' The conventions of art must be sacrificed: 'It can be done gently
the way doctors do it when they kill their patients with new medicines ... It can
also be done in barbaric fashion, in public and with pomp. This is what I like.'[18]
At the same time, Jorn's 'sacrifice' could prove effective against two other aesthetic
positions dominating the international circuit at that moment: the new American
abstraction on the one hand, and milder incursions into the vernacular on the other.

In London, to take the prime example of the latter, 1959 was the year when a
particular cohort of students entered the prestigious Royal College of Art and in
a matter of months rejected the ethos of 'fine painting' altogether. Their alternative
was to pay attention to more quotidian experiences, and in a particularly English
way. David Hockney, to name one member of the group, put aside his unquestionable
skills as a draughtsman in favour of a visual language derived in part from the graphic
style of scrawled numerals and doodles or the graffiti of public toilets – a *faux naïf*
manner that allowed him to assert his 'difference' as a homosexual in a coded yet
persuasive way (**fig. 17.15**). Nor was Hockney alone in his embrace of the off-limits
or the corny as values in the larger spectrum of taste. The London artist Peter Blake,
who had been a Royal College student slightly earlier, had tarried in the vernacular
culture of his childhood in Gravesend, Kent, which included fairground and canal-boat
painting, comics and the popular press. He had incorporated signs and emblems
from photo albums, tabloid headlines and royalty kitsch in early works such as
On the Balcony (1957), which presented in noticeboard format tokens of a vanishing
culture that seemed to invite being read in a genuinely nostalgic way.[19]

For others, immersion in the vernacular was soon taking on qualities of humour, colourful stylisation, even a celebration of topical ads, fashions and images from film. In the late 1950s in London, a generation that included Joe Tilson, Allen Jones and Derek Boshier became increasingly identified as 'Pop' artists. Yet the term 'Pop' was already in disarray. In writing to the architects Alison and Peter Smithson early in 1957, Richard Hamilton had referred to 'Pop' culture as 'designed for a mass audience', the city vernacular not subject to playful celebration but placed in dialogue with the corruptions of rampant commercial style. In his letter he had made a list of the relevant attributes of 'Pop'.

They comprised 'Transient (short-term solution) / Expendable (easily forgotten) / Low cost / Mass produced / Young (aimed at youth) / Witty / Sexy / Gimmicky / Glamorous / Big business' – all of which he believed the socially responsible artist should analyse and review. In a comment of the early 1960s, Hamilton added that what he called 'Pop-Fine-Art' descended from Dada and Futurism and must confront the commercialisation of the whole culture, including that of art.[20] To his credit, he was aware that the entire media-soaked public sphere was becoming a topic of concern, from war-torn Germany in the east to the new culture of plenty in California to the west. Coy affirmation was to be resisted. He preferred to keep in mind that what had begun as a dissection of the vernacular on the part of Eduardo Paolozzi and the Independent Group in London had been not merely a celebration, but also a critique.

17.14 (*opposite*) Asger Jorn, *Modifications: Two Penguins*, 1962. Oil on canvas, 120 × 200 cm. Städtische Galerie im Lenbachhaus, Munich

17.15 (*above*) David Hockney, *Adhesiveness*, 1962. Oil on board, 127 × 101.6 cm. Modern Art Museum, Fort Worth, Texas

Hard-edge, Kinetic and Minimal Form

Alongside the flowering of *art informel* and so many projects that addressed the marketing culture of the day – perhaps in reaction to them – another impulse begins with the city as an environment of sleek new architecture and crisp graphic forms that offered new types of interaction to the urban viewer.

 To many artists those interactions were in essence dynamic, in effect organising the viewer's awareness of space, form and identity over shorter or longer intervals of time. Take the example of the sharp new letterforms of advertising, the majority now modernised along approximately Bauhaus lines. When new billboards – *affiches* – were erected in post-war Paris, to take the example of one city, they were colourful and semantically whole – yet quickly suffered the effects of weather and commercial obsolescence to become ragged and unreadable. Noticing this developing incoherence,

the artists Jacques de la Villeglé and Raymond Hains took to combing the streets for suitable examples, then tearing them down and reframing the distressed fragments as a species of urban ready-made. Presented as art, such surfaces launched a kind of challenge to the viewer to negotiate the interface between the sharply defined and the incoherent, between glossy inducement and complete ruin. A so-called *affichiste* work such as Villeglé's *L'Humour jaune – boulevard Pasteur* of 1953 presented such a challenge in concise yet original form (**fig. 18.1**).[1] He reflected later that the subject of the post-war urban predicament had no option but to come face to face with the larger historical interplay between urban renewal and decay.

We may see too in the ready-made qualities of *affichiste* art a slight shift from the painterly dynamics of the *informel* style. When the American artist Ellsworth Kelly arrived in Paris in 1948, he brought with him a background in camouflage design for the US navy, followed by a period of study at the art school of the Boston Museum of Fine Arts, close to both the Bauhaus-influenced Harvard School of Design and MIT. He was immediately drawn to the work of such artists as Alberto Magnelli, Arp, Vantongerloo and Brâncuşi, who themselves encouraged a type of looking and making quite at odds with that of the *informel* school that was flourishing at the time. Now joined by a Boston friend, the architecture-trained Ralph Coburn, Kelly visited coastal locations – such as in Meschers, in the Gironde, with its pine woods, rivers and sea. Arranging same-format panels of blue and green in a larger array allowed Kelly to abjure 'expression' and give back to the viewer the pleasure of rhythmic looking and noticing itself, as if in replay of the artist's memory of the scene (**fig. 18.2**).

In New York as well, even among those journalistically linked with 'expression', the attractions of impersonal methods could be very strong. It was important to Mark Rothko, for example, after about 1950 or 1951, that his paintings contain very few gestural traces, but rather present a field of approximately rectangular patches of colour that floated within, while being defined by, the scale and rectangularity of the painting's format. In point of fact Rothko's beguiling paint surfaces exert a paradoxical appeal. Stood directly on or hung near the floor, they can appear rich in detail if approached close-to, all-enveloping if seen from a little further back, but nearly unitary shapes if glimpsed from still further away (**fig. 18.3**). Their subtlety is remarkable; for while in one kind of response the painting is a coloured panel, in another it can evoke a dialogue of intimacy and distance – even one comparable to that evoked by the presence of another person deemed worthy of the viewer's responsiveness and care.[2]

18.1 (*opposite*) Jacques de la Villeglé, *L'Humour jaune – boulevard Pasteur*, 1953. Torn and pasted papers, 93 × 110 cm. Musée d'Art Contemporain, Marseille

18.2 (*above*) Ellsworth Kelly, *Study for Meschers*, 1951. Cut and pasted printed paper, 59 × 59 cm. Museum of Modern Art, New York

18.3 (*above*) Mark Rothko, *No. 61 (Rust and Blue)*, 1953. Oil on canvas, 292.7 × 233.7 cm. Museum of Contemporary Art, Los Angeles

18.4 (*opposite*) Ad Reinhardt, *Red Painting*, 1952. Oil on canvas, 199 × 366 cm. Metropolitan Museum of Art, New York

Something similar can be said of Ad Reinhardt's paintings of the 1950s. He shared with Rothko and Barnett Newman a distaste for untidy brushwork and, like them but more so, came to conceive of a large frontal painting as supra-personal, yet still demanding of a response that may vary with the passage of time. Reinhardt's methods were both rhetorical and technical. On the one side he launched what amounted to a war against received epithets to the effect that art is ideal, noble, useful, instructive, and so on, asserting that art has 'its own thought, its own history and tradition, its own reason, its own discipline ... its own "integrity" and not someone else's "integration" with something else'. His list of exclusions included existentialism, Constructivism, *trompe l'œil*, collage, Fauvism, *Art Brut*, even nature. As he put it: 'The more stuff in it, the busier the work of art, the worse it is. "More is less".'[3] What Reinhardt called 'purity' was to be achieved by a series of further rigorous steps: eliminating brushwork, texture, chiaroscuro and all but the most subtle gradations of colour (**fig. 18.4**). By the decade's end, his paintings were made of all-black, identical rectangles whose divisions from one another are invisible to the uninquisitive glance and only available to the more actively scrutinising eye. The pay-off was to be a form of pictorial experience in which extended yet relaxed attention gives rise to flickering and not easily verifiable sensations, a drama of shifting opticality amounting to a modelling of the discriminations of consciousness more generally. The association of Reinhardt's paintings (he died in 1967) with modern-movement architecture was inevitable. Less obvious were the subtle forms of visuality that his practice was attempting to imply.

The new idiom of sharply defined form – Reinhardt's principle of 'brushwork that brushes out brushwork' – was taken up for other reasons in the very different cultural ambience of America's west coast.[4] In the bright light and radiant colour of southern California, and stimulated by the crisp new design style of architects of the quality of Richard Neutra, Rudolf Schindler and Craig Ellwood, painters who had once been peripheral followers of Surrealism turned increasingly to hard edges and near-rectangular coloured forms. Lorser Feitelson, the oldest of this group, looked for

colour forms that adhered to a surface as if gravity-free, neither rising nor descending, in bare pictorial occupancy of a given rectangular space and shape. His *Magical Space Forms* series of the early 1950s declared neither atmosphere, horizon nor analogue of the human body, as if by avoiding such references the painting would live by its intrinsic magnetism alone (**fig. 18.5**). Shafts of colour and light create an ambience of their own – achieved for both Feitelson and the much younger Frederick Hammersley by a compositional method that they compared with a jazz musician's pursuit of forms that just 'seem right'. A third figure, Karl Benjamin, defined his pictorial fields by interlocking shapes arranged stepwise in a sequence of mutually adjusting forms. The more austere John McLaughlin, meanwhile, had a sensibility more attuned to Japanese Zen. McLaughlin may be called the painter's painter of the group. Throughout a long yet modestly conducted career his aim was the creation of open, nearly empty spaces such as could be seen in the subtle volumes of Japanese temple architecture: 'the marvellous void', as McLaughlin put it, arising from diffuse rather than focused attention, an openness to calm spatiality and very gradual temporal flow (**fig. 18.6**). A collective label for these artists proved difficult to come by. The Los Angeles critic for *Art News*, Jules Langsner, tried 'the slide-rule school' in an early review of shows by McLaughlin and Benjamin; then tried 'abstract classicism' in a show organised at the Los Angeles County Museum in 1959 at which Feitelson, Hammersley, McLaughlin and Benjamin were presented as a group.[5] But strictly they were not; nor had Langsner grasped the musical or temporal patterning within the work. In now calling the work of the foursome 'hard-edged', Langsner launched a term that, like others in modern art, gained currency but without capturing the experiential richness of the work.[6]

Could it be that slowly rising levels of prosperity encouraged more interactive roles and functions for art – less despairing ones, roles more optimistic and future-tense? Brazil in the years since the Second World War had enjoyed significant inward investment and had developed an ambitious manufacturing industry. Museums of Modern Art had been opened in both São Paulo and Rio de Janeiro in 1948, and the award of the international sculpture prize at the inaugural Bienal de São Paulo in 1951 to the Swiss concrete artist Max Bill was one sign of enthusiasm for an aesthetic of clean edges and depersonalised methods in the visual realm (the design of the new federal capital Brasília in a rationalist idiom by Oscar Niemeyer was another). In 1952 it became the aim of a new São Paolo art group called Ruptura to build on the well-tried idea of Concretion in art and develop a direct engagement with actual material in the ebb and flow of real time. Ruptura's ambitions were strongly epistemological. 'The new can be accurately differentiated from the old,' Ruptura insisted, by being guided by 'clear and intelligent principles', by treating art not as self-expression but 'as a means to knowledge'.[7] Indeed, several artists close to Ruptura shared a utopian view of art not unlike Mondrian's some three decades before.

In Rio, a less cerebral emphasis was taken by the Frente group, which included Lygia Clark, Lygia Pape and Hélio Oiticica, who first showed together in 1954 and for whom both Mondrian and Vantongerloo were also the guides. Yet unlike the São Paulo group,

18.5 Lorser Feitelson, *Magical Space Forms*, 1953.
Oil on canvas, 91 × 59 cm. Orange County Museum
of Art, Santa Ana, California

who were fixated on theory, the Rio collective was more strongly animated by direct experiential qualities such as intense colour in the case of painting, and touch, scale and interactivity in the case of sculpture. By 1959 Frente were calling this standpoint 'Neo-Concretism' and were committing themselves to a re-evaluation of the De Stijl inheritance, discarding its 'dangerously acute rationalism' in favour of what they called a Concretism 'born of the need to express the complex reality of modern humanity' with 'a new plasticity'. The words are from the 'Neo-Concrete Manifesto' published by the poet Ferreira Gullar in 1959 in an attempt to rescue from Concretism 'the powers of expression so long neglected within it'.[8] Clark and Oiticica worked closely together –
as they put it, 'hand-in-glove'. Oiticica made paintings of clarity, optimism and colour from shapes in relation to each other organised dynamically within a frame, while Clark's creations often referenced bodily movements or the possible manipulations of the viewer – as in the hinged aluminium constructions she called *Bichos* (*Creatures*) (**fig. 18.7**).

In Europe, meanwhile, Neo-Concretism was taking several forms. So much had flowed from Mondrian and van Doesburg, from still active Constructivists such as Gabo and Pevsner, and from Bauhaus figures such as Albers, as to suggest any number of directions, each united in a dislike of Surrealism no less than the cult of 'expression' in art. Max Bill had played a major part in the planning and realisation of Allianz exhibitions in 1947 and 1954 in which the Zurich concrete artists were shown. Soon, however, non-Swiss artists such as Hans Hartung and Jean-Paul Riopelle were entering the fold, and to a severe rationalist that inclusiveness was a sign that Concretism was losing momentum, even if to others it was a promising path to follow. For a time the alternatives existed in tension at the Hochschule für Gestaltung in Ulm, Germany, where Bill took up the rectorship in 1953 – he would pass on the post to the rationalist Tomás Maldonado in 1956. In Switzerland the more inclusive approach reached another level in 1960 with the even larger and unwieldy show *Konkrete Kunst: 50 Jahre Entwicklung*

18.6 (*opposite, top*) John McLaughlin, *Untitled*, 1952. Oil and casein on Masonite, 80 × 96 cm. Private collection, New York

18.7 (*opposite, bottom*) Lygia Clark, from the *Bichos* series, 1959–60. Aluminium, dimensions variable

18.8 (*above*) Victor Vasarely, *Sauzon*, 1950. Oil on canvas, 113 × 97 cm. Private collection

(*Concrete Art: 50 Years of Development*) at the Zurich Helmhaus, where alongside canonical Swiss Concretists Graeser, Loewensberg, Bill and Lohse were shown recent works by Mathieu, Rothko, Tobey and Dubuffet – all now implausibly presented as 'Concretisations of a pictorial idea'.[9]

The possibilities for Concretism with or without the severest rationality were clearly numerous. Literal temporalisation was the option pursued by a group brought together in April 1955 in Paris in an epochal show, *Le Mouvement* (*The Movement*), at the Galerie Denise René. René had set up her gallery in the rue La Boétie in 1944 and had quickly become one of the most far-sighted dealers in the city, showing work by Abstraction-Création artists such as Alberto Magnelli, Herbin and Arp while proudly managing younger artists too. Early on she had become friendly with a Hungarian graphic designer Győző Vásárhelyi, working in Paris since 1930 under the name Victor Vasarely, who around 1950 began to paint hard-edge pictures of great clarity, subtlety and visual power, placing what he called 'colour-forms' relative to one another precisely in or on the visual plane (**fig. 18.8**).

René and Vasarely soon recognised the possibilities of an actually kinetic art. *Le Mouvement* in 1955 presented work by Pol Bury (from Belgium, with some acquaintance with CoBrA), Jean Tinguely (from Switzerland), Yaacov Agam (from Israel) and the Venezuelan Jesús Rafael Soto, together with the more senior figures Alexander Calder, Marcel Duchamp and the Danish artist Robert Jacobsen, from the Danish art association Linien II.[10] In *Le Mouvement* the motion of sharply defined forms relative to one another gave rise to several distinguishable types of kinetic sensation. One was the motor-driven rotation of coloured discs made by Duchamp that induced illusions of deep coloured spatial whirlpools in the mind and eye. A second was the motion of simple elements relative to each other in the wall-mounted reliefs of Pol Bury. A third was the changing perception of wall-positioned reliefs as the viewer moved relative to a work (Soto, Jacobsen, Vasarely, Agam). A fourth was the delicate movement of ceiling-hung mobile forms brushed by slow-moving currents of air (Calder).

Vasarely took the opportunity to publish a *Manifest Jaune* (*Yellow Manifesto*), in which he explained how, in his own work, large black-against-white forms intercutting each other functioned as 'positive–negative' opticality, giving rise to 'spatial feeling ... the illusion of motion and duration in the eye and mind'; more concisely, what he called 'the *plastique-cinétique* [plastic-kinetic] adventure'. By fusing the world of cinematography with 'abstract' forms or by subjecting 'abstract' forms to rapid positive–negative modulation, the result for Vasarely would be 'a new, moving and touching plastic beauty' available to all (**fig. 18.9**).[11] Thereafter the Galerie Denise René became the showroom for at least two generations of artists specialising in 'hard-edge' and kinetic effects from most mainland European countries and Scandinavia. René also organised a show of Mondrian's work in March 1957 – astonishingly, the artist's first solo exhibition to be held in the French capital.

In Germany, after a slow recovery from the trauma of war, young artists and museum professionals were also evolving new attitudes to form's interaction with movement and time.[12] In April 1957 the artists Heinz Mack and Otto Piene began to

18.9 Victor Vasarely, *Ilava*, 1956. Oil on canvas, 195 × 130 cm. Collection Lahumière, Paris

hold one-evening exhibitions in the latter's studio in Düsseldorf. Piene had been an anti-aircraft gunner in the war and had been fascinated by light beams, movement and patterning in the battles taking place in the night sky. Mack shared his interest in the collision of light, colour and technology. Several studio exhibitions later, the pair were publishing the first of three magazine-catalogues which they titled *ZERO*. Written by themselves, the message of *ZERO 1* of April 1958 was 'the purification of colour against the *informel* and neo-expressionism [and] the peaceful conquest of the soul by means of calm, serene sensibilisation'. It was an attitude that attracted several others to what became a European network; first Yves Klein, who explored monochrome surfaces, then Günther Uecker, who patterned his white paint and plaster objects and paintings with nails such as to capture moving ambient light (**fig. 18.10**). A relationship between human perception and machinery was in prospect. ZERO's mission was becoming to 're-harmonise the relation between man and nature ... the sky, the sea, the arctic and the desert, air, light, water, fire ... using actual technical invention as well as those of nature'.[13] Meanwhile other like-minded groups were forming: the Nul group in Holland; Gruppo T in Milan; Gruppo N in Padua; and the Centre de Recherche d'Art Visuel (CRAV), based in Paris, whose members included Julio Le Parc, François Morellet, Francisco Sobrino and Jean-Pierre Yvaral, son of Victor Vasarely. Other links followed, specifically with Milan, where Piero Manzoni and Enrico Castellani founded a gallery, Azimut, and a journal, *Azimuth*, with sympathies towards CRAV. In one sense the

18.10 Günther Uecker, *Untitled*, 1958. Nails, 50.5 × 31.5 × 9 cm. Kunstmuseum, Krefeld

18.11 Otto Piene, *Frequency*, 1957. Oil and aluminium paint on canvas, 40.5 × 30.5 cm. Kunstmuseum, Krefeld

ZERO network sought a path between expressionist *informel* on the one hand and rigid mathematisation on the other. In another, it was the play of light combined with serial motion, vibrations in time, optical tricks and even motorised incident that was to offer the viewer an interaction that could be mysterious, uplifting, a sort of dialogue of temporal awareness and contemporary scientific thought (**fig. 18.11**).

However, it was soon ZERO's very diversity that led to disagreements between the group's affiliates and the interests of Mack, Piene and Uecker. On the one hand a ZERO show in Antwerp in 1959 named *Motion in Vision – Vision in Motion* (a title derived from Moholy-Nagy's book of 1948) brought Pol Bury, Tinguely, Spoerri, Manzoni and Fontana together as if to demonstrate ZERO's determination to have no manifesto, no membership list and no defined affiliation requirements beyond a sympathy with research into light, colour and movement. On the other, and as names like 'Nul' and 'Zero' suggest, a desire for reduction, for unitisation, for emptying, for clearing away all but base-level conventions connected Manzoni's contemporary *Achrome* series of near-white compositions, Fontana's *Concetto Spaziale* (*Spatial Conceit*) series comprising simple cuts in the canvas, and the grindings of Tinguely's fairly primitive machines.

By the decade's end it was clear that a more complex generational change was occurring. In Zagreb, Yugoslavia, in 1961 a show took place under the title of *Nove Tendencije* (*New Tendencies*) that embraced not only ZERO but Azimut, Gruppo T, Gruppo N and CRAV. Yet *Nove Tendencije* was a specifically political initiative, one of moving away from the attitudes of ZERO's founders towards teamwork – towards complete authorial effacement as the cardinal property of a successful contemporary work of art. In turn, the Zagreb occasion lent its name to a further network known as Nouvelle Tendance (New Tendency) that devoted itself more fully to a rescheduling of the relationship between artwork and viewer, what the organisers called 'an ensemble of visualised ideas and common theories that could generate an anonymous work'.[14] In this project the Paris-centred CRAV would play a major part. Thus far, its outlook had been to proceed as if wanting to erase from the viewer's apprehension any sense of the artist's subjectivity or 'expression'. François Morellet, for example, had been working on minimal-format paintings from about 1956, made by simply drawing lines across a given square surface, systematically but such as to generate results that could not be completely foreseen but which, the drawing process finished, looked like bulging and contracting pools of attention that never appeared the same way twice (**fig. 18.12**).

For reasons that are still unclear, British and American artists played little part in these groupings. And if no British artists were shown at Denise René during the later 1950s it must be because there was so little enthusiasm for hard-edge work in London at that time. Even among the British Fitzrovia group, few relations existed with the French art world such as to make such cross-fertilisation possible. Nevertheless, and though Paule Vézelay from the Paris-based Groupe Espace had not succeeded in making common cause with London's Fitzrovia community, a multi-medium exhibition had been held at London's Royal Festival Hall in October 1955 in which works dedicated to the broadly spatial and environmental arts had been displayed: by architects (André Bloc, Walter Gropius), by painters (Sonya Delaunay-Terk, Peter Stroud, Paule Vézelay) and by sculptors (Arp, Étienne Béothy, Geoffrey Clarke, Victor Anton, Marlow Moss) in a spirit of dialogue on questions of dynamic form and the urban environment. Vézelay herself showed one of her *Lines in Space* series, comparable to the relief boxes of Jesús Soto

at the time. Marlow Moss (real name Marjorie Jewel), a British Mondrian follower who spent much of her career shunned by the British art establishment, showed a Moebius strip fashioned in marble in acknowledgement of recent three-dimensional work by Max Bill.

The more theoretically inclined members of the Fitzrovia group, the Martins and Anthony Hill especially, had meanwhile pursued their interests in converting hard-edge orthogonal geometry (proportional rectangles, number-sequenced intervals and ratios) into art. They had become absorbed by the Constructionist theories of the American Charles Biederman, whose 1948 book *Art as the Evolution of Visual Knowledge* seemed to supply (in contrast to the Zurich Concretists) a teleological view of modern art in

18.12 (*above*) François Morellet, *4 doubles trames, traits minces* (*4 Double Frameworks, Thin Lines*) *0°-22°5-45°-67°5*, 1958. Oil on canvas, 140 × 140 cm. Centre Pompidou, Paris

18.13 (*opposite*) Anthony Hill, *Five Regions Relief*, 1961. Aluminium and acrylic plastic, 61 × 61 × 2.5 cm. Huddersfield Art Gallery

its path by way of Cézanne, Mondrian and van Doesburg towards a fully temporalised form of knowledge in which active involvement by an observer was a necessary key. In the development of his theories Biederman had presented his own relief constructions alongside those of contemporary figures such as César Domela and Mondrian's pupil Jean Gorin, in which clean edges, clearly articulated linear relationships and evenly applied colour were essential. Hill's adherence to Biederman's position had led him in turn to Max Bill, and to a resolve to apply 'the principle of concrete art ... throughout the entire visual-plastic domain'. Now Hill's work was becoming temporalised too. As a trained mathematician he was absorbed by the play of square roots, prime number sequences and proportional rhythms, and would later publish lengthy analyses of his calculations. From the mid-1950s he experimented with reliefs made of ready-made industrial materials such as aluminium angle trim and plastic, organising them in a manner independent of the conventions of painting, sculpture or architecture yet maintaining relations with them all. In a work of 1961 belonging to a set of *Five Regions* reliefs, for example, he divided a square or rectangle into five unequal parts and repositioned them in a new format that was both equilibriated and unstable. His conviction was that the work of Constructionist art must never be totally subservient to mathematics – rather open to probing enquiry and ultimately completable by the dynamic attention of the viewer (**fig. 18.13**). As he put it in a summary, the viewer's first task was to collaborate with the artist in recognising the true function of every part of the work, to discover 'how a work of art functions'.[15]

On that evidence, a desire to synthesise a flexible Constructivism, a fully temporal Constructionism and a dynamic architecture was 'in the air' in London at the time. To this end a smaller yet challenging collaboration by Victor Pasmore and Richard Hamilton was held, first in Newcastle upon Tyne and then over a ten-day interval at London's ICA in August 1957. Called simply *an Exhibit*, it comprised no more – but no less – than a series of acrylic panels of various colours and transparencies suspended from the ceiling such that one could walk among them without fixed markers of direction, dominant axes of movement or symbolic hierarchies of position. Put another way, *an*

Exhibit offered no clues to the participant as to front, rear, entrance, exit or other markers of place and identity. It was 'a game to be played, an artwork to be viewed, an environment to be populated': a kind of model for the act of moving about in a city from which all positional coordinates had been removed (**fig. 18.14**).[16] Its challenge lay in transferring to the viewer-participant the work of constructing value relationships of his or her own: a model of democracy and participation through the agency of the gallery of art.

It was surely a project that anyone needing an alternative to *art informel* would want to notice and understand. When the young painter Robyn Denny graduated from the Royal College of Art in London in the summer of 1957 he first of all tried to reconcile the bold letterforms that he had used in his work with an *informel* attitude to composition – only to realise that a far stronger element of interactivity with a viewer was required. A first decision was to make paintings with interchangeable component parts, thus guaranteeing real-time encounters in which a viewer would be quite literally involved: these were his *Transformables*. Yet an interactive relationship with the viewer's very spatial positioning was still required, and the key came from an unexpected quarter. Seeing Mark Rothko's paintings in Venice at the Biennale in 1958,

18.14 (*above*) Victor Pasmore, Richard Hamilton, Lawrence Alloway, *an Exhibit*, June 1957, Hatton Gallery, Newcastle upon Tyne

18.15 (*opposite*) Robyn Denny, Ralph Rumney, Richard Smith, *Place* exhibition, September 1959, ICA, London

as well as Venetian frescos that visually transformed a given confined location, made clear to Denny the power of a painting to animate the space in which it was hung. A consequence was a project involving Denny, Richard Smith and Ralph Rumney called simply *Place*, at the ICA in September 1959, in which hard-edged paintings joined back to back in pairs and stood on the floor were placed zig-zag fashion across a cramped room in such a manner that no view of any particular work was possible without being distracted by a glimpse of other paintings nearby – a simulation of the conditions of the contemporary mass media, according to the group, and of the need to participate accordingly. 'The body should see pictures on the margins of perception,' said Rumney of the experiment, 'without ever being forced to look directly at them unless [one] so desires' (**fig. 18.15**).[17] Put another way, the *Place* experiment was supposed to induce a strategic posture that a player might need to develop in order to participate in a certain kind of game. We know that Denny and his friends had been dipping into John von Neumann's *Theory of Games and Economic Behavior* (1944), and in Denny's case John McDonald's *Strategy in Poker, Business and War* (1950). Given that the key to all game strategy is the construction and management of uncertainty, the strategic element offered by *Place* was one in which – in the words of a perceptive critic – '*the player is also played*'.[18] It was the crucial realisation for Denny, and one that led directly to the deployment of spatial, perceptual and psychosomatic uncertainty in his work. His breakthrough painting *Baby Is Three* of 1960 demonstrated that hard-edged areas and a minimal set of forms could provide interactivity for the viewer that was supple and engaging, and on negotiable terms (**fig. 18.16**).

Further still to the west, artists in New York were taking little from either Californian hard-edge, Brazilian Neo-Concretism, Nouvelle Tendance or the British *Place* group – yet some shared with them all a preference for clean, uncluttered forms and a posture of direct engagement between the artwork and the viewer. An important show at the Museum of Modern Art in 1959 titled *Sixteen Americans* brought to public attention some new works of that year by the young painter Frank Stella. In providing a context for his new and certainly startling work, Stella related in a lecture of 1960 how he had first set out as an artist trying to duplicate the techniques of Franz Kline, of Hans Hofmann, of Nicolas de Staël, but had become impatient with compositional decision-making and technical niceties too. 'The painterly problems of what to put here and there, and how much to make it go with what was already there became more and more difficult,' Stella confessed, 'and the solutions more and more unsatisfactory.'[19] What he called 'relational' painting would now be replaced by symmetry. The alternative to composing with colour was to have none at all. The alternative to fussy technical considerations was to use house painters' materials rather than specialist ones. Working from the

outside towards the centre, on canvases whose stretchers were the same thickness as a black stripe was wide, Stella's paintings of that moment had a provocative literalness, but at the expense of those values that the European tradition had for so long defined as intrinsic to art (**fig. 18.17**).

Now, it is often considered that Stella's black paintings of 1959–60 constitute the beginnings of a significant recasting of the viewer's relationship to the work of art. For one thing, their symmetry seemed arresting. So did their blackness – at a time of slowly simmering resentment among America's Afro-Caribbean poor. Stella's titles could be provocative too: *Arbeit Macht Frei* (*Work Makes you Free*) of 1958 and *Die Fahne Hoch!* (*Raise the Flag High!*) of 1959 make unmistakable reference to the European Holocaust, while others make reference to cumbersome tenement blocks in the Bedford-Stuyvesant neighbourhood of New York. Such references to outsider status reinforced the impression of the painter's wish to begin again in art, without the shilly-shally of European aesthetic traditions, including the by now thoroughly exhausted *informel* style. Was this a replay of the composition–construction debate that had so radically disturbed artistic traditions in Russia in the wake of the 1917 Revolution? What other developments might be prompted by the assertion of uncompromising symmetry in art?

18.16 (*above*) Robyn Denny, *Baby Is Three*, 1960. Household paint on canvas, triptych, 213.4 × 365.8 cm. Tate Gallery, London

18.17 (*opposite*) Frank Stella, *Die Fahne Hoch! (Raise the Flag High!*), 1959. Enamel on canvas, 308.9 × 194.9 cm. Whitney Museum of Art, New York

19. The 1960s:
After Modern Art

There is no single point at which modern art seemed to lose impetus, repeat old strategies, transition to another state. Yet one can detect that, by the later 1950s and early 1960s, some new emphases had arisen: new questions about what modern art was, or had by then become. By the start of the new decade enquiries were under way into such matters as the ontological condition of the work of art – its very mode of being as a thing. Or it was felt important to look critically at the new culture of the photo-image, or more widely at the sign-world of advertising and television. As for the artist, what was to be his or her ideological posture in a world of violence and inequality, of unresolved tensions of gender and race, not to mention simmering Cold War tensions that permeated the western hemisphere right up to the decade's end?

In sculpture, a modest revision of basic terms appeared to be under way in some new work by Anthony Caro around 1959–60. Switching from making clay figures to welding or bolting steel I-beams and metal plates in an open network seemed suddenly radical, as if the idea of a solid sculptural core was no longer pertinent. In fact, such works as Caro's *Midday* (1960) or *Early One Morning* (1962), for all their appearance of novelty, rehearsed all over again the semantics of the reclining figure and even the ground plane of the land (the times of day are referenced in both titles), as well as person-like silhouettes scaled in relation to the viewer who moves around them (**fig. 19.1**). Even David Smith, who produced a series of twenty-six steel sculptures called *Voltri* in a month-long burst of making in spring 1962, remained captive to the basic *gestalt* of the standing, looking, turning human figure. Likewise, the younger American Mark di Suvero, who worked with found wooden objects, ropes and other detritus at the beginning of the decade, soon turned like Caro to making steel-welded structures that for all their open spatial qualities could not easily evade figurative or creatural resonances somewhere within the work. How could three-dimensional art evade – or transcend – the narrative conventions of what seemed to be a vanished (or vanishing) age?

One part of the answer lay in the kind of nullity or blankness that had been proposed by the American painter Frank Stella in the late 1950s – the use of symmetrical formats fashioned in workmanlike materials and decorators' tools, and arguably neither 'painting' nor 'sculpture'. Never mind that symmetry had been the cardinal rule of architecture in the totalitarian parts of Europe in the 1930s and 1940s. To Stella and those who thought like him, asymmetric compositional formats still in use by European painters like Victor Vasarely were suddenly 'a curiosity', 'very dreary'.[1] To Stella's contemporary Donald Judd at that moment, symmetry was becoming a requirement too. Judd had done some

'hard-edge' paintings in the later 1950s before arriving at some curious floor-standing objects that might resemble wall corners, shelving or letterboxes that declared for symmetry while not being models of anything at all (**fig. 19.2**). Such objects launched some unfamiliar aesthetic terms. 'I'm interested in spareness,' Judd explained, and getting rid of European-type composition was an obvious way to achieve it. A work of sculpture 'should have a definite whole and maybe no parts, or very few'; at most, a repetition of identical elements in a serial order. His take on Vasarely was no less caustic. He has to have 'at least three or four squares, slanted, tilted inside each other, and all arranged', Judd complained: 'That's about five times more composition and juggling than he needs'.[2] When the exhibition *Black, White and Gray* opened at the Wadsworth Atheneum in Hartford, Connecticut, in March 1964 showing some blankly reductive paintings by Reinhardt and Newman as well as various basic, space-occupying objects by younger figures such as Tony Smith, Anne Truitt and Robert Morris, Judd was enthusiastic. He singled out Morris's pieces *Column* and *Slab* as being entirely 'whole' and yet expressive of a 'flat, unevaluating view'. They are 'next to nothing ... barely present', he said admiringly, admitting that you might well ask why anyone should make them. Yet 'they exist after all ... and in the most minimal way, but by clearly being art, purposefully built, useless and unidentifiable' (**fig. 19.3**). Ad Reinhardt's paintings in the Hartford show were 'a precedent for the work of art really being nothing'.[3]

What did that nullity mean – a mimicry of assembly-line repetition, perhaps, a refusal to 'speak' as an artist in the same terms as before? Blankness of expression worked comparably in the case of media photographs that had been rephotographed

19.1 (*opposite*) Anthony Caro, *Midday*, 1960. Painted steel, 235.6 × 378.5 × 96.2 cm. Museum of Modern Art, New York

19.2 (*above*) Donald Judd, *Untitled*, 1962. Cadmium red light oil on wood with black enamelled metal pipe, 121.9 × 82.6 × 54 cm. Judd Foundation

and serially screen-printed, as in Andy Warhol's work of that time. Warhol had worked in fashion illustration and window display in the later 1950s and had become open 'to liking everything', as he put it, in the media world of movie icons, political personalities and pop music stardom as then purveyed in the American daily press. Warhol's screen-painted near repetitions of Marilyn Monroe, Elvis Presley, Elizabeth Taylor, Muhammad Ali and other stars presented those figures as mutely as a grey slab or a minimal box. His use of dark or decaying colour tones could give his works a hidden poignancy however: the celebrated *Marilyn Diptych* of 1962 was made shortly after the filmstar's untimely death by probable suicide, its paired panels reflecting the routinised glamour that her stardom obliged her to, on the one hand, and its rapid decay after her death on the other. The consistently dark *Ten Lizes* of 1963 reflects the serious illness that Taylor suffered while filming *Cleopatra* shortly before (**fig. 19.4**).[4] Yet it should be said that while Warhol's serial images carried a comment on the cruelty of an image-rich culture, in the work of other so-called Pop artists the recasting of images from comics or glamour advertising – in the work of Roy Lichtenstein or James Rosenquist for example – provided less sceptical, often openly entertaining accounts of its everyday functions. Pop art thenceforward occupied both sides of the boundary between celebration and critique.

19.3 (*above*) Robert Morris, *Slab*, and other works, as displayed at *Black, White and Gray*, Wadsworth Atheneum, Hartford, Connecticut, 1964

19.4 (*opposite*) Andy Warhol, *Ten Lizes*, 1963. Acrylic on canvas, 201 × 564.5 cm. Centre Pompidou, Paris

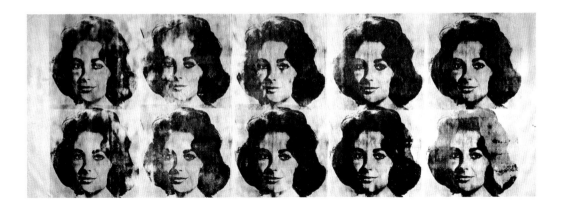

The public success of Pop art in the early 1960s also tells us something about the institutional organisation of art. In the United States pre-eminently, a shift in the very culture of art was emerging, as a generation of curators with art-critical as well as organisational skills became adept at packaging, labelling and displaying new art with the same marketing skills as were becoming typical in commerce. And such enthusiasms were increasingly supported by both privately run dealerships and the large and well-resourced museums of art – in New York, Boston, San Francisco and elsewhere. In the European cities, by contrast, the predominant pattern was for artists to practise in small, self-defining networks, often based around patterns of art school affiliation or word of mouth, framing their goals individually and finding patronage wherever they may.

In Germany, for instance, the stark differences between American-style capitalism and its nemesis, late Soviet communism, had by the early 1960s become very sharply defined. East Germany had been the plaything of the Soviet-controlled GDR (German Democratic Republic) since 1949, and for a time free movement between east and west remained possible. When the painter Gerhard Richter emigrated from East Germany to the West shortly before the building of the Berlin Wall in 1961, however, he set aside his previous training as a social realist artist and took to a kind of painted mimicry of the most clichéd photographic images under the generic title of 'Capitalist Realism'. The photographs that attracted him were first subjected to rough-and-ready copying in black and white, often with their news-printed captions intact. After 1963 a modicum of colour was introduced, but Richter would often distress the sharp photographic definition slightly by brushing drily across the painting's surface, thus camouflaging the image itself in an ironic pictorial key (**fig. 19.5**). Here was no playful reworking of the demotic, rather a caustic reconsideration of the image environment of the late Cold War. Nor was Richter alone in his critique. Capitalist Realism was in fact a grouping that included the Düsseldorf artist Sigmar Polke, who in one sense belongs with Warhol and Lichtenstein in his fascination for the dot structure out of which media images were then routinely made. Examining the process known as rastering whereby the photo-image is converted into unequal dot shapes and sizes, Polke would re-do the rastering process by a laborious routine of building the image dot-by-dot with the tip of a pencil eraser dipped in paint. For him, like Richter, the very mechanics of artifice would become the central topic of an original and critical art. Polke's raster-drawing *Lee Harvey Oswald*,

for instance, makes J. F. Kennedy's supposed assassin in late 1963 emerge as the figure
he had suddenly become – both a media icon and an individual opaque in character or
motivation, one almost without any identity at all (**fig. 19.6**).

At the same time, some new ideas were emerging about the role of the viewer as a
participant in art – not a passive bystander but one implicated in the process of making
itself. The Lithuanian-born artist and animator George Maciunas joined a circle of
young artists and musicians in New York around 1960–61 whose work he began to think
of as neo-Dadaism, but which he soon repackaged under the term 'Fluxus' – from the
term *flux*, meaning 'constant and ongoing change'. Its proponents in both America and
Europe were now committed not to art objects as objects of contemplation but to actions,
processes and events – whatever the outcome. 'Promote living art,' urged Maciunas's
'Fluxus Manifesto' of 1963. 'Promote living art, anti-art, promote non-art reality to be fully
grasped by all peoples, not only critics, dilettantes and professionals ...'[5]

That commitment to deprofessionalisation had other manifestations too: in Paris,
for example, where socially collective work was becoming the ambition of the CRAV
group around François Morellet and Julio Le Parc. CRAV issued a broadsheet in 1961
entitled 'Enough Mystifications', whose very title urged a closing of the gap, as they
saw it, between a generally supine mass public and the mystifications of 'inspiration',
'creativity' and so on perpetuated by moribund divisions in the culture as a whole.
A typical CRAV statement would declare an ambition 'to lead viewers out of their
apathetic dependency that makes them passively accept, not just what is forced
on them as art, but an entire way of life'. A work of art should provide 'a situation that
they activate and transform'.[6] Renaming themselves the Groupe de Recherche d'Art

19.5 Gerhard Richter, *XL-513*, 1964. Oil on canvas,
110 × 130 cm. Museum Frieder Burda, Baden-Baden

19.6 Sigmar Polke, *Lee Harvey Oswald: Raster-
drawing*, 1963. Poster paint and pencil on paper,
94.8 × 69.8 cm. David Zwirner Gallery

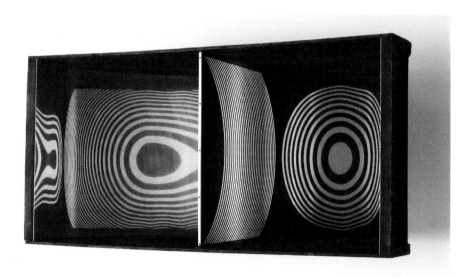

Visuel (hence GRAV), they staged collective installations from 1963 in which the visitor would be thoroughly immersed and involved. At least at the start of the decade GRAV was optimistic about the creation of a new type of viewer-citizen who would interact with the artwork in a spirit of free and critical enquiry – ultimately to become well equipped to handle instability and contradiction in the very conduct of life. Not even prestigious museums flinched from the anarchic possibilities implied. When the well-packaged *The Responsive Eye* exhibition opened at the Museum of Modern Art, New York in 1965, what the show's curator William Seitz called 'ophthalmic painting and construction' (later 'Op Art') claimed both a rich interdisciplinary relationship with research in graphics, technology and psychology but also a commitment to the emancipation of the viewer, beginning with the experience of art alone.[7] Well represented in New York, GRAV's dominant preoccupation at that moment was instability – optical and haptic variations leading to the viewer's own capacity to change, and at the same time the disappearance of the artist as the individual author of the work (**fig. 19.7**). Here, Western commercialised individualism was the target. Yet there was a paradox. When Julio Le Parc was awarded the Grand Prix for Painting at the Venice Biennale the following year the difficulty – perhaps the impossibility – of fully bypassing the concept of the individual became clear.[8]

In wider terms, how could artists reflect the desire of a young generation for personal emancipation at the same time as social change? What of confident new contributions in art by women, or those from ethnic minorities? By the early years of the 1960s some young and determined women artists had arrived in New York only to face barriers to assimilation that would be surmounted by a very few. The American Lee Lozano found a measure of acceptance at the Green Gallery after arriving in the city in 1961. Initially

19.7 (*above*) Julio Le Parc, *Instability through Movement of the Spectator*, 1962–4. Synthetic polymer paint on wood and polished aluminium in painted box, 72.6 × 145 × 92.8 cm. Museum of Modern Art, New York

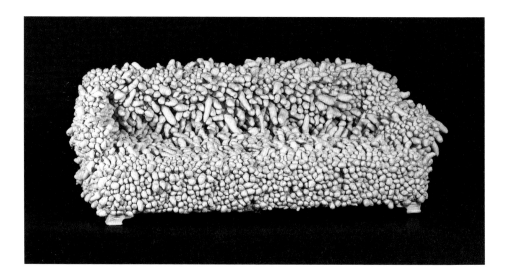

she produced drawings (subsequently paintings) of such things as tools and tool parts – drill bits, spanners, screw threads and the like – that explored some disturbing verbal–visual analogies between violence and sex. Her troubled energies could not easily be sustained: Lozano self-terminated a frustrated career in art in 1970.[9] A not dissimilar experience was that of the Japanese artist Yayoi Kusama, who arrived in the city in June 1958 already midway through a series of paintings she called *Infinity Nets*; small dots (or gaps in paint) covering a surface in intersecting swirls of emergent pattern, extremely delicate. In sculpture, Kusama embarked on some works titled *Accumulation* in which she would cover sofas, chairs, even boats with multiple soft phallic protuberances made of stuffed cloth and painted all white (**fig. 19.8**). Once more the Green Gallery gave support; while her works were praised in print by the sympathetic Donald Judd. He recognised early on that her compulsively repetitive technique was both an artistic refusal as well as a pointer to psychic anxieties lying beneath.[10] Together with work by Yoko Ono, Eva Hesse, Joan Jonas and Lee Bontecou, some specifically female – and also feminine – articulations in art were now coming into view.

It must be said too that, for those African Americans who managed to enter the (principally white) networks of patronage in the major cities, negotiating a compromise with the dominant culture was an intractable task. The painter Romare Bearden had studied under the self-exiled George Grosz in the late 1930s before a brief spell as an abstract painter in post-war New York. By the early 1960s, however, and now based in an art community named Spiral around Canal Street, Lower Manhattan, Bearden's seemingly abrupt switch to complex pictorial collages and a commitment to the Civil Rights Movement around 1964 produced some notable results. In a version of Cubist collage, he took fragments of photographic material and cut them across one

19.8 (*above*) Yayoi Kusama, *Accumulation II*, 1962. Sewn stuffed fabric, plaster, paint and sofa frame, 88.9 × 223.5 × 102.2 cm. Hood Museum of Art, Dartmouth, Connecticut

19.9 (*opposite*) Romare Bearden, *Evening 9:10, 461 Lennox Avenue*, 1964. Collage, 27.9 × 47 cm. Davidson College, North Carolina

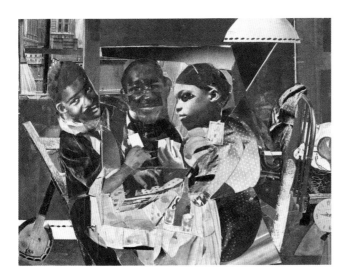

another such as to construct cramped yet panoramic scenes from his community's life at that time (**fig. 19.9**). Comparing his new-found optic with that of De Hooch and Vermeer long before him, his aim was to show the energetic multiplicity as well as the material confinements of African American life. In doing so he joined (and by joining, widened) the stream of modern Western art without falling into anecdote or documentary. 'My aim,' Bearden said, 'is not to paint about the Negro in America in terms of propaganda, rather to reveal through pictorial complexities the richness of a life I know.'[11] In concert with the struggle for gender equality, other conceptions of the Western individual were now beginning to take form, ones in which, in aspiration if not in immediate result, both artist and viewer would become at once self-doubting and curious, and increasingly demanding of the culture that contained them.

Looking back, it may be said that destabilising the senses in order that the viewer may comprehend the world anew has been an abiding motive of much, if not most, of the art identified as 'modern' in this book. Yet probably no single artistic tactic or technique could adequately furnish a definition of 'the modern' in the half century between 1910 and 1960. It is tempting to look for patterns among the instabilities – such as the divide between those adhering to logical method and those relying upon the illogic of the instincts, between clarity on the one hand and the pleasures of confusion on the other, between the knowable-in-principle and plunging enthusiastically into the unknown. By the end of the 1960s, experiments in both art and living took a set of further turns – exploding with the revolutions initiated by workers, artists and students in the spring and summer of 1968. By that time, and seemingly by no coincidence, a set of relatively austere experiments in the relations between printed text (theoretical, philosophical, speculative) and the visual fact was beginning to look like a further ground-clearing exercise of the kind by which 'modern' artists had successfully placed under review the cognitive habits of Western culture for well over half a century. Now, some even more strenuous demands for critical consciousness were coming into play. Whether 'conceptual' art as it became known marked the end of 'the modern' in artistic culture is a question beyond the scope of this book. Yet increasingly from this point onwards, attempts to describe what was vital in visual culture would be referred to no longer as 'modern', but as 'contemporary' art.

Notes

Preface

1. H. Arp and E. Lissitzky, *Die Kunstismen 1914–1924* (*The Isms of Art: 1914–1924*), Zurich: Eugen Rentsch Verlag, 1925.

The 1910s: When Human Nature Changed

1. Virginia Woolf, *Mr Bennett and Mrs Brown*, London: Hogarth Press, 1924, pp. 4, 5.

1. The Impulse to Express

1. Ernst Ludwig Kirchner, 'Programme of Die Brücke', woodcut, 1906.

2. 'What is great in man is that he is a bridge and not a goal; what is lovable in man is that he is an over-going and a down-going'; Friedrich Nietzsche, 'Zarathustra's Prologue', *Also Sprach Zarathustra* (*Thus Spoke Zarathustra*), 1883–5.

3. Ludwig Meidner, 'Anleitung zum Malen von Großstadtbildern' ('Introduction to Painting the Metropolis'), *Kunst und Künstler*, 12 May 1914, in Rose-Carol Washton Long (ed.), *German Expressionism: Documents from the End of the Wilhelmine Empire to the Rise of National Socialism*, Berkeley: University of California Press, 1995, pp. 101–4.

4. Theosophy was founded in New York in 1875 and quickly spread internationally. Kandinski is likely to have followed it through Rudolf Steiner, general secretary of the German section of the Theosophical Society from 1902 (Steiner went on to found Anthroposophy in 1912).

5. Wassily Kandinsky, 'Letters from Munich', no. 5, *Apollon* 11, October–November 1910; Wassily Kandinsky, 'Cologne Lecture', 1914, in Kenneth Lindsay and Peter Vergo (eds), *Kandinsky: Complete Writings on Art*, 2 vols, London: Faber & Faber, 1982, vol. 1, pp. 79, 394, 396.

6. Wassily Kandinsky, *Concerning the Spiritual in Art*, 2nd edn 1912, in Lindsay and Vergo (eds), *Kandinsky: Complete Writings*, vol. 1, p. 219.

7. Paul Schmidt, 'Die Expressionisten' ('The Expressionists'), *Der Sturm* 2, no. 92, January 1912, in Washton Long (ed.), *German Expressionism*, p. 15.

8. Henri Matisse, 'Notes of a Painter', 1908, in Jack Flam (ed.), *Matisse on Art*, rev. edn, Berkeley: University of California Press, 1995, p. 36.

9. Matisse, quoted in Richard Oldenburg et al., *Primitivism in 20th Century Art: Affinity of the Tribal and the Modern*, ed. William Rubin, New York: Museum of Modern Art, 1984, p. 288.

10. Matisse, 'Notes of a Painter', p. 36.

11. Dominique Fourcade and Isabelle Monod-Fontaine, *Henri Matisse 1904–1917*, exh. cat., Museé National d'Art Moderne, Paris, 1993, p. 86.

12. Carl Einstein's *Negerplastik* (*Negro Sculpture*), Leipzig, 1915, is a slightly later exception.

13. French artists included in the first *Knave of Diamonds* exhibition were Henri Le Fauconnier, André Lhote, Albert Gleizes and Jean Metzinger.

14. Aleksandr Shevchenko, *Neo-Primitivism: Its Theory, Its Potentials, Its Achievements*, Moscow, 1913; John Bowlt (ed.), *Russian Art of the Avant-Garde: Theory and Criticism 1902–1934*, London: Thames & Hudson, 1988, p. 45.

2. Futurism and Cubism

1. Umberto Boccioni, Carlo Carrà, Luigi Russolo, Giacomo Balla and Gino Severini, 'Manifesto of the Futurist Painters', *Poesia* (Milan), 11 February 1910, in Umbro Apollonio (ed.), *Futurist Manifestos,* New York: Viking Press, 1970, pp. 25–6.

2. Valentine de Saint-Point, *Manifesto of the Futurist Woman (Response to F. T. Marinetti)*, 1912, comp. J-P. Morel, Paris: Arabian Nights Publishing, 2005; 'Futurist Manifesto of Lust', 11 January 1913, in Apollonio (ed.), *Futurist Manifestos,* pp. 70–74.

3. Umberto Boccioni et al., 'Futurist Painting: Technical Manifesto', *Poesia*, Milan, 11 April 1910, in Apollonio (ed.), *Futurist Manifestos*, p. 28.

4. Boccioni et al., 'Futurist Painting: Technical Manifesto' in Apollonio (ed.), *Futurist Manifestos*, pp. 28–9.

5. The Duchamp brothers were Jacques Villon, Raymond Duchamp-Villon and Marcel Duchamp; others in this circle were Jean Marchand, the Czech painter František Kupka and the Hungarian sculptor Joseph Csaky.

6. Jean Metzinger, 'Cubisme et tradition', *Paris-Journal,* 16 August 1911, in Edward Fry (ed.), *Cubism*, London: Thames & Hudson, 1966, pp. 66–7; Albert Gleizes and Jean Metzinger, *Du Cubisme*, Paris, 1912.

7. Guillaume Apollinaire, *Les Peintres Cubistes: Méditations esthétiques*, Paris, 1913, p. 13. Orphic Cubism was a category that included Francis Picabia and Marcel Duchamp.

8. 'I love legends, dialects, grammatical errors ... and that trickster of a European who makes fun of modernity. Where am I going? I have no idea'; Blaise Cendrars, 'Inédits secrets', *Der Sturm*, September 1913, in Blaise Cendrars, *Oeuvres complètes*, ed. M. Cendrars, Paris: Denoël, 1969, vol. 16, pp. 360–61.

9. Gino Severini, *The Life of a Painter: The Autobiography of Gino Severini*, Princeton University Press, 1995, p. 96. (Severini's book was originally published under the title *La vita di un pittore* by Giangiacomo Feltrinelli Editore in 1983.)

10. John Richardson, *A Life of Picasso*, vol. 2, *1907–1917: The Painter of Modern Life*, New York: Random House, 1996, p. 212.

11. Perhaps Boccioni had noticed that the Italian Medardo Rosso (also from Milan and working in Paris) had shown how the presence of a person could be conveyed in material in his 1906 sculpture *Ecce Puer* (*Behold the Boy*) and similar works.

12. Umberto Boccioni, 'Technical Manifesto of Futurist Sculpture', 1912. Three of the four works have been reconstructed in digital clay; see Anders Rådén and Matt Smith, *Umberto Boccioni: Recreating the Lost Sculptures*, exh. cat., Estorick Collection, London, 2019, pp. 11, 6.

13. The result was Kahnweiler's *Der Weg zum Kubismus* (*The Path to Cubism*), 1920, written largely from the point of view of Kantian aesthetics and German idealism.

14. Jean Metzinger, letters to Albert Gleizes, 4 July and 26 July 1916; Daniel Robbins, 'Jean Metzinger: At the Centre of Cubism', in Joann Moser, Jean Metzinger and Daniel Robbins, *Jean Metzinger in Retrospect*, exh. cat, University of Iowa Museum of Art, 1985.

15. Amédée Ozenfant, *L'Élan* no. 9, February 1916.

16. Filippo Marinetti, 'The Founding and Manifesto of Futurism', 1909, in Apollonio (ed.), *Futurist Manifestos*, p. 22.

17. 'Manifesto', *Blast* no. 1, July 1914 (signed by Richard Aldington, Malcolm Arbuthnot, Laurence Atkinson, Henri Gaudier-Brzeska, Jessica Dismorr, Cuthbert Hamilton, William Roberts, Helen Saunders and Edward Wadsworth, as well as by Lewis and Pound); *Blast I*, Santa Rosa, CA: Black Sparrow Press, 1981, pp. 39–41.

18. Ezra Pound, 'Vortex', *Blast* no. 1, July 1914, pp. 153–4.

19. Wyndham Lewis, *Blast: War Number*, July 1915; *Blast I*, pp. 25–6.

20. Filippo Marinetti, letter to Gino Severini, 20 November 1914; Caroline Tisdall and Angelo Bozzolla, *Futurism*, London: Thames & Hudson, 1977, pp. 190–91.

21. Gino Severini, in Tisdall and Bozzolla, *Futurism*, p. 191.

22. Filippo Marinetti, 'Technical Manifesto of Futurist Literature', 11 May 1912, in Robert W. Flint (ed.), *Marinetti: Selected Writings*, London: Secker & Warburg, 1972, p. 84; Filippo Marinetti, 'Destruction of Syntax – Imagination without Strings – Words-in-Freedom', *Lacerba* (Florence), 15 June 1913, in Apollonio (ed.), *Futurist Manifestos*, pp. 98, 104, 105.

23. Isadora Duncan was 'childishly feminine', Valentine de Saint-Point was 'static, emotionless', Dalcroze eurhythmics 'merely muscular hygiene'. Nor was Loie Fuller quite enough: 'Dance of the Machine Gun', from Filippo Marinetti, 'Manifesto of Futurist Dance', 1917, in Flint (ed.), *Marinetti: Selected Writings*, pp. 140–41.

24. The painting is well discussed in Richardson, *Painter of Modern Life*, pp. 410–15.

25. Pierre Reverdy, 'Sur le Cubisme', *Nord-Sud* no. 1, 15 March 1917, in Fry (ed.), *Cubism*, pp. 144–6.

26. Georges Braque, 'Pensées et refléxions sur la peinture', *Nord-Sud*, December 1917.

27. Those exhibited were Auguste Herbin, Henri Laurens, Metzinger, Léger, Braque, Gris, Severini and Picasso.

3. Russian Experiments

1. Natalia Goncharova, preface to an exhibition of her work, Moscow, 1913; Bowlt (ed.), *Russian Art of the Avant-Garde*, pp. 55–60.

2. As reported in *Golos Moskvy*, 27 March 1913, p. 5; see Margarita Tupitsyn (ed.), *Russian Dada 1914–1924*, Cambridge, MA: MIT Press and Madrid: Museo Nacional Centro de Arte Reina Sofía, 2018, p. 261 n. 3.

3. Natalia Goncharova and Mikhail Larionov, 'Rayonists and Futurists, A Manifesto', July 1913, in Bowlt (ed.), *Russian Art of the Avant-Garde,* pp. 90–91.

4. Mikhail Larionov and Ilya Zdanevich, 'Why We Paint Ourselves: A Futurist Manifesto', *Argus* (St Petersburg), Christmas 1913, in Bowlt (ed.), *Russian Art of the Avant-Garde*, p. 83.

5. Zdanevich, 'Goncharova and Everythingism', text of a lecture of 5 November 1913, in Tupitsyn (ed.), *Russian Dada,* pp. 259–60.

6. Tupitsyn (ed.), *Russian Dada*, p. 179 n. 89.

7. Matyushin was the translator and publisher in 1913 of the first Russian edition of Gleizes and Metzinger's 1912 book *Du Cubisme*.

8. Filippo Marinetti, 'The Birth of Russian Futurism: Milan Paris Moscow Saint Petersburg', *Futurist Memoirs*, in Flint (ed.), *Marinetti: Selected Writings*, pp. 343–63.

9. Ilya Zdanevich, letter to Filippo Marinetti, 23 January 1914; Tupitsyn (ed.), *Russian Dada*, p. 263.

10. This is Kazimir Malevich, *Englishman in Moscow,* 1914, Stedelijk Museum, Amsterdam.

11. Nikolai Tarabukin, 'Ot molberta k mashine' ('From the Easel to the Machine') (written 1916), Moscow, 1923, in Andrei Nakov (trans.), *Le Dernier tableau*, Paris: Éditions Champs Libre, 1972, p. 104.

12. Nikolai Punin, 'Apartment no. 5', date uncertain, first published in *Panorama Iskusstva* no. 12, 1989; Tupitsyn (ed.), *Russian Dada,* pp. 271–2.

13. *Vladimir Evgrafovich Tatlin, Petrograd, December 1915*, in Larissa Zhadova (ed.) *Tatlin*, London: Thames & Hudson, 1988, illus. 126ff. and p. 331. The Wanderers or Peredvizhniki were a group of artists active in the later nineteenth century who travelled the Russian countryside in search of documentary themes in art, such as village life, poverty, religious rituals and inter-regional war.

14. Sergei Isakov, 'On Tatlin's Counter-Reliefs', *Novyi Zhurnal dlya Vsekh* no. 12, 1915, in Zhadova (ed.), *Tatlin*, pp. 333–4.

15. Malevich, 'From Cubism and Futurism to Suprematism: The New Painterly Realism', December 1915, in Bowlt (ed.), *Russian Art of the Avant-Garde*, p. 133.

16. A statement from the Scientific and Theoretical Department of IZO, 1919; Christina Lodder, *Russian Constructivism*, New Haven and London: Yale University Press, 1983, p. 50.

17. At Brest-Litovsk, Russia agreed to give up all claims to Georgia, Poland, the Baltic Provinces, Finland and Ukraine.

18. Varvara Stepanova, diary entry for 10 April 1919, in Peter Noever (ed.), *Aleksandr Rodchenko and Varvara Stepanova: The Future is Our only Goal*, New York: Prestel, 1991, p. 124.

19. Wassily Kandinsky, 'Little Articles on Big Questions: On Point, on Line', *Iskusstvo,* 1919, in Lindsay and Vergo (eds), *Kandinsky: Complete Writings*, vol. 1, pp. 421–7.

20. Aleksandr Rodchenko, *Notebook 1917–20*, in Aleksandr Lavrentiev, 'What Is Linearism?', *The Great Utopia: The Russian and Soviet Avant-Garde 1915–1932*, exh. cat., Guggenheim Museum, New York, 1992, p. 295.

21. Nikolai Punin, 'O pamyatnikakh', *Iskusstvo Kommuny*, 14 and 9 March 1919.

22. Leon Trotsky, *Literature and Revolution*, 1923, trans. Rose Strunsky, London: Redwords, 1991, p. 276.

23. Vladimir Mayakovski, in Lodder, *Russian Constructivism*, p. 61.

24. From 'Programma rabochei gruppy konstruktivistov INKhUKa', in Lodder, *Russian Constructivism*, pp. 94–5.

25. Lenin himself admired the work-time philosophy of the American engineer Frederick William Taylor, author of *Principles of Scientific Management,* 1911.

26. See *5 x 5 = 25: Russian Avant-Garde Exhibition, Moscow, 1921: A Catalogue in Facsimile*, with an essay by John Milner, Budapest: Helikon, Amsterdam: Van Gennep and Cologne: König, 1992.

4. The Dada Revolt

1. Hugo Ball, *Flight Out of Time: A Dada Diary*, intro. John Elderfield, Berkeley and London: University of California Press, 1974, pp. 2–3.

2. Ibid., 5 November 1915, acknowledging the writer and aphorist Luc de Clapiers, marquis de Vauvenargues, a friend of Voltaire's.

3. Ibid., 5 and 11 February 1916.

4. Ibid., 30 March 1916.

5. Hans Arp, 'Dadaland', 1915–20, in Marcel Jean (ed.), *Arp: Collected French Writings: Poems, Essays, Memoirs*, London: Calder & Boyars, 1974, p. 234.

6. Ball, *Flight Out of Time*, 23 June, 30 March and 12 June 1916.

7. Robert Motherwell (ed.), *Arp: On My Way: Poetry and Essays 1912–1948*, New York: Wittenborn, Schultz, 1948, p. 77.

8. Ball, *Flight Out of Time*, 29 March 1917.

9. Erdmute White, *The Magic Bishop: Hugo Ball, Dada Poet*, Columbia, MD: Camden House, 1997, p. 131.

10. Jung's researches were later published as *Synchronicity: An Acausal Connecting Principle*, Princeton, NJ: Princeton University Press, 1960.

11. Hans Richter, *Dada: Art and Anti-Art*, 1965, London: Thames & Hudson, 2016, p. 60.

12. Pierre Cabanne, *Dialogues with Marcel Duchamp*, London: Thames & Hudson, 1971, p. 47.

13. Duchamp, in ibid., p. 48.

14. Ibid.

15. A. Davies, 'Explanatory Statement', *International Exhibition of Modern Art,* New York, 1913.

16. At the University of Virginia in 1912 Georgia O'Keeffe learnt of Japanese artists' attitudes to nature from Alon Bement and Arthur Wesley Dow, and through the latter the art theorist Ernest Fenollosa.

17. Duchamp, in Cabanne, *Dialogues with Marcel Duchamp*, p. 50, and 'A Complete Reversal of Art Opinions by Marcel Duchamp', *Arts and Decoration* (New York), September 1915.

18. L. Norton, 'Buddha of the Bathroom', *The Blind Man* no. 2 (New York), May 1917; Dawn Adès (ed.), *The Dada Reader: A Critical Anthology*, London: Tate Publishing, 2006, p. 156.

19. Francis Naumann, 'Francis Picabia', in *New York Dada 1915–23,* New York: Harry N. Abrams, 1994, pp. 60–61.

20. Tristan Tzara, 'Francis Picabia', *Littérature*, December 1919, p. 81.

21. See Allan Antliff, 'Man Ray's Path to Dada', in *Anarchist Modernism: Art, Politics and the First American Avant-Garde*, Chicago, IL: University of Chicago Press, 2001, pp. 71–92.

22. Richard Huelsenbeck, *En Avant Dada*, 1920, in Robert Motherwell (ed.), *The Dada Painters and Poets,* New York: Wittenborn, Schultz, 1951; 2nd edn, Cambridge, MA: Harvard University Press 1989, pp. 39, 35–6.

23. Richard Huelsenbeck, 'First Dada Lecture in Germany', in *Dada Almanac*, London: Atlas Press, 1993, p. 113.

24. Novembergruppe, 'Draft Manifesto 1918' and 'Open Letter to the Novembergruppe', June 1921, in Charles Harrison and Paul Wood (eds), *Art in Theory 1900–2000: An Anthology of Changing Ideas*, Oxford: Blackwell, 2003, pp. 265–6 and 267–9 respectively.

25. Huelsenbeck, *En Avant Dada*, in Motherwell (ed.), *Dada Painters and Poets*, p. 29.

26. Raoul Hausmann, 'New Painting and Photomontage', 1958, in Lucy Lippard (ed.), *Dadas on Art*, Englewood Cliffs, NJ: Prentice-Hall, 1971, pp. 61–2.

27. 'Interview with Hannah Höch by Édouard Roditi', 1959, in Lippard (ed.), *Dadas on Art*, pp. 71–2.

28. Huelsenbeck, *En Avant Dada*, in Motherwell (ed.), *Dada Painters and Poets*, p. 44.

29. Raoul Hausmann and Richard Huelsenbeck, 'What is Dadaism and What Does It Want in Germany?', 1920, in Huelsenbeck, *En Avant Dada*, Motherwell (ed.), *Dada Painters and Poets*, pp. 41–2.

30. Richard Huelsenbeck, 'First Dada Manifesto', 12 April 1918, in *Dada Almanac,* pp. 44–9.

31. Kurt Schwitters, 'Merz Painting', 1919, in Kurt Schwitters, *I Is Style*, Amsterdam: Stedelijk Museum, 2000, p. 91.

32. *Exposition Dada Max Ernst: Au-delà de la peinture* (*Exhibition Dada Max Ernst: Beyond Painting*) was held at the Paris bookshop Au Sans Pareil, with a preface by Breton.

33. André Breton, 'Max Ernst', 1920, in Robert Motherwell (ed.), *Max Ernst: Beyond Painting and Other Writings by the Artist and His Friends,* New York: Wittenborn, Schultz, 1948, p. 177. The full title of Ernst's work is 'The grassy bicycle garnished with bells the spotty greybeards and the echinoderms bending the spine to look for caresses'.

34. Julius Evola, letter to Tristan Tzara, March 1920; Elisabetta Valento (ed.), *Lettere di Julius Evola a Tristan Tzara 1912–1923*, Rome: Fondazione Julius Evola, 1991, p. 18; see Jeffrey Schnapp, 'Bad Dada (Evola)', in Leah Dickerman and Matthew Witkovsky (eds), *The Dada Seminars*, Washington, DC: National Gallery of Art and Distributed Art Publishers, 2005, p. 38.

35. Julius Evola, lecture of 30 April 1921 at the Casa d'Arte Bragaglia, Rome, April 1921; Schnapp, 'Bad Dada', p. 39.

The 1920s: Looking Forward, Looking Back

5. Modern Classicisms

1. Paul Dermée, 'Quand le symbolisme fut mort', *Nord-Sud* no. 1, 15 March 1917, pp. 2–3.

2. Maurice Denis, *Aristide Maillol*, Paris, 1925; Elizabeth Cowling and Jennifer Mundy (eds), *On Classic Ground: Léger, De Chirico and the New Classicism 1910–1930*, London: Tate Gallery, 1990, pp. 148–9.

3. Apollinaire, catalogue to André Derain exhibition, Galerie Paul Guillaume, Paris, 1916.

4. *Le Rappel à l'ordre* was the title of a collection of essays published by Jean Cocteau in 1926.

5. Picasso, letter to Gertrude Stein, 1917, in William Rubin (ed.), *Pablo Picasso: A Retrospective*, New York: Museum of Modern Art, 1980, p. 197.

6. 'Vacuous and lethargic', with 'troubling suggestions of the figure's all-too human vulnerability' is the description given to Picasso's 1921 *Large Bather* by Elizabeth Cowling; *Picasso: Style and Meaning*, London: Phaidon, 2002, p. 422.

7. Henri Matisse, letter to his wife, 9 January 1919, in Hilary Spurling, *Matisse the Master*, vol. 2, *1909–1955, London*: Penguin, 2005, p. 223.

8. 'I work without a theory … I am conscious only of the forces I use, and I am driven by an idea that I really only grasp as it grows with the picture'; Matisse, 'Notes of a Painter on His Drawing', 1939, in Flam (ed.), *Matisse on Art*, p. 132.

9. 'Picasso Speaks', *The Arts* (New York), May 1923, in Fry (ed.), *Cubism*, pp. 166–7.

10. Amédée Ozenfant, 'Notes sur le Cubisme', *L'Élan* no. 10, 1 December 1916, n.p., emphasis added.

11. Guillaume Apollinaire, 'The New Spirit and the Poets', lecture of December 1917, published posthumously in *Mercure de France*, December 1918.

12. Amédée Ozenfant and Charles Édouard Jeanneret, *Après le Cubisme*, Paris: Éditions des Commentaires, 1918; Carol S. Eliel, *L'Esprit Nouveau: Purism in Paris 1918–1925*, Los Angeles, CA: Los Angeles County Museum of Art and New York: Harry N. Abrams, 2001, p. 142.

13. Amédée Ozenfant and Charles Édouard Jeanneret, *L'Esprit Nouveau* no. 1, October 1920, n.p.

14. Fernand Léger, 'Correspondance' (1922), *L'Esprit Nouveau* no. 4, April 1924.

15. Fernand Léger, 'The Machine Aesthetic', *Bulletin de L'Effort Moderne* nos 1–2, January– February 1924, in Herschel B. Chipp (ed.), *Theories of Modern Art: A Source Book by Artists and Critics*, Berkeley: University of California Press, 1968, pp. 277, 278.

16. Fernand Léger, *The Little Review* (Paris) 11, no. 2, Winter 1926, pp. 7–8; Chipp, *Theories of Modern Art*, p. 279.

17. The project occupied the architect between 1920 and 1922. See Le Corbusier, 'Maisons en serie', *L'Esprit Nouveau* no. 13, December 1921, p. 1538; Eliel, *L'Esprit Nouveau*, p. 46 n. 83.

18. Le Corbusier, *The City of Tomorrow and Its Planning*, London: John Rodker, 1929, p. 231; Eliel, *L'Esprit Nouveau*, p. 51.

19. Le Corbusier, *L'Art décoratif d'aujourd'hui*, Paris: Éditions Crès, 1925, p. 98; Eliel, *L'Esprit Nouveau*, p. 47.

20. Gino Severini, *Du Cubisme au Classicisme: Esthétique du compas et du nombre*, Paris, 1921, p. 11.

21. Giorgio de Chirico, 'Max Klinger', in Massimo Carrà (ed.), *Metaphysical Art*, London: Thames & Hudson, 1976, p. 99.

22. Carlo Carrà, from 'Our Antiquity' and 'Metaphysical Painting', both in *Pittura metafisica*, Florence, 1919, in Carrà (ed.), *Metaphysical Art*, pp. 34 and 52 respectively.

23. See Ara Merjian, *Giorgio de Chirico and the Metaphysical City: Nietzsche, Modernism, Paris*, New Haven and London: Yale University Press, 2014. The Turin paintings are *Still-Life: Turin Spring*, 1914, and *Melancholy of Turin*, 1915.

24. Giorgio de Chirico, 'The Return to the Craft', *Valori Plastici*, November–December 1919, in Carrà (ed.), *Metaphysical Art*, pp. 141, 144, 146.

25. Margherita Sarfatti, 'Letter from Berlin', in Catherine Paul and Barbara Zaczek, 'Margherita Sarfatti and Italian Cultural Nationalism', *Modernism/ Modernity* 13, no. 1, January 2006, pp. 889–916.

26. *Opera omnia de Benito Mussolini*, ed. Edoardo and Duilio Susmel, Florence: La Fenice, 1951–63, vol. 20, pp. 82–4; Emily Braun, 'Political Rhetoric and Poetic Irony: The Uses of Classicism in the Art of Fascist Italy', in Cowling and Mundy (eds) *On Classic Ground*, p. 356 n. 33.

6. Surrealism and Painting

1. See the account of Hans Richter in Richter, *Dada: Art and Anti-Art*, pp. 188–91.

2. Joan Miró, letter to Josep Ràfols, 26 September 1923, in Margit Rowell (ed.), *Joan Miró: Selected Writings and Interviews*, London: Da Capo Press, 1992, p. 82.

3. Joan Miró, letter to Michel Leiris, 10 August 1924, in Rowell (ed.), *Miró: Writings and Interviews*, p. 86.

4. Guillaume Apollinaire, *Parade*, programme note, 18 May 1917, in Martine Kahane, *Les Ballets Russes à l'Opéra*, Paris: Hazan / Bibliothèque Nationale de France, 1992, p. 110.

5. André Breton, *Manifesto of Surrealism*, 1924, in *André Breton: Manifestoes of Surrealism*, trans. Richard Seaver and Helen Lane, Ann Arbor: University of Michigan Press, 1972, pp. 9–10, 10.

6. Ibid., p. 27 n.

7. Ibid., p. 23. See also André Breton and Philippe Soupault, 'Les Champs magnétiques', *Littérature* nos 7–12, 1919–20.

8. Breton, *Manifesto of Surrealism*, pp. 23, 26, 29–30. Freud's *The Interpretation of Dreams* (1900) was not published in French translation until 1925.

9. See *La Révolution Surréaliste* no. 2, January 1925.

10. Pierre Naville, *La Révolution Surréaliste*, no. 3, April 1925.

11. Breton's brief for painting was published as *Le Surréalisme et la peinture*, Paris: Éditions Gallimard, 1928.

12. Picasso, *Man with a Guitar* (1912–13) and *Montrouge in the Snow* (1917).

13. From André Masson, 'About Surrealism', lecture given at the Pavillon de Marsan, Paris, March 1961; Gaëtan Picon, *Surrealism 1919–1939*, Geneva: Skira and London: Macmillan, 1977, p. 101.

14. See Michel Leiris, 'Toiles récentes de Picasso', *Documents* no. 7, 1930.

15. An English-language version (caption translations by Dorothea Tanning) was published by George Braziller, New York, 1981.

16. René Magritte, 'Les Mots et les images', *La Révolution Surréaliste* no. 12, December 1929, pp. 32–3.

17. Salvador Dalí, 'La dada fotogràfica' ('Photographic Dada'), *Gazeta de los Arts / Gazeta de les artes* (Barcelona), 6 February 1929, in Haim Finkelstein (ed.), *The Collected Writings of Salvador Dalí*, Cambridge: Cambridge University Press, 1998, pp. 68–7.

18. From Breton's preface to Dalí's November 1929 show at Galerie Goemans; Franklin Rosemont (ed. and intro.), *André Breton: What is Surrealism?*, New York and London: Pathfinder Press, 1978, pp. 62–3.

19. Louis Aragon and André Breton, *La Révolution Surréaliste* no. 7, 1926; Marcel Jean, *The History of Surrealist Painting*, London: Weidenfeld & Nicolson, 1960, p. 156. The music was by Constant Lambert.

20. André Breton interviewed by André Parinaud, 1952, in *Conversations: The Autobiography of Surrealism*, New York: Paragon House, 1993, p. 117.

21. Georges Bataille, 'Le "Jeu lugubre"', *Documents* no. 7, December 1929, in Harrison and Wood (eds), *Art in Theory*, p. 485.

22. André Breton, *Second Manifesto of Surrealism*, in Seaver and Lane (trans.), *Manifestoes of Surrealism*, pp. 180, 181.

23. Carl Einstein, 'Pablo Picasso: Quelques tableaux de 1928', *Documents* no. 1, 1929, p. 36; Leiris, 'Toiles récentes de Picasso', pp. 69, 70.

7. The Elementarist Ideal

1. 'Manifesto I of De Stijl, 1918', *De Stijl* 2, no. 1, November 1918, in Stephen Bann (ed.), *The Tradition of Constructivism*, New York: Viking Press, 1974, p. 65. The signatories were the painters Theo van Doesburg, Piet Mondrian and the Hungarian Vilmos Huszár, the architects Robert van 't Hoff and Jan Wils, the poet Antony Kok and the Belgian sculptor Georges Vantongerloo. Bart van der Leck had by 1918 broken with the group.

2. Hubert van den Berg, *The Import of Nothing: How Dada Came, Saw and Vanished in the Low Countries 1915–1922*, Boston, MA: G. K. Hall, 2002, p. 132.

3. 'A Call for Elementarist Art' (October 1921, Berlin), *De Stijl* 4, no. 10, 1922, in Bann (ed.), *Tradition of Constructivism*, p. 51.

4. 'Statement by the International Faction of Constructivists' (signed by El Lisitski, Theo van Doesburg and Hans Richter), *De Stijl* 5, 1922, in Bann (ed.), *Tradition of Constructivism,* pp. 68–9.

5. 'Proun' is the acronym of 'proekt utverzhdeniya novogo', 'project for the affirmation of the new'.

6. El Lissitzky, 'PROUN – Not World Visions BUT – World Reality', *De Stijl*, 6 June 1922, in Sophie Lissitzky-Küppers, *El Lissitzky: Life, Letters, Texts*, London: Thames & Hudson, 1980, p. 347.

7. 'Perpetual hurry, fast movement, cause all colours to melt into grey'; thus wrote László Moholy-Nagy in *Painting Photography*

Film, 1925 (London: Lund Humphries, 1967, p. 15).

8. Paul Klee, *Pedagogical Sketchbook*, 1925, with a foreword by Sibyl Moholy-Nagy, London: Faber & Faber, 1953.

9. Wassily Kandinsky, 'The Basic Elements of Form' and 'Colour Course and Seminar', both 1923, in Lindsay and Vergo (eds), *Kandinsky: Complete Writings*, vol. 2, pp. 500–01, 502.

10. Wassily Kandinsky, *Point and Line to Plane: A Contribution to the Analysis of Pictorial Elements*, 1926, in Lindsay and Vergo (eds), *Kandinsky: Complete Writings*, vol. 2, pp. 524–699.

11. Theo van Doesburg, 'Towards Elementary Plastic Expression', *G* no. 1, July 1923, in Joost Baljeu (ed. and intro.), *Theo van Doesburg*, London: Studio Vista, 1974, pp. 140–42.

12. See further Marjorie Perloff, *The Poetics of Indeterminacy: Rimbaud to Cage*, Princeton, NJ: Princeton University Press, 1981.

13. Theo van Doesburg, 'What is Dada???', *De Stijl*, 1923, in Baljeu (ed.), *Van Doesburg*, pp. 131, 134.

14. Van Doesburg, 'Towards Elementary Plastic Expression', p. 141.

15. The same emphasis is given to architectural systems: see 'Towards Plastic Architecture', *De Stijl* 12, nos 6–7, 1924, in Baljeu (ed.), *Van Doesburg*, p. 144.

16. Theo van Doesburg, 'Painting: From Composition towards Counter-Composition', *De Stijl* no. 13, 1926, in Baljeu (ed.), *Van Doesburg*, p. 155.

17. Theo van Doesburg, 'Elementarism (the Elements of the New Painting)', signed Paris, 13 July 1930, and published in *De Stijl: Van Doesburg Issue*, January 1932, pp. 17–19; Baljeu (ed.), *Van Doesburg*, p. 184.

18. Theo van Doesburg 'The Will to Style', *De Stijl* no. 2, February 1922, and no. 3, March 1922, in Baljeu (ed.), *Van Doesburg*, p. 121.

19. Theo van Doesburg, letter to Antony Kok, 23 January 1930, in Els Hoek (ed.), *Theo van Doesburg: Oeuvre catalogue*, Utrecht: Centraal Museum, 2000, p. 533.

20. Theo van Doesburg et al., 'Art Concret: The Basis of Concrete Painting', *Art Concret*, April 1930, and Theo van Doesburg, 'Towards White Painting', *Art Concret*, April 1930, in Baljeu (ed.), *Van Doesburg*, pp. 180, 183.

21. Henryk Berlewi, 'The International Exhibition in Düsseldorf', *Nasz Kurier* no. 209, 2 August 1922, in Timothy O. Benson and Éva Forgacs, *Between Worlds: A Sourcebook of Central European Avant-Gardes 1919–1930*, Cambridge, MA: MIT Press, 2002, p. 399.

22. See the editorial statement 'What Constructivism Is', *Blok* nos 6–7, 1924, in Bann (ed.), *Tradition of Constructivism*, pp. 103–6. Berlewi's manifesto *Mechano-Faktura* dates from the same year.

23. Władysław Strzemiński, *Unizm w Malarstwie / Unism in Painting*, 1928, English trans. Wanda Kemp-Welsh, Łódź: Muzeum Sztuki, 1994, p. 16.

24. See Janusz Zagrodzki, *Katarzyna Kobro i kompozycja przestrzeni (Katarzyna Kobro and the Composition of Space)*, Warsaw, 1984, in *Katarzyna Kobro 1898–1951*, exh. cat., Henry Moore Institute, Leeds, 1999, p. 117.

25. Katarzyna Kobro, 'Sculpture and Solid', *Europa* no. 2, 1929, in *Kobro 1898–1951*, p. 149.

26. Katarzyna Kobro and Władysław Strzemiński, *Composition of Space: Calculations of Space–Time Rhythm*, in Ryszard Stanislawski, *Constructivism in Poland 1923–1936*, exh. cat., Rijksmuseum Kröller-Müller, Otterlo, 1973, pp. 107, 108.

27. Van Doesburg et al., 'Art Concret: Basis of Concrete Painting', p. 181.

8. Germany and Russia in the 1920s

1. Interview with Otto Dix, 'Über Kunst, Religion und Krieg', 1963, in Matthias Eberle, *World War I and the Weimar Artists: Dix, Grosz, Beckmann, Schlemmer*, New Haven and London: Yale University Press, 1985, p. 22 n. 3, p. 129.

2. Carl Einstein, 'Rudolf Schlichter', *Das Kunstblatt* no. 4, April 1920; Dennis Crockett, *German Post-Expressionism: The Art of the Great Disorder 1918–1924*, University Park: Pennsylvania State University Press, 1999, p. 46. *Valori Plastici*, published in Rome by Mario Broglio between 1918 and 1920, was available in certain gallery bookshops in Germany.

3. The Novembergruppe Opposition (Otto Dix, Max Dungert, George Grosz, R. Hausmann, Hannah Höch, Ernst Krantz, Franz Mutzenbecher, Thomas Ring, Rudolf Schlichter, Georg Scholz, Willi Zierath), 'Offener Brief an die Novembergruppe', *Der Gegner* no. 2, 1921, pp. 300–01; Crockett, *German Post-Expressionism*, p. 55, translation modified.

4. Editors of *Veshch* (in fact El Lisitski), 'Statement', *De Stijl* 4, no. 4, 1922, in Bann (ed.), *Tradition of Constructivism*, p. 63.

5. Gustav Hartlaub, 'Zum Geleit', *Ausstellung 'Neue Sachlichkeit': Deutsche Malerei seit dem Expressionismus,* Städtische Kunsthalle, Mannheim, 1925, in Anton Kaes, Martin Jay and Edward Dimendberg (eds), *The Weimar Republic Sourcebook*, Berkeley and London: University of California Press, 1995, p. 492. After Mannheim, the exhibition toured to Dresden and Chemnitz.

6. See Franz Roh, *Nach-expressionismus: magischer Realismus: Probleme der neuesten Europäischen Malerei*, Leipzig: Klinkhardt & Biermann, 1925, p. 119.

7. The sentiment here is that of Misch Orend, 'Magic Realism', *Siegenbürgische Zeitschrift* no. 5, January 1928, in Kaes et al. (eds), *Weimar Republic Sourcebook*, p. 495.

8. Albert Renger-Patsch, 'Ziele' ('Aims'), *Das Deutsche Lichtbild*, 1927, in Christopher Phillips (ed. and intro.), *Photography in the Modern Era: European Documents and Critical Writings, 1913–1940*, New York: Metropolitan Museum of Art / Aperture, 1989, p. 105.

9. Another Münzenberg magazine, *Arbeiter-Illustrierte-Zeitung* or *AIZ* also began publishing in the 1920s and from 1930 carried the biting photomontages of John Heartfield that confronted the 'objective' facts of German capitalism in its new alliance with fascism. See D. Evans, *John Heartfield AIZ/VI 1930–1938*, New York: Kent Fine Art, 1992.

10. László Moholy-Nagy, 'Unprecedented Photography', *Das Deutsche Lichtbild*, 1927, in Phillips (ed.), *Photography in the Modern Era*, pp. 83–5.

11. J. Hernand, 'Neue Sachlichkeit: Ideology, Lifestyle or Artistic Movement?', in Thomas Kniesche and Stephen Brockmann (eds), *Dancing on the Volcano: Essays on the Culture of the Weimar Republic*, Columbia, SC: Camden House, 1994, pp. 57–67.

12. Paul Schultze-Naumburg in 'Who is Right? Traditional Architecture or Building in New Forms (a dialogue with Walter Gropius)', *Uhu* no. 7, April 1926, in Kaes et al. (eds), *Weimar Republic Sourcebook*, pp. 443, 444, 445.

13. Paul Schultze-Naumburg, *Kunst und Rasse,* 1928, in Kaes et al. (eds), *Weimar Republic Sourcebook*, pp. 498, 499.

14. 'Manifesto of the "41°"', 1919, in Tupitsyn (ed.), *Russian Dada*, p. 283.

15. Trotsky, *Literature and Revolution*, trans. Strunsky, p. 277.

16. Grigori Kozintsev, *Sobranie sochineniya (Collected Works)*, Leningrad: Iskusstvo, 1982–6, vol. 3, pp. 73–4. The FEKS manifesto of 1922 was published in translation the same year as *Eccentrism,* and was reprinted with an introduction by Marek Pytel as *The Eccentric Manifesto* by Eccentric Press, London, in 1992.

17. See Sergei Eisenstein, 'Montage of Attractions', *LEF* (Moscow), May 1923, in Sergei Eisenstein, *The Film Sense*, trans. and ed. Jay Leyda, London: Faber & Faber, 1943, pp. 166–8.

18. Osip Brik, 'From Picture to Calico-Print', *LEF* no. 6, 1924, in Harrison and Wood (eds), *Art in Theory*, p. 349.

19. Aleksandr Bogdanov, speech of 25 September 1918, published as 'The Proletarian and Art', *Proletarskaya Kultura* no. 5, 1918, in Bowlt (ed.), *Russian Art of the Avant-Garde*, p. 177.

20. Statements from both Concretist and Projectionist groups can be found in Bowlt (ed.), *Russian Art of the Avant-Garde*, pp. 240–41. For these and other groups see Brandon Taylor, *Art and Literature under the Bolsheviks*, vol. 1, *The Crisis of Renewal 1917–1924*, London: Pluto Press, 1991, pp. 150–60.

21. Brandon Taylor, *Art and Literature under the Bolsheviks*, vol. 2, *Authority and Revolution 1924–1932,* London: Pluto Press, 1992, p. 13.

22. Pavel Filonov, 'Deklaratsiya mirovogo rastsveta', *Zhizn Iskusstva* (Moscow) no. 20, 1923, p. 13, in Bowlt (ed.), *Russian Art of the Avant-Garde*, p. 287.

23. 'Declaration of the Association of Artists of Revolutionary Russia', 1922, in Bowlt (ed.), *Russian Art of the Avant-Garde*, p. 266.

24. Osip Brik, 'The Photograph versus the Painting' and 'What the Eye Does Not See', *Sovetskoe Foto* no. 2, 1926, in

Phillips (ed.), *Photography in the Modern Era*, pp. 213, 217 and p. 220 respectively.

25. Osip Brik, 'From the Painting to the Photograph', *Novy LEF* no. 3, 1928, in Phillips (ed.), *Photography in the Modern Era*, p. 230.

26. 'Oktyabr Group Declaration', *Sovremennaya Arkhitektura* no. 3, March 1928, pp. 73–7; Bowlt (ed.), *Russian Art of the Avant-Garde*, p. 277.

27. 'Programme of the Oktyabr photo-section, *Izofront*, Moscow / Leningrad, 1931; Phillips (ed.), *Photography in the Modern Era*, pp. 283–4.

28. For an example of Oberiu's brevity: 'The other day a man went to work, but on his way he met another man, who had brought a loaf of Polish bread and was on his way home to his own place. That's about all': *The Meeting*, c. 1927–8; and Oberiu, *Manifesto*, January 1928, in George Gibian (ed. and intro.), *The Man in the Black Coat: Russia's Literature of the Absurd*, Evanston, IL: Northwestern University Press, 1987, p. 63 and pp. 247–8, 246 respectively.

29. Gibian, introduction to Gibian (ed.), *Man in the Black Coat*, p. 22.

The 1930s: The 'Low Dishonest' Decade

1. W. H. Auden, 'September 1, 1939', *New Republic*, 18 October 1939, in W. H. Auden, *Another Time*, New York: Random House, 1940.

9. Surrealism: Objects and Sculpture

1. Francisco Melgar, 'Spanish Artists in Paris', *Ahora* (Madrid), 24 January 1931; Joan Miró, statement to Tériade, *L'Intransigéant*, 7 April 1930; Joan Miró, letter to Sebastià Gasch, April 1932; Rowell (ed.), *Miró: Selected Writings and Interviews*, pp. 116 and 117, p. 314, p. 120 respectively.

2. Louis Aragon, 'La Peinture au défi', catalogue to *Exposition*

de collages: Arp, Braque, Dalí, Duchamp, Ernst, Gris, Miró, Magritte, Man Ray, Picabia, Picasso, Tanguy*, Galerie Goemans, Paris, March 1930, in Lucy Lippard (ed.), *Surrealists on Art*, Englewood Cliffs, NJ: Prentice-Hall, 1970, pp. 49–50, 48.

3. Sebastià Gasch, cited in Adele Nelson, 'Constructions and Objects 1930–1932', in Anne Umland (ed.), *Joan Miró: Painting and Anti-Painting 1927–1937*, New York: Museum of Modern Art, 2008, p. 102.

4. Michael Leiris, 'Alberto Giacometti', *Documents* no. 4, September 1929, pp. 201–10.

5. Alberto Giacometti, letter to his parents, June 1931, in *Alberto Giacometti: In His Own Words: Sculptures 1925–34*, London: Luxembourg & Dayan, 2016, p. 106.

6. Alberto Giacometti, 'Objets mobiles et muets', *SASDLR* no. 3, 1931, pp. 18–19; Leiris, 'Giacometti', pp. 209–10.

7. Hans Arp, 'Looking', in James T. Soby (ed.), *Arp*, New York: Museum of Modern Art, 1958, pp. 14–15.

8. Hans Arp, 'Concrete Art', in Motherwell (ed.), *Arp: On My Way*, p. 70.

9. Katarzyna Kobro, 'Functionalism', *Forma* no. 4, January 1936, in translation in Lise-Lotte Blom, *Tre pionérer for Polsk avant-garde | Three Pioneers of Polish Avant-Garde*, Odense: Art Museum of Funen, 1985, p. 61. For the 'organic' in art, see Brandon Taylor, *The Life of Forms in Art: Modernism, Organism, Vitality*, London: Bloomsbury, 2020.

10. André Warnod, '"En peinture tout n'est qu'il signe" nous dit Picasso', *Arts* (Paris), 29 June 1945, in John Richardson, *A Life of Picasso*, vol. 3, *The Triumphant Years 1917–1932*, New York: Random House, 2009, p. 349.

11. See note 5 above.

12. André Breton, 'Introduction to the Discourse on the Paucity of Reality', 1924, in Rosemont (ed.), *What is Surrealism?*, p. 26.

13. The work is treated in detail in Georges Didi-Huberman, *The Cube and the Face: Around a Sculpture by Alberto Giacometti*, Zurich: Diaphanes, 2015.

14. Reported by Jean, *History of Surrealist Painting*, p. 228.

15. Salvador Dalí, 'Surrealist Objects', *SASDLR* no. 3, 1931, p. 17, in Finkelstein (ed.), *Collected Writings of Dalí*, pp. 234, 232.

16. Salvador Dalí, 'Posicío moral del surrealisme', *Hélix* (Barcelona), 22 March 1930, and *Conquest of the Irrational*, New York: Julien Levy, 1935, in Finkelstein (ed.), *Collected Writings of Dalí*, pp. 221–2 and p. 265 respectively.

17. Salvador Dalí, 'The Object as Revealed in Surrealist Experiment', *This Quarter* (Paris), September 1932, trans. D. Gascoyne, in Finkelstein (ed.), *Collected Writings of Dalí*, p. 241. The book is Aurel Kolnai's *Der Ekel (On Disgust)*; see Barry Smith and Carolyn Korsemeyer (eds), *Aurel Kolnai: On Disgust*, La Salle, IL: Open Court, 2004.

18. Dalí, *The Conquest of the Irrational*, in Finkelstein (ed.), *Collected Writings of Dalí*, p. 272.

19. Georges Brassaï, 'Involuntary Sculptures', *Minotaure*, nos 3–4, December 1933.

20. Karel Teige, 'Poetism', *Host* 3, nos 9–10, 1924, pp. 66–7.

21. The phrase is from Teige, 'Báseň, svět, člověk', *Zvěrokruh* no. 1, November 1930, pp. 9–15. The theme is developed in Karel Srp, *Karel Teige*, Prague: Torst, 2001.

22. In the words of Marcel Jean, himself a contributor to the show: Jean, *History of Surrealist Painting*, pp. 247–51.

23. See Bice Curiger, *Meret Oppenheim: Defiance in the Face of Freedom*, Cambridge, MA: MIT Press, 1989, and Heike Eipeldauer

(ed.), *Meret Oppenheim: Retrospective*, Ostfildern: Hatje Cantz, 2013.

24. André Breton, 'Crisis of the Object', *Cahiers d'Art, 1936*, in André Breton, *Surrealism and Painting*, trans. Simon Watson Taylor, London: MacDonald, 1972, p. 280.

25. Salvador Dalí, 'Honneur à l'objet', *Cahiers d'Art, 1936*, in Jean, *History of Surrealist Painting*, pp. 248, 251.

26. W. Chadwick, *Women Artists and the Surrealist Movement* (1985), London: Thames & Hudson, 2021.

27. See Breton, 'Des tendances les plus récentes de la peinture surréaliste', *Minotaure*, 12-13, May 1939.

10. Battles over 'Abstract' Art

1. Christian Zervos, in *Cahiers d'Art*, 1925, in response to the exhibition *Art d'Aujourd'hui*; see Paul Overy, *De Stijl*, London: Thames & Hudson, 1991, p. 178.

2. 'Comments on the Basis of Concrete Painting', *Art Concret*, April 1930, in Baljeu (ed.), *Van Doesburg*, p. 182; 'From Intuition towards Certitude', dated Paris, 1930 (*Réalités Nouvelles* no. 1, 1947); and 'Elementarism', dated 13 July 1930, published in *De Stijl: Van Doesburg Issue*, January 1932, in Baljeu (ed.), *Van Doesburg*, p. 184.

3. The exhibition showed van Doesburg, Lisitski, Mondrian, Anton Pevsner, Malevich, Vantongerloo and Friedrich Vordemberge-Gildewart on the geometric side, and Arp, Dalí, Picasso, Masson and others on the Surrealist side. See Carl Einstein, 'L'Exposition de l'Art Abstrait à Zurich', *Documents* no. 6, 1929, p. 342.

4. Hans Reichenbach, 'Crise de la causalité', *Documents* no. 2, 1929, p. 108.

5. For example, Paul Klee, 'Exakte Versuche im Bereich der Kunst', *Bauhaus: Zeitschrift für Gestaltung*

2, nos 2–3, 1928, in Paul Klee, *On Modern Art*, Bern: Verlag Benteli, 1945; Georges Vantongerloo, 'Exakte Gestaltung', *Bauhaus: Zeitschrift für Gestaltung* 3, no. 4, 1929.

6. The other female members represented in the exhibition were Ingibjoerg Bjarnason, Marcelle Cahn, Aleksandra Ekster, Sophie Taeuber-Arp, Adya van Rees, Franciska Clausen, Nadia Chodasiewicz-Grabowska, Nechama Szmuszkowicz and Wanda Wolska. See M. Llüisa Faxedas, 'Women Artists of "Cercle et Carré": Abstraction, Gender and Modernity', *Women's Art Journal*, January 2015, pp. 37–46.

7. Theo van Doesburg, 'Editorial', *Cercle et Carré* no. 2, April 1930; Carl Einstein, 'L'Enfance néolithique', *Documents* no. 8, 1930, p. 42.

8. At a screening of Dalí and Buñuel's film *L'Âge d'Or* (1930) at Studio 28, Paris, in December 1930, paintings hung in the foyer by Miró, Ernst, Dalí and Tanguy were torn down and trampled by the extreme-right group Camelots du Roi, who were attached to the royalist newspaper *Action Française*; Jean, *History of Surrealist Painting*, p. 215.

9. Theo van Doesburg, letter to František Kupka, 9 February 1931, in Baljeu (ed.), *Van Doesburg*, p. 103.

10. *Abstraction-Création: Art Non-Figuratif* no. 1, 1932, pp. 1–2.

11. *Abstraction-Création: Art Non-Figuratif* no. 2, 1933, p. 1.

12. Auguste Herbin, *Abstraction-Création: Art Non-Figuratif* no. 1, 1932, p. 19.

13. See the exhibition catalogue to *Herbin*, Bernard Chauveau, Paris, 2012.

14. Kandinsky, interview with Karl Nierendorf, 1937, in Lindsay and Vergo (eds), *Kandinsky: Complete Writings*, vol. 2, p. 807.

15. Alexandre Kojève, 'Les Peintures concrètes de Kandinsky', *Revue de Métaphysique et de Morale* 90, no. 2, 1985, pp. 149–71. See also Alexandre Kojève, 'Pourquoi Concret?' ('Why Concrete?'), *XXe Siècle* no. 27, December 1966, in G. di san Lazzaro, *Homage to Wassily Kandinsky*, New York: Leon Amiel, 1975, p. 125.

16. Wassily Kandinsky, 'The Value of a Concrete Work', *XXe Siècle* no. 5/6, Paris 1938–9; Wassily Kandinsky, 'Abstract of Concreet?', in *Tentoonstelling abstracte kunst*, exh. cat., Stedelijk Museum, Amsterdam, 1938.

17. Jerzy Ludowski and Hubert Zawardski, *A Concise History of Poland*, Cambridge: Cambridge University Press, 2001, pp. 242–4.

18. Anatole Jakovski, in *Thèse-Antithèse-Synthèse*, exh. cat., Kunstmuseum, Lucerne, 1935, pp. 12–13.

19. Anatole Jakovski, *Five Swiss Artists*, Abstraction-Création Gallery, Paris, 1934.

20. Max Bill, 'Konkrete Gestaltung', in *Zeitprobleme in der Schweizer Malerei und Plastik*, Zurich: Kunsthaus, 1936, p. 9. The Swiss artists Tonio Ciolina, Hans Seiler, Georges Aubert and Theo Eble also explored rational and constructive systems for art.

21. Georges Vantongerloo, *Paintings, Sculptures, Reflections*, New York: Wittenborn, Schultz, 1948; Guy Brett et al., *Georges Vantongerloo: A Longing for Infinity*, Madrid: Museo Nacional Centro de Arte Reina Sofía, 2009, p. 78.

22. Max Bill, 'Konkrete Kunst', *Zürcher Konkrete Kunst*, exh. cat., Stuttgart and Munich, 1949, in Margit Staber (ed.), *Konkrete Kunst: Manifeste und Künstlertexte*, Zurich: Museum Haus Konstruktiv, 2001, p. 32, emphases added.

23. Paul Nash, 'Going Modern and Being British', *Weekend Review*, 12 March 1932, pp. 322–3.

24. The other British artists in *Recent Paintings by English, French and German Artists*, Mayor Gallery, London, April 1933, were Edward Wadsworth, John Armstrong, John Bigge, Edward Burra, Tristram Hillier, Henry Moore and Barbara Hepworth.

25. Paul Nash, 'Unit One', *The Listener*, 5 July 1933, pp. 14–16.

26. Herbert Read, *Unit One,* London: Faber & Faber, 1934. The *Unit One* exhibition toured to Liverpool, Manchester, Hanley, Derby, Swansea and Belfast.

27. See Chris Stephens, 'Ben Nicholson: Modernism, Craft and the English Vernacular', in David Peters Corbett et al. (eds), *The Geographies of Englishness: Landscape and the National Past 1880–1940*, New Haven and London: Yale University Press, 2003, pp. 225–457.

28. The threat to the ancient landscape by building projects such as roads and factory buildings was perhaps a further theme of Nash's painting. See Sam Smiles, 'Equivalents for the Megaliths: Prehistory and English Culture, 1920–50', in Corbett et al. (eds), *Geographies of Englishness*, pp. 199–223.

29. Paul Nash, 'For, But Not With', *Axis* no. 1, January 1935, p. 26.

30. Geoffrey Grigson, 'Comment on England', *Axis* no. 1, January 1935, pp. 10, 8.

11. Art and Politics in the 1930s

1. *Za Proletarskoye Iskusstvo*, 14 July 1931: see Matthew Cullerne Bown, *Socialist Realist Painting*, New Haven and London: Yale University Press, 1998, p. 116.

2. 'O perestroike literaturno-khudozhestvennykh organizatsii', 1932, in translation in Bowlt (ed.), *Russian Art of the Avant-Garde*, pp. 288–90.

3. Karl Radek, 'Contemporary World Literature and the Tasks of Proletarian Art', in Maxim Gorky et al., *Soviet Writers' Congress*

1934: The Debate on Socialist Realism and Modernism in the Soviet Union, 1935, London: Lawrence & Wishart, 1977, p. 153.

4. J. Stalin, speech of 26 October 1932. For the evolution of policy, see Cullerne Bown, *Socialist Realist Painting*, p. 141.

5. Hildegard Brenner, 'Art in the Political Power Struggle of 1933 and 1934', in Hajo Holborn (ed.), *Republic to Reich: The Making of a Nazi Revolution*, New York: Random House, 1972, p. 419.

6. The Dresden *Entartete Kunst* exhibition toured to Dortmund, Regensburg, Munich, Ingolstadt, Darmstadt and Frankfurt; see Christoph Zuschlag, 'An "Educational Exhibition": The Precursors of Entartete Kunst and its Individual Venues', in Stephanie Barron (ed.), *'Degenerate Art': The Fate of the Avant-Garde in Nazi Germany*, Los Angeles: Los Angeles County Museum of Art and New York: Harry N. Abrams, 1991, pp. 83–103.

7. Adolf Hitler, *Mein Kampf*, 1926, trans. Helmut Ripperger, New York, 1938.

8. Barron (ed.), *'Degenerate Art'*, pp. 360, 364–80.

9. Over 2 million visitors attended *Entartete Kunst* in Munich, following which the exhibition travelled to Berlin, Leipzig, Hamburg and Düsseldorf (all 1938), Stettin, Weimar and Frankfurt am Main (all 1939), with further shows in 1941.

10. Dino Alfieri and Luigi Freddi (eds), *Guida della Rivoluzione Fascista*, Rome: Partito Nazionale Fascista, 1933.

11. Margherita Sarfatti, 'M. Sironi', *La rivista illustrata del Popolo d'Italia*, March 1931, in Braun, 'Political Rhetoric and Poetic Irony', Cowling and Mundy (eds), *On Classic Ground*, p. 348.

12. Mario Sironi, 'Manifesto della pittura murale', *Colonna* 1, no. I, December 1933, n.p.

13. The invited artists included Giorgio de Chirico, Alberto Savinio, Gino Severini, Carlo Carrà, Massimo Campigli, Achille Funi, Corrado Cagli, Enrico Prampolini and Fortunato Depero. See Simonetta Fraquelli, 'All Roads Lead to Rome', in David Elliot et al., *Art and Power: Europe under the Dictators 1930–1945*, exh. cat., Hayward Gallery, London, 1996, p. 132.

14. Ibid., pp. 133–4.

15. Filippo Marinetti, 'Beyond Communism', 1920, in Flint (ed.), *Marinetti: Selected Writings*, pp. 153–5.

16. Filippo Marinetti, 'Portrait of Mussolini', from *Marinetti and Futurism*, 1929, in Flint (ed.), *Marinetti: Selected Writings*, p. 159.

17. Boccioni, 'Technical Manifesto of Sculpture', in Apollonio (ed.), *Futurist Manifestos*, pp. 63, 65; Marinetti, 'Technical Manifesto of Futurist Literature', in Flint (ed.), *Marinetti: Selected Writings*, pp. 85, 84.

18. Filippo Marinetti with Mino Somenzi, 'Manifesto dell'Aeropittura', 1929, trans. B. Mantura, 'Painting in Air', in *Futurism in Flight: 'Aeropittura' Painting and Sculptures of Man's Conquest of Space 1913–1945*, London: Accademia Italiana, 1990, p. 16.

19. Gerardo Dottori, cited in Mantura, 'Painting in Air', p. 18.

20. Fraquelli, 'All Roads Lead to Rome', p. 133 n. 21.

21. Jean, *History of Surrealist Painting*, p. 220.

22. 'These benign creatures mutually devouring each other in autumn express the pathos of Civil War considered as a phenomenon of natural history': Robert Descharnes, *Dalí de Gala*, Paris: Bibliothèque des Arts, 1962, p. 169.

23. See, for instance, *Enlèvement* (1931, Pompidou), *Les Captives* (1932, Gianna Sistu, Paris), *Silènes* (1932, Pompidou).

24. See André Malraux, *Picasso's Mask*, Paris: Gallimard, 1974, rpt. New York: Da Capo Press, 1992, pp. 36–8.

25. Michel Leiris, *Miroir de la tauromachie*, Paris: Gim, 1938; trans. A. Smock as 'The Bullfight as Mirror', *October* no. 63, Winter 1993, pp. 22, 21.

12. Modern Art in America

1. Thomas Hart Benton, *An Artist in America*, rev. edn, 1951, in Barbara Rose, *Readings in American Art 1900–1975*, New York: Praeger, 1975, p. 88.

2. Thomas Craven, *The Men of Art*, New York, 1931, in Rose (ed.), *Readings in American Art*, p. 85.

3. On three other Precisionists, Stefan Hirsch, Louis Lozowick and George Ault, see Andrew Hemingway, *The Mysticism of Money: Precisionist America and Machine Age America*, Pittsburgh, PA: Periscope, 2013.

4. The steadily enlarged collection of the Société Anonyme was eventually bequeathed to Yale University in 1941.

5. An early announcement headed 'The Museum of Modern Art: A New Institution for New York', 1929; Harriet Schoenholz Bee and Michelle Elligott (eds), *Art in Our Time: A Chronicle of the Museum of Modern Art*, New York: Museum of Modern Art, 2004, p. 27.

6. The story is told in Marina Coslovi, 'Gertrude Vanderbilt Whitney: A Poor Little Rich Artist and the Museum She Made', in Rosella Mamoli Zorzi (ed.), *Before Peggy Guggenheim: American Women Art Collectors*, Venice: Marsilio, 2001, pp. 171–84.

7. Stuart Davis, 'SDD', *The Morgan*, 19 May 1921, in Barbara Haskell, 'Stuart Davis: A Chronicle', *Stuart Davis: In Full Swing*, eds Harry Cooper and Barbara Haskell, exh. cat., National Gallery of Art, Washington, DC, 2016, p. 160.

8. These objects had appeared in modern art already: an egg beater in Man Ray, an electric fan in Marcel Duchamp, a rubber glove in de Chirico. Were they Davis's acknowledgement of precedent?

9. Stuart Davis, 'The New York American Scene in Art', *Art Front*, February 1935, p. 6. The term 'Negro' is no longer deemed appropriate within the Black American community.

10. Jacquelynn Baas, 'The Epic of American Civilization: The Murals at Dartmouth College 1932–34', in *José Clemente Orozco in the United States 1927–1934*, Hood Museum of Art, Trustees of Dartmouth College, 2002, pp 142–85.

11. Among the latter were the art historian Meyer Schapiro and the poet and critic Harold Rosenberg. See Andrew Hemingway, *Artists on the Left: American Artists and the Communist Movement 1926–1956,* New Haven and London: Yale University Press, 2002.

12. Stuart Davis, 'Why an Artists' Congress?', in *Artists against War and Fascism: Papers of the First American Artists' Congress*, eds Matthew Baigell and Julia Williams, New Brunswick, NJ: Rutgers University Press, 1986, pp. 65, 68–9.

13. See Davis, 'New York American Scene in Art', p. 5.

14. The single American artist included was Alexander Calder, represented by mobiles dated 1934 and 1936 respectively.

15. Alfred H. Barr Jr, *Cubism and Abstract Art*, exh. cat., Museum of Modern Art, New York, 1936, p. 200.

16. Holger Cahill, 'New Horizons in American Art', *New Horizons in American Art*, Museum of Modern Art, New York, 1936, p. 14.

17. Among them a panel by Willem de Kooning and Arshile Gorky's models for (and one completed panel of) a murals scheme for Newark Airport.

18. Alfred H. Barr Jr, introduction to *Fantastic Art, Dada, Surrealism*, exh. cat., Museum of Modern Art, New York, 1936, p. 9.

19. See John Elderfield, 'American Geometrical Abstraction in the Late Thirties', *Artforum*, December 1972, pp. 35–42, and Susan Larsen, 'The AAA: A Documentary History 1936–1941', *Archives of American Art Journal* 14, no. 1, 1974, p. 2–7.

20. See William Agee et al., *American Vanguards: Graham, Davis, Gorky, de Kooning and their circle 1927–1942*, exh. cat., Neuberger Museum of Art, New York; New Haven and London: Yale University Press, 2012.

21. See Ruth Bowman et al., *Arshile Gorky's Aviation Murals Rediscovered*, exh. cat., Newark Museum, New Jersey, 1978.

22. See Debra Balken and Robert Lubar (eds), *The Park Avenue Cubists: Gallatin, Morris, Frelinghuysen and Shaw*, New York: Taylor & Francis, 2002.

23. Albert E. Gallatin, press release, *Five Contemporary American Concretionists*, Paul Reinhardt Galleries, New York, March 1936, Archives of American Art.

24. *Plastic/Plastique* contained texts in English, French and German. It ceased publication in 1939.

25. In the event, *Swing Landscape* was deemed unsuitable for the Brooklyn housing complex and removed to storage for safe keeping. It is now in the Eskenazi Museum of Art, Indiana University.

26. The Museum of Modern Art displayed wooden artefacts from West Africa in its *African Negro Art* exhibition, March–May 1935.

27. The case was urged by Romare Bearden in 'The Negro Artist and Modern Art', *Opportunity: Journal of Negro Life* no. 12, December 1934.

28. André Breton, 'Frida Kahlo de Rivera', 1938, in Breton, *Surrealism and Painting*, p. 144.

29. Breton interviewed by André Parinaud, 1952, in Breton, *Conversations*, p. 148.

30. Also announced was the setting up of a Fédération Internationale de l'Art Révolutionnaire Indépendant (FIARI), which in practice attracted little attention. See André Breton and Diego Rivera, 'Towards a Free Revolutionary Art', *Partisan Review* (New York) 4, no. 1, 1938.

31. Stuart Davis, 'Abstract Painting Today', second draft dated 14 November 1939, in Francis O'Connor (ed. and intro.), *Art for the Millions: Essays from the 1930s by Artists and Administrators of the WPA Federal Art Project*, Greenwich, CT: New York Graphic Society, 1973, p. 124.

32. See Vivian Barnett et al., *Art of Tomorrow: Hilla Rebay and Solomon Guggenheim*, New York: Solomon R. Guggenheim Foundation, 2005.

The 1940s: Transatlantic Exchanges

13. Geometries of Hope

1. Piet Mondrian, 'Letter to B. Hepworth', 24 September 1939, in S. Bowness, 'Mondrian in London: Letter to Ben Nicholson and Barbara Hepworth', *Burlington Magazine* 132, no. 1052, November 1990, p. 784.

2. Charles Biederman, *Art as the Evolution of Visual Knowledge,* Red Wing, MN: Charles Biederman, 1948.

3. Susan Larsen, 'The American Abstract Artists: A Documentary History 1936–1941', *Archives of American Art Journal* 14, no. 1, 1974, p. 6.

4. Piet Mondrian, 'Statement', 1946, in Chipp (ed.), *Theories of Modern Art*, pp. 363–4.

5. Anni Albers, 'Working with Material', *Black Mountain College Bulletin* no. 5, 1938, reprinted in *College Art Journal* no. 3, January 1944, pp. 51–4.

6. Josef Albers, 'Concerning Abstract Art', 1939, in Lauren Hinkson (ed.), *Josef Albers in Mexico*, New York: Guggenheim Museum, 2017, p. 16.

7. Pereira's talent is 'steady and most inspiring … through sheer merit she has worked her way to the top in the non-objective field'; 'Current Shows', *New York Times*, 9 January 1943.

8. Pereira and Jackson Pollock were given simultaneous one-person shows at the Arts Club of Chicago in March 1945. See Karen A. Bearor, *Irene Rice Pereira: Her Paintings and Philosophy*, Austin: University of Texas Press, 1993.

9. Naum Gabo, 'Letter to Alice Duckworth', 6 June 1941, in Martin Hammer and Christina Lodder, *Constructing Modernity: The Art and Career of Naum Gabo,* New Haven and London: Yale University Press, 2000, p. 275.

10. Naum Gabo, 'Letter to Herbert Read', 27 November 1942, in Hammer and Lodder, *Constructing Modernity*, p. 287. Specifically, Gabo envisaged *Linear Construction in Space No. 1* as suitable for the vicinity of a textile factory. Nylon thread became available in 1942–3.

11. Naum Gabo and Herbert Read, 'Constructive Art: An Exchange of Letters', *Horizon* 10, no. 53, July 1944, pp. 60–61.

12. Naum Gabo, 'On Constructive Realism', Yale University, Trowbridge Lecture, 1948, in *Gabo: Constructions, Sculpture, Paintings, Drawings, Engravings*, London: Lund Humphries, 1957, p. 178.

13. Joaquín Torres-García, 'The Constructive Art Group: Collaborative Work', *Guiones* (Madrid) no. 3, 30 July 1933, in Bann (ed.), *Tradition of Constructivism*, pp. 195–6.

14. Joaquín Torres-García, 'Introduction to Constructive Universalism'/'Introducción al universalismo constructivo',

1942, in Yve-Alain Bois et al., *Geometric Abstraction: Latin American Art from the Patricia Phelps de Cisneros Collection,* exh. cat., Cambridge, MA: Fogg Art Museum, Harvard University, 2001, pp. 137–8.

15. Carmelo Arden Quin, 'Arturo Manifesto', *Arturo* (Buenos Aires) no. 1, Summer 1944, in Bois et al., *Geometric Abstraction*, p. 142.

16. See Gyula Kosice, 'Madí Manifesto', Buenos Aires, 1946, in Bois et al., *Geometric Abstraction*, pp. 144–5.

17. Rhod Rothfuss, 'El Marco: Un problema de la plástica actual' ('The Frame: A Problem for Contemporary Art'), *Arturo* no. 1, Summer 1944, n.p.

18. Carmelo Arden Quin, 'El Móvil' ('The Mobile'), speech read at the home of psychoanalyst Enrique Pichon-Rivière, 1945, in Bois et al., *Geometric Abstraction*, p. 143. There is a Museum of Geometric and Madí Art in Dallas, Texas.

19. Gyula Kosice, 'Continuo de arte Madí a treinta y seis años de una fundación esencial', *Arte Madí* (Buenos Aires), 1960, p. 13.

20. See further Lucas Zwirner (ed.), *Concrete Cuba: Cuban Geometric Abstraction from the 1950s*, New York: David Zwirner Books, 2005.

21. See Georges Vantongerloo, 'The Curve in Plastic Arts: Art from Surface to Universe', in Brett, *Longing for Infinity,* pp. 112–230.

22. Max Bill, 'The Mathematical Approach in Contemporary Art', *Werk* no. 3, 1949; Kristine Stiles and Peter Selz (eds), *Theories and Documents of Contemporary Art: A Sourcebook of Artists' Writings*, Berkeley: University of California Press, 1996, p. 76.

23. Max Bill, 'Konkrete Kunst', in Staber (ed.), *Konkrete Kunst*, p. 32; Stiles and Selz (eds), *Theories and Documents of Contemporary Art*, p. 74.

24. See Richard Lohse, 'Standard, Series, Module: New Problems and Tasks of Painting', in György Kepes (ed.), *Module, Symmetry,*

Proportion, London: Studio Vista, 1966, pp. 146, 147.

25. Hans Heinz Holz, 'Dialectic – Given Visual Form / Dialektik – anschaulich geworden', in *Richard Paul Lohse: Modulare und Serielle Ordnungen 1943–84 | Modular and Serial Orders 1943–84*, Zurich: Waser Verlag, 1984, pp. 107, 108.

26. Richard Lohse, 'Entwicklungslinien seit 1943, Düsseldorf', 1972, reprinted in Hans Heinz Holz et al., *Lohse Lesen: Texte von Richard Paul Lohse 1902–1988*, Zurich: Offizin Verlag, 2002, pp. 188–9.

27. Robert Goldwater, 'A Season of Art', *Partisan Review*, July–August 1947, p. 414ff.

14. Art between Paris and New York

1. Surrealist activities in Marseilles are related in Alyce Mahon, *Surrealism and the Politics of Eros 1938–1968*, London: Thames & Hudson, 2005, pp. 65–75.

2. Carrington's *En Bas* (*Down Below*) was published in *VVV* in 1944.

3. Chicago, St Louis, Boston, San Francisco, Cincinnati, Cleveland, New Orleans and Pittsburgh.

4. A transcript is available in Martica Sawin, *Gordon Onslow Ford: Paintings and Works on Paper 1939–1951*, exh. cat., Francis Nauman Fine Art, New York, 2010.

5. Jean, *History of Surrealist Painting*, p. 299.

6. Peter Busa, 'Concerning the Beginnings of the New York School: 1939–1943', *Art International* 11, no. 6, Summer 1967, pp. 20, 19.

7. *Exhibition by 31 Women* included Leonora Carrington, Leonor Fini, Dorothea Tanning, Hedda Sterne, Méret Oppenheim, Vieira da Silva, Sophie Taeuber-Arp, Barbara Reis and Buffie Johnson and three recommendees of Alfred Barr's, Suzy Frelinghuysen, Irene Rice Pereira and Esphyr Slobodkina. All except Djuna Barnes were under thirty years of age.

8. Howard Devree, 'A Reviewer's Notebook', *New York Times*, 25 April 1943, and 'Concerning the Beginnings of the New York School; An Interview with Robert Motherwell conducted by Sidney Simon in New York in January 1967', *Art International* 11, no. 6, Summer 1967, p. 22.

9. James Johnson Sweeney, foreword to *Jackson Pollock, Paintings and Drawings,* exh. cat., Art of This Century, New York, 1943, in Susan Davidson and Philip Rylands (eds), *Peggy Guggenheim & Frederick Kiesler: The Story of Art of This Century,* New York: Guggenheim Museum, 2005, p. 299.

10. Adolph Gottlieb and Mark Rothko (assisted by Barnett Newman), 'Letter to the Editor', *New York Times*, 13 June 1943, pp. 2, 9.

11. Howard Putzel, preface to *A Problem for Critics*, exh. cat., 67 Gallery, New York, 1945.

12. Clement Greenberg, 'Review of an Exhibition of Arshile Gorky', *The Nation*, 24 March 1945, in John O'Brian (ed.), *Clement Greenberg: The Collected Essays and Criticism*, vol. 1, *Perceptions and Judgements 1939–1944*, Chicago, IL: University of Chicago Press, 1986, p. 13.

13. Robert Motherwell, 'The Modern Painter's World', *DYN* 1, no. 6, November 1944, in Dore Ashton (ed.), *The Writings of Robert Motherwell*, Berkeley: University of California Press, 2007, pp. 27–35.

14. Robert Motherwell, 'Beyond the Aesthetic', *Design*, April 1946, in Ashton (ed.), *Writings of Robert Motherwell*, p. 55.

15. Clement Greenberg, 'Art', *The Nation*, 11 November 1944, in O'Brian (ed.), *Greenberg: Collected Essays and Criticism*, vol. 1, p. 241.

16. Clement Greenberg, 'An American View', *Horizon*, September 1940, in O'Brian (ed.), *Greenberg: Collected Essays and Criticism*, vol. 1, p. 39.

17. Clement Greenberg, 'Review of the Exhibition *A Problem for Critics*', *The Nation*, 9 June 1945, in John O'Brian (ed.), *Clement Greenberg: The Collected Essays and Criticism*, vol. 2, *Arrogant Purpose, 1945–1949*, Chicago, IL: University of Chicago Press, 1986, p. 30.

18. André Breton, 'Prestige d'André Masson', *Minotaure*, nos 12–13, May 1939, p. 13.

19. Francis Ponge, *Note sur les Otages de Fautrier*, Paris, 1946, n.p.

20. Gaston Bachelard, *L'Eau et les rêves: Essai sur l'imagination de la matière*, Paris, 1942, trans. Edith Farrell, *Water and Dreams: An Essay on the Imagination of Matter*, Dallas, TX: Dallas Institute, 1983, here pp. 104–6.

21. Jean Dubuffet, 'Notes pour les fins-lettrés' ('Notes for the Well-read'), in *Prospectus aux amateurs de tout genre*, Paris: Gallimard, 1946.

22. Le Corbusier wished to visit his cousin the musician and artist Louis Sutter, at that point living in a hospice in Ballaigues, Switzerland.

23. Jean-Paul Sartre, 'Doigts et non-doigts', 1962, in *Portraits (Situations IV)*, London and New York: Seagull Books, 2009, pp. 603–41.

24. Clement Greenberg, 'Review of Exhibitions by Jean Dubuffet and Jackson Pollock', *The Nation*, 1 February 1947, in O'Brian (ed.), *Greenberg: Collected Essays and Criticism*, vol. 2, pp. 123–5.

25. Clement Greenberg, 'The Situation at the Moment', *Partisan Review*, January 1948, in O'Brian (ed.), *Greenberg: Collected Essays and Criticism*, vol. 2, p. 193.

The 1950s: Climates of the Cold War

1. But see George A. Dondero's speech 'Modern Art Shackled to Communism' delivered to Congress in August 1949; Chipp (ed.), *Theories of Modern Art*, pp. 496–7.

15. *Informel* **International**

1. Dominique Quignon-Fleuret, *Mathieu*, Naefels: Bonfini Press, 1977, p. 19.

2. See Daniel Abadie, *Bryen, abhomme*, Brussels: La Connaissance, 1973.

3. *Concrete Art* at the Galerie Drouin in July 1945 showed the work of Arp, Robert and Sonya Delaunay, César Domela, Auguste Herbin, Kandinski, Otto Freundlich, Jean Gorin, Alberto Magnelli, Mondrian, Taeuber-Arp and van Doesburg.

4. Artists involved in the *Salons des Réalités Nouvelles* included Vantongerloo, Vieira da Silva, Antoine Pevsner, Georges Folmer, César Domela and Hans Arp.

5. Édouard Jaguer, 'Les Chemins de l'abstraction', *Juin*, 1 October 1946. See further Serge Guilbaut, 'Postwar Painting Games: The Rough and the Slick', in Serge Guilbaut (ed.), *Reconstructing Modernism: Art in New York, Paris and Montreal 1945–1964*, Cambridge, MA and London: MIT Press, 1990.

6. Georges Mathieu, *Au-delà du Tachisme*, Paris: Julliard, 1963, p. 47 n. 16.

7. From France, aside from the organisers and Atlan, works by René de Solier, Raoul Ubac and Jacques Verroust were included.

8. Paul-Émile Borduas et al., *Refus Global*, 1948, in Paul-Émile Borduas, *Refus Global et autres écrits*, Quebec: Éditions Typo, 2010, pp. 13–36.

9. See François-Marc Gagnon, 'Borduas and Modernism', *artscanada*, Winter 1979/80, pp. 15–18.

10. 'La Cause est entendue' ('The Case is Heard'), joint statement of the French and Belgian Surrealist groups, 1 July 1947, in Willemijn Stokvis, *COBRA: The Last Avant-Garde Movement of the Twentieth Century*, London: Lund Humphries, 2004, p. 147.

11. Constant, 'Manifesto', *Reflex* no. 1 (Amsterdam), September–October 1948.

12. Christian Dotremont, statement of 3 November 1949, *Cobra* no. 4, November 1949, in Stokvis, *COBRA*, p. 206. By 'formalism' Dotremont here means any narrowly defined tendency, including Surrealism and 'geometric' art.

13. Asger Jorn, letter to Constant, 1950, in Stokvis, *COBRA*, p. 243.

14. Asger Jorn, *Held og Hasard (Happiness and Hazard)*, 1952, in Stokvis, *COBRA*, p. 262.

15. Camille Bryen and Jacques Audiberti, *L'Œuvre-boîte: Colloque abhumaniste*, Paris: Gallimard, 1952, pp. 34, 35. See also Abadie, *Bryen, abhomme*.

16. Michel Tapié, *Un art autre: Où il s'agit de nouveaux dévidages du réel*, Paris: Gabriel-Giraud, 1952, n.p., emphasis added.

17. Charles Estienne, 'Une Revolution: Le Tachisme', *Combat-Art* no. 4, 1 March 1954, p. 1. Contrary to Estienne's intentions, the term *tachisme* soon became used internationally.

18. Tapié, *Art autre,* n.p.

19. See Michael Leja, *Reframing Abstract Expressionism: Subjectivity and Painting in the 1940s*, New Haven and London: Yale University Press, 1997, pp. 203–74, in which he refers to popular books of the order of Harvey Fergusson, *Modern Man: His Mind and Behaviour*, 1936, which Pollock and others owned.

20. Jackson Pollock, draft statement for *Possibilities*, 1947, in Francis O'Connor and Eugene Thaw (eds), *Jackson Pollock: A Catalogue Raisonné of Paintings, Drawings and Other Works*, New Haven and London: Yale University Press, 1978, vol. 1, p. 230; Jackson Pollock, 'My Painting', *Possibilities* no. 1, Winter 1947/8, p. 79.

21. Henry McBride, 'Jackson Pollock', *The New York Sun*, 23 December 1949, in Daniel C. Rich (ed.), *Henry McBride: The Flow of Art: Essays and Criticisms*, New Haven and London: Yale University Press, 1997, p. 425. The painting is *Number 14*, 1949, oil on paper, 57.1 x 78.7 cm, now destroyed.

22. See William Barrett, *What is Existentialism?*, Partisan Review pamphlet no. 2, New York: Grove Press, 1947.

23. Robert Motherwell and Willem de Kooning, in Robert Motherwell and Ad Reinhardt (eds), *Modern Artists in America*, New York: Wittenborn, Schultz, 1951, pp. 12, 13.

24. Robert Motherwell, 'The New York School', 1950, in Ashton (ed.), *Writings of Motherwell*, pp. 94–5.

25. Robert Motherwell, preface to *Seventeen Modern American Painters*, exh. cat., Frank Perls Gallery, Los Angeles, 1951, in Ashton (ed.), *Writings of Motherwell*, pp. 154–5.

26. Jirō Yoshihara, 'The Gutai Manifesto', 1956, in Alex Danchev (ed.), *100 Artists' Manifestos: From the Futurists to the Stuckists*, London: Penguin, 2003, pp. 332–5.

27. See 'Jackson Pollock: Is He the Greatest Living Painter in the United States?', *Life* 27, no. 6, 8 August 1949, pp. 42–5.

28. Irving Sandler, *The Triumph of American Painting*, New York: Harper & Row, 1970, p. 264.

29. For Hartigan's own reflections on her work, see William La Moy and Joseph P. McCaffrey (eds), *The Journals of Grace Hartigan 1951–1955*, Syracuse, NY: Syracuse University Press, 2009, pp. 132–3.

30. 'Women Artists in Ascendance: Young Group Reflects Lively Virtues of US Painting', *Life*, 13 May 1957, pp. 74–8. The artists featured were Joan Mitchell, Helen Frankenthaler, Grace Hartigan, Nell Blaine and Jane Wilson.

16. London in the 1950s

1. Lord Keynes, 'The Arts Council: Its Policy and Hopes', *The Listener*, 12 July 1945, pp. 31–2. See further Brandon Taylor, *Art for the Nation: Exhibitions and the London Public 1747–2001*, Manchester: Manchester University Press, 1999, pp. 167–202.

2. Taylor, *Art for the Nation*, p. 173.

3. 'The Institute of Contemporary Art: A Statement of Policy …', London, 1947.

4. The familiar term for the Servicemen's Readjustment Act 1944, allowing former US servicemen to resume a course of education interrupted by the war.

5. 'Eduardo Paolozzi: Retrospective Statement', in David Robbins (ed.), *The Independent Group: Post-War Britain and the Aesthetics of Plenty*, Cambridge, MA: MIT Press, 1990, p. 192.

6. Herbert Read, *New Aspects of British Sculpture*, exh. cat., British Council, London, 1952. The sculptors were Eduardo Paolozzi, Bernard Meadows, Lynn Chadwick, Robert Adams, Kenneth Armitage, Reg Butler, Geoffrey Clarke and William Turnbull. The 'silent seas' citation is from T. S. Eliot, 'The Love Song of J. Alfred Prufrock', 1915.

7. 'Eduardo Paolozzi: Retrospective Statement', in Robbins (ed.), *Independent Group*, pp. 192–3.

8. Nigel Henderson, 'Memorandum – ICA', 27 March 1953, in Victoria Walsh, *Nigel Henderson: Parallel of Life and Art*, London: Thames & Hudson, 2001, p. 90.

9. Alison and Peter Smithson, 'The "As Found" and the "Found"' (written late 1980s), in Robbins (ed.), *Independent Group*, p. 201.

10. Reyner Banham, 'The New Brutalism', *Architectural Review*, December 1955, pp. 355–671.

11. The talks were titled 'Dadaists as Non-Aristotelians'. Contributors included Anthony Hill, Toni del Renzio, Donald Holms and John McHale.

12. John McHale, 'The Plastic Parthenon', *Dot-Zero Magazine*, Spring 1967, reprinted in Gillo Dorfles (ed.), *Kitsch: The World of Bad Taste*, New York: Universe Books, 1969, pp. 98–110.

13. Eduardo Paolozzi, 'Notes from a Lecture at the ICA', *Uppercase* no. 1, 1958, n.p.

14. Exhibitions at 22 Fitzroy Street were in March and July 1952 and May 1953. For Martin's and Hill's statements, see Alastair Grieve, *Constructed Abstract Art in England after the Second World War: A Neglected Avant-Garde*, New Haven and London: Yale University Press, 2005, pp. 20, 22.

15. John W. Power, *Éléments de la construction picturale: Aperçu des méthodes des Maîtres Anciens et des Maîtres Modernes*, Paris: Éditions Antoine Roche, 1932. Power was a member of Abstraction-Création, a painter, collector and benefactor who later gave his name to the Power Institute, University of Sydney.

16. Roger Hilton, statement for *Nine Abstract Artists*, exh. cat., Tiranti, London, 1954, p. 29, and for *Roger Hilton: The Early Years 1911–55*, exh. cat., Leicester Polytechnic, November 1984.

17. Lawrence Alloway, introduction to *Nine Abstract Artists*, exh. cat., Tiranti, London, 1954, p. 12.

18. De Staël had a well-received show at the Matthiesen Gallery, London, in February–March 1952.

19. Aside from Patrick Heron, the exhibition displayed works by Alan Davie, Terry Frost, Roger Hilton, Ivon Hitchens, William Johnstone, Peter Lanyon, William Scott, Keith Vaughan; see Patrick Heron, *Space in Colour*, exh. cat., Hanover Gallery, London, 1953, in Mel Gooding (ed.), *Painter as Critic: Patrick Heron, Selected Writings*, London: Tate Gallery Publications, 1998, pp. 86, 87.

20. Francis Bacon, interview from 1962, in David Sylvester, *Interviews with Francis Bacon 1962–1979*, London: Thames & Hudson, 1980, p. 12.

21. This was Kitaj's designation on the occasion of the exhibition *The Human Clay*, Hayward Gallery, London, 1976.

22. The roles played by MoMA, the United States Information Agency (USIA) and the CIA are the subject of Eva Cockcroft, 'Abstract Expressionism, Weapon of the Cold War', *Artforum* 12, no. 10, Summer 1974, pp. 39–41.

23. Rasheed Araeen, 'Conversation with Aubrey Williams, *Third Text* 1, no. 2, 1978, p. 44.

24. A brief account is Margaret Garlake, 'New Vision Centre', in *New Vision 56–66*, Jarrow: Bede Gallery, 1984, n.p. The Italian group Movimento Arte Nucleare, founded in Milan in 1957 by Enrico Baj, was a comparable enterprise.

17. In the Vernacular: Beat and Assemblage

1. Kerouac considered calling his novel *The Beat Generation*. It was typed on a single 120-foot roll of paper, which is now restored and in private ownership. *On the Road* was published in 1957.

2. J. Clellon Holmes, 'This is the Beat Generation', *New York Times Magazine*, 16 November 1952.

3. Richard Cándida Smith, *Utopia and Dissent: Art, Poetry and Politics in California*, Berkeley: University of California Press, 1995, p. 111.

4. Michael Auping, 'An Interview with Jess', in *Jess: A Grand Collage 1951–1993*, exh. cat., Albright-Knox Art Gallery, Buffalo, New York, 1993, pp. 24–5.

5. Cándida Smith, *Utopia and Dissent*, pp. 202–3 n. 53, p. 493.

6. Allen Ginsberg, *Howl and Other Poems*, intro. William Carlos Williams, San Francisco: City Lights Books, 1956.

7. Anastasia Aukeman, *Welcome to Painterland: Bruce Conner and the Rat Bastard Protective Association*, Berkeley: University of California Press, 2016; Rudolf Frieling, *Bruce Conner: It's All True*, exh. cat., San Francisco Museum of Modern Art, 2016.

8. Leo Steinberg, *Other Criteria: Confrontations with Twentieth-Century Art*, Oxford: Oxford University Press, 1972, p. 90.

9. Brian O'Doherty, 'Rauschenberg', in *American Masters: The Voice and the Myth*, New York: Random House, 1974, pp. 194–8.

10. William Seitz, *The Art of Assemblage*, exh. cat., Museum of Modern Art, New York, 1961, p. 89.

11. See Nan Rosenthal, 'A Conversation with Jasper Johns', in *Jasper Johns: Grey*, exh. cat., Art Institute of Chicago, 2008, p. 161.

12. Pierre Restany, 'Nouveau Réalisme', declaration issued at the Galleria Apollinaire, Milan, in 1960, and also signed by Arman, Yves Klein, Martial Raysse, Daniel Spoerri, Jean Tinguely, Raymond Hains, François Dufrêne and Jacques de la Villeglé.

13. Seitz, *Art of Assemblage*, p. 89.

14. Wolf Vostell with Allan Kaprow, 'The Art of Happening', lecture of 1964, transcribed in Jürgen Becker and Wolf Vostell (eds), *Happenings: Fluxus, Pop Art, Nouveau Réalisme, Eine Dokumentation*, Hamburg: Rowohlt, 1965, p. 403.

15. Wolf Vostell, in *Dufrêne, Hains, Rotella, Villeglé, Vostell: Decollagen: Plakatabrisse aus der Sammlung Cremer*, exh. cat., Staatsgalerie Stuttgart, 1971.

16. Vostell, cited in Brandon Taylor, *Collage: The Making of Modern Art*, London: Thames & Hudson, 2004, p. 177.

17. Debord's city maps were issued as *Mémoires* in 1959; his theoretical prescriptions were published under the title *Le Societé du Spectacle* (*The Society of the Spectacle*) in 1967.

18. Asger Jorn, 'Détourned Painting', 1959, in Elisabeth Sussman (ed.), *On the Passage of a Few People through a Rather Brief Moment in Time: The Situationist International 1957–1972*, Cambridge, MA: MIT Press and Boston: Institute of Contemporary Art, 1989, pp. 140–42.

19. It was a quality that a decade later would endear him to the Beatles – for whose *Sgt Pepper's Lonely Hearts Club Band* album of 1967 Blake designed a collage rich in references to brass bands, municipal flower beds, Edwardian clothing and the like.

20. Richard Hamilton, letter to Alison and Peter Smithson, 16 January 1957, and 'For the Finest Art Try – POP', *Gazette* (London) no. 1, 1961, in *Richard Hamilton: Collected Words*, London: Thames & Hudson, 1982, pp. 28 and 41.

18. Hard-edge, Kinetic and Minimal Form

1. Jacques de la Villeglé, *Un Homme sans métier*, Paris: Éditions Jannick, 1995, pp. 41–3.

2. The argument is made in Charles Harrison, 'Disorder and Insensitivity: The Concept of Experience in Abstract Expressionist Painting', in David Thistlewood (ed.), *American Abstract Expressionism*, Liverpool: Liverpool University Press, 1993, pp. 111–23.

3. Ad Reinhardt, 'Twelve Rules for a New Academy', 1953, published in *Art News* 56, no. 3, May 1957, pp. 37–8; Stiles and Selz (eds), *Theories and Documents of Contemporary Art*, p. 88.

4. Ad Reinhardt, '25 Lines of Words on Art: Statement', *It Is* no. 1, Spring 1958, p. 42, in Barbara Rose (ed.), *Art-as-Art: Selected Writings of Ad Reinhardt*, Berkeley: University of California Press, 1991, pp. 51–2.

5. Jules Langsner, 'Art News from Los Angeles', *Art News* no. 55, May 1956, p. 60. Art and design in southern California is captured in Elizabeth Armstrong (ed.), *Birth of the Cool: California Art, Design and Culture at Midcentury*, New York: Prestel, 2007.

6. Jules Langsner, 'Four Abstract Classicists', in *Four Abstract Classicists*, exh. cat., Los Angeles County Museum of Art, 1959, p. 10.

7. Waldemar Cardeiro, 'Manifesto Ruptura', 1952, in Bois et al., *Geometric Abstraction,* p. 152.

8. Ferreira Gullar, 'Neo-Concrete Manifesto', *Jornal do Brasil* (Rio de Janeiro), 22 March 1959, in Bois et al., *Geometric Abstraction: Cisneros Collection*, pp. 152–5.

9. *Konkrete Kunst: 50 Jahre Entwicklung*, exh. cat., Helmhaus, Zurich, 1960.

10. Linien II was the successor to the pre-Second World War group Linien that had adopted a hard-edged geometrical manner but had been largely overtaken by the success of CoBrA in the post-war years.

11. Victor Vasarely, 'Notes for a Manifesto' ('The Yellow Manifesto'), in Stiles and Selz (eds), *Theories and Documents of Contemporary Art*, pp. 109–12.

12. Arnold Bode of the Kassel Kunsthochschule launched the first of a series of international exhibitions of modern and contemporary art at the Fridericianum, Kassel, in 1955 and known as *documenta*. Documenta 2 was in 1959, *documenta 3* in 1964.

13. Otto Piene, 'The Development of the Group Zero', *Times Literary Supplement*, 3 September 1964, p. 812. The *ZERO* magazines are reprinted

in facsimile in Heinz Mack and Otto Piene, *ZERO,* Cambridge, MA: MIT Press, 1973.

14. Nouvelle Tendance-recherche continuelle (NTrc), 'Bulletin No. 1', August 1963, cited by Valerie Hillings in 'Concrete Territory: Geometric Art, Group Formation and Self-Definition', *Beyond Geometry: Experiments in Form, 1940s–1970s*, ed. Lynn Zelevansky, exh. cat., Los Angeles County Museum of Art and Cambridge, MA: MIT Press, 2004, p. 73 n. 78.

15. Anthony Hill, 'The Structural Syndrome in Constructive Art', in Kepes (ed.), *Module, Symmetry, Proportion*, p. 163.

16. Lawrence Alloway, *an Exhibit*, exh. cat., ICA, London, 1957, n.p.

17. Ralph Rumney, quoted in Robert Kudielka, *Robyn Denny*, exh. cat., Tate Gallery, London, 1973, p. 27. See also *Guide to Place* (text by Roger Coleman), London: ICA, 1959.

18. Kudielka, ibid., p. 24, emphasis added.

19. Frank Stella, 'The Pratt Lecture', 1960, in Stiles and Selz (ed.), *Theories and Documents of Contemporary Art*, pp. 113–14.

19. The 1960s: After Modern Art

1. Bruce Glaser, 'Questions to Stella and Judd', February 1964, in Gregory Battcock (ed.), *Minimal Art: A Critical Anthology*, New York: E. P. Dutton, 1968, p. 149.

2. Ibid., p. 150.

3. Donald Judd, 'Nationwide Reports: Hartford', *Arts Magazine, March 1964*, in *Donald Judd: Complete Writings 1959–1975*. Halifax: Nova Scotia College of Art and Design and New York: New York University Press, 1975, pp. 117–18.

4. See Thomas Crow, 'Saturday Disasters: Trace and Reference in Early Warhol', *Art in America*, May 1987.

5. George Maciunas, 'Fluxus Manifesto', 1963, in Danchev (ed.), *100 Artists' Manifestos*, p. 365.

6. CRAV/GRAV, 'Assez de mystifications' ('Enough Mystifications'), in Yves Aupetitallot (ed.), *GRAV – Groupe de Recherche d'Art Visuel 1960–1968*, Grenoble: Le Magasin Centre d'Art Contemporain, 1998.

7. William Seitz, 'Acknowledgements', in *The Responsive Eye*, exh. cat., Museum of Modern Art, New York, 1965, p. 3.

8. GRAV's other representatives in *The Responsive Eye* were Jean-Pierre Yvaral, Francisco Sobrino, Horacio Garcia Rossi, Joël Stein and François Morellet. For the careers of the smaller European groups in the years 1967 to 1969 see Jacopo Galimberti, *Individuals against Individualism: Art Collectives in Western Europe 1956–1969*, Liverpool: Liverpool University Press, 2017, p. 278ff.

9. For a recent account see Jo Applin, *Lee Lozano: Not Working*, New Haven and London: Yale University Press, 2018.

10. Donald Judd, 'Reviews and Previews', *Art News*, October 1959, and 'In the Galleries', *Arts Magazine*, September 1964, in Judd, *Complete Writings*, pp. 2 and 134–5 respectively. A decade later Kusama would return to Japan to pursue an extraordinary career: *Infinity Net: The Autobiography of Yayoi Kusama* (2002) was published in English in 2011.

11. Romare Bearden, 'Rectangular Structure in My Montage Paintings', *Leonardo* no. 2, 1969, pp. 11–19.

Further Reading

The literature of art in the modern period is vast and constantly changing as new documents and translations become available. Readers wishing to explore beyond the narratives contained in the present book should go first to the footnotes to the various chapters, where the source material in English and other languages is contained. For particularly significant texts in English, the lists that follow offer an abbreviated guide. Many of the major artists of the period were themselves writers, both on their own work and that of others, therefore the titles contained in the first section should be of immediate interest. In the second section are listed further titles, some artist-written and some not, which relate primarily to a particular decade but often extend beyond it. Since only recently published titles are likely to be in print, readers should consult a good university art library, consult the Internet, or ask for inter-library loan services through your local library.

Anthologies of Artists' and Critics' Writings

Antliff, Mark and Leighton, Patricia (eds), *A Cubism Reader: Documents and Criticism 1906–1914*. Chicago, IL: University of Chicago Press, 2008

Ashton, Dore (ed.), *Picasso on Art: A Selection of Views*. Boston, MA: Da Capo Press, 1972

——, *The Writings of Robert Motherwell*. Berkeley: University of California Press, 2007

Bann, Stephen (ed. and intro.), *The Tradition of Constructivism*. New York: Viking Press, 1974

Bowlt, John (ed. and intro.), *Russian Art of the Avant-Garde: Theory and Criticism 1902–1934*. London: Thames & Hudson, 1988

Boyd Whyte, Iain and Frisby, David (eds), *Metropolis Berlin 1880–1940*. Berkeley: University of California Press, 2012

Breton, André, *Manifestoes of Surrealism*, translated by Richard Seaver and Helen Lane. Ann Arbor: University of Michigan Press, 1972

Coolidge, Clark (ed.), *Philip Guston: Collected Writings, Lectures and Conversations*. Berkeley: University of California Press, 2010

Flam, Jack (ed.), *Matisse on Art*. Revised edition, Berkeley: University of California Press, 1995

Flint, Robert W. (ed.), *Marinetti: Selected Writings*. London: Secker & Warburg, 1972

Harrison, Charles and Wood, Paul (eds), *Art in Theory 1900–2000: An Anthology of Changing Ideas*. Oxford: Blackwell, 2003

Jean, Marcel (ed.), *Arp: Collected French Writings: Poems, Essays, Memoirs*. London: Calder & Boyars, 1974

Lavrentiev, Alexander (ed.), *Aleksandr Rodchenko: Experiments for the Future: Diaries, Essays, Letters and Other Writings*. New York: Museum of Modern Art, 2005

Lindsay, Kenneth and Vergo, Peter (eds), *Kandinsky: Complete Writings on Art*. 2 volumes, London: Faber & Faber, 1982

Motherwell, Robert (ed.), *The Dada Painters and Poets*. New York: Wittenborn, Schultz, 1951; 2nd edn, Cambridge, MA: Harvard University Press, 1989

Phillips, Christopher (ed. and intro.), *Photography in the Modern Era: European Documents and Critical Writings 1913–1940*. New York: Metropolitan Museum of Art / Aperture, 1989

Richter, Hans, *Dada: Art and Anti-Art*, 1965; new edition with a preface by Michael White, London: Thames & Hudson, 2016

Rose, Barbara (ed.), *Art as Art: The Selected Writings of Ad Reinhardt*. Berkeley: University of California Press, 1991

Stiles, Kristine and Selz, Peter (eds), *Theories and Documents of Contemporary Art: A Sourcebook of Artists' Writings*. Berkeley: University of California Press, 1996

Washton Long, Rose-Carol (ed.), *German Expressionism: Documents from the End of the Wilhelmine Empire to the Rise of National Socialism*. Berkeley: University of California Press, 1995

Titles Relating Primarily to a Particular Decade

1910s

Adès, Dawn (ed.), *The Dada Reader: A Critical Anthology*. London: Tate Publishing, 2006

Andersen, Troels (ed. and intro.), *Kasimir Malevich: Essays on Art 1915–1933*. 4 volumes. London: Rapp & Whiting, 1969

Apollonio, Umbro (ed.), *Futurist Manifestos*. New York: Viking Press, 1970

Ball, Hugo, *Flight Out of Time: A Dada Diary*, with an introduction by John Elderfield. Berkeley and London: University of California Press, 1974

Dickerman, Leah (ed.), *Dada: Zurich, Berlin, Hanover, Cologne, New York, Paris*. Washington, DC: National Gallery of Art and Distributed Art Publishers, 2005

The Great Utopia: The Russian and Soviet Avant-Garde 1915–1932. Exhibition catalogue, Guggenheim Museum, New York, 1992

Green, Christopher (ed.), *Cubism and War: The Crystal in the Flame*. Barcelona: Museu Picasso de Barcelona, 2016

Huelsenbeck, Richard, *Memoirs of a Dada Drummer*, edited and with an introduction by Hans J. Kleinschmidt. New York: Viking Press, 1974; Berkeley: University of California Press, 1991

Lewis, Percy Wyndham, *Blast I*. Santa Rosa, CA: Black Sparrow Press, 1981

Lodder, Christina, *Russian Constructivism*. New Haven and London: Yale University Press, 1983

Richardson, John, *A Life of Picasso*, volume 2, *1907–1917: The Painter of Modern Life*. New York: Random House, 1996

Severini, Gino, *The Life of a Painter: The Autobiography of Gino Severini*. Princeton, NJ: Princeton University Press, 1995

Tupitsyn, Margarita (ed.), *Russian Dada 1914–1924*. Cambridge, MA: MIT Press and Madrid: Museo Nacional Centro de Arte Reina Sofía, 2018

1920s

Baljeu, Joost (ed. and intro.), *Theo van Doesburg*. London: Studio Vista, 1974

Carrà, Massimo (ed.), *Metaphysical Art*. World of Art series. London: Thames & Hudson, 1976

Cowling, Elizabeth and Mundy, Jennifer (eds), *On Classic Ground: Léger, De Chirico and the New Classicism 1910–1930*. London: Tate Gallery, 1990

Golan, Romy, *Modernism and Nostalgia: Art and Politics in France between the Wars*. New Haven and London: Yale University Press, 1995

Kaes, Anton, Jay, Martin and Dimendberg, Edward (eds and intro.), *The Weimar Republic Sourcebook*. Berkeley and London: University of California Press, 1995

Kniesche, Thomas and Brockmann, Stephen (eds), *Dancing on the Volcano: Essays on the Culture of the Weimar Republic*. Columbia, SC: Camden House, 1994

Léger, Fernand, *Functions of Painting*, edited and with an introduction by Edward Fry. London: Thames & Hudson, 1973

Mansbach, Steven, *Modern Art in Eastern Europe: From the Baltic to the Balkans, ca 1890–1939*. Cambridge: Cambridge University Press, 1999

Moholy-Nagy, László, *Painting Photography Film*. Bauhausbücher no. 8, 1925; London: Lund Humphries, 1967

Motherwell, Robert (ed.), *Max Ernst: Beyond Painting and Other Writings by the Artist and His Friends*. New York: Wittenborn, Schultz, 1948

Ozenfant, Amédée and Jeanneret, Charles Édouard, *Après le Cubisme*. Paris: Éditions des Commentaires, 1918; translated by John Goodman, in Carol S. Eliel, *L'Esprit Nouveau: Purism in Paris 1918–1925*, Los Angeles, CA: Los Angeles County Museum of Art and New York: Harry N. Abrams, 2001

Rosemont, Franklin (ed. and intro.), *André Breton: What is Surrealism?* New York and London: Pathfinder Press, 1978

Trotsky, Leon, *Literature and Revolution*. 1923; translated by Rose Strunsky, London: Redwords, 1991

1930s

Brett, Guy et al., *Georges Vantongerloo: A Longing for Infinity*. Madrid: Museo Nacional Centro de Arte Reina Sofía, 2009

Clark, T. J., *Picasso and Truth*. Princeton, NJ: Princeton University Press, 2013

Cooper, Harry and Haskell, Barbara (eds), *Stuart Davis: In Full Swing*. Washington, DC: National Gallery of Art, 2016

Cullerne Bown, Matthew, *Socialist Realist Painting*. New Haven and London: Yale University Press, 1998

Elliott, David et al., *Art and Power: Europe under the Dictators 1930–1945*. Exhibition catalogue, Hayward Gallery, London, 1996

Finkelstein, Haim (ed. and trans.), *The Collected Writings of Salvador Dalí*. Cambridge: Cambridge University Press, 1998

Grigson, Geoffrey (ed. and intro.), *The Arts Today*. London: The Bodley Head, 1935

Harrison, Charles, *English Art and Modernism 1900–1939*. New Haven and London: Yale University Press, 1981

Juler, Edward, *Grown but Not Made: British Modernist Sculpture and the New Biology*. Manchester: Manchester University Press, 2015

Katarzyna Kobro 1898–1951. Exhibition catalogue, Henry Moore Institute, Leeds and Muzeum Sztuki, Łódź, 1999

Read, Herbert, *Art Now*. London: Faber & Faber, 1933

Rowell, Margit (ed.), *Joan Miró: Selected Writings and Interviews*. London: Da Capo Press, 1992

Taylor, Brandon, *The Life of Forms in Art: Modernism, Organism, Vitality*. London: Bloomsbury, 2020

Umland, Anne (ed.), *Joan Miró: Painting and Anti-Painting 1927–1937*. New York: Museum of Modern Art, 2008

1940s

Bearor, Karen A., *Irene Rice Periera: Her Paintings and Philosophy*. Austin: University of Texas Press, 1993

Bois, Yve-Alain et al., *Geometric Abstraction: Latin American Art from the Patricia Phelps de Cisneros Collection*. Exhibition catalogue, Cambridge, MA: Fogg Art Museum, Harvard University, 2001

Davidson, Susan and Rylands, Philip (eds), *Peggy Guggenheim & Frederick Kiesler: The Story of Art of This Century*. New York: Guggenheim Museum, 2005

Grieve, Alastair, *Constructed Abstract Art in England after the Second World War: A Neglected Avant-Garde*. New Haven and London: Yale University Press, 2005

Guilbaut, Serge (ed.), *Reconstructing Modernism: Art in New York, Paris and Montreal 1945–1964*. Cambridge, MA and London: MIT Press, 1990

Hammer, Martin and Lodder, Christina, *Constructing Modernity: The Art and Career of Naum Gabo*. New Haven and London: Yale University Press, 2000

Leja, Michael, *Reframing Abstract Expressionism: Subjectivity and Painting in the 1940s*. New Haven and London: Yale University Press, 1997

Mahon, Alyce, *Surrealism and the Politics of Eros 1938–1968*. London: Thames & Hudson, 2005

Motherwell, Robert (ed.), *Arp: On My Way: Poetry and Essays 1912–1948*. New York: Wittenborn, Schultz, 1948

O'Brian, John (ed.), *Clement Greenberg: The Collected Essays and Criticism*, volume 1, *Perceptions and Judgements 1939–1944*, and volume 2, *Arrogant Purpose 1945–1949*. Chicago, IL: University of Chicago Press, 1986

1950s

Bradnock, Lucy, Martin, Courtney and Peabody, Rebecca (eds), *Lawrence Alloway, Critic and Curator*. Los Angeles, CA: Getty Publications, 2015

Foster, Hal, *Brutal Aesthetics: Dubuffet, Bataille, Jorn, Paolozzi, Oldenburg*. Princeton, NJ: Princeton University Press, 2020

Hamilton, Richard, *Richard Hamilton: Collected Words*. London: Thames & Hudson, 1982

Marter, Joan (ed.), *Women of Abstract Expressionism*. New Haven and London: Yale University Press and Denver Art Museum, 2016

Phillips, Lisa, *Beat Culture and the New America 1950–1965*. New York: Whitney Museum of American Art and Paris: Flammarion, 1995

Robbins, David (ed.), *The Independent Group: Post-War Britain and the Aesthetics of Plenty*. Cambridge, MA: MIT Press, 1990

Rose, Barbara (ed.), *Art as Art: The Selected Writings of Ad Reinhardt*. Berkeley: University of California Press, 1991

Seitz, William (ed), *The Art of Assemblage*. Exhibition catalogue, Museum of Modern Art, New York, 1961

Stokvis, Willemijn, *COBRA: The Last Avant-Garde Movement of the Twentieth Century*. London: Lund Humphries, 2004

Zelevansky, Lynn (ed.), *Beyond Geometry: Experiments in Form 1940s–1970s*. Exhibition catalogue, Los Angeles County Museum of Art and Cambridge, MA: MIT Press, 2004

Zwirner, Lucas (ed.), *Concrete Cuba: Cuban Geometric Abstraction from the 1950s*. New York: David Zwirner Books, 2005

1960s

Battcock, Gregory (ed.), *Minimal Art: A Critical Anthology*. New York: E. P. Dutton, 1968

Brauer, David E. et al., *Pop Art: US/UK Connections 1956–1966*. Exhibition catalogue, Menil Collection, Houston, TX and Ostfildern: Hatje Cantz, 2001

Brett, Guy, *Force Fields: Phases of the Kinetic*. Exhibition catalogue, Hayward Gallery, London, 2000

Galimberti, Jacopo, *Individuals against Individualism: Art Collectives in Western Europe 1956–1969*. Liverpool: Liverpool University Press, 2017

Judd, Donald, *Donald Judd: Complete Writings 1959–1975*. Halifax: Nova Scotia College of Art and Design and New York: New York University Press, 1975

Kusama, Yayoi, *Infinity Net: The Autobiography of Yayoi Kusama*. London: Tate Publishing, 2013

Index

Picture Credits

Acknowledgements

My first debt is to the Yale University Press team at Bedford Square, to my editors Sophie Neve and Julie Hrischeva as well as to Stuart Weir and my copy-editor Hilary Hammond, all of whom guided me impeccably at every stage. I am grateful also to Mark Eastment for his encouragement at the very start. My picture researcher Susannah Stone has been a model of energy, determination and wise counsel where it mattered most. The art librarians at Oxford University, the University of Southampton and the Courtauld Institute, London have been prompt and efficient at every turn. Necessarily, I have depended on friends and colleagues for advice and conversation, among them Simon Chatwin, Adam Clark-Williams, David Cottington, Jenny Cuffe, Peter Jones, Thomas Felici, Keiran Phelan, Irina Nekhlyudova and Leslie Thompson, and I thank them all. My sister Christine Kehrer offered me help in organising spreadsheets, for which I am most grateful. My wife Lucia and daughters Frances and Camilla have been unfailingly supportive throughout.

First published by Yale University Press 2022

302 Temple Street, P. O. Box 209040,
New Haven CT 06520-9040

47 Bedford Square
London WC1B 3DP

yalebooks.com | yalebooks.co.uk

Copyright © 2022 Brandon Taylor

Library of Congress Control Number: 2022937503
ISBN 978-0-300-25365-8 HB
A catalogue record for this book is available from the British Library

10 9 8 7 6 5 4 3 2 1
2026 2025 2024 2023 2022

Text design by Emma Kalkhoven
Jacket design by Steve Leard
Copy edited by Hilary Hammond

Printed in Slovenia by DZS-Grafik d.o.o.

Front cover: CoBrA exhibition at Stedelijk Museum, Amsterdam, 1949. Installation: Tonie Sluyter and Aldo van Eyck in room 6 (detail). © Aldo and Hannie van Eyck Foundation. © Karel Appel Foundation/DACS 2022

Frontispiece: Philip Guston, *The Mirror*, 1957. Oil on canvas, 172.8 × 153.6 cm. © The Estate of Philip Guston. Courtesy Hauser & Wirth. Digital image: The Guston Foundation

Brandon Taylor is Professor Emeritus of History
of Art, University of Southampton, and Visiting
Tutor in History and Theory of Art, Ruskin School
of Art, University of Oxford. His previous books
include *Art Today*; *Collage: The Making of Modern Art*;
After Constructivism; and *The Life of Forms in Art:
Modernism, Organism, Vitality*.